THE FLOW OF ART

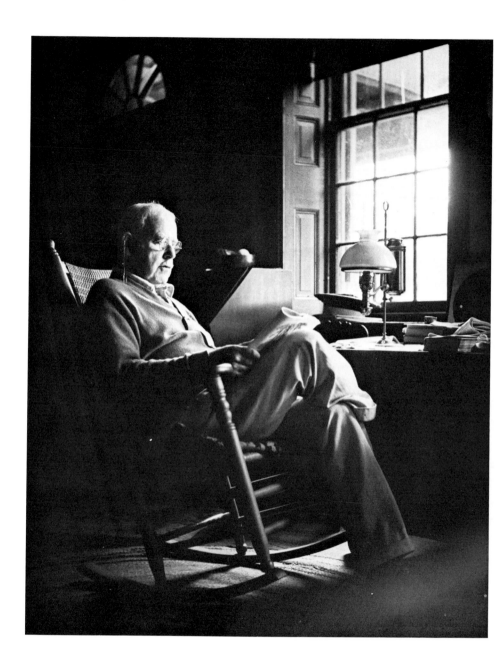

THE FLOW OF ART

Essays and Criticisms

of

Henry McBride

Selected, with an Introduction, by

Daniel Catton Rich

Prefatory Essay by

Lincoln Kirstein

A *Chancellor Hall* BOOK *published by*

ATHENEUM *PUBLISHERS*

NEW YORK

CONTENTS

The articles reproduced are of the McBride collection in the Collection of American Literature, Beinecke Rare Book and Manuscript Library, Yale University, New Haven, Connecticut.

1920 - 1928

1929 - 1938

1939 - 1952

Illustrations between pages 244 and 245

THE FLOW OF ART

A QUASI-PREFACE

HENRY McBRIDE

BY *Lincoln Kirstein*

ANY ATTEMPT to equate a man's taste, the quality of his imagination, the extent of his influence, in visual terms, must fail. Assuming that one could borrow all the pictures and sculpture he particularly liked, even pictures and sculpture of exceptional merit, the objects themselves remain disinterestedly beautiful and seem to have no special connection with one man's position except that (like many others), he loved them. But when one looks at the objects and thinks of the particular man in terms of time, a connection grows. Understood as objects chosen by their early, and in this country, often their initial, champion, something of his position emerges. Something, but something only. For the valuable position of Henry McBride as critic depends upon his persistence in time, and his insistence over extended time on certain elements of freshness, elegance and humanity which are exemplified in the works of art arranged here in his honor.

He was born in West Chester, Pennsylvania in 1867. After graduating from local public schools, he illustrated seed-catalogues for the George Achelis Nurseries. This was scarcely inspiring and he came to New York to study at the Artists and Artisans Institute under John Ward Stimson, an erratic teacher, but something of a provincial genius. Stimson was an early American admirer of William Blake, an enemy of John Sargent and both Academies, National and Royal. Later, McBride worked at the Art Students League. After his formal training

This essay is reprinted with the kind permission of Mr. Kirstein and the Knoedler Galleries. It was written as an Introduction to the catalog of an exhibition made by the Galleries in 1947 honoring Mr. McBride.

3

as painter, he inaugurated the Art Department of the Educational Alliance at East Broadway and Jefferson Street, which he directed, as well as teaching life-drawing, for five years. At the same time he was the Director of the School of Industrial Arts in Trenton, New Jersey, where he worked three days a week, during the same period.

I recall an incident connected with my work (at the Educational Alliance), which may interest you (Mr. McBride wrote in an autobiographical sketch for the *Sun* in 1931). This was my meeting with the late Andrew Carnegie. The iron-master had been inveigled into the building in the hope that he might become interested in the work and possibly contribute to its maintenance. In the course of his inspection he was brought to my 'life-class,' and asked me what the students hoped to be. I answered that all sought professional careers. Suddenly, and to my surprise, the great Andrew pointed to one of the men and said: "That one. What does he expect to be?" And I replied: "He is already an exhibiting artist in the galleries up town." He had pointed to Jo Davidson, thus again justifying the Carnegie reputation for picking talent!

Among others that McBride taught in these days were the painters Samuel Halpert and Abraham Walkowitz, but after five years he was driven to feel that, by and large, at this state of our historical development, although many Americans possessed talent, few had drive. He stopped teaching and passed much time abroad, mainly in England, France and Italy, where he began to consider writing as a profession. He actually came to be an art-critic in a roundabout way.

Sometimes it seems only yesterday (this in 1931) that I climbed the two flights of wooden stairs in the Old *Sun* building on Park Row to interview Chester Lord and seal the agreement between us. I account for the difference between real and apparent time by the swiftness with which Thursdays (press-days) reappear. Thursdays follow each other just like minutes in the lives of ordinary people. It was their extraordinary frequency that first gave me an inkling of what Prof. Einstein's relativity was all about. If you have any doubts about that theory, try art criticisms for a year or two and it will become clear to you.

Mr. Lord's instructions to me were comparatively simple. About all he said to me was: 'Don't be highbrow.' The late Samuel Swift and I had followed James Huneker in the art department, and it was Mr. Swift who was to be highbrow and I was merely the humble assistant. But during that first winter (1913), Mr.

Swift and Mr. Reick, who was then *The Sun*'s owner, disagreed about something and suddenly, and in spite of Mr. Lord's warning, I was obliged, as Frank Sullivan would say, to shift my brow 'into high.' I was left in command of the department and made responsible for the activities of about a hundred art galleries. It was then that the calendar speeded up and the whole week melted into a succession of Thursdays.

However, for two years, McBride's notices remained unsigned. Then, for no apparent reason except that a copy-boy attached his already familiar name to some copy, or forgot to remove it before handing it to the press, upon returning from Europe to his winter's duties, he found that he had acquired a by-line, which has, in the subsequent thirty years become as familiar as many metropolitan landmarks.

Mr. McBride was involved in the progressive movements of his epoch long before they had been (in Auden's phrase), tidied into history. In 1913, for example, he pounced on a portrait by Thomas Eakins in the 'morgue' of the National Academy, a small room chiefly dedicated to failures. His enthusiastic discussions of this picture with Bryson Burroughs (an intimate friend), had much to do with encouraging him in undertaking the large Eakins retrospective show at the Metropolitan which, of course, was the starting point of Eakins' modern fame. McBride was perhaps the first critic to call Eakins "great," at first causing some dismay among his Philadelphia friends. He wrote at the time of the Metropolitan exhibition in *The Sun,* 1917:

Eakins is one of the three or four great artists this country has produced, and his masterpiece, the portrait of Dr. Gross, is not only one of the greatest pictures to have been produced in America but one of the greatest pictures of modern times anywhere.

In February, 1922 in his regular *Dial* commentary, McBride compared Eakins with Melville, an astute judgment (made on the heels of the first complete Constable edition and Raymond Weaver's pioneer biography). His reference and correspondences ranged far, like those of his critical masters, Heinrich Heine and Charles Baudelaire, two great poets whose records of the annual Salons of the mid-nineteenth century (together with Ruskin), mark the peak of modern art-criticism. And like Heine and Baudelaire, both of whom de-

fined a spiritual dandyism, and could surprise magic out of the ordinary in rehabilitating the commonplace, McBride became the friend of poets and painters. He. met Gertrude Stein through Mrs. Bryson Burroughs, and as early as 1913 suggested that Miss Stein's peculiar plays (in prose ? in verse ? in what ?), be publicly performed. He tried to have the actress Minnie Ashley (Mrs. William Astor Chanler) perform them in New York. He told Miss Stein that they were rather static, and could be improved by a stage-direction imitating the poses in stained-glass windows. The poet agreed. McBride's idea was prophetic of the hieratic production of *Four Saints in Three Acts* many years later. The New York production did not come through; McBride then suggested they be done at the San Francisco World's Fair of 1915. He wrote her August 28, 1913:

> The San Franciscans would love to be up to date, or a little ahead of it. Like my friend Mr. Polk (the Fair's Commissioner), I should like to keep up, too. . . .*

He counted on Miss Stein in Paris to keep him informed of developments for New York, from where he wrote her on December 12, 1913:

> I hoped to keep your good opinion and I was afraid you might not, after all, know me well enough to allow me to be both gay and serious at the same time. In this country of rural pedagogues and long-faced parsons, to laugh at all is to be thought frivolous. I laugh a great deal (so do you). I laugh like an infant at what pleases me. Americans as a rule laugh bitterly, at what they hate, or at what they consider misplaced.

Gertrude Stein prevailed upon Ambroise Vollard to send McBride his big life of Cézanne. In her *Autobiography of Alice B. Toklas* she acknowledged the service:

> There were Cézanne's to be seen at Vollard's. Later on Gertrude Stein wrote a poem called Vollard and Cézanne, and Henry Mc-Bride printed it in the New York *Sun*. This was the first fugitive piece of Gertrude Stein to be so printed and it gave both her and Vollard a great deal of pleasure.
>
> McBride also devoted a large Sunday article to the Vollard biography, and much of our local general interest in and influence of the Master of Aix dates from this notice.

The friendship with Gertrude Stein, dating from 1913, was the occasion of a full and charming correspondence, fortunately preserved in the Collection of American Literature in the Yale University Library.* In 1916, Miss Stein composed *Have They Attacked Mary. He Giggled.* (A Political Caricature). It was first printed by the late Frank Crowninshield, editor, in *Vanity Fair* (June, 1917). He had been introduced to Miss Stein's writing by McBride. For reasons of space, thirty-five lines were omitted. It was later reprinted, complete, as a pamphlet, with a woodblock frontispiece, a portrait of McBride, by his friend, the painter Jules Pascin. A note stated:

It has been referred to as a 'portrait' of Henry McBride, art critic. It is in fact a genre picture and Mr. McBride is but one of the personages.

In *Have They Attacked Mary*, each paragraph is given a page numbering, thus:

page xxv
What can you do.
I can answer any question.
Very well answer this.
Who is Mr. McBride.

page xxxi
I cannot destroy blandishments.
This is not the word you meant to use. I meant to say that being indeed convinced of the necessity of seeing them swim I believe in their following. Do you believe in their following.

page xxxii
Can you think in meaning to sell well. We can all think separately. Can you think in meaning to be chequered. I can answer for the news. Of course you can answer for the news.

page xlii
You say he is that sort of a person. He has been here again. And asked about pitchers.

This indeed was a genre picture, a portmanteau composition of picture-dealing, art manipulation, the salon world of Miss Stein's domesticated power-politics during the first World War. The other personages were Miss Stein and her friend Mildred Aldrich, author of *A Hilltop on the Marne*, one

of the great popular patriotic successes of the day. The ladies considered the war in a fiercely proprietary fashion; although McBride was long past military age, and America was not yet in the war his presence in Paris, out of uniform rankled them, and this, too, emerges from the portrait. But McBride was philosophical, even about his friends, and wrote of war and patriotism in his note on Claggett Wilson's battle pictures, in 1928.

> . . . as an American critic of art I have objected strenuously to foreignness in our native artists. . . . Yet just the same I make exceptions. When it appears to be "plus fort que moi" I have nothing to say. I have never thought it worth while to point the finger of scorn, for instance, at Mary Cassatt or Walter Gay, both of whom gave themselves up into such an wholesale admiration of the French that the French ended in claiming them to belong to French schools. They took their "bien," like Molière, where they found it and with a vengeance.
>
> . . . At the same time he (Claggett Wilson) fought with the American forces; and the soldiers in his drawings are our soldiers and this is "our" record of it. If there is anomaly here, make the most of it. For my part, I prefer to side-step, for twenty years or so at least, all these questions pertaining to the exact ratio of innate patriotisms. According to the slang of the day, one is either one hundred per cent or one is not one hundred per cent. There are no gradations, so they say at present, yet "they" are often wrong and probably are in this matter. At all events, it is one of those things that the future decides, like the Germanism of the Heine who lived in Paris years ago, and which has now been arranged to the satisfaction of all concerned. Probably Claggett Wilson found himself in the war as Heine found himself in Paris – with mixed feelings. It was just this equal balance between the "for" and the "against" that is responsible for his tinge of Spanish. . . .

In 1920, McBride became the art critic on *The Dial*, which had been recently bought and entirely reorganized by Schofield Thayer and Dr. James Sibley Watson. For nine years *The Dial* would maintain a distinction of artistic and literary values unequalled in America, before or since. Dr. Watson recalls the association:

> In 1920 when we had the happy thought of asking Mr. McBride to be our chronicler of modern art, his critical writings in the New York *Sun* were much admired and had been for some time. They revealed a spontaneous gift for gentle kidding, together

with wonderfully complete information, amiability, and good sense. As we found out later he was and is the most unegotistical of writers; if he sometimes lost patience with the *Dial* management, they never knew it.

I remember the interview when Schofield (Thayer) made Mr. McBride one of his elaborately persuasive editorial propositions. It needed to be elaborate, for as it turned out we were asking him to find time to write for us every month for nearly ten years. The editors never stopped congratulating one another on his having accepted.

Mr. McBride's first article (July), covered the Walter Arensberg collection of classic cubist masters, as classics, even though they were then only installed in an apartment on West 67th Street, where he went with Marcel Duchamp. He also added a charming story of Albert Ryder and Kahlil Gibran; he noted in William Gropper here at last was one American cartoonist who looked better in reproduction than in his originals; hence his success. McBride's informal, informative, yet carefully conceived *Dial* articles remain unmatched in this country for their charm, perception and urbanity. They should be collected (together with others from *The Sun, The Arts* and *Creative Art*) to instruct a generation which has not known the rewards of courage and cultivation. Miss Marianne Moore, *The Dial*'s ultimate editor, has described the magazine's attachment to McBride with her unique, though perennial precision and gusto:

With regard to Mr. McBride and his Modern Art commentary in *The Dial,* mere fact in the way of editorial gratitude has the look of extravagance. It is hard to credit Mr. McBride's innate considerateness as synonymous with his unfailing afflatus, thought so substantial as coincident with gaiety, and so wide a range of authority as matched by ultra-accuracy.

Each month, usually in the morning, Mr. McBride would bring his three pages of Modern Art commentary to *The Dial*, visit without hurry, but briefly, and infect routine with a savor of hieratic competence. The word 'competent' may have connotations of mildness, but not in this connection. Mr. McBride and insight are synonymous. You may have gone to the fair and come away with a gross of green glasses but not Mr. McBride. As he said of Elie Nadelman: "Directly in proportion to the vitality of an artist's work is the reluctance of the public to accept it."

You may have premonitions but Mr. McBride has the data, is succinct and matter-of-fact, — be your investigations in what field they may —: houses, furniture, dress, printing, painting, dancing, music, verse, sculpture; the camera, movies, the drama. Wit that is mentality does not betray itself and Henry McBride is adamant to the friend of a friend desiring encomiums.

He is not susceptible to self-eulogy. Where feeling is deep it is not a topic. Reverence that is reverence is a manifestation, as has never been proved better than by Mr. McBride.

Running through the bound volumes of *The Dial* today, it is difficult to realize that thirty years have passed. McBride's articles for the first three years alone give vital indication of the bearing of his mind and eye (entirely apart from his weekly stint on The *Sun*). For August 1920 there is a striking appreciation of Elie Nadelman's sculpture; together with Martin Birnbaum of Scott & Fowles, he was the first American critic to estimate this great artist at his just value. For September there was a delicious disagreement (and agreement) with Plato; for October, a fair statement of Gauguin's rebirth; for November, a subtle critique of The American Shyness (or Henry James and American portraiture; how James was what Sargent was not). For December, he wrote in words which only this year acquire the full measure of their modest irony, on the occasion of the first Van Gogh show in America (at Montross):

It does not now appear likely that the Metropolitan Museum will ever own as representative a group of his paintings as it does, say, of Manet.

In March, 1921 there was a splendid description of Rousseau's "Sleeping Gypsy." He had already long been the friend and admirer of Hartley, Demuth and Marin. Stieglitz said later that it was McBride who put Marin "on the map." With admirable restraint McBride wrote of Stieglitz (April, 1921):

To say that Stieglitz portraits go beyond, or even come up to the wonderful daguerreotype portraits taken by Lewis Carroll (the Alice-in-Wonderland Carroll) in the early days of the art, would perhaps be to say too much, (I myself have not given up the use of

the word 'art,') but to recall photographs to the essential powers of
the camera as he has done is a great deal.

Of John Marin, and the violent initial reaction to his early
and greatest watercolours McBride wrote in March, 1922, part
praise and part prophecy.

The antagonism to Marin is the more curious in that, strictly
speaking, he is not an innovator. He seems to grow more and more
abstract as he grows older, but he is not the first to be abstract nor
is it the fact that he is abstract that makes him notable. First and
foremost he is a poet who is stirred at times to emotional heights.

In April 1922, he described the show of Brancusi at
Brummer's with lapidary grace.

A head in this collection and a hand, both evidently late
'releases,' have the air at first glance, of having been polished by
the sands beneath the sea for ages, like certain antiques that have
been rescued from ancient waters with surface details polished
off, but all the essential virtues intact. There is something ineffably
precious and tender about these pieces and the workmanship in
them is beyond anything hitherto encountered.

In Paris once, Marcel Duchamp and Madame Picabia
were taking McBride to dine chez Brancusi, whose reputation as
a chef only equalled that of his stonecutting. But McBride felt
sick, unto death, and begged off. Duchamp said: "You'd better
come along; you can die any time." Cured by Brancusi's cui-
sine, McBride remarked that he, too, had his two or three
specialités. "Oui," said Brancusi, "comme les artistes mo-
dernes."
 Lachaise, McBride had first admired at the Bourgeois
Galleries in 1918, particularly in the large figure of a man
holding a woman in his arms, which the sculptor destroyed
in plaster, in discouragement as the perennial difficulties he
had, even maintaining a permanent studio. Later Lachaise did
McBride's bust, in gratitude, and every year, in spite of La-
chaise's extreme penury, he and his wife invited McBride to a
ritual dinner at the Lafayette, afterwards repairing to Ma-
dame Lachaise's apartment for hours of talk, which the critic
still recalls as so exalted, on such a lofty plane of abstraction

and penetration that it made him proud that he belonged to his profession.

And naturally day in and day out, week in and week out, year in and year out, all art-events were not of the same high interest. He would patiently write in *The Dial*, January 1923:

> The passions were not excited by the art shows of December (1922). There seemed to be no occasion to send a telegram to Charlie Demuth, at Lancaster, Pa.: "Mustn't Miss It. Come At Once," except possibly in the case of his own show at Daniel's and that of course he had seen already.

Demuth was a particular friend and favorite. McBride wrote often of him, perhaps never so suitably as in *Creative Art*, September 1929:

> The fuzzy bloom of the peach, the glittering polish of the aubergine, the controlled richness of the opulent zinnias, all these and other such splendours from the vegetable world inform the new Demuth water-colours with a style that it rejoices one to see appreciated.

McBride eventually assumed the editorship of *Creative Art*, which at first had been little more than an American supplement for the London *Studio*. He followed Lee Simonson, and in taking over his new duties, wrote to an audience already familiar with his "Palette Knife" praising Simonson as "a reformer," but making a personal distinction. He himself was no reformer:

> I like the world far too well to wish it changed in any of its essentials. But if I work on one principle more distinctly than another it is aiming at frankness rather than infallibility. "Being right" is lovely but it is not a condition that even a critic arrives at unaided. His chief business when confronted by a new problem is to think it out as best he may and then entrust it fearlessly to the public that in the end is the true arbiter of values.

While disclaiming the ambitions of a reformer and always preferring an almost anonymous and rambling easy tone, underneath it all there is always a seriousness masked by a modest mockery. Elizabeth Luther Cary noted this best of anyone in her appreciation of Mr. McBride when he retired from *Creative Art*, due to ill-health in December 1932.

... Mr. McBride, beyond contradiction is a moralist. He might deny it, although he has cheerfully acknowledged himself a sentimentalist, which he is not. It is not only his sense of humor that imperils our understanding of his moral outlook. It is even more the fact that his own understanding of morality is more penetrating than most that find their way into the periodicals of the day, especially those that deal with art. ...

Mr. McBride, in "The Palette Knife" editorial section of *Creative Art* made his attitude towards morality quite clear, although it always remained implicit. It would be illuminated in little bursts, as exemplary notices of passing events, but his system was as orderly as a philosopher's, and when his scattered writings are brought together they could easily be grouped under the headings of: The Critic, The Artist, the Public (or Society). In December 1931, he wrote:

It may be an unpleasant fact, but it is a fact nevertheless that fifty years hence but a scant half-dozen of our living artists will be remembered with interest. It is a museum's first task and a contemporary critic's first task to be as right as possible about these half-dozen representative artists. ... The gift of prophecy is not an endowment of the expert. Expertism operates on the past, not on the future. Prophets and seers are apt to be fakey and I believe the police are quite right in chasing them from our midst.

And he was rarely afraid to formulate a careful, light but nevertheless, when read aright with the full knowledge of his habitual courtesy, crushing judgment on influential individuals, with the full realization that he was exposing, first and foremost, himself. In April, 1931, even in the respectful atmosphere of *nil nisi bonum,* he could say:

The thought of Ruskin's error (in the case vs. Whistler) is enough to stay any critic's hand, but *que voulez vous?* — the moral of that affair was this: that it is the people who decide; and so I am fortified to put another unpleasant question up to the people. It becomes my painful duty to confess that, in my opinion, the memorial show to the work of the late Robert Henri at the Metropolitan Museum is not a triumph.

Nor was he easily taken in by the perennial dilution of art by the pressure of extraneous events, which sometimes

produce polemic, at others caricature, but rarely fine painting. Diego Rivera, the weakest of the famous Mexicans of the Thirties, but at the time the first to be well-known here, painted some cursory frescoes of a portable and ephemeral nature at the time of his show at the Museum of Modern Art. One showed a flop-house over a bank-vault. Wrote Mr. Mc-Bride in February 1932:

I believe I am as horrified as any man at the thought of the discomforts of the poor, but I don't seem to be outraged with the city's attempt to give them a shelter for the night. I am not at any rate outraged by Rivera's documents. They seem unofficial and second-hand. They seem to be the fruit of too much reading in the communist newspapers in the railroad train on the way up — a preconceived notion of "seeing New York" rather than a matter of personal observation. And New York, like Mexico can only be properly shown up by some one who has it in his blood. . . .

I admit that it is not as thematic pictorially as it might be, yet just the same, our life has its moments. How electrified we might have been, had Rivera chosen instead to do a fresco of our handsome Mayor Walker hurling defiances at the Seabury Committee from a cactus garden in California . . . or Miss Belle Livingstone triumphantly receiving her friends after a month's stay in jail for the most popular infringement of the law that we have.

Robert Chanler had just died, and with him a whole chapter of frontiersman flamboyance in American Bohemia. McBride wrote a generous epitaph, defending Sheriff Bob's famous, or infamous all-night routs on East 19th Street.

It is not so much that artists are to be immune to the law, like the ancient aristocracy of England, but that they can only arrange their systems of values in a state that gives them complete liberty. Artists approach morality through beauty, and if they are good artists find both; but people who have no eyes for beauty are incapable of judging their processes until, as I have pointed out, history has enabled them to take a more generous attitude. My present argument is simply this: why should you postpone generosity to artists since you must yield it in the end?

Robert Chanler painted McBride's portrait (now lost) and others who had him pose, besides Pascin and Lachaise, were Florine Stettheimer and Virgil Thomson. Miss Stettheimer indicated for a background palms in a Winslow Homer hurri-

cane, Marin's lower Manhattan skyscrapers and the international tennis matches at Seabright, New Jersey, since Mc-Bride was passionately interested in the game and particularly admired the *trois mousquetaires,* Cochet, Borotra and Lacoste. As for Thomson, McBride had written Gertrude Stein (May 20, 1929), on hearing the first audition of *Four Saints in Three Acts,* which had taken place in the Stettheimer studio, adorned with Nottingham lace and silver lilies which would become incorporated into the magnificent scenic investiture of the opera five years later:

But young Virgil Thomson really is a wonder. I never saw such self-possession in an American before. He is absolutely unbeatable by circumstance. When singing some of the opera to me he was constantly interrupted but never to his dis-ease. He would stop, shout some directions to the servant, and then resume, absolutely on pitch and in time. We all pray that the opera will be given. . . .*

Mr. Thomson is famous for his musical renderings of his friend's psychological characteristics. When Mr. McBride went to pose, in the ample salon of Mrs. Kirk Askew's in the East Sixties (in the mid Thirties), Thomson placed him in a comfortable chair. McBride took a book, commenced to read, silently. "Perhaps Virgil would like to have been interrupted, but I didn't." At the end of the portrait there is a brilliant tennis game, perhaps a reference to the Seabright matches in the Stettheimer picture. When McBride was played the finale, which enchanted him, he said: "Evidently, I won the game." Replied the composer, "You certainly did."

Mr. McBride closed his tribute to Florine Stettheimer in the catalogue of her memorial show at the Museum of Modern Art in 1946, with these words:

Now what pleases the 'discerning few' can please the general if the general be given a chance at it. In art, as in religion, the public finally arrives at the true values. You remember in *The Brothers Karamazoff* the old priest's dying admonition to the younger men: 'Give them the Bible. Do not think they will not understand.' Nothing that is worth while is above the public comprehension. There are no closed doors to opinion and certainly there is no class distinction in thought. 'What Plato has thought you can think. Shelley told one of his friends that he 'wrote for only six people,' Gertrude Stein told me personally in 1914, 'but

I'd like to be acknowledged and have my books on the bookshelves like other writers.' At a time when no one else in England thought much of William Blake, Charles Lamb said: 'But there is really something great in "Tiger, Tiger burning bright."' The six people who believed in Shelley, the six who believed in Gertrude, the six who believed in Blake have all had followers. The first step in acquiring fame is to obtain the six believers. . . .

"What Plato thought you can think." Certainly: as soon as Plato thinks it, but in the time afterwards taken to think it, too, — lies the tragedy. The battle against the time-lag in appreciation of arts and letters has been one of the big actions of our anxious epoch. A tuck in time, we tell ourselves, might have made Shelley an old man, made Blake's hell easier, stopped Van Gogh from gunshot or Lachaise from fatal frustration, made Nadelman appreciated in his fullness, or Eakins at the end of his long life. Today, as never before, museums and dealers do their busy, useful work, almost as if they were making up in guilt, for lost time. But Time still remains unimpressed and allows its own disinterested time to be taken. Artists who are hopefully 'discovered' rarely make up for those who are forgotten or remain to be uncovered, or set in their true stature. Today it is still easier to have six hundred, or six hundred thousand people admire a peripheral personality than to have six poets or critics define the figure, estimate it, fix it, as did Heine and Baudelaire, for Time's ultimate acceptance. For forty years Henry McBride has been one of the half dozen serious writers in America who has humorously drawn time's attention to half a dozen serious artists.

* Courtesy of Collection of American Literature, Beinecke Rare Book and Manuscript Library, Yale University.

Introduction

THE ART CRITICISM OF

HENRY McBRIDE

IN 1913 when Henry McBride climbed the two flights of wooden stairs in the old building on Park Row to take a job on *The New York Sun*, he was forty-six years old. So far he had done little writing on art. Born in Westchester, Pennsylvania, he came from Scottish and native American stock. His family were Quakers and he was brought up frugally. His first employment, at the age of about eighteen, was in a local nursery. Significantly, this job displayed two of his talents. He could draw and he could use words and soon he was illustrating seed catalogues and writing copy and characteristically saving money to study art. In 1889 he came to New York with two hundred dollars and enrolled in the Artists and Artisans Institute. Its superintendent was a somewhat advanced figure for his day, Professor John Ward Stimson. Stimson stressed not only drawing and painting but design in the nineteenth-century meaning of the word – applied pattern, tying in with the traditions of Ruskin and William Morris. More important, he tried to instill a sense of independence and excitement into his students. His teaching on color was ahead of his time as was his unacademic insistence on the connection of art with life. McBride was an apt pupil and in 1892 received an enthusiastic testimonial letter from Professor Stimson.

Summers, McBride spent in Pennsylvania with his relatives, walking the Brandywine Valley, painting and sketching. He was always to have this need for nature, a desire to get out of the city from time to time and return to the landscape where he was born.

In 1893 the World's Columbian Exposition burst upon the country. McBride travelled to Chicago and saw the "City White," that plaster extravaganza on the Midway which Burn-

17

ham and his crew of eclectic architects had spread before the
astonished gaze of Mid-Westerners. Amid the acres of academic
painting he undoubtedly noted the brisk canvases of Zorn
(local critics dismissed them as "loose" — almost a moralistic
judgment) and dazzling portraits by Sargent. Did he venture
into the Women's Building with its strung-out mural by Mary
Cassatt and did he pause before Louis Sullivan's golden Trans-
portation Pavillion, the one piece of original architecture in the
Fair? He did become entranced with Javanese art and he did
save money, about three hundred dollars, put aside to visit
Europe the next year.

His first trip to Paris at the age of twenty-seven was to be
one of many. Out of them came an early article on Puvis de
Chavannes. He was now teaching at the Artist and Artisans
Institute but pay was small and he tried his hand at writing.
Rejections and some slight success. McBride practiced literary
skills through an art almost forgotten today — letter writing.
Abroad he wrote to his kin in Pennsylvania and to a few
devoted friends. His style was easy, his interests wide and from
the first his word pictures of places and people showed a
trenchant sense of humor.

In 1900 he joined the staff of The Educational Alliance, a
lower East Side settlement house. There he taught among
others, Walkowitz, Samuel Halpert, Jacob Epstein and an "un-
ruly" boy of twelve who was to become the sculptor, Jo David-
son. His interest in the poor of New York may have reflected his
Quaker's conscience. At least it furnished him copy, sometimes
accompanied by his own sketches for a stray article in a
magazine or newspaper. Now in 1901, the Director of the
School of Industrial Art in Trenton, he wrote his first serious
criticism of painting on two pictures by Manet in the Metropoli-
tan Museum.[1] In it he frankly admitted that he could not ex-
plain why Manet's "Girl with a Parrot" should be admired but
that he admired it all the same.

During these early years McBride was broadening his
horizon. A strong admirer of Ralph Waldo Emerson he prac-
ticed his own brand of self-reliance. He taught himself to read
and speak French. He devoured novels, philosophy, poetry,
history, belles-lettres. He went constantly to the theatre and
to opera. Making repeated trips abroad, he walked and sketched

1. "The Two Paintings by Manet at the Metropolitan Museum,"
Alliance Review, Vol. I (No. 1, April)

through England, Belgium, Holland, Germany, Spain and North Africa. In 1907 he met the Bernard Berensons in Florence. He dined with the brilliant critic of Italian painting and took a special liking to Mary Berenson, his wife. In 1910 he was taken by Roger Fry and Bryson Burroughs to visit Matisse in his studio. As a child he had no doubt that the greatest picture in the world was Raphael's "Transfiguration." Now coming across the painting in Rome – years later – he was astonished at his feeble interest in the original. It was probably at that psychological moment he felt that he became an art critic.

All these experiences of travel and contact with personalities in the art world prepared him for the role of a newspaper reviewer in New York in the fateful year of 1913. In February, soon after McBride was hired by the *Sun*, there opened at the 69th Regiment of Infantry building, the notorious Armory Show. Organized by the Association of American Painters and Sculptors, it started as a worthy attempt to acquaint the city with some of the new experiments in European art along with works by American artists of liberal tendencies. Arthur B. Davies, Walter Pach and Walt Kuhn were among its organizers and before they knew it, they had assembled a vast display of violent and exciting importations from the Continent. This European section became the Trojan horse of the Armory Show. Here by comparison, the Americans appeared timid and provincial. Modern art had come to America with a vengeance and the public was shocked and horrified. Marcel Duchamp's "Nude Descending a Staircase" was surrounded by laughing or furious visitors and even Theodore Roosevelt was heard to mutter something about "the lunatic fringe."

During this art scandal the *Sun* kept fairly cool. In the articles which McBride contributed (then unsigned) along with those of his friend and chief critic of the art page, Samuel Swift, the tone is moderate and informative. Until recently the paper had enjoyed a notable writer on art, James Huneker. Primarily a music critic, Huneker also concerned himself with literature and painting and in 1910 had published a volume, *Promenades of an Impressionist* in which his admiration for Degas and Monet and Renoir were cogently expressed. But Huneker had balked at Cézanne, "crude, ugly and bizarre canvases . . . the results of a hard-laboring painter without

taste, without the faculty of selection, without vision, culture —
one is tempted to add intellect . . ."[2]

Samuel Swift resigned and McBride was promoted — but
anonymously. At first his articles ran without a by-line. Then,
by a curious quirk of fate, a typesetter included his name
and from then on the page was signed. In the first article
published under his name he took up where Huneker had
left off. The Metropolitan Museum had purchased a mild
Cézanne, "La Colline des Pauvres" from the Armory Show and
McBride devoted a long understanding column to the artist.
As the furor over Cubism continued, he made gentle fun of
the senseless battle. Admitting that he had known little of the
movement before the recent exhibit, he solemnly reported the
hysterical outpourings of Kenyon Cox in Philadelphia and
followed Cox by printing a little piece by Gertrude Stein.

Without planning it — or recognizing it for some time —
the Sun had acquired a critic who would soon become known
as perhaps the leading journalist to write winningly, as well
as convincingly, on modern art. McBride handled a host of
other exhibitions: old masters, Persian miniatures, medieval
sculpture, nineteenth-century etchings, the menu is long and
varied but his emphasis on contemporary painting is consis-
tent. In some ways he was ideally fitted for the job. He had a
direct pipeline to Paris where modern art had been born and
was flourishing. Gertrude Stein put him in touch with Picasso,
Braque and Juan Gris. He was in Paris when the war broke
out and managed to get back to New York at the end of
August, 1914. He returned to Paris in 1915 for two months,
June and July, as a war correspondent for the Sun and met,
among others, Raoul Dufy. Luncheon with Dufy, on leave from
the front, is revealingly set down in one of his lengthier col-
umns. Besides painting, McBride was familiar with other
avant-garde experiments. He knew — and corresponded with —
Guillaume Apollinaire, the poet, an early enthusiast of Cubism,
and read widely in contemporary French letters. He attended
concerts of "new" music and "new" ballets and plays by young
playwrights. By 1915 when Vanity Fair published its honor role
of eight established American art critics, McBride was among
them, no small recognition for one who had entered the field
only two years before. In 1917, McBride received from Ger-
trude Stein a poem, "Have They Attacked Mary. He Giggled,"

2. London, 1910, p. 4

which he took to his friend, Frank Crowninshield, the lively editor of *Vanity Fair*. Crowninshield decided to publish it and it appeared in the June issue.[3] It was said (McBride never denied it) to be a portrait of McBride, himself. It seems to have been the first serious publication in an American magazine of any of Stein's work.

An invitation to join the staff of *The Dial* in 1920 made by its two young editors, Scofield Thayer and James Sibley Watson, allowed McBride to write a monthly essay on modern art. Both Thayer and Watson were crusaders. They bought up the assets of the old *Dial* (which had started out in the 1840's as the organ of the Transcendentalists, edited by Margaret Fuller and Ralph Waldo Emerson, and more lately had turned into a political and social review). They transformed it into a magazine devoted exclusively to "the best in all the arts." This meant "the best in both the accepted and unconventional forms of expression without prejudice to either." The new and old in America were to be placed next to the new and old produced abroad. For nine years *The Dial*, in its handsome format designed by Bruce Rogers, combined some of the best of contemporary literature with reproductions and criticism of contemporary art. McBride was not the only writer on art. Roger Fry, wisest of the formalist critics, and Thomas Craven, heavy-handed and often opaque, were occasional contributors but only McBride was given a monthly spot in this publication.

Taste in America was broadening. After the end of the First World War, a new tolerance towards modernity in the arts was apparent. The old isolationism in culture was disappearing. There was curiosity and even satisfaction with the new and foreign. In painting this meant catching up with masters like Cézanne and Van Gogh and Seurat and reporting on what was going on in Paris at the moment. The *Société Anonyme*, captained by the resolute Katherine Drier and advised by that international superstar, Marcel Duchamp, not only collected fascinating samples of "the new tendencies" but was on the alert for any defense of modern art. In 1923 a group of McBride's articles in the Sun from 1915–1922 were gathered into a publication by Duchamp who designed, as well, its eccentric format, a type of loose-leaf notebook, which has,

3. Vol. 8, no. 4, p. 55. Thirty-five lines were omitted in this publication. Later the entire piece was reprinted in a little pamphlet with a cover from a design by Pascin, a portrait of McBride

somehow, the air of one of Duchamp's "ready-mades."[4] The
effect of this jumble of articles is not altogether happy. There
is considerable repetition and good things are lost in the
design of the publication, which, in reproducing McBride's
actual newspaper columns, makes reading difficult. As propa-
ganda for modern art it was undoubtedly astute.

Part of McBride's significance today lies in his early
recognition of talent. His writings should be read in relation
to the years when they were first published. For this reason,
I have arranged them chronologically in this volume. It was
not enough for him to expound the virtues of Matisse, Picasso
and Braque. He chose to defend Léger, for many a difficult
artist, and from the first he championed Stieglitz and his group,
particularly Marin, Demuth and Georgia O'Keeffe. He under-
stood Max Weber's gifts and deplored his unpopularity. In
1928 he saw his first Mirós and was immediately converted.
He spotted Gorky at his original New York showing. From
Hopper's first etching exhibit he understood that artist's quali-
ties ("composed with a sense of dramatic possibilities of
ordinary materials"). Mark Tobey, Eli Nadelman, Stuart Davis,
Joseph Stella – these and many others were quickly identified
as significant. Of course, McBride was not the only writer
on art in America to favor modernism. Charles H. Caffin,
Sadaikichi Hartmann, Frederick James Gregg and Forbes Wat-
son, among others, stoutly attacked American provincialism
and wrote warmly of modern artists abroad and at home. But
as one turns the yellowing pages of the *Sun*, one is struck by
the absolute rightness of many of McBride's judgments. In
1913, poking about the "morgue," that poorly lighted back
room at the National Academy, he came upon his first portrait
by Thomas Eakins. By 1917 he was proclaiming the painter
of "The Gross Clinic" as one of the four greatest artists America
had produced and in 1923 he put Eakins first in figure paint-
ing. Once it had been Sargent, with Whistler a close second,
but his pleasure in Whistler had evaporated. Beside Eakins,
Sargent now seemed "paltry."

There is another dimension to McBride's criticism beyond
that of spotting – and defending – new talent. He was deeply

4. *Some French Moderns Says McBride*, selected by Marcel Du-
champ, 200 numbered copies. The artists included are: Cézanne, Rodin,
Brancusi, Matisse, Dufy, Signac, Segonzac, Gleizes, Villon, Duchamp,
Gauguin, Picasso, Picabia, Van Gogh, Derain and Marie Laurencin.
(*Société Anonyme*)

interested in the social stage on which contemporary art was played. Next to seeing how he took to pictures he dearly loved, as he remarked, to see how others took to them. In the *Dial* articles he aimed "to touch upon the highlights of the New York season and to give his readers an echo of the talk and opinions that generate when individuals who have access behind the scenes meet." At one time his page in the *Sun* was headed *What is Happening in the World of Art.*

Wryly he observed visitors at an exhibition of Sert: "The Sert crowds I saw with my own eyes and I can certify that they were indeed immense, richly apparelled and awaited without by motors but in the end as completely flabbergasted by M. Sert's art as though they had not been awaited by motors." By 1924 he found the old-time fury against Picasso abating. It was hard for Americans to vituperate anything for two years in succession and it was doubly difficult for them to see immorality in a good investment. It appeared to him that Picassos were going up. By 1926 he found the crowd at the Tri-National exhibition walking about in a reverend manner. This was too much revering for McBride. It was apparent that modern art had now reached the state when it must be protected from its friends rather than its enemies.

Two years later he found that it now took some courage to oppose the art of the great French modernists and that especially toward Matisse the public's attitude had changed. Therefore he was dismayed at the "discreet" audience being entertained in 1930 by Mr. and Mrs. Arthur Sachs in their apartment "hissing" at lantern slides of pictures by Matisse. McBride's reaction was typical: "It is clear that a little more Matisse work needs to be done this winter." In 1948 at a great Picasso exhibit he found an audience of a totally different kind. On the first day the crowds of visitors were mostly savage young artists who would have liked to be Picasso themselves. Many stood with their backs to the pictures, eyeing the visitors menacingly. McBride got the impression if anybody said anything, he would be rigorously pounced upon. But he couldn't decide if it was envy, defense of the movement or a failure to understand the pictures that made them so belligerent. He certainly found anger in the air.

What a valuable account of changing American taste comments like these provide and what lively bits of reporting are McBride's columns on the Brancusi case where the U.S.

Customs at first refused to allow Brancusi's "Bird in Flight" to enter as sculpture but tried to charge duty on it as raw material. One remains delighted at his reactions to the première of the Gertrude Stein–Virgil Thomson opera, "Four Saints in Three Acts" at Hartford.

Not that he did not have limitations. He was primarily a critic of painting and the graphic arts. With sculpture he was less secure. He failed to rise to Giacometti and he had a peculiar, gallant and somewhat misplaced tenderness toward lady sculptors. The names of Edith Woodman Burroughs and Janet Scudder often appear in the early days of the *Sun*, though he justly ignored Malvina Hoffman. When forced to review a huge exhibition by Miss Hoffman in Virginia, he cannily concentrated on what the ladies were wearing and gossiping about – scarcely mentioning her art.

He had a deep distaste for German Expressionism. Max Beckmann he passionately attacked, finding him an "unentertaining and uninstructive Schopenhauer." At first he considered Vuillard and Bonnard unfit for export. Parisians could appreciate their refinements, but not Americans. Later, during the large Bonnard Exhibition at the Museum of Modern Art, he revised his opinion of this artist upward, discovering more than chic in Bonnard's paintings.

It is evident in studying his writings that the period between 1913 and 1930 was McBride's best. One of his last pieces, a short foreword to an exhibition of *"The Dial and the Dial Collection"* at the Worcester Art Museum in 1959, he titled "Those Were the Days" and it is significant that after 1930, some of the élan and drive are missing in his criticism.

The form in which McBride succeeded best was the short essay or trenchant paragraph. He was first and last a journalist, what the French call a *feuilletoniste*. And he needed the work of art, painting, drawing, print or sculpture as a springboard. There is often a striking difference between the freshly observed pages in the *Sun* and the more formal treatment of the same artists in *The Dial*. The *Sun* pages have a spontaneous and vivacious touch which the more structured articles in *The Dial* lack. When McBride attempted a longer, conventional appraisal, as in his monograph on Florine Stettheimer for her retrospective exhibition at the Museum of Modern Art in 1946 or in his little book on Matisse, published in 1930, he was less

successful. He had a clear realization that this was not his métier. "My Matisse book is out," he wrote to Malcolm Mc-Adam, a friend of many years, "and it is terrible. I haven't had the courage to glance at it and it's been in the house four days."[5] The year before he had finished a Matisse essay "in the greatest state of rebellion — for I am an impressionist and I had no new experience to write from. I can't sit at a desk and churn myself into a state of excitement."[6] McBride needed the inspiration of the work of art.

Though he was prophetic in seeing that American art during the decade of the 1930's would gain popularity (and for that he cheered), it took a direction that did not much please him. Determined to be a 100-percenter, he found the proletarian drift of the depression years distasteful. "The determined patriot," as he called himself, was not at home in this drab America. There are contradictions between McBride's taste in art and taste in his pattern of living. Though he resided with Quakerish austerity in one room at the Herald Square Hotel during the season, escaping to the country to a little house he owned in Pennsylvania during the summer, McBride was essentially a conservative in politics and an aristocrat in manner. He had his suits and shirts tailored in London; his shoes were handmade and he enjoyed the social life of New York where he was a welcome guest at the homes of those rich who amused him. In the 1930's he bore down heavily on propaganda in art which he felt was swamping the American scene. True, he could enjoy Grant Wood's "American Gothic" but chiefly as caricature. (Hadn't he written an early article on "The Technical Tendencies of Caricature," illustrated by his friend, Gus Verbeck, the caricaturist?) He tried — during this period — to be fair. Thomas Benton's murals at the Whitney Museum "set his teeth on edge" but he recognized their force. When Ben Shahn showed his series on Sacco and Vanzetti, he acknowledged their validity but disliked their message. His greatest scorn was reserved for Rivera and Orozco. He felt that most of what Rivera had done outside Mexico was "trash" and he dismissed Orozco without, presumably, having seen his murals at Dartmouth.

Frequently McBride was attacked as an "apostate" because

5. Dated February 8, 1930 6. To Gertrude Stein, November 4, 1929

he refused to admire native achievement above French. The record shows that he wrote far more on American art than foreign and was sympathic to many of those Americans we now consider as firmly established. From the beginning he appreciated Charles Burchfield and Stuart Davis. He took up the cause of somewhat neglected painters like Vincent Canadé and Oscar Bleumner. When Marcel Duchamp pointed out Eilshemius in the first Exhibition of the Independent Artists, he took "a second look" at the Mahatma and called him a genuine lyric poet. Walt Kuhn and Reginald Marsh he admired. For Gaston Lachaise he had – from the first discovery – nothing but praise.

From 1930 to 1932 Henry McBride was editor of *Creative Art*. Though he brought distinction to its pages and contributed a section, "The Palette Knife," he was forced to resign at the end of the second year from sheer exhaustion. At that time he was writing 6,000 words a week for the *Sun* and visiting thirty or forty exhibitions. From time to time I would run into him in the galleries, a tall, dignified figure, looking keenly at some picture. His expression seemed skeptical and his sidewards glance is perfectly caught in a caricature by Peggy Bacon.

Strongly opposed to prizes and juries for art, McBride applauded the founding of the Society of Independents in 1917. He looked upon it as a place to express new ideas and to find new artists. Some thirteen years after its first exhibition he found that it had indeed brought a number of unknown talents to public attention. The "new ideas" he remarked dryly "have not been so many or so serviceable." As for the National Academy, he treated it as though it were the skeleton of some prehistoric monster. He walked round it, eyeing it with mock seriousness, constantly ridiculing its pretensions. The comparison between his columns on the Academy and the Independents gives us considerable insight into the vast gap separating establishment art and art free from censorship or constraint.

In 1950, after thirty-six years at the *Sun*, McBride's career at that paper suddenly came to a stop. The *Sun* had been sold and he was not hired by the *World Telegram–Sun*. Almost immediately *The Art News* appointed him to write a monthly page and until 1955 he continued to contribute opinions and reminiscences. From time to time he wrote a preface to a

catalogue and still walked about Fifty-Seventh Street looking for rising talent. In 1952 he was writing sympathetically of Bradley Tomlin and Mark Rothko and he was quick to recognize in canvases by Jackson Pollock of that same year that "he almost alone among the American practitioners of the abstract uses a technique not entirely imported from Europe and – this is the thing the lone watchers of the skies have been waiting for so long – a semblance of a native touch."

By this time he had given up all desire to revisit Europe. As early as 1922 he had found that he simply couldn't stand Paris. There was nothing there, he decided that he couldn't get as readily at home. "Paris is still beautiful," he wrote to Georgia O'Keeffe,[7] but it is a far off beauty of another period that has little to do with this one." After 1937 he never went abroad again.

His last few years were spent philosophically and calmly, tidying up his affairs. Sitting in his favorite arm chair in a sunlit apartment in Peter Cooper Village, he would read from one of his well-loved authors, Henry Adams or Santayana, or pick up a new book by an unknown. By this time his walls were bare of the pictures which grateful young artists had given him. In 1955 they had been sold at auction and he missed the Miró and the Demuth. Looked after by his devoted friend of over twenty-five years, Max Miltzlaff, McBride had finally retired.

For over four decades he had written about art. At times there had been discouragement. Years before he had acknowledged to Gertrude Stein[8] "that the present is black. There seems to be nothing doing in art, and I have the devil's own time in pretending to write art stuff. In fact I don't even pretend. That's why I don't send any of my pages because I know myself they are empty." Again, to Georgia O'Keeffe[9] he wondered if he ought to have written about the theatre instead. It would have been easier and more constructive. "One can do something with the threatre still, simply because so many people follow it."

By now he was the Dean of American Art Critics. The press said so and I can imagine that McBride was amused by the term. He had been honored by an exhibition that showed

7. On July 19, 1922 8. January 5, 1920 9. July 11, 1932

works he had especially admired. He knew that over the years he had seen with the eyes of an artist and had written literate prose, devoid of jargon. He had recorded his thoughts and impressions without a furious rancor. He had made it a point not to bully the public but to lead it gently, even sub-humorously. To the end he wrote to educate, not in the manner of the "professors" but to enlighten through persuasion.

Other critics came and went. McBride survived. Through the best of his words we participate in an exciting epoch of twentieth-century art. One is always grateful to those critics who lead us early to what later becomes accepted judgment. During his period Henry McBride contributed importantly to that acceptance. One wonders at times how much he reflected the world of art and how much it – in the end – reflected him.

Daniel Catton Rich

THE ART CRITICISMS

OF

HENRY McBRIDE

1913–1918

CÉZANNE AT THE METROPOLITAN

"But how hard it is to be precise about Cézanne." — MAURICE DENIS.

THE EVENT of the week took place this time in the Metropolitan Museum of Art. There, on Monday, were unveiled and shown to the public two works of art of importance, a large and showy but hitherto almost unknown Tintoretto, and a landscape by the once rejected Paul Cézanne, whom now more than seven cities would willingly claim.

The Cézanne is "La Colline des Pauvres," which had already been seen this winter in the Armory Exhibition of International Art. Its theme is not extraordinary. It takes one of the softest and most ingratiating of outdoor topics, the stir of gentle winds upon the tree tops of a wooded valley, with a house roof or two in the middle of the greens. It is painted with great simplicity and an honesty that cannot be questioned. Its color might even have been called "sweet," were not the workmanship so robust that a manlier adjective becomes necessary.

There does not seem to be anything dangerous or revolutionary about it. It hangs now in the room at the museum with the Renoirs, the Monets and Manets and holds its own in such company firmly but quietly. To the students of art who rely exclusively upon the Metropolitan for their knowledge of contemporary French work, why the advent of so innocuous a landscape should be considered momentous must be puzzling.

Cézanne painted other landscapes than the "Colline des Pauvres." He has, it is estimated, seven or eight hundred works to answer for, not all of them so persuasive as the museum's new possession, and about them oceans of ink have been spilled, and spilled in such a fashion that the waters have become rather muddied. It seems awfully difficult, as Maurice Denis pathetically observes, for anybody to be precise about Cézanne.

People who never before were interested in art suddenly understood him and became collectors. It is called "new" art, "post-impressionism"; and strange words such as "synthesis" and "reciprocal" colors are hurled about recklessly in brochures that come to us damp from the printing presses. Young paint-

ers hearing the loud voices in the marketplace join in the fray and cite this artist in defence of their own projects.

The established writers of the day who have been dignified and orderly enough in their estimates of Rembrandt and Andrea del Castagno, suddenly seem to go quite off their heads and hastily sign their names to nonsensical utterances that haven't even a bearable literary quality.

What a pity all this is, and how unnecessary! From an economic point of view, what a waste of force! Hasty criticisms are so apt to be wrong, and yet all of our best advisers have by some "cursed spite" been rushed to their tables and been compelled to deliver to us their half-thought thoughts. It is not fair to them, nor to us. The gentle Amiel, we may recall, brooding upon his terrace at Geneva, came to more just conclusions about Wagner than did the professional litigants battling nearer Bayreuth, with louder but since forgotten words.

So, since the times seem out of joint for a correct definition of this baffling talent, let us pray our busy recorders who live for the most part across the seas, to confine their efforts to the gathering of facts. We should like to have all the items à la Vasari, that it is possible to collect, all the personal recollections of people who saw Cézanne paint and a volume or two of Cézanne's letters. With these and the 800 paintings that are known to exist some astute person yet to be born will be enabled to tell us whether the painter of Aix was an impressionist, a classicist, or perhaps something else. In the meantime we may be consoled by the recollection that the essential point is not in dispute. Cézanne is a great painter. All the fuss is over the descriptive adjectives.

The Sun, May 18, 1913

BAKST

BAKST HAS come to us at last. At the very moment that you read these lines a hundred and more of his water color drawings are hanging in the galleries of the Berlin Photographic Company all ready to be shown to you to-morrow. Are you "en rapport," as the spiritualists say? Do you feel in the calm of the quiet Sunday morning a sense of something strange hanging over you? Has your wife remarked as she gave you your coffee at breakfast that she "doesn't know why it is, but she feels sure something is going to happen"? If so it is these Baksts. Please advise us. It would prove two things — first that these drawings are dynamic, and second that your wife has a truly sensitive nature.

By "dynamic" we do not mean that these drawings are in any way like the horrid pictures that shocked you last year at the Armory. Oh, no! Nothing like that. Anyone, even a child, can understand these. But they are painted in what may be called "bursting" colors. Something goes out from them. People who see them make exclamations. If one-half or one-tenth of what Miss Gertrude Stein's young friends say about dynamism be true then not only your wife but even you, solid, respectable businessman as you are, ought to feel uncommonly restless this day.

We are not referring to the Sultana couchée either. The rooms of the Berlin company are intimately small and the floral ornaments in the centre of the room force the disciples of modernism into solid phalanx close to the pictures, which is fortunate, for the "Sultana" hangs low, and the businessmen who will have given up the front places to the ladies will not be distracted by the Sultana from the main issue, which is dynamics. The Sultana is a "femme dangereuse." She cannot help it. It was the result of environment. No European lady likes to be considered harmless. She is exceedingly well wrapped up about the neck and shoulders. But we mustn't go into details. First we must recount the Bakst history, ferret out the causes of his success so that you who are ambitious

35

may study it and do likewise, and finally we must decide whether we ought to like him or not.

Certainly we ought to like him. Is he not the fashion? Why next to Charpentier, the boxer, and Nijinsky, the dancer, he is the most popular person in France. He eclipses Poincaré by far. Merely by talking about him we shall become fashionable ourselves. Gratitude alone should compel us to like him, for now that the weather shows signs of becoming settled we shall need topics that may be indefinitely extended for the tea hour.

Nobody realized how much of its fame the Armory Show owed to last year's tea drinkers. The half of the party that had been shocked talked so jubilantly of their experiences that the other half were compelled to inspect the exhibition the next day merely to get into the conversation of subsequent occasions. History may repeat itself. There is no serious obstacle, not even the election, for that has become too disturbing to be taken with meals.

Should M. Bakst develop into this sort of New York success it will be accompanied by considerable gush; in fact we cannot allow it to be a success without the gush. To those with a sense of humor gush is not unduly trying, and particularly not in this case, where, just as likely as not, it will tend to excite equally two such opposite poles as Alfred Stieglitz and Kenyon Cox. It would be great to see those two warring under one banner against Bakst, would it not? However, let us not hope for too much. Just to show you to what lengths some of the Parisian "gushers" spouted we recall that some of them likened the performances of the Ballet Russe to the perfections of the works of Æschylus, Dante, Donatello and Bach, and called down upon themselves in consequence the righteous wrath of good Gordon Craig. But we shouldn't have mentioned the Ballet Russe. That brings us to another chapter.

You have been feverishly waiting, no doubt, to learn the secret of success. You would like to know how to become a world famous and wealthy artist in one year or less. It is very simple. Secure a job as designer for the Ballet Russe. The Ballet Russe will do the rest. Every time that Nijinsky leaps into the air, and he is certainly a leaper, your fame ascends with his. It is a case in which there is too much glory for one

individual, and in the entr'actes, when the leaping has ceased, the audience has leisure to read upon the programmes that the decor is by one L. Bakst. Comprenez-vous?

But before you decide positively to get rich and famous within the year think over the case of Bakst. Ponder it well. Venture into Mr. Birnbaum's back room, where the latest work is hidden. Then go back to the main gallery. It is a hard thing to have to say, but the latter is less admirable than the early work. Would you rather rush into riches and fame and be a worse artist a year hence than you are now or would you prefer to stick to the novel and guard your artistic soul? It is a tough proposition, but I am afraid some such choice is before you. You are more fortunate than Bakst in having the matter placed before you in so point blank a fashion.

Bakst, poor fellow, probably never decided the matter consciously. He just slipped and slipped and Nijinsky leaped and leaped, and then they had the exhibition at Bernheim-Jeune's, and then along came D'Annunzio with his St. Sebastian and Pisanelló and all was over, except cleverness. Bakst will always be clever, I suppose, but the possibility of preciousness has departed.

Would you believe it that the Bakst of the Bernheim-Jeune show of 1910 was actually timid? It is a fact. It was the timidity that is finer than strength, the timidity of the Persian miniatures, of a shy poet to whom colors are as jewels or fine gold.

We students used to saunter into the gallery every day. There would be five or six in the little room. About the second day a silver star appeared upon the very finest Bakst, indicating that purchasers were hanging about. Then rapidly we saw more and more stars, and soon all the best Baksts were gone. In Paris there always seem to be some who know.

From this time on the gallery filled with spectators and upon the last day there was a crush. I remember a magnificent motor arriving from which a lady of great distinction descended. Upon the front seats were a chauffeur and a valet in tall beaver hats and brown broadcloth coats that fell to their ankles, magnificently embroidered about the neck in silver. We decided she was one of those Russian princesses that one reads so much about, and it was about this era, we estimate, that Bakst's timidity began to slip.

Of course in those days we were all mad over Diaghilev's

ballet. We went every night. There are some in Paris who have never missed a performance. They regard it as they would some miraculously happy bubble that is liable to be swept away in an instant. The recrudescence of Bagdad's glories in a world from which the outward visible trappings of beauty are so remorselessly falling day by day warmed us "to the innermost fibres of our being," as Jane Eyre used to say feelingly. Fancy our delight in discovering that even the water color drawings for this thousand and second entertainment were works of art.

I don't think in those days that any of us students ever likened them to Dante and Bach. Art students are essentially artistic in their pleasures and never go in strongly for estimates and comparisons. They like what they like because they like it and never make any serious mistakes in consequence. I believe it was the Princess who lugged in Æschylus and Donatello. The Princess, it seems, in spite of the silver embroidery upon the brown broadcloth, was not any too secure socially and sought to strengthen her position by patronizing the arts. At any rate, hearing all this talk, every theatrical producer in Paris began running Bakst-ward.

Human nature is human nature. Given a fixed set of circumstances and a definite individual end it is a poor romancer who cannot work out the result. Take any timid, sensitive, aspiring artist, tell him that the great Serge de Diaghilev deigns to permit him to decide upon a decor for the great ballet. It is the chance of a lifetime. He toils over the ancient manuscripts, dreams, worries, tears his soul to tatters, prays to the moon and hands in his completed designs. They are good. Serge de Diaghilev is great. The schemes are carried out to perfection. Then Paris. Then the Princess. Then the rival theatrical managers. Then the Pisanello drawings that clever Mr. Birnbaum hides in his back parlor.

The Sun, November 2, 1913

ARTHUR B. DAVIES AND CUBISM

WELL, WELL, well. It seems that Arthur B. Davies has been and gone and done it. Is everybody going to do it? We knew all along that the Armory Show wasn't the last of it, still we never suspected that Mr. Davies was being inoculated during that month last spring. Had it broken out in Jerome Myers or Gregg or Walt Kuhn or some of those other fellows who simply lived at that exhibition it would have been, we would have all said, no more than a mere proof that their health was in a perfectly normal state, nicely reacting under an exposure to a contagion that might not after all prove fatal. But to have post-impression, cubism, dynamism and even disintergation suddenly appear all in one picture by Davies is surprising, to say the least.

Yet the new picture, now to be seen in the exhibition of American paintings at Macbeth's, exhibits all of these symptoms and even some new ones as yet undiagnosed. It is, as the doctors would say, a highly interesting case.

And the patient is doing well too. We hasten to reassure you. Be not alarmed. The picture is a good one.

The painting is about the usual size that Mr. Davies affects. There is a lady who turns her back to us, clad in a robe that is designed in squares of color, colors that vibrate and refract, but always in harmonies. Then there are two characteristic Davies nudes, one of them with a Monna Vanna cloak; then the two trees, the "Jewel Bearing Trees" that give the picture its title, and basking in their precious shade are three more figures, one with fiery persimmon red flesh, one who is lemon colored, and one in ordinary flesh color.

"Bearing" in the title of the painting is used not so much in the sense of producing as supporting. The jewels of all the madonnas in the composition have been inlaid in spirals upon the bark of these trees. The trees have "assumed" virtue like the Queen in "Hamlet." They have passed through many trials, those trees, and have risen again beside the waters; among

others the circular saw test. The painter quite frankly permits
you to see the sections into which the tree trunks were cut,
to allow of their being carried back and forth from the jewel
inlayer. This is, however, the days of realism. Miss Gertrude
Stein says that the one quality above all others that most im-
presses her in the work of Picasso is its intense realism.

But it is absurd of us to attempt to describe this picture
for you. It is a picture that cannot be described. Besides, you
will all have to see it. It is the best thing Mr. Davies has
publicly shown in several years, and in consequence it will
become a necessary part of our educations. It is in charming
color, color that for want of a better adjective might be called
"musical"; and the two standing figures have the strange wist-
ful aloofness that these best Davies people have.

This is perhaps what we should have told you at first.
The Davies "audience" is a large and respected one, the last
in America that we would willingly disturb. It "took" slowly
to its favorite artist, it learned from him a difficult lesson, and
for them to fear even for a moment that Mr. Davies could be
harmed by a contact with the Cubists would be a tragedy —
for them. Not for him. Mr. Davies takes his Cubism lightly.
He quotes it, just as he and any other stylist quotes, knowing
what he quotes, and enjoying the aptness of it. Nothing is such
fun in art as a really pat quotation. The grass is so quoted,
but no one will mind, we think. Even the most straitlaced of
us can stand cubistic grass. And the dark mound upon which
the figures sit is quoted from "Sumurun" and even the "Jewel
Bearing Trees" are — are —

The Sun, November 16, 1913

AT MATISSE'S STUDIO

THAT REMINDS us. We may be, we hope we are, addressing some of the Davies audience. In that case we should like to give them a tiny but sincere word of caution. Don't understand this too precipitately. "Understanding" a work of art anyway has come quite, quite out of fashion. Didn't you know that? It is a fact, really.

Only this summer a crowd of us motored out to Meudon to see the latest things of Matisse. There were four canvases awaiting our inspection all about the same size. All of them would be considered odd if exposed to view in a Fifth Avenue shop, but one of them was very odd.

The three odd pictures had undeniably interesting color, and somewhere in each one was something that resembled a motif — something that we could grasp at, but the fourth picture, the very odd one, contained nothing that had hitherto been associated in the mind of any of us with anything upon earth, or in the heavens about or in the sea beneath. Looking back upon it now, in calmness, we suspect the subject might have been obtained from the sea beneath — but we didn't think of it at the time.

We were naturally expected to discuss these pictures, and although Miss Stein was present, it fell to Miss Mildred Aldrich's lot — Miss Aldrich is a well-known Parisian amateur — to be pushed into the foreground and to speak. You know all those awful moments when an artist brings forward into the light his newest canvas and you are called upon to say what you think!

Miss Aldrich began glibly enough. "I like that," she said, to the first one, "and I like that" and "I like that" to the third one. Then came the very odd fourth picture and Miss Aldrich became silent. The silence prolonged itself and became so terrifying that some of the weaker vessels in the party half turned as though to escape from the place.

At last Miss Aldrich blurted out, "I — I don't understand

that" said she; or rather, she said, "Je — Je ne comprends pas ça."

"Moi non plus," replied Matisse coolly, lighting a cigarette, as though nothing had happened.

The Sun, November 16, 1913

STIEGLITZ AND WALKOWITZ

IT IS sometimes a question in our minds whether it is Mr. Stieglitz or the pictures on the wall at the Photo-Secession that constitute the exhibition. The pictures change from time to time in the little room, different artists emerge from somewhere to puzzle us, and having succeeded go again into the mist, but Mr. Stieglitz is always in the centre of the stage, continually challenging us, continually worrying us, teasing us, frightening and inflaming us according to our various natures.

We suppose there have been more violent altercations upon the subject of art in that gallery in the last ten years than in all the rest of the city combined, including even the Lotos Club. The maimed, the blind and the halt among the academicians are held up relentlessly to the light, that we may see them as they are. The villains in that body—there are some, it seems — are mentioned fearlessly by name and consigned to the exact strata that they shall occupy in the new Stieglitz inferno. Had ever a detectaphone been installed in the establishment we shudder to think of the consequences. As it is, the defenders of the faith, the faith that was, that is, can be seen almost any day fleeing from the Walkowitz drawings with hands raised to heaven, or eyes moist with vexatious tears

as the minion of the little elevator conveys them down to outer darkness.

Of course business is not as it was. The great eruption of last year, when the armory exhibition showed us fashions in art that none of us had dreamed of, and that were as repulsive to our eyes as the hobbled skirt was at first to ladies, cannot be duplicated even in miniature so soon. Nature requires time to store up sufficient steam, gas or whatever it is for loud noises. But on the other hand it would never do to close up the shop. Mr. Stieglitz therefore resumes business at the old stand.

How people can have the heart to quarrel with Mr. Stiegliz we cannot comprehend. Like Charles II, he never says an absolutely foolish thing. He is most guarded in his references to Rembrandt. Comparison between the work of Rembrandt and the particular young artist who is exhibiting at the time in the Photo-Secession are always quoted. It is a young Harvard student who hitherto had not been much interested in art who sees the marked rapprochement between the new and the older master. It is a young lady, daughter of a clergyman who owns a precious Rembrandt etching and who finds that a Whistler cannot be hung in the same room with it but that a Walkowitz can. There is no hint in this of Mr. Stieglitz's own opinion.

He says invariably that he has had no occult vision that the protégés of his are to be the great men of the future. He Merely feels that they are tender, sympathetic beings, who seem to him keyed to our present needs. He doesn't know that they are great, but he intends to give them a chance to be great. Anything to quarrel about in that? On the contrary, it's fine.

Mr. Walkowitz's new work cannot properly be called cubistic. It is rhythmic, synthetic, disintegrated, but it takes more than that to be cubic. In the unfairly cursory glimpse of the drawings that the fates permitted us we detected no hint of fourth dimensions. We spent an hour and a quarter in the gallery, ten minutes of which was devoted to the pictures and one hour and five minutes to delightful conversation. Hence we feel we have a legitimate excuse to go again — and we shall.

In the meantime we can only report vaguely of Mr. Walkowitz that the influences brought to bear upon him during the

past year have produced visible results. The work last year had a hushed quality. It was as though some one were communicating to us in a whisper the news of some dreadful calamity. The voice this year is distinctly louder. The colors are brighter, much bolder, but still mournful. The people lying upon the grass in Central Park are not holiday makers. There will never be a holiday for Mr. Walkowitz. Instead they have been flung down in an exhausted state upon the lawn, worsted but still breathing, after another of the unkind tussles with misfortune that Mr. Walkowitz's dream people are always undergoing.

To get mournfulness into such bright colors is strange. Only the Orient has hitherto done that. We shall have to ask Mr. Walkowitz about his progenitors. The Spaniards, the Moors, the Arabians, you know, are sad even when they smile.

The Sun, November 30, 1913

EPSTEIN'S MONUMENT

TO OSCAR WILDE

THE VICISSITUDES of the Oscar Wilde monument in Pere Lachaise, Paris, have a special interest to New Yorkers, as the sculptor, Jacob Epstein, began his art career here as a boy and still has many friends in New York. In a recent letter the sculptor refers to a frolicsome adventure of the twenty Latin Quarter students who hastened to the cemetery upon a dark night and forcibly removed the draperies, "for the freedom of art," which the Paris Prefect of the Seine had placed upon the much discussed monument "for the public good."

"Perhaps you have heard," writes Epstein, "of the latest

attempt made in Paris to get the monument unveiled and I enclose a clipping from the *Times* of the 6th and a letter of mine printed in the *Times* to-day.

"As you know, when the monument was placed, the Paris authorities made objections. An agitation in favor of the work was started and a petition headed by Paul Fort and signed by writers and artists and people with brains was presented to the Prefect, but this was of no avail. Among the signatures were those of Bernard Shaw and H. G. Wells.

"Shortly after this I was asked to modify or alter the monument, which I flatly refused to do. Later I was told that the monument had been added to to the extent of placing upon it a pair of bathing trousers or draperies in bronze. Still the work remains covered, and personally I would rather it remained hidden from sight. I favor an agitation for the removal of the additions to the tomb and no other. The sculpture must remain as I originally left it. What will now be done I do not know.

"I have been at work on new things and hope to have a show in London in December, mostly new carvings in stone and marble. I am sending you a photograph taken by the *Daily Mirror* of a group of birds intended for a garden which is now showing with the post-impressionists and futurists in the Gallery, in New Bond street. It is a large carving in Paros marble about twice the natural size of birds and it might interest you, I thought, to see a photograph of it.

"I recall old times in New York and have often thought of going across, but have always been prevented. Perhaps I shall come with some sculptures. That is what I should like to do. I have done many carvings, some of which are very large and some of which, though I should like to show in public places, yet would raise such a storm of protest from the puritans that it would scarcely pay me to do so. Subject seems to count for so much with people; much less to me than my critics think; for the final test of a work is whether it is well done or not, isn't it?"

As it happened, a letter from Paris received in the same mail touched upon the same subject, but speaks for the opposition. The writer, a lady who has just jubilantly celebrated her sixtieth birthday, has known more or less intimately all of the celebrities of both London and Paris for a generation past, and among them the unfortunate poet Wilde. She says:

"It was not an unveiling that took place months ago, at which time the Prefect of Police decided that the monument was not appropriate for a cemetery. It was not a question of its decency or indecency; it was a question of its taste as a funeral monument, and many of Wilde's friends have never liked it.

"At the time of its unveiling the Prefect of Police asked a modification, and that being refused ordered it to be taken away and covered it until one thing or the other should be done. About a forthnight ago Alesteir Croley announced that if it were not uncovered and 'Epstein's masterpiece,' as he called it, made visible he should cut the cover off. This he did, but the police covered it again and up to date that is the situation."

Ardently as we desire new blood in our sculptural circles and however much we may believe in the benefits that may accrue to us from a discussion that may arouse the public and cause it to take an interest in and to look at sculpture, yet we cannot conscientiously invite Mr. Epstein to visit us with his carvings. He has said just enough about the puritans to frighten us and just enough about the "subject matter" to convince us that his sculptures have subjects.

Here we have done with that sort of thing this long time past. There is scarcely a week in which we do not have an exhibition of "absolute" art. And our absolutists, Mr. Epstein, are puritans. In the little gallery of the Photo-Secession, where Mr. Stieglitz and his disciples hold forth for months together, there is never so much as a lead pencil sketch in the little exhibitions which may be properly said to have so much as a shred of a subject, and the word of all other words that may be constantly overheard in the discussions there is the word "pure." Mr. Walkowitz's little drawings last year were pure. This year they are still purer. There is nothing in the current show to bring blushes to modesty's cheeks or to cause virtue to turn away her head.

It seems to be quite in the line of our natural national development. We wish to be up to date in our own way. Mr. Epstein's is the ancient London way. There everybody from Bernard Shaw down to Mr. Epstein makes a living by attacking the established moral code. Here we get along by submitting to it.

The Sun, November 30, 1913

JULES PASCIN

THE HUNGARIAN, Bohemian and Austrian show of graphic art crowds the little gallery of the Berlin Photographic Company with 368 examples signed by gentlemen whose names, we think, would be greatly benefited by a subjection to the Andrew Carnegie-Brander Matthews system of reformed spelling. What a tax upon strength it would be to have to learn to pronounce and to spell such names as Ferenc Medgyessy and Jan Zrzavy, for instance, and yet these are among the easy ones! Happily our fears in this respect were ungrounded. So slightly had Mr. Zrzavy's and Mr. Medgyessy's works affected us that even before we had completely toured the gallery we had forgotten the particular prints they had signed. They will have to show us – with the Missourian accent upon "us" – before we begin to learn those names.

All of the latest fashions are represented in this exhibition. There are "color etchings" that look like mezzotints, and "color etchings" that look like Japanese prints. There are lithographs that appear to be porcelain tiles and others that seem to be sections of wall paper – much of the ultra-modern art consists in trying to be what it isn't, you know – naturally there is a deal of cubism. When we had quite finished our painstaking inspection of the exhibition it developed that the one individual that rewarded study, the artist who outtopped all his neighbors by far, was, if you please, not a Hungarian, a Bohemian, nor even an Austrian, but a Croatian – the familiar reprobate, but admirable draughtsman, Jules Pascin.

He is in this show by courtesy and in fact is only a Croatian by courtesy – the accident of birth counting as little in his case as with the "Americans," Whistler and Sargent – finding in Paris the particular sort of human documents that he elects to rework into art. The documents are more than shady, but the Pascin results are undeniable art.

Paris pays a penalty for being the playground of the world. The solid members of French society are continually in a state of mind when the straggler within the gates seizes upon

certain sights and scenes of the capital as being characteristic-
ally Gallic and publishes them as such to the rest of the world.
They say: "We do not support these institutions, they are not
for us, but for vous autres, you foreigners," and that may be
in effect true. Certainly the tourists, even the most straitlaced
of them, eye with a peculiar fascination the seamier examples
of frank depravity that parade the boulevards for their ex-
clusive entertainment. After a month or two of acclimatization
the healthy tourist usually forgets "le ruisseau" and secures
as best he may his place in the main stream of French culture.

There are exceptional visitors whose health is not their
most striking attribute. Pascin is one such. He never gets over
his fascination for the dusty street acrobats, the travelling
Kirmesses and the denizens of certain Montmartian resorts;
and he paints them not with the simple humanity through
which Degas peered at his ballet girls, but with all of the un-
canny suggestiveness of a Beardsley. Pascin is as great as
Beardsley, if not greater. His interest in horrors is more gen-
uine, and his power to suggest them greater. With Beardsley
vice was arrived at, more or less, intellectually. He and
Arthur Symons, the poet, at the beginning of their careers
deliberately weighed the modern situation in the balance, and
deciding that respectability was over-worked material went in
heavily for "vice," as something "that had not been done."
Consequently, even with the best intent, they saw it from the
outside. The extraordinary Pascin has obtained a nearer view.

His women "In the Park" give themselves, and also the
artist, away terribly. Among other things, since they have seen
everything, "they have looked upon the line of beauty, but have
departed from it." In other words in these unlikely habitations
a shred of conscience lingers still to make them even more
repellant. There is an uneasy tinge to their fat bodies, heavy
eyelids and yellowed hair. They are the sort of creature that
the daylight of any park exposes too pitifully.

The children in the Pascin drawings are little monsters.
The animals are even worse than monsters. In "Dressing" some
young women array themselves for the boulevard and one of
them already in costume waits for her companions. Over the
back of her chair a dog climbs. Such a dog! A skinny beast that
creeps stealthily, fearfully, like an animal born and bred in
some dank reptilian cave.

Nevertheless, it is very fine art. This is perhaps not the

place to explain to our friend Anthony Comstock what is and what is not allowable in art. Suffice it to say that the source of an artist's inspiration is of no concern to any one but himself. We are not contenancing murder when we praise "Macbeth" and we are not commending vice in recommending Pascin.

The Sun, December 14, 1913

THE SPECTRE OF CUBISM

IN PHILADELPHIA

THE COMFORTING assurance was preached last spring that that horrid spectre cubism had been laid low. It had been vanquished, quite scotched. It was but "an error," as Mrs. Eddy would have said. We were to forget it and be good. But Banquo's ghost has appeared again. Not only that, but three New Yorkers went all the way to Philadelphia last Monday to hurl ultimatums at the apparition, and the Quakers at the seance grew quite frightened at the spectacle and published columns about cubism the next day with scare head lines.

The *Press* headline read: "Artists Snap at Each Other Over New Art," and the *Ledger* had it: "Contemporary Club Laughs at Cubists."

"It fell to the lot of Kenyon Cox," said the *Press*, "to open the discussion."

Mr. Cox is a tall, bearded, but withal a mild mannered looking, person. He carries his honors and reputation gracefully, and one would never expect him to say mean things.

"He started all the trouble. He said the present group of cubists and so on are only the imitators of the early school

of Post-impressionists who suicided, starved and died in divers ways because they could not get recognition, but they did not know the gentle art of advertising, said Mr. Cox; they did not capitalize morbidity, eccentricity and indecency. Their successors, Mr. Cox went on, did not want the enduring flame, but merely the flaming notoriety.

" 'I know of nothing more favorable to rapid changes than putrefactions. They are not vital, as is good art, but decayed and corrupt.'

"The audience had not known Mr. Cox well, but simply by reputation. His really refined way of saying nasty things impressed them, but every one sat pretty quiet waiting further developments before showing where to give sympathy. When Frederick James Gregg had spoken a little while the doubt was lifted.

"Mr. Gregg represents the school of the Isms. He is not at all backward about saying so, and in his early speech one knew that this was to be a debate of personalities. He disclaimed any intention of committing suicide or allowing any of the things that happened to the Post-impressionists to happen to him. He said that Mr. Cox had been speaking this nonsense all over the country, that his facts were vulgar and horrid untrue, and that Mr. Cox should put that in his pipe and smoke it. This drew a gasp from the listeners.

"He likened the interest in the present new art to the curiosity which brought about the Renaissance, and said no one ever went to an Academy exhibition any more. (He referred to the New York Academy.) 'You can bet your last dollar on that,' he added. He accused the artists of Mr. Cox's school of considering only their bread and butter when they refused to indorse the art of the cubist school, and concluded with the comment that Mr. Cox has a really develish quality of being very angry and very meek.

"They don't hiss at the Contemporary Club meeting, but it is certain that Mr. Gregg's address was not received in good humor.

" 'How insulting,' 'What bad taste,' 'He ought to be ashamed of himself,' were some comments."

"The gem of the evening came," said the *Ledger,* "when William M. Chase, taking a clipping from his pocket, read seriously an appreciation of Matisse, written by Gertrude Stein,

sister of Matisse's patrons, who writes in a strange jargon quite as queer as the pictures.

" 'He is doing what he had been doing; he was certain then that he was a great one, for he was doing what he was doing and was a great one when he was doing what he was doing,' read Mr. Chase, and the audience roared. For five minutes Mr. Chase read. Then he folded the paper and with evident disgust asked whether art was served by such 'stuff.' Then he declared that true art could only thrive through work and high ideals."

The *Press* declares the Contemporary Club has seldom had a better time. "They went to be informed and instead were amused. The temperaments of artists are not often exposed to view." But they claim to be as much as ever in the dark as to what cubism really is.

The Sun, December 14, 1913

THE GROWTH OF CUBISM

THE MONTROSS show isn't the only one. It is a good one, but it isn't the only good one. The Macdowell Club is a good one. It knew that it was a good one, so it lent some good ones to the National Arts. The National Arts knew that the Montross was a good one. We are good ones and we stand for the whole thing. Vive the good ones, as Walt Whitman would say! Isn't it a shame all of us good ones cannot get together? Couldn't there be a bus line established for round trips, and guides with megaphones pointing out to the tourists the palaces now occupied by the artists who paint and dealers who sell the good

ones? At $1 "per" there would be millions in it for some one.
You see we could easily afford the dollar. Last year we had to
pay that entire sum just for the one armory show. This year
the Montross, the Macdowell and the National Arts are free,
comprenez vous?

We are also great believers in having some slight refresh-
ment with pictures. Don't you recall how delightful the Verest-
chagin battle pictures were, served with Russian tea? If our
manager for the bus line — by the by, it would have to stop at
Alfred Stieglitz's also, for the Hartley Berlin experiences are
still there — should prove to be a good one with half the sense
of even the most senseless of our new cubists he could include
the refreshments within the dollar. But the refreshments, we
insist on't, must be good ones.

The first sensation of the week naturally was the capture
of Montross' by the cubists. Since the Fall of the Bastille noth-
ing has been so astonishing. But the sun rises and sets just
the same. Managers of rival galleries gnash their teeth as they
see the crowds turn Montrossward, but the sun really rises and
sets just the same. Nature apparently accepts cubism as she
accepted all the other things, with complacence, so why
shouldn't we?

There is nothing in it to be frightened at or to be be-
wildered by. Don't worry if you find you don't like it. Why
should you? Perhaps you'll have other consolations. One of the
most deplorable attributes of the modern mentality is its
breadth. Breadth is essentially inartistic. If you find you don't
like cubism, cheer up. You'll be rather distinguished, upon the
whole. We know, for instance, a highly cultivated and charm-
ing individual who has been everywhere and done everything
except that he has not heard Caruso. It adds immensely to his
popularity. People make him tell about it at dinner parties.

The whole thing with cubism, as it is with every other
art form, is simply whether you like it or you don't like it. If you
don't like it, don't try to persuade your neighbor who does of
the error of his ways, for you will simply get disliked for your
pains and convince him that you are the old fogy that you are.
The person who doesn't like the big general art movement of
the day is an old fogy.

It is nonsense to pretend it isn't the movement of the

day — and still moving. It occupies the centre of every art stage in civilization and affects all the arts. Characteristically the barricades are most stoutly defended in the art that is most completely a common property, literature. Miss Gertrude Stein of Paris is not only the patron saint to the new artists, but is herself an artist in the new use of words. Her poems, plays and essays enjoy an extraordinary distinction that is somewhat akin to the immense private fame that Rossetti began with. She is one of the most talked about creatures in the intellectual world and the slightest scrap from her pen is read with delight even by those "who do not get it," as the phrase is. Yet no single magazine or publisher sees the immense advantage to be gained from a satisfaction of the public curiosity in regard to this work. It is a curious and strange impracticability upon their part. When eventually a Mr. Montross, theatre manager, does produce a Gertrude Stein play, involving as it will a complete departure from the technique at present in vogue, with different lights, different costumes, action and a very different tempo in speech, what fun it will be!

Music is already there. "Le Sacre du Printemps" set all Paris by the ears, but even the most drastic of the critics admitted it to be sincere.

When an art striving or impulse keeps the world talking for six or eight years and affects all the sister arts, when emporiums spring up for the sale of works in the new system and magazines are created for its discussion, the affair may safely be called a "movement." That authoritative books upon the style have not yet been written merely means that the movement is still in progress. One never writes with authority upon a style until the style has passed. The funeral sermon is preached in the presence of the corpse. Without meaning to be unnecessarily unkind, and simply in an effort to end this paragraph, we may mention that authoritative works upon the subject of impressionism have long since been at hand.

America has a fine dashing way of naming things to suit itself and over here when we say "cubism" we mean everything and anything that is unacademic. As a matter of fact very little in any of the three shows corresponds to what the French call "cubism," involving the four dimensions. The followers of Picasso are few. A lady exhibitor in the Macdowell Club show

deliberately apes Matisse, and several here and there are doing the Odilon Redon business. Most of them, though, here as elsewhere, go in heavily on Cézanne.

Hastily summarized here are a few of the features of the three exhibitions: At Montross's the popular puzzle will be the Shamberg "Wrestlers" and the popular appreciation will be the Stella "Battle of the Lights, Coney Island," many people having been heard to acknowledge that Coney Island always did affect them that way.

At the Macdowell Club Rudolf Dirk's color explosions will be rated No. 1, with a startling and beautiful landscape to top his individual list.

The National Arts Club is the biggest of all the shows and covers the widest range. Here are the very wildest of the futurists, as well as the solid and enduring George Luks and Jerome Myers. Two works here are sure to rival the celebrated lady who went down stairs last spring as a topic for social debate. They are by Andrew Dasburg. One is entitled "To Mabel Dodge," wonderful convolutions in scarlet in the midst of which a little tulip blooms. The other is called "Absence of Mabel Dodge," and the lines of scarlet have gone plumb to smash, as though shrivelled by lightning.

Being "in the swim" is very exhilarating. It has its attraction for every human being. People will go to the most stupid parties, hobnob with insufferable bores, learn excruciating new dance steps, give up their present life, and sometimes the hope of a future one, all to be "in the swim." Being "in the swim" is fine, we've got to admit, but it isn't necessarily being great.

Greatness in the arts is obtained from two sources, from nature and from within one's self. "Art is nature plus human nature," a famous old art teacher used to say. Both remarks are equally platitudinous and true. It is not, however, worth the pains to say these tiresome truths over and over again to all the young people who will now rush into cubism.

Thousands of them have already adopted this new uniform, and they will die in the fight unheralded, just as they fell in the battles of other days. They will be heroes, it may be, though obscure ones, and a sister or an aunt off back in the hills will shed a tear from time to time, but the great

world will not concern itself overmuch. Soldiers in the ranks are necessary. If you submit to being one the more fool you, says the great world.

If your idea is to be great you may gain a pointer from the position of Arthur B. Davies in the exhibition. The people laugh at Mr. Stella's "Coney Island" and Mr. Schamberg's "Wrestlers" and even at Mr. Taylor's linoleum designs, but to "Potentia" and the "Peach Stream Valley" of Mr. Davies they say, "How beautiful." No matter how abstract this artist may be he holds his audience. He has the power of interesting people and whatever manner he assumes, the essential fact is that it is Mr. Davies who is assuming it.

The moral is: to hold fast to yourself.

In the pedigree supplied for cubism by the writers upon the subject the great Ingres occupies an exalted position. Ingres is a fine name and all the different art sets are glad to own him. In the show last year at the armory Albert P. Ryder, the American, was proudly included. As in the case of Ingres, it is a name that any society would willingly admit.

Even among the Montross cubists you will find works by Maurice Prendergast, who hangs lovely color mosaics upon slight shreds of subjects, and the clever Mr. Glackens, who paints so like Renoir that he will be regarded as a mere trouble maker for Renoir enthusiasts fifty years hence, Renoir himself, they say, having painted six thousand of them. Ernest Lawson isn't there solely because he is inconsiderately having a one man show of his own around in the Daniel gallery. So you see if you have the courage or the "energia" to be "different," even the coming revolutionists of ten years hence who will look upon these present cubists as Quakers will take you in. But they certainly won't if you are only a poor cubist.

The Sun, February 8, 1914

BRANCUSI

THOSE WHO didn't "see" it last year at the show of international art ought to this year. Now that it finds itself in the sympathetic guardianship of Mr. Stieglitz in the little gallery of the Photo-Secession, at 291 Fifth avenue, which seems to have no secret architectural differences from other galleries and yet has the faculty of showing off modern wares that seem dubious in other places to extreme advantage, like the tailor's mirror in which you never can locate the imperfections that you fancied in the glass at home, the Brancusi art seems to expand, unfold and to take on a startling lucidity.

But a few short months ago there were jeers for the "Mlle. Pogany" and the "Is it an egg?" witticism threw the philistines into such paroxysms of uncontrolled glee that a consideration of the "Sleeping Muse" had to be postponed. It is impossible to reason with people in the grip of a passion, whether for laughing or weeping. It is perhaps impossible ever to reason the adverse into an appreciation of a work of art. Art is felt, not understood. All the talk and loud shouts in the world won't cause you to like a picture that you are convinced you loathe. But the laughters are finally stilled through sheer weariness of their own laughter. The thought imprisoned in the bronze at last speaks, and soon, if the idea be a pretty one, there is an audience so large for it that the fatuous laugher becomes an object for mild pity. People laughed at Beethoven! It is difficult for us now to see upon what they pinned their joke.

Brancusi, Beethoven! They are not precisely mates. Beethoven never laughed, or at least if he did you were more frightened than at his thunder. Brancusi laughs. Beethoven is godlike, primeval, ungentlemanly. Brancusi is suave, witty, elegant and rococo. There is no reason whatever for linking them save that their loves spell their loves with a B and both were mocked. If one must find a musical affinity for Brancusi, Rameau is nearer. But must one? He is more literary than musical.

56

One naturally seeks for comparisons for most of our modern artists among the musicians, for the continual search for the abstractions of beauty that goes on among our new men is only to be matched by the "absolute" in music that fascinated even the apostles of the leitmotif among our composers. One would wish that modern art would not borrow so much from music. One would wish that painting and sculpture might develop more strictly within their mediumistic limitations, or progress by adding more and more restrictions to method.

But what have one's private opinions to do with an age whose rallying word is "liberty"? An age in which all barriers are down; an age in which the women wish to be men; every country wishes to be like its neighbor, and an expert is required to tell the difference between an aristocrat and a democrat? With everything "upon the level" what's the use of kicking because painting has become another form of music? Or because sculptors take on the license of poets?

Those who deny "progress and liberty" will deny Brancusi. Those who are interested in life as it is and are more interested in the actual, unsolved, confronting problems of the day than in the completely solved, tabulated, indexed problems of the long dead past will accept him.

Those who can bear to look at Brancusi's sculptures, however, will find it difficult to understand the shudders of the philistines. They are not after all so very abstract. There is a tangible subject to each work. "Mlle. Pogany" is, if you will, a delicious piece of satire as soulful and ecstatic as dear Lady Angela in "Patience." She leans her amusing head upon her hands and bends forward properly "yearning" at the, to us, inaudible Bunthornish strain. The eyes in such creatures dilate until they are all of the lady that the watchers at the comedy see. Brancusi has dilated them until we see nothing but eyes. But what of that? Pray let us be consistent for once. It is an abstraction, but since we understand it what's the harm? Our ultra-moderns complain that it is too easy, that they "understand" it, in fact. If that should prove to be its fault, it is a fault that will make its appeal to all Academicians."

"Mlle. Pogany's" ear is a droll ellipse and may worry beginners in modern art study, but the same individual who will be astonished at such an ear in modern art admires exactly the same sort of art convention in a Chinese jade. As

the light strikes it now in the little gallery it is very like jade. The whole piece of marble is delightful as stone, and the artisan has cut it with fine appreciation of its quality. The "touch," to apply still another musical term to Brancusi's chisel, is extraordinarily caressing. Few pieces of modern stone cutting come up to it in "preciousness," and none that we have seen eclipse it. Certainly Rodin's do not. Sculptors who have any love for their trade as such and know in theory what "respect for the marble" is will concede this success to Brancusi.

The new piece, the "Danaide," is far more subtle and refined than the "Mlle. Pogany." Why she smiles we do not know, this Danaide. Is she the one who didn't murder her husband upon her wedding night or one of those who did? It is a most elusive smile, difficult to translate, but charmingly high bred. A Japanese noblewoman would smile like that just before committing harakiri. From every point of view the lines as lines are good. The swollen neck does not explain itself to us, but in another light "it might," as the young person in "General O'Regan" says. The hair is suggested in a most interesting way and the tenderness of execution is even more marked than in "Mlle. Pogany." "Mlle. Pogany" has the advantage in marbles, though.

The Sun, March 22, 1914

A VISIT TO GUILLAUMIN

IT HAPPENS in France, as it happens here, that an artist may do excellent work through a long term of years and escape notoriety. The modern machinery for publicity, although an immense affair, is also very simple, and is easily controlled by

those who take the trouble to learn the system. Once you get it started the movement is almost automatic; a touch or two to the levers, occasionally, a little pétrole, and there you are, almost famous.

To disregard the machine, to take yourself off to the country, to imagine that the charming picture that you have just painted will fly of its own accord to Paris, there to alight upon some place of honor and be raved over by poets, fashionable actresses and the Government, is to indulge in a pleasant but unpractical dream. There are all sorts of things to be done first before that can happen. They need not be recounted here. Those of you who already know the ropes and are highly successful and prosperous would only be bored by my repetition of the principles involved, and you who have never discovered them probably have the sort of genius that comes to its fullest fruition in loneliness and neglect. At any rate I shall not be sidetracked here into telling all I know of the publicity game.

The charming picture that you have just painted will eventually arrive somewhere where it can be compared with other pictures and after that it will take a rating in the world's affections. If you ignore "publicity," however, that moment just as likely as not, will be delayed until after your death or until the good opinion of your contemporaries has become a matter of indifference to you, which is next door to death. Cézanne had practically arrived at this stage when notoriety, or perhaps in his case the appropriate word is fame, knocked at his door. It is quite safe to say he never guessed how much Destiny was occupying herself with him.

Émile Bernard recites in his "Souvenirs" that he had owned a Gézanne still life for fifteen years and when he showed it to Cézanne the latter said:

"It's poor. If that's what they are admiring in Paris nowadays the rest of the art up there must be mighty weak!"

In the case of Armand Guillaumin, who was Cézanne's chum at the period of the Impressionistic Sturm und Drang and who is one of the most important of the valiant group of 1880 and in fact one of the strongest of modern landscape painters, there is every indication that the Fates are bestirring themselves to render unto him a little justice during his life-

time. He now has a dealer, which is a good sign. There is a shop in Paris where you can always find Guillaumins. He has had one man exhibitions recently with a unanimously amiable press.

More important still, his works have appeared in auctions and at a recent sale in Paris the prices advanced. And even more important than that, the young people who are thrilled by the canvases of the Salon des Indépendants have become aware of him. They place his name on the list of those they admire along with Cézanne, Redon, Rousseau le douanier, Maillol, Renoir and the new lot. To be admired by the new people who are coming along is one of the most reassuring things that can happen to any artist.

At the same time the world in general scarcely knows his name.

Until the Hayashi sale last winter at the American Art Association I for one had never heard of him. Mr. Hayashi, it seemed, was a Japanese art dealer in Paris who had assembled a most interesting private collection of the works of the moderns years ago, many of which it was said he had acquired from the artists in exchange for Japanese prints. At the time of Mr. Hayashi's death these pictures found themselves in Japan and as they had to be sold the heirs thought it the part of wisdom to sell them in New York.

Among them were twelve Guillaumins, mostly landscapes. Fortunately most of them were hung in a group. They made a stunning impression. They were decorative; they were simple; they were brilliant in color, and just about as powerful for landscape as Winslow Homer is for marine.

Who is Guillaumin? we asked. Nobody knew. Of course one always makes such discoveries at the eleventh hour just before the auction takes place. So there was a wild scurry here and there to warn one's friends that bargains were to be had. Here were perfectly good pictures by someone we had never heard of and some one who was not affiliated with any of the great dealers. It was a chance too good to be missed!

After the auction – it was a most enjoyable auction – need we say that some of the Guillaumins went to the right people? – we proceeded to look him up. Duret in his book on impressionism gave a whole chapter to Guillaumin and a few

facts that were not only piquant in themselves but explained why Guillaumin had remained so long unknown to us.

M. Guillaumin in the early days of his painting had some modest employment in the Orleans railway service and lived at Clanmart. His landscapes were painted in that suburb of Paris and met with slight appreciation outside of the little band of enthusiasts of whom Manet was chief. It was as unfashionable to like a Clanmart landscape in those days as it was to live there.

Before the battle of the impressionist was won for Manet, Renoir, Monet and Pissarro, a surprising thing happened to Guillaumin. He drew a prize in the Credit Foncier of 100,000 francs. This was a fortune, so he promptly withdrew from the Sturm und Drang, gave up the search for his dealer, who is as important to an artist as his architect is to a sculptor, and retired with his family to Agay, there to paint to suit himself, the world forgetting and by the world forgot.

"Write him that you are coming," said M. Bolt last August to me. "Guillaumin will drive over for you to the station. Crozant, where he lives, is six miles from St. Sebastian."

The fact was I had decided to take the five hour run down to the Creuse country just to call upon the artist whose work I had admired and then five hours back again to Paris. It takes the truly timid for bold projects. But I decided against a warning letter. It must be excruciating enough to have strangers popping in upon one without the extra agony of knowing the day before that the visitation is imminent. Besides I did not wish to put my victim to the trouble of a carriage.

The god who attends to the venturesome apparently had nothing else to do the day of my journey and gave his services exclusively to me. I had begun to feel excessively foolish as I landed upon the lonely railroad station and realized that cabs, trams and things of that kind did not exist. It developed, however, that there was a diligence.

The diligence driver was he, so the porter informed me, who was at that moment busily engaged in pinching the young ladies who sold the station's newspapers, with attendant shrieks and retaliatory blows upon the part of these young persons. He interrupted this pleasant pastime willingly enough when he learned there was a passenger for the diligence. There

were in fact two passengers. A lady mounted to the one seat of the high wheeled vehicle with the driver and me, so the drive across country was enlivened by conversation. It was indeed, thanks to the driver, a lively trip.

He was one of those fellows who are interested in everything and who waken others up. There was scarcely a dull moment and if there was the driver took advantage of it to crack his long whip, which he did dexterously. We narrowly missed running over some sheep, we scattered some ducks that ambled upon the roadway right and left, we spoke to every one as we passed, and as for the man shingling a roof, we commanded him to stop pounding for a minute and then informed him in a roar that "his cousin had not come." Finally, as we were nearing Crozant, we came up with a bridal party in two coaches, who hurled facetious remarks to us and to whom we, or at least our driver, replied in kind. It was a very enjoyable excursion.

Between four and five in the afternoon I was set down before Guillaumin's house. It was close to the road, a simple, massive stone house of the kind that artists like. Knocks upon the various doors awakened echoes but no responses. Passers by informed me that Mme. Guillaumin had gone with monsieur, who was painting down by the Creuze.

There were offers to inform the artist of the arrival of a visitor and offers to conduct the visitor to the scene of the painting, all of which were refused. Instead, a little tour of the village, which is near by and which appears to be quite worthy of the diligence driver, for all the inhabitants are hearty, enthusiastic and well individualized. The same may be said of the animals that find their way into the village street, so the entertainment to be found there is constant and varied.

Later I sat upon the stone wall near the Guillaumin house and waited.

Finally a boy comes along bearing a wooden color box. Behind him there are a slight old gentleman with two canvases tacked together and a lady with a sun umbrella. It must be Guillaumin. I approach with the question. It is "yes." M. Guillaumin appears somewhat astonished, as well he may, at my apparition, especially when I announce that I have come all the way from Paris merely to say "bonjour," but he recovers

himself quickly, presents me to madame, and explains that he has a sore throat and cannot talk in the evening air, so we will go to the house.

In the meantime servants have arrived from somewhere and the doors and windows are open.

"We are not well installed," said the painter, "but the village houses are not especially nice and here we have the view. It is simple — "

"I like it for that," I interrupted.

"Moi aussi," responded M. Guillamin with a sympathetic glance. "Come up these steps. I will show you some of my canvases."

On the floor above there was a little room with many pictures on the white-washed walls gleaming through the half light like colors from stained glass. M. Guillaumin put aside a curtain from a little window which looked upon as fair a prospect as one could imagine. The ground dropped sharply off into a steep and intimate little valley all green with turf, and a few cypresses pointed upward. Umbrian fashion, upon the hill en face. To the right was the amusing village, with its church spire, just near enough for its evening sounds to melt into poetic jumble. A horse teased by flies galloped about one enclosure kicking vigorously. An old man leaned over a wall to direct an earnest dog in the fetching in of some cows. But I turned my back upon the panorama.

The canvases that had just been brought in were unhooked. They were Guillaumins! Both were of the same motif, the river and a denuded branch of tree straggling across the toile. The color was undeniably the color of the pictures I had seen in the Hayashi sale. In spite of my cerebellum I actually had a moment's surprise in finding what I had come to seek.

Mme. Guillaumin enters. There are wine, biscuits and conversation. I recount that my windows in New York give upon a busy thoroughfare that is noted for its traffic and noise. The day after the Hayashi sale I was busily occupied in writing when I interrupted my task to gaze from the window a moment. There, in all the tangle of motors and carriages, some flashing colors caught my eye, paintings that were piled upon the back seat of a victoria. "Surely those are Guillaumins," I thought, and a little later I caught a glimpse of my friends riding backward on the front seat carrying home the

spoil from the auction and knew that I was right. As I finished my little story I found my host blushing like a schoolboy.

"Ce que vous me racontez la," said he. "What you tell me gives me great pleasure. I have always held that style should be as recognizable as people."

A little later he said, "I always work outdoors from nature. It is an exhausting way to work, because the effects change so. I have a number of canvases going at once. The effect of course never is quite repeated and one must have a clear idea in one's head of what one is after.

"I have worked in the atelier, but the more I succeeded in that method the less interested I became. Now I have given the atelier up. But here is a canvas I began over a year ago and never have had a chance to finish."

It was beginning to be dark and we had had recourse to candles. I saw that it was time to make my adieux.

"When do you return to Paris?" inquired monsieur and madame.

"By to-night's train," said I.

"Impossible! You must not. I'll tell you! Stay to-night at the little hotel in the village. Then come immediately after your breakfast. I shall take you for a walk along the Cidelle, where I paint, it is very beautiful. You must see my country. After that we shall have luncheon here. Luckily for you, there are perdreaux. The hunting season has just begun. Then Josef can take you in the diligence to the comfortable afternoon train."

And so it was arranged.

Flourishing air about the hotel. Madame herself was pouring burnt sugar over flat dishes of pudding as I peered in at the kitchen door to inquire about rooms. Pots and pans, eggs on table, interesting debris, very paintable. "La cuisine française," cried madame gayly as she saw me grinning at her procedure.

There was a choice of two rooms in the annex over the garage. One room had a small bed and a fine view and the other had a grand bed and view ordinary. With inward qualms I recollected I had come to Crozant in my capacity as art critic and had a character to live up to. I therefore chose the poor

little iron cot and the grand view, which I forgot to look at next morning in my rush for breakfast.

There were about twenty at the table d'hôte. The cuisine was all right but not pretentious. The conversation unpretending also. Just at the last there was a flash of something Gallic. Mademoiselle at the end of the table rose to leave first. "Bon soir, messieurs, bon soir mesdames!"

"Where are you going like that?" asked one of the married ladies, with an appearance of concern.

"Oh, for a little promenade," returned mademoiselle, who had a sad, tired face, heavy drooping lids and ringlets that had once been effective and were still capable of certain effects.

"Are you not afraid?"

"Not at all. I'll not go far. Besides I have a conscience tranquil. Nothing will happen to me."

"Voilà!" exclaimed the married lady's husband, "that's the supreme reason for courage!"

"I think there are dangers. Have you never fear alone? Which is your room?" continued the alarmist.

"This one just over us, with windows on the square."

"Just the same, they can enter there, these villainous characters!"

"Or by the chimney," laughed mademoiselle, "if they fail at the windows." And then everybody joined in the most complimentary suggestions of possible ways which the rufflans might use to seize upon and carry off the fair hostage.

The village street was very dark. The shop opposite gave streaming light and peasants inside were talking excitedly, probably about the shooting season which had just begun. I watched them while screwing up my courage to enter. Suddenly a woman's voice out of the darkness beside me asked me if I wanted something.

"Yes, tobacco," said I with great presence of mind. "Are there cigarettes here?"

"No, m'sieu, not here. Tenez, I will take you."

We turned the corner into a narrow lane. The blackness was Egyptian. We turn another corner, guided by the sound of our footsteps. Suddenly we bump into a haystack.

"Mon dieu!" shrieks my guide, "what is it?"

At the same moment some men appear flashing a lantern. An enormous load of hay drawn by a donkey blocks the passage from wall to wall. Six men and three women shout and pull at the donkey. The load has attempted to upset and is propped.

"Voilà," said my guide. "There is your tobacco shop."

I enter the garden in front of the shop. The crowd continues to exhort the donkey. By a great effort the load moves one foot and I am sealed in the garden. Every one laughs, says "Quoi fare?" and disputes. Pitchforks arrive and they pitch the hay into the garden.

"Take care of my roses!" shrieks a jeune fille.

The sad mademoiselle from the hotel arrives upon her promenade.

"Qu-est-ce que c'est?" says she. "O the poor little donkey under that great load of hay! Has no one, then, had the courage to give him a morceau to eat?" And she presses a wisp from the load to the sober animal's mouth, who lets it fall unheeding to earth.

"Ma foi," remarks the owner of the beast, "the whole load is for him and he knows it."

The Sun, May 3, 1914

PASCIN IN NEW YORK

JULES PASCIN of Paris has arrived in New York. He says he is not an emigré. He came to this country simply because he wished to see America. He will stay a fortnight with us and then flit southward to Florida, Cuba, he doesn't know where.

A number of us were trying to persuade him, since he must quit New York, to go to New Orleans, assuring him that

it was beautiful down there – lovely architecture, rare colors, "as swell as Venice," some one in the crowd ventured; soft climate, "beaux negres" eminently paintable, good opera and eating; all in fact that the soul of an artist could desire, but Pascin did not succumb to our enthusiasms. Something that somebody told him years ago fixed Florida in his mind as desirable, and besides he firmly insists that Florida is not so far away as New Orleans!

Not that it is our affair! The choice of habitat by an artist of imagination is often swayed by trifles light as air. The planting of Gauguin upon Tahiti and Stevenson upon Samoa could not have been arranged by others, and the only point that concerns us is that in these places they found soil upon which they could flourish. Unlike Gauguin and Stevenson, Pascin is not looking for an asylum. He is a passenger bird. Be sure he will abstract honey from Florida, although personally I am not at all sure that Florida herself will recognize Pascin's product as honey.

To us disinterested Northerners it will be great fun to see what Pascin brings back in his portfolios from down there. For that matter, since he is to be with us a fortnight, we had better watch out ourselves. Mr. Benson's "Dodo" said of the marriage state. "It is both a responsibility and an opportunity," and the same may be said of Mr. Pascin's visit to us. It is all very well for us to brush our hair pompadour fashion, and sit straight up and down in our chairs in respectable poses. We can't, of course, keep that sort of thing up forever. We cannot even keep it up two weeks, and the exactly wrong moment of the tango is the moment that Mr. Pascin will catch us, you may be sure.

As an artist he is not enamoured of masks and poses. He has not said so, but judging by his drawings, I should say he is not deeply concerned with recording the outward aspects of respectability. Respectability is a thing that is sure to get itself recorded, automatically if no other way, and for that reason probably Mr. Pascin lets it alone. There is no crying need to publish it, since it publishes itself. He has none of the animosity against virtue that seems to put bitterness into the pens of our modern English satirists. He is, to put the matter as simply as possible, more concerned with beauty than with satire, although satire is there. It is as though the beauty in his drawings is conscious, the satire unconscious.

Digging in subterranean passages has its dangers and so have the searchings of an artist among the wreckages of the human stream. The topic is an inviting one and one that must be discussed and understood in America before we can hope to make New York the capital of the arts. We have poised morality and art in the scales before this and sometimes morality wins and sometimes art wins, but so far, at each decision, there is always a voice that insists that there has been juggling with the scales! So much depends in young countries. such as ours, for instance, upon who is umpire! Emily Dickinson, our almost forgotten poetess, claimed in a poem that all Boston agreed was perfectly all right, that truth and beauty were one, and as truth and morality are also one, it follows as the night the day that morality and beauty are one; and consequently if Pascin's drawings are beautiful they are moral.

We may all agree nicely to this deduction at once or we may make a fuss and try to stamp upon Pascin as we stamped upon Gorki, Walt Whitman and Poe, but sooner or later we must come around, for art always wins in the end, and Pascin has a talent that's prodigious.

It is altogether likely that before the season is over we shall have a public exhibition of his work and then all the moral and scientific phases of his art may be considered in detail. It would be nothing less than a crime if we fail to show this stuff to our students. Think of a Degas coming to town with a hundred or so water colors and no one seeing them but a handful of experts! At any rate this visit is sure to figure in art history. As far as modern art is concerned nothing of greater importance may happen throughout the winter.

The Sun, October 25, 1914

DEMUTH'S FIRST EXHIBITION

IT IS Charles Demuth who now makes his debut in the Daniel Gallery. He exhibits twenty-five aquarelles, which are washed in with great freedom and are in pretty color, but whose landscape subjects are sometimes so vaguely indicated as to be practically negligible. This drawback will not puzzle that portion of the public which has learned to admire the faint color evocations of John Marin, but then it must be confessed that this portion of the public is the scared minority not numerous enough as yet to dare to raise the voice of praise.

John Marin's "indicated" water colors are not more elusive than many of Whistler's most popular pastels, but then Whistler went further upon occasions into completed portraits that anybody could recognize to be likenesses, and these could be rushed to the defence by the Whistler enthusiast, when attacked. Marin laughs at likenesses and defies you to recognize the particular hill or particular bridge. For that matter it is seldom that he even admits it is "a bridge." In consequence his followers get into difficulties when proselyting for him, and are sometimes called "highbrows." Nevertheless, their number increases steadily.

For them the question will not be "Is Mr. Demuth too vague?" but "Is he sufficiently different from Marin?"

This the present exhibition does not answer with sufficient distinctness. It will be allowed that Mr. Demuth's drawings are worthy of exhibition and that they have merit enough to induce us to hope that this artist will do still better. He has at his present command a good but not extraordinary sense of color. His drawing is uncertain and in consequence the waters in some of his seascapes travel up and down over a too concave earth. This might be forgivable if the color had been sought for in passionate subtleties, but the color is only "good"; and if the lines as lines had relationships to an idea worth expressing, but they are not concerned with ideas, and so as drawing must be rated "weak."

An amusing and novel feature of Mr. Demuth's show

is the extreme simplicity of his catalogue. Six of the aquarelles are labelled with the same title, "Trees," five are called "Dunes" and five "The Bay." Two are called "Conestoga." We have a vague notion that "Conestoga" is somewhere in Pennsylvania and that therefore our artist is a Quaker. In that case he will be more than ever worth watching, for he must be revolutionary, his sense of color being already beyond what we expect from a Hicksite.

The Sun, November 1, 1914

AFRICAN ART AND STIEGLITZ

THE GRAY WALLS of the little gallery of the Photo-Secession now support carvings, strange wooden carvings, queerer carvings than you will see anywhere else in town. Mr. Stieglitz is on deck with sensational and sardonic theories that surmount the din of battles and shine above the dust clouds arising from crumbling empires. His first lieutenant, Mr. Walkowitz, is there also, less wan and pale than of yore, but more unutterably philosophic than ever. Mr. Zorach, who is a primitive, very fond of painting his personal recollections of ancient Egyptian history, now enters upon his sophomore year in this academy of arts and thrills. Several of the new recruits had the look of being permanent additions to this society, although one of them, a most clever young man, an Albanian refugee 'twas said, had rather too decided and forceful a manner for a recruit. Being clever, no doubt he will soon subdue himself.

All of the dramatis personae are on the scene, you understand. They are all word perfect in their parts and eager for

the curtain. Hamlet, that is to say, Mr. Stieglitz, can hardly wait until the big scene in the fifth act, where he jumps into the grave and defies Mr. K-ny-n C-x to outweep him in grief for the corpse. The anticipatory emotion is so strong and so contagious that you, even you, who have seen the rehearsals and know that it is only a play, are beginning to wonder whether you are going to disgrace yourself by blubbering outright, when suddenly a horrid doubt intrudes itself. Perhaps we had counted too naively upon Mr. K-ny-n C-x always playing opposite roles to us. Mr. K-ny-n C-x likes ancient art of any sort. These are ancient carvings that we are about to show you, ladies and gentlemen. Mr. K-ny-n C-x will like these wooden images. He will not clash swords. He is, in fact, upon our side. Is it not wonderful? And vexatious?

It spoils our big scene completely. It's no fun having art shows unless we may wake somebody up with 'em. Whom can we wake up with these carvings? No one. They are several hundred years old and, therefore, hors concours. Everybody will love them. It would have been awfully wicked, perhaps, but in the interest of art, justifiable, to have dissembled a bit with this show. Suppose Mr. Stieglitz had assumed a timid air which he can do very well and had announced that he wasn't at all sure that there was merit in these productions, the work of a little colored boy named Rastus Johnson, who lived at 137th street and Lenox avenue, but he was determined to give them a trial; what a fuss there would have been!

Then when Mr. K-ny-on C-x had had his fit, and all of us critics had tied ourselves up into irretrievable conclusions, we ourselves probably holding Rastus to be an impudent little upstart totally lacking in sense of decorum and religious instinct, then, we say, Mr. Stieglitz could have come forward with the truth about these carvings, and he would have had us.

The Sun, November 8, 1914

ROBERT HENRI'S CALIFORNIA

PAINTINGS

"AFTER ALL not to create only," but to rally around the flag, boys! I confess I took almost as much pleasure in thinking of the joy that the youthful adherents and followers of Mr. Henri will take in this artist's new Chinese, Mexican, Indian pictures as in the more obvious first fact that Mr. Henri's new canvases are the strongest that he has shown for some years. Mr. Henri is to be congratulated; Mr. Macbeth is to be congratulated and the boys are to be congratulated! Mr. Macbeth will say, "I told you so," Mr. Henri will say modestly, "I can do still better" and the boys will say, "Ain't they great?" There will be sufficient glory, as Admiral Schley remarked upon a similar occasion, to go all around; so you boys must not take more than your share.

Mr. Henri, who has been wooing the muse in Spain and Ireland recently with fitful success, has worked in southern California during the past season and now has the air of having discovered a new country in having discovered his own. It is impossible to acquire in one short season in Ireland the rich brogue of a J. M. Synge or a Frederick James Gregg, and in returning thence with his spoils Mr. Henri must have felt this. The pupils, who are loyal or nothing, enthused as usual over the Irish brush strokes, but the great wide world clamored for the brogue, and being denied passed along.

This time they will linger. Our artist may not have studied these types to which he calls our attention as deeply as Leonardo studied Mona Lisa, nor even with the sympathy and insight of a Bret Harte, to get nearer to our locality, but he has been violently stirred, it is clear, by their strangeness, and has expressed his emotion, incoherently perhaps, but with such great passion that the public will be surely impressed.

We say "incoherently perhaps" because we ourselves cannot see the reason for the passion. After all not one of this wild coterie tells you a secret. The young Indian has been commissioned to dress up in his feathers, that is all, and he

does so. The little Chinese girl has been persuaded, no doubt against her will, to put on her pale blue dress that is edged with wine color. Even the old reprobate of a Chinaman, Jim Lee, seeing coins flashing, smiles a smile "that is neither child-like nor bland" and also poses. They pose.

One succeeds the other quickly and the gaudy colors are slammed upon the canvas. There is nothing reported that the ordinary tourist doesn't see. The ordinary tourist who has seen these Mexicans and Indians skulking about the railway stations in the far West will be glad to see them again, with nothing in the way of vividness of coloring left out. The stay at homes will also wish to see Tam Gan, a fat woman terrify-ing in her Chinese sleekness; Yen Tsidi, the Indian brave, with feathers and a pure vermilion blanket, and Ramon the Mexi-can, who smiles and shows you his gold tooth. The passion in this painting mystifies us because the soul, the secret, the representative quality, call it what you will, has not been sought for. Why get in a passion over the husks, the shell?

There is nothing of the sort of thing here that Lafcadio Hearn dug and died for in Japan. Who could forget the ex-quisite little lady who called with smiling lips upon Lafcadio's family, smilingly saying good-by although she knew she was saying good-by for ever, her physician having warned her of the imminence of death? Who could read the little sketch with-out a pang of illumination into a whole nation's refinement? Or reading, forget?

Have you read Parkman's "Oregon Trail"? Something about Indians in it. Indians in action, Indians on the job. Splendid that it has been written, splendid that a monument to so natural and poetic a race has been secured for all time. Read it, do. Since that day the Indian sun has almost set. The beaten people know they are beaten and for the most part live pitifully upon our "bounty." It is a horrid story from some points of view, but like all true stories of great fights has an invigorating and useful thrill for the spectator. Here and there in the West a flash of the old time spirit gleams occasionally from the dusk with a real echo of the former nobility; just as in Tangier there are Moors who dance and sing nightly, for pay, alas! of their glorious and historic "victory" over the Spaniards, forgetting entirely the subsequent and complete successes of the hated rival.

It is all "material for the artist," the episode of grandeur

which can still be seen by poets, and the sorry decline from the former standard that now hangs about the railway station. The failure is just as interesting to a Walt Whitman as a success. All that is required is an interpretation.

The sum of our feeling in regard to Mr. Henri's new work is that it will have immediate but not a lasting success with the public. These are all interesting people that he shows us, that silly and wicked Jim Lee, the little dolls of Chinese girls, the brown Mexican and the Indian in feathers. We would all pop our heads out of the windows in a jiffy to see them and would part with them reluctantly as the train moved on again, wishing that we might know positively whether that doll was a good little Chinese girl or a bad bittle Chinese girl, and all sorts of things like that. We get cross at ourselves afterward for not having descended from the train to find out, and we grow annoyed at clever Mr. Henri, who might have found out more about these people, but didn't.

Mr. Henri can and will no doubt win a harvest of prizes with his Indians this year. To win a prize in the public exhibitions nowadays one does not have to compete with Goya and Holbein. We don't mean that in any unkind spirit. We have an admiration for the earnestness of Mr. Henri which we have many times publicly avowed, but we cannot suppress the desire to extend our admiration.

It is easy to win a series of prizes in the string of exhibitions that dot across our country, because all our artists, good, bad and indifferent, if they live long enough and play the game properly, win them. The prizes mean nothing except the emolument and the trifling "ad" that go with them. They have nothing to do with one's permanent reputation. For that we must keep an eye on Goya and Holbein.

Mr. Henri himself will not object to such a statement so much as will "the boys." Nothing annoys our young people so much as this constant harking back to the great names. Yet there are instances enough in history to show that those who achieved greatness, for the most part, aimed at it. Turner may or may not have been an intensely disagreeable person in the flesh, but there was no doubt in his own mind as to what he was after. He did the "Liber Studiorum" avowedly to eclipse the sketch book of Claude Lorraine, and he commanded that his pictures should be hung side by side with Claude's in the National Gallery. There never was a minute that he was not

considering Claude, and he scarcely thought at all of and certainly took scant pleasure in eclipsing the feeble contemporaries who he knew would be speedily forgotten.

The Sun, November 22, 1914

MATISSE AT MONTROSS

IF YOU do not wish to succumb to modern art, keep away from it. Mr. Kenyon Cox and Mr. William M. Chase are already lost, although they may not know it. But they have looked upon it. To look is fatal. We wish to give all of our other faithful readers the friendly warning that drawings, etchings, lithographs, sculptures (oh, those sculptures!) and paintings by Henri Matisse are now on flagrant view in the Montross Galleries.

Poor Mr. Montross! Little did he dream two short years ago that he would have such a show as this in his beautiful galleries. But he was led into it by degrees. He went to the armory exhibition frankly as a scoffer and he scoffed some, at the beginning, but the constant click of the turnstiles admitting famous ex-Presidents of the United States and other great dignitaries who do not as a rule frequent our exhibitions sobered him and put him in the proper mood for reflection.

He vowed then and there, mark his words, that the day would come when he would have turnstiles clicking ex-Presidents into his galleries. Art he saw was for the people. You might fool some of the people some of the time; but when they get to yawning at the academies and to saying that art is probably very fine and they are sorry but they don't care for art, and then when these same reprobates rush off by the

hundred thousand to the "modern art" show to giggle and argue and come to blows over the objects on display, there is something in the situation that the progressive art dealer, whose science it should be to know his public, might well ponder over.

For over a year there have been rumblings of modernism at the Montross establishment, little indications that those who know how to take a hint understood, but this great eruption of Matisse and the actual, visible turnstiles that refuse to turn until cold cash has been deposited will come as a surprise to some. We believe there is a limited free list for well known artists. Mr. Cox and Mr. Chase are both upon the list, we rejoice to say. Students later on will be allowed certain days for their hilarious selves.

But here is the curious thing that has happened. Mr. Montross, who sent for these Matisse things simply because he believed the public wished to see them, simply, in other words, as a business proposition, already admits that he likes them. He goes even so far as to say the paintings are beautiful!

There is no occasion to enlarge upon this phenomenon. You, dear reader, are likely to fall into the same state of mind if you go to see the pictures. If all that you know about modern art is what Mr. Cox told you, and you are perfectly satisfied with his account, then it will be much wiser for you not to go to the Montross Galleries. Much wiser. Even if all your young friends go and talk by the hour for and against the great or infamous Henri Matisse, be adamant. Don't go. To go is to fall into what Mr. Cox and the late Mrs. Mary Baker G. Eddy call "error."

Just there we felt a tug at our sleeve. We are writing this in a French café. We do not as a rule write criticisms in cafés, but there are times when every little bit of atmosphere counts. This is one of those times.

The tug came from a friend, an academician.

"Say, tell us: What's he driving at, that fellow Matisse?"

"Merciful powers! Have you never seen his work?"

"Sure; but the more I see of them the more my head spins. I thought at first they were simply fakes; but all you fellows see something in them, and maybe you're crazy, or perhaps it's me" — Anglais tel qu'on parle! — "that's crazy, but if there's an idea in it I'd like to know what it is."

"The idea? My poor academical friend, that's what you'll never get from me. Did you ever hear a Cook's guide explaining the Puvis de Chavannes style to a party of Nebraskan schoolma'ams in the Pantheon? Did you ever read Ruskin's art made easy for dull intellects? Explanations that do not explain! When a picture can be explained it's already en route for the garret."

"Well, what pleasure do you get from him, then?"

"Part of the pleasure is in seeing you ruffled, my friend."

"Nice character you give yourself. Easily entertained, you are."

"Yes. If you want to know I'll tell you something. I don't know any more about Matisse than you do. It's just by accident I happen to be in the fashion by liking him. If I were out of fashion I shouldn't worry in the least. I don't believe in fussing about him. I like some Matisses and dislike others, just as I accept certain Grecos and discard others. You wouldn't argue yourself into liking an artist, would you? What is it to you if you don't like Matisse?"

"I don't like to feel I'm missing something."

"On the contrary, you're acquiring an opinion. Always feel like congratulating a fellow who distinctly doesn't like a public favorite. My own pet vanity is a loathing for Murillo. I should have disliked Rubens, I think, but that Thackeray disliked him first. Cox and Chase are simply stunning, you know, in the hearty, wholesome way they detest Matisse. All the 'moderns' love to have Cox and Chase detesting Matisse. Some of the younger fellows weren't even sure that Matisse amounted to anything until Cox came out with his denunciations. Great sport, isn't it?"

"Tell me one thing. Is he honest?"

"Who, Cox?"

"No, Matisse."

"How on earth should I know? Honesty isn't an essential to good art, as Jimmy Whistler and Oscar Wilde discovered simultaneously. It was Whistler who found out that the lovelier the blue and white ginger jar was the less could one count upon the moral character of the Canton opium eater who had painted it! All that I can say about Matisse is that he is now rich enough to be honest if he wishes. He can certainly afford it. I really think, and this is the only critical opinion you shall

get from me, that the work Matisse has done since he became rich is remarkably true to the ideals he promulgated when poor."

I regret to say that at this point my academical friend lost his temper. He was leaving anyhow, and in fact was getting into his greatcoat with the assistance of Dubois the waiter, when he began to shout incoherently at me. I thought at first it was my innocent reference to the Matisse riches, for nothing irritates an academician so much as the idea, that idiots actually buy these things, but my poor friend thumped the table with his feet so heavily that a coffee glass jumped into the air to fall in fragments upon the mosaic floor.

"Dishonest, is it? I knew it all along. I don't give that for an art that's founded on dishonesty," pounding the table again so that two liqueur glasses joined the coffee glass, and then angrily stamping out of the room, leaving me to pacify the emotional Dubois.

The discussion had, in fact, the usual Matisse ending. Why even old friends cannot talk Matisse talk without squabbling is one of the mysteries, and, shall we say? one of the blessings of the modern movement.

Businessmen and people in general take a more rational viewpoint than my academical friend. My friend wishes to know how Matisse's work conforms to the principles of Leonardo da Vinci, as though that were the only test for a work of art. The businessman merely desires to know if the public is interested. The principle involved in art dealings is the same whether one disposes of picture post cards or Sung porcelains – one meets the demand.

The public, the dear public, knowing almost nothing of Leonardo and caring less, simply sees in these strange new paintings something that corresponds to some of their own experiences. They jump at them, as children do for new toys. It's an extravagant age. These are extravagant pictures. That they are accepted by the people any one may see who goes to the show.

The spectators glue their eyes to the weird colors and shapes, they linger long. The attention given is the sort that would have flattered Leonardo himself in his day. They were accepted by the people some time ago. They have now been accepted by the dealers. But it will be years before our public museums accept them.

"Yes," said one of the rival picture dealers, "Brother Montross has stolen a march upon us. Undoubtedly he will be able to do good business with this Matisse show. I'm sorry now I allowed him to get it away from me. Of course I've been selling old brown Dutch pictures for years and my eyes are unaccustomed to such straight, frank methods of painting. Still, now, that I have opened my eyes I can see the facts.

"Matisse is the greatest name in art to-day. There is no one in France who is talked about with the same earnestness, no one who arouses deep interest but him. Vuillard, Bonnard and Roussell are immensely clever Parisians who will be admired in America some day for their 'chic' just as they are appreciated for that quality now in Paris, but they owe too much to Matisse not to acknowledge him themselves as their master. There is nobody in England much in the public eye, and since Davis became accepted by fashion in America he has no longer been a subject for debate.

"Now there is the little point that strikes a businessman. The detractors say modern art is dead — that the great war has killed modern art. They forget that Matisse was the great name current upon people's lips all the critical period before the outbreak; a period, you may be sure, that will be analyzed by future historians from every point of view. To have been the conspicuous painter of such a day bespeaks future attention for him.

"No doubt so great a cataclysm will change the atmosphere. It always does. It is difficult to see how people for years to come in Europe will care for the refinements of Matisse. Watteau and Boucher went out, as you know, in a similar situation, but they came back. Matisse may go out too, but he will come back. The world always has its recurring aspirations for the softer side once its robust, impatient gesture for fresh air has shaken down all the housetops.

"Art never had been so refined before, for the alliances and intermarriages between nations, due to the modern world welding brought about by science, compelled art to distil all perfumes into one essence. Congo and Persia, yes and no, thunder and flute pipings, nothing could be too blended for an age that knew everything, desired everything and got everything. The state of modern art did not bring on the war, as some cruel people suggest, but it clearly foreshadowed the in-

evitability of war. Anything so perfectly typical therefore will be invaluable later on.

"One has occasionally to hand out such bitter pills to your friends the academicians that it would be nice to pick something comforting in the way of a moral out of this great smash for them, but really I don't see anything coming to them out of the war. Matisse himself will not be broken. He and Rodin will go on working out their characters formed long ago. It is the great crucible that moulds public opinion that is broken.

"They will not have successors in the same line. But the academicians will not get back their dear Bouguereau. Very likely the history of our civil war will be duplicated. For a decade or so there may not be any art at all. Heroes and persons capable of great energy will give all their force to State and business reconstruction."

The Sun, January 24, 1915

MARIN AND TASTE

THE RECENT number of *Camera Work* seems to have been well timed. The enthusiasm of the young artists and art lovers who wrote down their reasons for liking the Photo-Secession gallery is of a sort to incline sceptics who have occasionally been shocked by exhibitions in the little gallery to give it one more chance. Those that make the venture will now find a John Marin show there which ought permanently to convert them.

Marin, as an artist, has so long been a private force among aspiring students that it is amazing to realize that he is not yet a celebrity. Mr. Stieglitz, who is in charge of the Photo-Secession, states that no public museum owns Marins as yet. This seems strange. He says too that certain American con-

noisseurs have already seen Marins and have failed to appreciate them. This is extraordinary. One feels quite helpless to combat so unreasonable a situation. Not to like Marin is as inconceivable as not to like Chopin.

Not long ago at a little dinner a lady was heard to announce in a most sprightly fashion that she did not like the Boston Symphony Orchestra. She had been bored past endurance, she said, and at last had resolved to fling off the mask she had worn and never to hear the orchestra again. A frightened silence fell about the table, for the lady plainly believed she was saying something clever. Finally a gentleman turned to her and said, "What a misfortune!" and then immediately all of the guests talked about something else.

In fact nothing could be done for the poor lady and nothing can be done for people who do not like Marins. Talking to them won't help them. Explaining won't help them. As for the museum directors, that's another matter. Much more serious than the lady's non-comprehension of the orchestra! You would not, for instance, take such a lady and make her director of the orchestra, would you? Then why put men in charge of our museums who cannot respond to Marins? It makes one feel quite ashamed to think there are no Marins in the museums.

By and by, of course, they will be in the museums, just as the Whistlers are now, but for a long, long time the museums would not touch Whistler. It is understood of course that we are referring to museums in general, to those of Germany, England and Ireland as well as our own. The museums, in fact, would not touch Whistlers until after they had become expensive. Isn't that really curious? France was the exception. France bought Whistler's portrait of his mother for much less than she would have to pay now. France always spends her public art money better than the other nations, but that was an especially effective purchase, for it made Whistler.

Whether a museum could now make Marin by purchasing him is a question. The matter of ultimate success is so delicate. The weight of a hair sometimes starts the scales that finally register justice. If Whistler had kept perfectly quiet in his lifetime, had never quarrelled and had never written stinging letters, he must have arrived, we all think, at his present fame, by this time, upon pure merit as a painter. But it is not sure.

In a certain country that won't be named the phrase "making good" is frequently heard. The prevalent opinion of the people of that country is that a genius who does not "make good" is not a genius. It is, however, an opinion that THE SUN's chronicler has not been able to adopt. Full many a gem the dark unfathomed caves of ocean bear, THE SUN believes, and if it were not so mean to keep pressing the point, it would mention one or two undoubted geniuses long since mouldered to dust that the unmentioned country gave birth to and has not yet honored.

A fine, spectacular death, however, is undoubtedly an aid. Chatterton's sudden and painful taking off put an extravagant valuation upon his verses that has not even yet entirely worn from them. It is not a method to be conscientiously recommended though to painters. There are in fact many serious thinkers who hold that complete and universal fame is no longer desirable for an artist during his lifetime. They say that the world has grown too large, that the modern machinery of publicity puts too strong a light upon his every action, and that the crowd, even though they be admirers, rob him of his creative moments and his still more precious hours of solitude. Rodin is the instance most often referred to.

Whistler's name has been mentioned in connection with Marin's chiefly because it would seem that museum directors must have been prepared by Whistler for Marin. Marin has not so wide a range as Whistler, but in many departments of the game he is more elusive and subtle. Marin may or may not approach the standard of Whistler's big figure pieces. It is too soon to say. But in the present Marin exhibition there are a dozen watercolors which, if they bore the butterfly signature, would be rated, even by museum directors, as ranking near the top of Whistler's achievement. Pray, don't imagine for a moment that Marin is a Whistler copyist, however. Had he been he would have been adopted by the Philistines instantly. No; he is a living, live original. That's the rub.

He paints invariably in rare colors. There is the stir of air upon the waters and among the trees of Marin's pictures and a sense of arrangement that is quite Japanese. The trouble is that he sometimes attempts the impossible. For that the students love him. All genuine art lovers love a sport. Marin has never been accused of not being a sport. His reachings out for impossibilities result in certain works that appear to be mere

confusions to the museum directors. My advice to the museum directors would be to leave these experiments at one side for the present.

The experiments, you must not forget, have been made by an intelligent artist, and have that interest. Later experiments by Marin and future artists may go further along the same lines, and then these present "confusions" may appear sweet and reasonable.

The Sun, February 28, 1915

MAURICE STERNE'S BALI PAINTINGS

LAST WEEK, when talking of the charming and insufficiently appreciated water colors of John Marin, we permitted ourselves to moralize a bit upon the advantages and dangers of a quick success for artists, but in the course of the essay the dangers suddenly began to appear so formidable that we wound it up lamely and in confusion. As the article appeared to be addressed particularly to Mr. Marin we hesitated to recommend him to take a single step in the direction of the Hall of Fame. He knows and we know that those who knock most loudly at that door are the least likely to be admitted.

So we religiously closed our lips last week upon the several ways of gaining the public confidence with which we are conversant. Last week! How difficult it is to live up to one's principles! This week everything is quite changed and now we would just as lief tell all we know of fame's weak armament as not.

This moral debacle upon the part of THE SUN's chronicler is due to the advent of Maurice Sterne, who shows his Balinese paintings in the Berlin Photographic Company's gallery. Here

the mysteries of artistic succcess are laid bare, he who runs may read, and it will be no longer possible to protect John Marin if worldly success be really a temptation to him.

The John Marins (there are more than one of them) must go to Bali for fame. Bail is an island in the South Seas. A sojourn there will make one famous. It never fails. At least it never has yet. Herman Melville looked upon a South Sea island and became an artist. John La Farge and Stevenson looked and became greater as artists. Gauguin tried it and succeeded, and now Maurice Sterne tries it and returns with a cargo of marketable drawings.

Ten thousand of them he brings us, they say. Nevertheless, John Marin, the vein is not worked out. If you must be famous go likewise to Bali and when you return after a two years visit Sir William Van Horne and the Toledo Museum will buy your drawings almost before you get them unpacked. And, please don't you make more than about three thousand five hundred drawings. That's plenty for two years work. Leave at least a bone and a hank of hair for the next chap to do.

So much for fame and the sure method of entrapping her. In the meantime Maurice Sterne awaits without. A thousand pardons! It was not intended, we assure you. We know the respect that is due to talent. Louder with that fanfare, if you please. John Marin, take off your hat.

We are pleased to hear about the island in the South Seas whose religious customs are so different from our own. We are pleased to enter one more name upon our far too meagre list of geniuses. You are very welcome, Mr. Sterne. Ten thousand drawings! Thank heaven they are big ones, No, no, Mr. Sterne, drawings can never be too big. You are far too modest. We Americans like big drawings. We rejected one artist lately — what was his name? Oh, yes, Jules Pascin, just because he drew tiny pictures.

But yours are quite different. There will be no difficulty about yours, we assure you. Sir William was very clever to have secured that one. We should have chosen it had he not beaten us to it. Never mind. These are wonderful too. Pray give us an option on this half hundred for a few days until we may decide upon ten of them. Thanks so much. We have room but for ten. It is difficult to choose ten from ten thousand, is it not?

You like that one best, Mr. Marin! Why? That's like you to fix upon the most incomplete sketch in the exhibition! Don't you know that Sterne's forte is his line? Hush, he will hear you. Yes, they say no one gets so quick and powerful a line as he.

A good line is an intellectual attribute. Artists love those blocky, straightish lines. That is, the older artists like them. It is clear he was taught to block the figure in. The habit still clings to him, but he surmounts it. They can't kill a real artist, no matter what they teach him. They certainly cannot kill a man of intellect.

How finely he writes. Listen to this; it is from the foreword:

"When Java at the end of the fifteenth century was invaded by the Mohammedans the Javanese fled to this thinly populated neighboring island with their customs and religion, leaving all worldly possessions behind them. This spirit was again shown eight years ago, when the price of cocoanuts having risen and Holland decided to annex Bali, about eight thousand of the highest caste of the population having arrayed themselves as for a temple festival, with precious golden bowls, silk brocades, lances and spears, they went to meet the conquering Dutch troops, with their guns and powder, and at a given signal the men, women and children drew their flame shaped krisses and killed themselves."

After that we trust you are sufficiently sobered to peer into these dusky, sombre canvases with the proper seriousness.

The sombreness must be meant. Artists who work outdoors without the protection of sun umbrellas sometimes get their work unintentionally black. But this lowness of tone fits in too closely with all that Melville and the other travelers have written of the beautiful Malaysian life that enacts itself in the mysterious and shadowy cocoanut and bread fruit forests not to have been intended. It fits in too with this artist's character, who unlike Melville saw little comedy in the South Seas, and to whom the women selling rice moved like stern goddesses. But there are no nuances. The shadows are not played upon. They are not used thrillingly. It is as though the artist said "Let the canvases be dark" and thought that enough upon such a point.

The commemorative pictures — perhaps that is not the word, the descriptive pictures, let us say — are few and con-

cern themselves with two sacred dances, one scene in a theatre and two in which Mr. Sterne's goddesses sell cocoanuts and rice in the bazaars. The other nine thousand works are sketches of female figures, some of whom happen to be doing something, and so the study, in the hasty, modern acceptation of the word, passes as a finished picture. There are no warriors brandishing spears, no weavers weaving, no boys and girls making love, and no lean missionaries being roasted alive. Some of these things are no longer done, it is said, but even so there is more to Bali than sacred dancing, although that would quite content Mr. Sterne's friend old Monsieur Rodin, who is quite fou, as everybody knows, over the gestures that these Eastern dancers make, particularly the flat posturing of their hands.

M. Rodin himself has drawn these gestures with the ineffable, indescribable effect of remoteness from us that these dancers make upon emotional Western natures. Mr. Sterne does the gesture well too, but without much mystery. He explains it to us, we understand it, we are not disturbed and we pass on to something else. Even John La Farge, who was quite as intellectual as Mr. Sterne or perhaps more so (we prefer to err, however, always upon the side of the living), got more of the haunting element into his pictures of Eastern dancers. Gauguin got more of the strangeness of the East into his color. It is true Gauguin's color was already Tahitian before he started for the Pacific, but we Gauguin admirers believe that his color was given to him in advance "as a sign."

To sum it up, Mr. Sterne explains where Gauguin suggested. Mr. Sterne gives facts where Gauguin, Melville and even La Farge made music. Mr. Sterne is an academician. We prophesy an instantaneous success for him in America.

There remains the apology that is due to Mr. Sterne for having so loosely grouped the various islands of the South Pacific in one class. He has so recently returned from Bali that he is probably still hot with a sense of all its differences from the thousand and one other islands. We are aware of some of these differences ourselves, but for the purpose of a review, written for an audience to whom all Malays look alike, they were considered de trop. It is but fair, however, in closing, to particularize upon the island, and for that Mr. Sterne may speak for himself:

"But wherein it will be asked does Bali differ from her

neighbors – from Java, Sumatra, Celebes? The Balinese alone of all the inhabitants of the archipelago have to this day retained the Hindu religion. Islam, with its art barrenness, has been imposed upon the neighboring islands.

"In abstract, austere Mohammedanism there is little room for art – it has sunk to mere decoration, tolerated as a prayer rug under the feet of the devotee – whereas to the impassioned Hindu it is a means of getting closer to God. With them art is religion's language, understood by God. Symmetry are its words, rhythm its phrases, perfect balance its sentences.

"Like the immense active volcano towering above the terraced rice fields and teeming tropical vegetation, religion, passionate and agitated, projects from their daily tasks. The same fire or unknown force which from the bowels of the earth exhales steam and molten lava from the mouth of the crater, gushes from the heart of the frenzied worshipper, leaving him prostrate and in a deathly stupor at the feet of his diety.

"The religious rites are for the most part hysteric trances or frenzies, and the elements are symbolically expressed in their sacred dances at the temple festivals. In the largest painting shown in the present exhibition I have tried to show one of these dances. Fire, water and air are represented by priests and priestesses carrying incense burners, bowls of water and fans. Rapid upward flickering action of flames, threatening sinuous flow of water, and irresistible air, are expressed in rhythmic movement and significant gesture."

The Sun, March 7, 1915

PICASSO AND GERTRUDE STEIN

IN PARIS

WHILE THERE may be no historic disputes over cubism in the Carroll Galleries during the present exhibition, the elect at least may have what young Mr. Demuth calls "moments." Mr. Demuth has a "moment" whenever he looks at a Picasso. There are in fact seven Picassos in the show.

Considering the gravity of the public exhibition of seven Picassos in New York it is a matter of deep personal regret that I am unable to contribute any first hand facts in regard to the master in honor of the event. It is true I had the pleasure of meeting him and madame one evening last summer at Miss Stein's, but because of my sins I was not permitted to see his studio nor his latest work.

He was leaving Paris the following Wednesday. Could I come to see him Monday morning at 11 o'clock? I said I could, and after wasting some minutes upon a taxi that didn't appear I set out in the Metro foreseeing that I should be one-quarter of an hour late. But the Metro is of no assistance when one searches for a new address in Paris. Neither are the gendarmes. They are not to be blamed. No intellect not Goethe's nor Voltaire's could master those little streets and impasses.

The gendarme on the Boulevard Raspail, somewhere near where I knew Picasso must live, blithely sent me on a mile out of the way. Eventually I retrace my steps and reach the atelier building precisely one hour later than the time appointed. I ring and there is no response. I hear a wild, melancholy cat yowl. There is no doubt it is the proper place. That is the famous cat about which we talked all that evening at Miss Stein's. Finally the loud thumps of the concierge upon the door bring a maid, and finally pretty Mme. Picasso.

The lean yellow and black spotted tiger cat stretches herself menacingly, feverishly along the floor. A wolflike dog

behaves himself with difficulty in a corner of the room. But Picasso himself had gone out.

He had been positively obliged to keep an appointment at 12 and had just gone out. The cat yowled so loudly we could scarcely hear ourselves. The wolflike dog was invited to assist the cat to depart. The acceptance of the invitation and exit of both animals were instantaneous. The cat's name was Zoise, madame informed me. She always called all her cats that. It was a good cat name, she considered. Down the passage way from a back room the animal noises were still arriving, though muffled.

I agreed to come again Tuesday morning, if possible at 10 o'clock; it would be better at 10, madame thought. But this time I was not serious in making the engagement, for experience had taught me that I was never fortunate in early morning adventures. Picasso would be désolé at not seeing me, madame said.

The next day prevented even an attempt to gain the studio, and the day after that Picasso and Mme. Picasso left for the south of France. I believe they took Zoise with them.

Shortly after their departure, I was twelve minutes late for a dinner at Miss Stein's. This was a triumph. In the late afternoon it had seemed written that I was to be an hour or even two hours late for this festivity, and there were questions of telegrams, petits-bleus and agonies. But miraculously I arrived but twelve minutes late.

Miss Stein said it would not have mattered in the least. No one in all the quarter was ever on time for anything. The only person she knew who was prompt was Picasso. He was never late, that is he was never late but once, and that wasn't his fault.

The Picassos were coming to the Stein's for luncheon, and the united households were then going to the vernissage of the Salon d'Automne. Mme. Picasso was to bloom in a new gown. But the dressmaker held off until the last moment. The Picassos were half an hour late for luncheon. Pablo was in a dreadful state. "Record of a lifetime smashed," added Miss Stein. "We led an awful life for three or four days because of it, and of course the vernissage was quite ruined for us."

The Sun, March 14, 1915

MURALS BY KENYON COX

THIS IS the last afternoon in which Keyon Cox's decoration for the Senate chamber of the State Capitol at Madison, Wis., may be seen in the Vanderbilt gallery at 215 West Fifty-seventh street. It is entitled "The Marriage of the Atlantic and the Pacific": it is in three panels and is a characteristic work by this painter.

New Yorkers will relinquish these decorations without any great strain upon their philosophies, but those of us who have relatives in this far Western city feel somewhat disturbed.

Two figures representing the oceans (the Atlantic, being the older, is the gentleman) are being married by a third figure, in the central panel. The European nations coming to the ceremony occupy one side panel and the Oriental nations balance them in the third canvas. It would be easy to be facetious in describing these figures, for not a gleam of humor has restrained the artist in carrying out his motif.

In a picture painted for all time of course one is justified in ignoring the temporary differences of opinion that so inflame the Europe of the present, but even in an interval of peace there is something ludicrous in the way in which Mr. Cox has grouped his arriving nations in little boats. In any epoch so constrained, an embarcation would produce sea changes of dire consequence.

To be quite frank, and this is an occasion upon which French candor is called for, the composition is excessively amateurish and feeble. It is the sort of arrangement that art students who afterward give up art make, hard, awkward and without illusion. The expressions of the faces mean nothing, the figures themselves are monotonously out of proportion and the color, to put it mildly, is very unpleasant.

Mr. Cox has long been a conspicuous figure in our art life and in one or two ways has served this public well, but upon the whole his career has been unfortunate both for himself and us. He writes well. He has recently published his study of Winslow Homer, which is a credit to all of us, expressing

beautifully all that we have ever felt of Homer. There is no living American who could have written it better. He is a trifle more technical than the late John La Farge would have been upon the same subject, but his volume is likely to stand as an authority upon the most native artist this land has yet produced.

As a critic Mr. Cox is sound only upon work that is al-already a part of our traditions. Facing new forms of expression Mr. Cox is always hopelessly adrift and in consequence he did more damage to the generation he dominated than any individual in it. His influence upon students was not less fatal than his relentless attitude toward new talent in the public exhibitions, for which he seemed to be a perpetual juryman.

As a painter his successes have been few. In the early days there was the portrait of Miss Morgan, the harpist, that was not bad and there were occasional portraits of fellow artists that had merit. I have always felt that had Mr. Cox confined himself to portrait making and to illustrations in black and white he might have achieved a real reputation instead of this crumbling and shadowy one which a species of terrorism has imposed upon us. Color was impossible to him and design was not easy; but one can do portraits even without color.

I should be really grieved if this article should be misconstrued as an "attack" upon Mr. Cox. It is nothing of the sort. I have a sneaking respect for him which I cannot overcome, for I am a lover of traditions, and he has been with us so long and has always been such an Old Roman!

Besides, though unfortunate, he is incontestably honest. I consider that he should not have allowed himself to have been persuaded into the making of the long series of joyless mural paintings, but after all the real blame for this lies upon us, upon you who were smiling just now and upon me, because for years we have been permitting all the Western Senates in the land to acquire them without protest.

The Sun, October 17, 1915

MAX WEBER AT MONTROSS

THE MAX WEBER exhibition in the Montross Galleries is of the highest importance and one that no one who is interested in the art life of the day can afford to miss. Mr. Weber more than any of the native artists who have made themselves visible above the horizon of what is known now as "publicity" formerly known as "fame" faces the problems of the art expression of this time with courage equal to that that masters have ever employed.

There are still some people who ignore the fact that there is such a thing as "modern art," in spite of the constant succession of pictures and sculptures that are imbued with it, the new music in the concert halls and the new literature. It is of no great moment that so many philistines rebel at the new forms, for those rebel loudest who really care least for art of any kind. There are persons in this country still who would be revolted if confronted with a picture by Manet, for the millions still prefer J. G. Brown. Yet the cause of Manet is won in spite of the ignorance of the mobs, and it is now history.

Max Weber's cause, and the modern cause generally, is partly won, but not wholly. For that reason it is doubly interesting, because alive. Manet's cause, being won, is dead as a cause. There is nothing left to be recorded about it except its bibliography, which is immense. But one would imagine that the mental and soul courage of Max Weber and Picasso would be admired even by those who consider them mad men, yet I do not perceive that this is so. Art courage is as descried to-day as scientific fervor was in the Middle Ages. Yet without the spirit of the inventor what is art? Practically we put a premium upon the lowest forms of art, such as imitation and the mechanics, and endeavor to crucify those who listen to the voices of inspiration.

That individuals, who would pass as sensitive consider beauty a fixed state and the expression of it a fixed formula is sufficiently curious. There are such countless illustrations to the contrary in art history that it is embarrassing to choose

among them. Our gradual appreciation of the Oriental stand-
ards is as illuminating as any. Numberless Japanese prints
and Chinese porcelains found their way to these and European
parts, and cultured "sensitive" people here and abroad owned
these things, lived with them and exploited them for years
as "curiosities," never suspecting that they were subtle art
works put forth by most aesthetic races. We looked on beauty,
but we saw it not.

When the De Gourmont brothers discovered Utamaro
many Frenchmen saw beauty in Japanese art for the first
time; Dante Gabriel Rossetti did as much in the way of illu-
minating the English, and Whistler's ravings over blue and
white compelled some Americans to use their finer senses in
the matter for the first time. It seems so obvious now that
some of the hard headed types who are shutting their eyes to
modern art will scarcely believe that Toyokuni and Haronobu
once had to be fought for.

That it was inevitable that "modern art" should take the
several forms it has adopted I do not insist. But now that it
has laid an emphasis upon the abstract and upon plasticity
I can see that it is apropos. The essence of modern art, which
is the deep, heartfelt yearning for new forms of beauty that
shall be in correspondence with present day experiences,
might have been differently voiced. But the new art is express-
ing the aspiration, and it is not for us to quarrel with the
form. Spirit is always wrecked upon too strict an allegiance to
the letter. The outlines of all of our old faiths, customs, habits,
had become blurred. The barriers between nations and reli-
gions had become broken — some call the new thing Trium-
phant Democracy, and perhaps that is its name — but at any
rate the time was ripe for new ideals. They have appeared in
all the arts and they are being denied. They came in an un-
expected guise. The King of the Jews was not the sort of king
that had been looked for. He was mocked and despised by the
"best element" of his time, and it is a matter of comment that
He disliked Philistines.

<div align="center">FORM</div>

From origin and space unknown,
Rolling, thundering, deep blended matter tints meet;
And like current-tides contours make
And new form born must be.
The force of tide and time is the urge in me,—

The tints with mood must blended be,—
Their volume pulsed and breathed must be,—
And all in all the inner voice must be.—
My mind, magnet like,
Holds all——
All, that by it times,
To all new being it gives.

—BY MAX WEBER

As an artist Max Weber will be admitted by all to be an excellent colorist and strong in design. With his abilities it is altogether likely that he would have become prominent had he lived even in the preceding generation, with its so different viewpoint. He was born in his epoch, however, and his sensitive makeup seems to respond to the influences that are now in the air, with perfect reaction into art.

Picasso, the Spanish-Frenchman, whose latest work is now on view a few doors below on the avenue in the Modern Gallery, and who is the leading exponent of the school in Paris, is a classicist in comparison. His latest painting is so pure in spirit that the only thing it can be compared to for purity is with Greek sculpture. But Max Weber, as befits an American, is less ethereal and more tumultuous; he is as all accepting as Walt Whitman, and at last we have an artist who is not afraid of this great big city of New York.

For Max Weber has been listening "to the voices" in New York, and the mere titles to the pictures ought to send all the pupils in the art schools to the show. Here are a few: "A Comprehension of the Grand Central Terminal," "Interior With Music," "Interscholastic Runners," "Memory of a Chinese Restaurant," "An Idea of a Modern Department Store" and a "Comprehension of the International Exhibition at the Armory."

Just how necessary the titles are to the success of the pictures I leave to others. Whether I should have known what the "Chinese Restaurant" was without the title I am not sure, but this I do know, I should have taken great joy in its rhythms and placements and startlingly agreeable and novel colors.

Abstract pleasures of that kind of course are not new but customary, for artists have always been more or less addicted to the abstract. I remember possessing years ago a charming Japanese print in which a few splashes of black upon the paper might be interpreted, if you held the paper just so, as a withered tree trunk; but no matter if you held it

upside down, as many of my friends frequently did, it was still charming and satisfactory. The streaks from the painter's brush had been most carefully reproduced by the patient Japanese engraver. I once in a fit of arrogance endeavored to enlarge upon my appreciation of this print to a Japanese collector who chanced to visit me and I asked him if the Japanese cared also for the happy go lucky quality of the painter's soft touches regardless of what they might be supposed to mean. Of course he gave me a stare of mild pity and quickly placed me where I belonged, among the ranks of the barbarians!

I considered myself fortunate in meeting Mr. A. W. Bahr at the Weber exhibition. Mr. Bahr is well known in New York as an authority upon Chinese art, and as he was born in China and has lived there much, he has had the opportunity to study their viewpoint. We met in front of the "Chinese Restaurant" just as some one pronounced the name of the picture for us. "You can almost smell the Chinese food," exclaimed Mr. Bahr, laughing heartily, as he gazed with instant and complete appreciation of the new painting.

Immersed as Mr. Bahr is in the philosophies and ideas of the "unchanging East," it was almost a surprise to see how casually and easily he accepted and took pleasure in these "modern works" that certain upstarts of the day before yesterday declare to be a menace to tradition!

"What's that one?" he asked of a large canvas filled with well balanced swirling curves in soft grays and browns.

"An Interior with Music" I read from my list. "Lovely color" was his reply, and indeed the canvas had some of the mellow tones of Korean and Chinese tomb ware.

"You know this art might not be so difficult for the Orientals," he added. "You know they always hold the accusation against you Westerners, that the moment they begin to talk of things not actually seen you imagine them to be crazy!"

Young Mr. Weber was in the gallery too, and although I don't believe in asking artists about their pictures I couldn't resist the impulse, and just as though I were one of the hoi polloi asked him: "What are these big black things in the Comprehension of the International Exhibition at the Armory?"

"Those are the crowds around the paintings; see, each

spot is labelled with an artist's name, 'Cézanne, Redon, Matisse, Picasso, &c.' "

"And what are the wavy white lines on the big black splotches?"

"Those represent the people thinking!"

The Sun, December 19, 1915

CÉZANNE

THE CÉZANNE exhibition in the Montross Galleries and the French art at Knoedler's continue to excite attention, and no doubt profound results will flow from both events. The Cézanne episode is almost being turned into a religious festival by the young artists of advanced tendencies, who openly acknowledge this artist to be the fountain head of modern art. The water colors in the Montross Galleries yield them especial instances for their arguments, and promulgations in hushed but earnest tones may be heard at any hour of the day. These young people are right to emphasize the water colors, for they illustrate perfectly certain things this artist contributes to modern art; whereas the oils, although fine as examples, are not so overpoweringly convincing (with the exception of the superb portrait of a man), as certain others that might have been shown.

Conversions to the faith, however, have not been so numerous nor so spectacular as those that are numbered and assorted by the publicity agents of the Rev. Billy Sunday. It doesn't seem possible that they ever will be. Adherents to the cause of Cézanne and the new school must come from the young. In other words, you must be born "modern" to be modern.

This has always been the case with innovations and innovators. The history of the previous great art cause, impressionism, is not much taken up with distinguished conversions. The prominent, important, powerful people who opposed it went to their graves for the most part in perfect assurance that Manet and Monet were charlatans. We might console ourselves with the reflection that now that they have ascended to celestial glory they see things truly, that is to say, impressionistically; were we not too busy trying to make the prominent, important, powerful people of the present see truth from a totally different angle. The saints above, it is altogether likely, look with great leniency upon these ophthalmic sins of the flesh, so we must try to, too. The efforts of the prominent, important and powerful to stop the clock at exactly the point where they achieved their own material successes must look very amusing to them after they have quite done with earthly strife, and they look down upon each succeeding generation from the realms above and see each new set of successful old persons denying that what the new young crowd has discovered has any element of truth in it.

Life changes and so-called "truth" changes with it.

Lunching to-day with an academician I advised him to see the Montross show. "I will not," came so forcibly in reply that I saw indeed that it would be useless for him to see the pictures. He would not see in them the things he puts into his own work, and would be so outraged that he would be incapable of feeling the new thing that Cézanne does contribute. The new generation that does not share my academician's belief that art can be expressed only in an academical fashion, and seeks for something more subtle, palpitating, and nervously alive, finds it in Cézanne.

The young explain it, as I said, in hushed earnest tones. But to whom do they explain it? Only to each other.

It would be a miracle as astonishing as the conversion of St. Paul, were they to get a single feeling of theirs into the bosom of an academician. To me it is a thing impossible, therefore useless to attempt. The real thing is not to convert academicians but to proselyte among the immense number of human beings who won't go to academic shows, but who nevertheless live in the life of the present and can be interested in presentments of the emotions that they too have experienced.

The explanations that one hears offered by the young people are, however, too technical. Cézanne tried intensely to get the essence of the thing he felt to be beautiful, and although his water colors are told in but a few touches they give a sense of great completion. Every touch in them is meant. They are put in with so much certainty and power that even the spaces of white paper take on quality and meaning. Those who feel this and are enraptured by it lay too much stress upon what is after all a technical feat. To say that Cézanne is great because he makes these blank spaces vibrate, or because he interlaces forms, or notes the reaction of one color upon another, is quite as bad as Kenyon Cox's statement that Winslow Homer is great because he is a great designer. Cézanne is great because he is a great artist. This saying doesn't explain much, but, as has been said before, genius is unexplainable. It can be weighed and its effects measured, but it cannot be understood. The secret hope of the feeble is to unlock Cézanne's mystic power and to rework the vein again, for self-exploitation. It's quite useless, of course. No one can be Cézanne over again. The secret of being the intense vital artist who shall stand as chief representative of an epoch does not consist in imitating some preceding chief, not even Cézanne.

There is little hope that Max Weber's "foreword" to the Cézanne catalogue will explain much to the academicians. As art appreciation it will seem to them to be as wild as the pictures. It is, however, only fair to reprint it, as it shows the way the young now talk. The modern artists will like it, and nothing derisive or derogatory that the philistines may say will affect their appreciation. Who cares what Philistines say anyway? This is Max Weber's foreword:

"The rhythms, the interlaced and contrasted quantities and their energy of contour, are what he sought out in nature through these water colors.

"They are expressions of the first vital, fresh sensations he received from closest and intense observation, and they are his freshest expressions of what one might call colored geometry sought out by him in the landscape. They serve as a most satisfying and comprehensive introduction to his complete sculpturesquely painted pictures, the areas of which are constructed with color nuances and gradations — only Cézannesque — unknown to and unequalled by any other master or school in the history of painting.

"His art is the most marvellous example of the reorganization of the natural into a purely plastic domain. The reality of his art is so marvelous, concrete and poetic that he succeeds to a rare degree in making the static to vibrate. It is the very spiritualization of matter form on earth. They are the first writings of a powerfully creative, placid organizing, mind controlling emotion and blazing intellect. In these water colors can be seen and felt his power of synthesis in transforming the chaotic into the purely architectural plastic.

"So intense, and often final, are these colored contours that the blank areas stir the imagination, for they are imbued with constructive color and form and are at once as satisfying as if they had been carried as far as his most complete works. So full of suggestion are these water colors that the spectator, artist or layman, must for the time being become creative. To me these water colors are complete works of art of great distinction, wholly as important as the oil pictures."

The Sun, January 16, 1916

MARIN'S WATERCOLORS

THE IMPORTANT show of the week is the John Marin exhibition of water colors in the Photo-Secession Gallery, at 291 Fifth avenue. Mr. Marin's is one of the most undoubted talents in America, and its slow progress into the consciousness of the great public is a tragedy — for the public. It would seem that such exquisite work would win instant applause, would be its own recommendation; but the same old painful period of purgatorial tests, it now begins to be apparent, will be exacted of it, before it enters into the holy places of the museums and picture auctions.

What is the public's loss is, I am inclined to think, Mr. Marin's gain. As an artist he continually grows, and the present exhibition is one of the best he has ever given. Certainly the work is more subtle. This unmolested utterance of "melodic" color (the felicity of the work has a Mozartian strain) could hardly continue were Mr. Marin as great a popular favorite as, say, Harrison Fisher or Dana Gibson.

He would be owned too much by his admirers, and as the money value would be quickly and precisely fixed upon his efforts so would the immense weight of the public opinion (something that can be laughed at when you are safe from it, but which no giant can slay single handed in actual combat) be entirely borne upon the desire to make this money producer do the much advertised Mozartian strain over and over again ad infinitum, ad nauseam.

One of the most comforting things about Mr. Marin, the artist, is that though he belongs unmistakably to this year of Our Lord, he yet escapes from complete identification with any of the various cliques or schools. Like Albert P. Ryder, he would be gladly claimed by all the factions. There is frequently in his work a breaking up of outlines and a recomposition of them in the "modern art" fashion, yet I should hate to call Mr. Marin a cubist, a post-impressionist or any other term except "artist."

I am never very enthusiastic about labels or classifications, however, and in the present instance it contents me that Mr. Marin is a poet, and that in the development of his impression he even gives one vivid, if etherealized, realism. In almost every water color save those that look like Chinese hieroglyphics I get decided realism. It is realism to something rare, subtle, fleeting, dreamlike in the actual scene, and facts and measures have little to do with it. Even the Chinese hieroglyphics I "understand" sufficiently for myself. They are pleasing forms from nature juggled together in agreeable color and have the effect of the stamps one sees upon the back of a fine porcelain.

The Chinese feeling they suggest is continued in practically all the landscapes, although it appears simply in the increased mellowness and subtlety of the color. Many correspond in the harmonious use of grays to old Chinese temple paintings, but there is no sign that the artist himself was striving for such an effect. It is merely a coincidence. Chinese art

gives one the sense of age, of vast knowledge, of the accumulation of thousands of years of resignation to the difficult facts of life, and to thankfulness, just the same, for the good moments here and there.

Mr. Marin's art seems old, too, this year; much older than ever before. The fact is the whole world is feeling its age at present, and it is no surprise to find one of our most sensitive artists swayed by it.

The Sun, January 22, 1916

JOHN SLOAN

THE EXHIBITION of the American Hogarth, John Sloan, in the studio gallery of Mrs. H. P. Whitney on West Eighth street is fairly complete, and one may judge of his performance in many mediums — oils, etching, lithography, monotypes and drawings.

In such an exhibition the paintings naturally dominate, and as Mr. Sloan's chief gift is for satire, the satiric oils are those that attract first notice. The most prominent of them is called "Three A.M." and in the kitchen (or perhaps parlor, it is not easy to tell) of a tenement two unpleasant females are regaling themselves with food in the middle of the night. One, in a nightgown the reverse of chic, is frying a steak upon the stove and smoking a cigarette at the same time. The other is drinking coffee in an abandoned fashion from a cup that lacks the support of a saucer. The room is in disorder and the woman cooking the steak has unnecessarily thick and foolish ankles.

Just what the moral lesson is I am not sure, but of

course there must be one else it wouldn't be satire. The paint-
ing as painting has animation and there is excellent still life
work in it here and there.

The "Haymarket" is more clear cut as satire. Two young
women in extravagant white finery are entering the once no-
torious dance hall, and a laundress-mother and her child are
passing. The little girl gazes backward as the dazzling crea-
tures enter the brightly lit hall, and the mother drags her
forward reproachfully. The idea here is unmistakable. It has
not been carried out with the care and thoughtfulness that
Hogarth would have lavished upon such a theme, but it is
too much to expect an artist in rapid New York to rival in
finish the artists of more leisurely epochs. Of course comple-
tion as to detail in such pictures is not of high importance. The
important thing is to have such details as are used vitalized to
the highest degree. Every shred of the thought should be made
to count. The satire should be stamped upon the spectator's
brain unforgettably.

In the "Carmine Theatre" a sister of charity passes with
uncouth stride and gives a glance that may be interpreted in
several ways to some children who pine to enter the abode of
the movies. The intention here is satiric, no doubt, but again
the shaft just misses. The "Savings Bank" shows a gloomy
room, with crowds of depositors awaiting their turns in the
shadow. As a picture it is not exhilarating. It has the look of
a comment upon society, but ended in realism.

The fact is Mr. Sloan is most interesting when most
satiric. It is curious to observe that when he sets out to record
the fairer aspects of nature he is scarcely bearable. His land-
scapes have a certain vigor, but little beauty. The strangest
part is that in them the color is quite obvious and unconvinc-
ing, while in the frankly caricatured pieces the color is all right.
In the "Elevated Railway," which is caricaturistic in manner,
the sky is excellent. In a neighboring landscape the sky is
merely paint.

He needs the spur of the comic impulse it seems, to make
him surmount consciousness of the paint brush. The little
girls seating upon the rock are hopelessly inhuman and un-
interesting, but the woman hanging out the wash upon the
housetop and who put the clothespins in her mouth, being a
funny object, is so much better that one might imagine it the
work of another artist.

This phenomenon is frequently encountered among artists, and many who fail as artists fail for the reason that they never encounter a motif that carries them off, out of themselves. I heard a successful painter comment upon this subject aptly once in the lobby of the Grand Union Hotel (now a hole in the ground), which was adorned with the prize burlesques by the Fakirs of the Art Students League. He pointed out a number of capital burlesques of pictures, burlesques that had wit as well as clever painting, and moralized upon the fact that some of the most brilliant caricatures were by students who had done nothing since that were of equal merit. The opportunity to burlesque a Sargent, a Chase or a Saint Gaudens, so frequently offered in those days, had made the students lose the thing that artists are always lucky to lose, consciousness of themselves.

I should not, of course, forbid Mr. Sloan his search for "absolute" beauty. I think his best chance for a greater success lies in the direction of satire, but it is generally conceded to be wise for an artist to round himself out, and the part of the equipment that is weakest is the part that most needs to be fortified. A caricaturist needs to know beauty. A tragedian is in a dangerous state unless he has a sense of comedy, and the comedian for the same reason must practise tragedy. I once knew a musician who had a tendency toward the too heavily solemn and whose instructor forced him to play jingling, frivolous melodies for a time, in the effort to lighten up the opaque gloom of his style.

The Sun, January 30, 1916

MAURICE STERNE IN CHICAGO

*"The American people do not buy pictures
— they have pictures sold to them.*
—MAURICE STERNE.

THERE IS THE most disturbing news from the middle West. Chicago and Maurice Sterne have had a quarrel. Chicago, to put the matter bluntly, was not up to Maurice Sterne. Chicago betrayed in this instance a revolting misconception of what is correct in present day standards of art.

Is it not really too bad! Just at the moment that all of us were hoping that at last Chicago was on the mend! But Chicago is no more able to appreciate Maurice Sterne than Lowell, Mass., was able to assimilate Whistler.

From a distance Chicago was as nice as she could be. She made the softest, blandest overtures, promising everything the heart of a sensitive artist could desire. Was not Sterne "modern," was he not a sensation in New York? What New York could digest she could digest. What New York could understand she could understand.

As for etiquette, Maurice Sterne need have no fear. Did not Chicago once entertain the Princess Eulalie of Spain without a mishap? In short, the burden of all the love letters exchanged between the Art Institute and Maurice Sterne was: "Come, only come, give yourself to us. You will find us worthy. Lend us your priceless art and your gracious presence for a little while. We thirst for what you can give us. Come, oh, come!"

Alas! many are called but few are chosen. In fact, no Maurice Sternes whatever were chosen in Chicago. Absolutely none. Not a single solitary sale was made.

To make matters worse Chicago openly avowed a preference for Redfield landscapes. Incomprehensible, dear reader, is it not? But the bulletins that have been received from Chicago leave no room for doubt. The benightedness of that hopeless land seems complete.

The icy temperatures that can develop along Michigan avenue would scarcely be credited by the New York newspaper reader, but a phenomenally chilly blast descended upon the

Art Institute consonant with the opening of the Maurice Sterne packing boxes. What it must have been to the poor Javanese who are pictured in the Maurice Sterne canvases heaven alone knows, for most of them wear loincloths only, but the director of the institution, who one would think should be immune to climatic changes by this time, and besides, like all other museum directors, probably owns a fur coat, took fright and never smiled again, or at least not to Maurice Sterne.

It amounted, so read the bulletins, to a suspension of diplomatic relations between this artist and this director. Mr. Sterne during the time of the exhibition of his pictures wandered about the city finding other museums that were more to his taste than the Art Institute and other individuals who were a degree more sympathetic than its director. When the time came for his departure, they do say that Mr. Sterne walked unseeingly by the chief custodian of art in Chicago and after taking formal and pointed leave of the fair typist in the office shook off the atmosphere of the Institute forever.

Maurice Sterne has now returned to New York. He is alive, but something in his interior has been damaged. He thinks it is his heart. He is so crushed that he has taken the old J. G. Brown studio for the winter. After his cruel experiences in the West he imagines that atmospheres can no longer affect him. Besides, atmosphere is not what J. G. Brown specialized upon. When seen recently, for a long time Mr. Sterne refused to speak but finally he said:

"Chicago is the most wholesale place that I have seen. Everything is thought out in figures. About the first remark that the director of the Institute made to me was, 'Do you know what our biggest attendance has been? It was twenty-four' – or perhaps more, for I'm not much on figures myself – 'thousands on such and such a date.' The vindication for anything in Chicago seems to be the figure that can be attached to it.

"My exhibition in the Institute was like a section of a department store; there were several other one man exhibitions going on at the same time in various rooms. I had no success whatever in the emporium. Nothing was sold. I have found out one thing anyway, the American people do not buy pictures – they have pictures sold to them.

"I found no art intelligence in Chicago to speak of. I

had a press success," said Sterne, shrugging his shoulders, "but met no one who comprehended in the least what I was after. One young woman, I think she was a critic, actually asked me what first induced me to paint as I did, in a manner so different from the standard artists, pointing to some things by Redfield, Bellows and other chaps that were near by!"

At this, Mr. Sterne laughed heartily, and all the bitterness that had hitherto curved his lips left them.

"I tried to tell her that the 'standard art' of the great classics was just what had influenced me most, and that Redfield and the others were the ones who had forsaken the standards, but I fear she did not understand, for when she used the word 'standard' she thought of Redfield, who had been accepted by her world, whereas when I used it I was thinking of Lo Spagna, Donatello, Michelangelo, Signorelli and the others who had been accepted in my world.

"I found one pleasant oasis of art in the city. It was, I believe, some sort of ethnological museum, called the Marshall Field Museum, but it had some really superb works of ancient Chinese art. They exhilarated me immensely so that I felt quite repaid for my journey to Chicago.

"No one goes to see them, however. The gentleman in charge told me that the attendance upon the day of my visit was three. He appeared to tell me that with pride," and Sterne shrugged his shoulders again, this time triumphantly as though to imply that there were directors and directors.

The Sun, January 14, 1917

NADELMAN'S SCULPTURE

THE ELIE NADELMAN sculptures in the Scott and Fowles Gallery are important and should not be missed by any one. It is difficult enough for the public in general to follow all the activities in the art world, and most people take their galleries idly and their art education as it happens.

It is a nice, sunny afternoon, just the thing for a stroll upon Fifth avenue. The crush at Forty-second is worse than ever. Why join that dodging, dishevelled and rather absurd mob? It is too soon for tea, but there's — well's there's a picture gallery! Nice comfortable sofas. Let's sit down a moment and see what they have. So think our elite of New York, and they occasionally see in that way some excellent works of art and some that are not.

The few who have a deeper feeling for the significant in art have secret methods of intercommunication, just as true book lovers and musicians have, and they allow much less to chance. These, of course, already know Nadelman, for he has shown once before in New York, and will not think it a hardship to undertake a special journey to a particular gallery to see his new things. They will be repaid by being in a position to inform their more careless friends. There are in fact a half dozen or so exhibitions during the winter that are remembered afterward, and this is one of that sort.

Nadelman's art has certain points of perfection and certain difficulties, both so evident that even its admirers debate it more or less, while those who object to difficulties of any kind take the perfections as brazen impudences levelled at their academic minds.

This perfect part of the work is technical. There is no wish on my part even to hint that it is wholly technical. On the contrary, Nadelman the poet may be considered later, but when an artist possesses a quality that is superlative that is the quality that springs first to the lips. Nadelman is an able craftsman. I don't recall any of the modern men, with the single exception of Brancusi, who has seemed so freed from

and so superior to his technic. The things that he has done seem to be authoritatively and exactly as the sculptor wished them to be. The manner for the marbles especially seems to have been pushed to the extreme. The spectator upon seeing them feels inclined to cry to the sculptor, "Fine, but enough. Go no further along that path." But before going further along that line myself perhaps a word about Nadelman's general style is necessary.

It is in a word refined. It is in the highest degree a before the war art. It is cultured to the breaking point. It seems to breathe out all the rare essences that were brought by the wise men from all the corners of the earth to be fused by the Parisians (yes, Paris was the crucible for that sort of thing) into the residuum called "modern civilization," which now so many million are dying for. It's for the boudoir. It seems to call upon Louis Seize courtiers for applause and to Horace Walpole for patronage. It's Greek, it's Italian and it's yesterday in France. The past and the present are blended almost cruelly. For that reason it recalls to me every time I see it the last chapters of the "Ile des Penguins," that bitter before the war book of Anatole France's, in which the early enamelled and sculptured representations of the St. Orberose reappear in the salons of the less than demi-mondaine. I find myself growing frightened in the presence of this sculpture, just as I was frightened by the two last books of Anatole France, for I think and I thought, "Something awful is going to happen." Then I recollect myself and grow more cheerful, for the "something awful" has happened, is happening, and there is nothing left for us appraisers and merchants of art but to set values upon it, and high values; for art history, unlike the other kind, repeats itself and before the war productions have two chances on the market — as souvenirs and as works of art.

Nadelman's sculpture is nothing like Clodion's, but it has this in common with it, it was built for a civilized audience, people who lived in houses. Although this work looks very well at Scott and Fowles the gallery in reality does it an injustice. The pieces need placement in relation to something architectural to speak properly. The bronzes will probably meet the easiest acceptation, especially the bronzes of animals. The conventions Nadelman imposes are rather steep, but although we are not used to seeing stags and colts with such slender shanks, still we see it to be a convention, and one that other

modern artists have prepared us for. At the second glance we become so enamored of the spirit of these beasts that we accept everything. The "Jeune Cerf" is particularly engaging. There's a mixture of a Greek vase and the Central Park zoo in it. But who cares? It's really like Debussy music.

But for the marbles, as I said, I hope Nadelman will stop right where he is. The pieces he submits are immensely interesting and some of them are very beautiful. The faces have a haunting grace, and a type that resembles Luini's Madonnas seems to lure Nadelman on and on, from marble to marble. In the last one I think the artist got her. In token of the intoxication that this Luini woman plunged Nadelman into, he lavished all sorts of affectionate extravagance upon her portraits, polishing them until they shone like water. Extravagance is becoming to a poet — but still there are bounds, as in everything else. Why should sculpture look watered? Positively I thought one of the heads had been dipped in glaze at first. Nadelman is sensitive in his appreciation of materials — notice the lovely patina on the bronzes — but I should like to check his extreme cleverness in stone cutting and polishing at a point somewhere before the porcelain effect is reached.

The Sun, February 4, 1917

ROCKWELL KENT

NINE PAINTINGS and a number of drawings by Rockwell Kent, all of which are upon the imaginative order, are being shown in the Daniel Gallery.

In each picture there is something to astonish or offend the lovers of the academic, and this is balanced by passages

of undeniably good painting. Whether the unusual manner and the clever technique are secondary to a message of profound spiritual importance or not is something the present writer has not yet discovered. The cleverness and the strangeness, however, are acknowledged with gratitude.

The "House of Dread," which was reproduced upon this page last Sunday, is perched upon a desperately steep cliff by the sea. A brilliant light as from a calcium in a theatre beats upon the far corner of the domicile, where a man, nude, leans against the wall in a dejected attitude. From an upper window a woman bends, her tumbling hair obscuring her head. Only sufficient touches have been bestowed upon these figures to indicate that they are meant for human figures.

The sea is dark and forbidding. The horizon line wabbles, but the uncertainty of its edge does give an extra vastness to the ocean. Instead of focusing at a given point the eye wanders around the sea as it does when searching the actual sea; and greater space is felt than had the horizon line been done in the approved fashion with a ruler. The sense of space and loneliness upon the sea is all I got from the picture. The troubles of the man and woman and the calcium light upon the house scarcely awakened my interest.

In the "Voyager Beyond Life" a man, nude, sprawls along the bowsprit of a ship and there is a green sky, studded with stars in odd constellations, and a forbidding sea below. Odd constellations of the stars appear in most of the pictures. The stars are trickily conventionalized. They twinkle cleverly, however, from the funny circles in which they are embedded like jewels. In another canvas a small ship is about to sink with conventional circles of water about it, and shafts of light stretching down from a leaden sky. In still another, a young sailor appears to be crucified upon the top of a bare pole, which may possibly represent the mast of a ship. A landscape, and I think it's the picture I like best of the series, has corrugated ridges of rusty rock stretching across the picture in parallel lines, and above the sea horizon the leaden clouds that hover over Mr. Kent's dream country continually are also in corrugated ridges.

This is a hasty and hurried description, but it is perhaps sufficient to indicate that the pictures are odd. The reader has also read between the lines that I was not frightened to death by the pictures as I sometimes am by a tiny scratch from the

pen of William Blake. Mr. Kent is far cleverer than William Blake when it comes to a representation of things, and each of his pictures has something that seems vividly realistic in spite of the artist's evident desire to shun representation. But in qualities of soul, or even in command of a mood there is no excuse to bring our artist's name into comparison with that of the great English mystic.

Mr. Kent, it seems, has been sojourning for months upon one of the bleak northern American shores, Labrador, Nova Scotia, or somewhere. He has communed with himself and apparently has been interrogating the stars. All that I like and commend him for. I am continually beseeching our artists who find themselves in a rut to get out of the rut. There are too many agencies, particularly in New York, that are calculated to make artists think alike and to think like the mob. Artists have no business to think like the mob. They must think for the mob. The regularity of our streets, the similarity of our buildings, with elevators and studios all of the same boxlike pattern, and the same reading matter for all; and is it a wonder that no one dares to be a Daniel, and that artists yearn to have motors and wear spats like the dealers?

But the gift of the spirit does not descend upon one the instant one quits Broadway. It takes time to shed old habits. However, the door will not open at all unless one knocks — and Mr. Kent may be said to have knocked.

Puzzling over the question as to why Mr. Kent's pictures only impress me upon the technical side, I have come to this conclusion in regard to them — that he is still too much in love with that popular and entirely worldly quality known as "the punch." Most of our hasty artists are enamored with the thing they call "the punch," and I think more of our bad pictures have resulted from this fad than from any other recent one. "The punch" is something that affects the unthinking, the torpid, the heavy souled. Blake in a whisper can breathe you into heaven or blast you to hell; but a cheaper artist with a "punch" merely causes you a temporary pain.

And I fear our artist has been levelling a blow that was meant to be dynamic for the mob. Did Blake or any other genuine seer secure the mob? The desire for applause upon the part of the artist is innocent enough. There are writers who say it is necessary for their sustenance. I only know that some of the greatest get along without it.

It can be argued that Christ himself spoke to the mob. But the mob understood only the miracles. "Immediately His fame spread abroad" when the man in the synagogue with the unclean spirit became cleansed. Once the multitude assembled came the sermon on the mount, but in spite of the extraordinary clearness of the words there is no hint that they alone made converts. The people were astonished at the tone, not at the words, "for He taught them as one having authority and not as the scribes." There is no indication even yet that the mob understands the sermon on the mount, but it is sufficient that a few get it. For the really supreme artist how can there be a large audience?

The Sun, March 4, 1917

UNEVENNESS OF BELLOWS

THE MOMENT the George Bellows lithographs were installed in the windows of the Milch Galleries the crowd began to form around them. The crowd will stop to see a Bellows in the window. There is something about almost everything this artist does that arrests the idle glance. It is not everything he does, however, that holds it long.

Inside the galleries the show is fairly comprehensive. It includes more of the lithographs and a number of paintings upon varied subjects that branch out in various directions. Success does not attend upon all of them. Mr. Bellow's muse rides a recalcitrant steed. Sometimes she is jolted terribly, sometimes actually flung to the ground and trampled in the dust. But muses, like able horsemen, love a spirited nag. There

is no reason why Mr. Bellows should discharge his muse. She has plenty of time even yet in which to make a Garrison finish.

But there is one picture in the exhibition that will startle and possibly disconcert many of those who are a little impatient to have Mr. Bellows and his muse come to terms, and that is his "Docks in Winter," an early work, and incomparably the best thing in the gallery. It was first shown a number of years ago and was much admired at the time and it is still admirable.

Two horses huddle together on a snow covered pier by the river and the sturdy horseman in attendance braces himself to withstand the gale that whistles through every portion of the picture. It is really strong. Apparently there was no thought in the mind of the painter at the time of the picture save that of the theme in hand, the fierceness of a storm in winter. He was not aware of spectators, and the regrettable self-consciousness that was to trouble him later had not put in its appearance.

The next best things are certain of the lithographs, and those that approach nearest to abstract art are the most successful. The "Preliminaries to the Big Bout" and the "Between Rounds" have interesting blacks nicely distributed, and the play of lights and shadow is well done. In other plates where one comes closer to details one doesn't like them. The burlesque is heavy, the humor forced.

Such things as "The Prayer Meeting" and the "Duties of Jurors" are not funny. The "Artists Judging Works of Art" sit around in barroom attitudes and might just as well be longshoremen in the midst of a carouse. Heaven knows the present writer holds no brief for art juries and would welcome gleefully any satiric shafts from any source that would aid in keeping them in order. But Mr. Bellows wields a lumbering stick where he should have employed the rapier. One's sympathies go, in consequence, where they shouldn't, to the art juries.

The "Sawdust Trail" has some rough laugh getting points, but it belongs to the series in which the artist overloads his composition with figures. Certain of the drawings and certain of the paintings are simply crawling with figures. The handling of crowds is as difficult for artists as it is for the police. So far Mr. Bellows has not approached within hailing distance

of solving the problem. Some painters can suggest a crowd while in reality employing but few figures. Mr. Bellows employs many, to his confusion — and ours.

Among the new paintings a portrait called "Lillian" and a picture of wharf buildings at "Mattinicus" are the most successful. To the great surprise of everybody this "Mattinicus" of Mr. Bellows's was hung in "The Morgue" when it was shown at the Academy, in spite of the fact that it was the best landscape in the exhibition by far. Probably the jury was misled by the touch of burlesque in the work, for even in landscape this artist yearns to satirize.

The buildings in "Mattinicus" actually look as though they were drunk. They seem about to gallop off into some sort of a monstrous mazourka. But it's no matter. They are all right for all that. If an artist is really in earnest everything goes, and Mr. Bellows was playing the game all through this odd landscape "Mattinicus."

Of some of the other landscapes in which our artist attempts to poetize the less said the better. There is a cattle picture in which the cows are a city person's idea of cows and the composition a country person's idea of composition. The colors in some of these unhappy landscapes are perfectly desperate combinations of purples, burnt siennas and the like. Even from a distance they refuse to melt into relationship and shriek through the gallery roof to heaven. Perhaps they typify the unrest of the times.

The Sun, March 18, 1917

THE DEATH OF RYDER

Heard melodies are sweet, but those unheard
Are sweeter; therefore ye soft pipes play on,
Not to the sensual ear, but, more endeared,
Pipe to the spirit, ditties of no tone.
—KEATS, *Ode on a Grecian Urn*.

ALBERT RYDER is dead. Ryder the artist. He lived a long life. He painted some great pictures. He lived quietly as he wished, apart from the throng. He died quietly, and, it may be presumed, as he would have wished, apart from the throng. So we need not weep for an Adonais, cut off in youth, whose name was writ in water, but may rejoice full heartedly in a life successfully spent for American art. For almost the first time I can comprehend the requiem dances of the antique Greeks. There is something special and triumphant about Ryder's death. If we had poets I would command them to celebrate it cheerfully.

Ryder was the painter for poets. He was their man as they were his. He knew them and strove to meet them on equal terms. The subjects he essayed are proof. "Constance," in the Sir William Van Horne collection, was inspired by the "Lawyer's Tale" of Chaucer; the "Temple of the Mind," belonging to R. B. Angus of Montreal, was suggested by Poe's "Haunted Palace"; a "Moonlight Journey" came from Sterne's "Sentimental Journey"; then there were "Siegfried and the Rhine Maidens," "The Flying Dutchman," the "Forest of Arden" and "Macbeth and the Witches," and the most wonderful of all poems gave Ryder his "Jonah."

Ryder spent laborious days, some say laborious years, in creating these pictures. In the period in which patrons began to appear he was almost as difficult for them, it is said, as was Whistler for his. Mrs. Richard Watson Gilder waited twenty years before the "Melancholy" that she had commanded was given to her. Tales of impatient clients are numerous and amusing. To them Ryder was adamant. The heavens might fall, but nothing could compel him to hurry with the peculiar alchemy that finished his pictures.

"One man," said Ryder once, "told me he had left instructions that his funeral procession was to stop here in passing

to obtain his painting. I told him it couldn't go out then unless 'twas done."

The processes of the artist were mysterious, and no man can explain Ryder's system of painting. Ryder could not explain them himself. He simply painted until he got a satisfactory result. He never learned how to draw, and it can't be said that he knew really how to paint, but he was a great artist just the same.

In his small, enamelled and fussed over panels he could put the weight and the power of the mighty ocean, and he recorded the most terrifying and dreamlike events with a biblical intensity. His color was good. It was as impossible to analyze it as it was to get the technical secret of his effects, but it had that supreme quality of good color of being inexhaustible.

The longer you peer into the moonlit oceans of a Ryder the more profound seem their depths. There is something supreme, too, in Ryder's sense of design. It is rarely faulty and is often masterly. He painted clouds and skies with an audacity and a strangeness that have not been matched this side of the early primitives by any one save Blake.

His career upon the whole was uneventful. He was clearly marked from the beginning to be a dreamer, and the fleshpots of Egypt had slight attraction for him. He lived with the simplicity of the prophets, and as he grew older drew further and further away from mundane things.

He had patrons, as has been said, who were his warm friends and who kept quiet eyes upon him to see that he had what was necessary for his comfort. All that is necessary for the comfort of a petted citizen of the world, however, is not necessary for a genuine John the Baptist, a William Blake or a Ryder, and so our artist's surroundings, it must be confessed, developed of late years into the decidedly bizarre and eccentric.

A writer in the *Press* of December 16, 1906, who penetrated into the small room that Ryder occupied at that time in a modest house in Greenwich Village gives this description of what he saw:

"Two-thirds of that room was full, packed solid, with things that had never been moved since they were set three years before, chairs, tables, chests, trunks, packing boxes,

picture frames, vast piles of old magazines and newspapers. Overhead long streamers of paper from the ceiling swayed in the air. All around the edge of the conglomeration sat dishes on the floor, tea cups with saucers over them, covered bowls, crocks, tin pails, oil cans, milk bottles, boxes of apples and packages of cereals.

"In one corner a pile of empty cereal packages mounted to the ceiling. In another a stately tall chair staggered under its accummulated load. A black wedding chest rich with carving was almost undiscoverable under the odds and ends that burdened it. A splendid Greek head, stands on top of the cupboard with a foot bath on one side and a box of hay on the other. Against an exquisite piece of portrait sculpture, the work of a master hand, a friendly package of rice. The confusion was unimaginable, incredible."

That was Ryder's room. Something to smile over, nothing to weep about. It suited Ryder and that was all there was to that. After his dangerous illness of two years ago that obliged him to go to St. Vincent's Hospital his old friends, Mr. and Mrs. Charles Fitzpatrick of Elmhurst, L. I., persuaded Ryder to come to their house for the advantage of the pure air and the country walks, and it was in their house that death came to him last Wednesday.

Mrs. Fitzpatrick herself had been an art student and had in that way come to know the artist, who took an interest in her studies and often gave her criticisms. It is a matter of deep congratulation for all those who have a sense of the fitness of things that Ryder was thus allowed to live his last years unmolested by the fashionable sentimentalists who might have descended upon him in worrying crowds had they suspected the combination of his innocent singularity and his true greatness; and also that when the end came he was cared for by friends of his own choosing.

It happened that the old firm of art dealers Cottier & Co. was to be the engine that was to bring Ryder's art to the attention of collectors. The late Daniel Cottier, according to William J. McGuire, who was once connected with the firm and knew Ryder for thirty-five years, was the first to take a serious interest in the artist.

It was through Mr. Cottier that certain Canadian clients of his became aware of the new artist, and in that way many

of Ryder's most admired pieces escaped across the border and became famous in Montreal long before a public was found for the work here. I have been told, but not by Mr. McGuire, that the first painting by Ryder that was acquired by Sir William Van Horne was sent to him as a Christmas gift by Mr. Cottier. This perfectly innocent and legitimate dealer's trick apparently worked, for shortly after that we heard of the "Siegfried and the Rhine Maidens" and the "Tristan" as gracing Sir William's collection, and the "Temple of the Mind" going to R. B. Angus, and others to E. B. Greenshields, both of whom are also of Montreal. It is a tragedy for us New Yorkers that another group of Mr. Cottier's customers lived so far away as Portland, Ore., for in that remote region a second nest has been provided for Ryder masterpieces. It is to that veritable jumping off place that one must travel who would see the "Jonah," possibly the greatest of all Ryder pictures, in the collection of Col. C. S. Wood. Col. Wood also owns the "Tempest." Mrs. Helen Ladd Corbett of Portland owns the "Lorelei" and several are in the Ladd collection.

This wide division of the artist's work has had a retarding effect upon his reputation. Artists know of Ryder and speak of his great pictures with veneration, but trips to Portland and Montreal are out of the question, and it is not every one who has access to John Gettatly's collection in this city, where the great "Flying Dutchman" reposes, so little by little the enthusiasts lessen their tones in speaking of Ryders seen so long ago that the fine details can no longer be distinctly recalled.

Under the circumstances they will be a retrospective exhibition. It should be held preferably in the Metropolitan Museum, and it should be well done. That is, every effort should be made to induce our distant fellow citizens of Portland, and our cousins from Montreal, to be nice to us in this matter. We should do something nice in return, of course. We might offer Portland the entire present exhibition of the Spring Academy, for instance. For keeps, too. They could retain the pictures permanently. Do you suppose that would have any weight, that offer? But in that case, Col. Wood must lend us "Jonah" for three months at least. Everybody in New York should be given the chance to see "Jonah." Once the public has seen "Jonah," the "Flying Dutchman," the "Temple of the Mind" and half a dozen other of the famous Ryders it

will easily understand why our artist has been placed at the top of the list among the imaginative painters of America.

The admiration for Ryder is by no means local. All of the foreign experts who have seen the pictures share the American enthusiasm for them. Roger Fry, one time curator of paintings at the Metropolitan Museum of Art, is inclined to place Ryder at the very top of the American production and Dr. Willy Valentiner, our former curator of decorative arts, also rated him highly.

When Dr. Valentiner started the review *Art in America* he asked me to write a Ryder article for him. At that time I knew little of the circumstances of the poet-painter, and Dr. Valentiner only knew that he was great, that he was living in obscurity and that he was insufficiently appreciated by the public. I was quite eager to do something for Ryder if I could, and agreed with Dr. Valentiner that a personal contact with the artist would be the thing, so he introduced me to young Mr. Fearon, who could arrange a meeting for me with the artist.

Mr. Fearon was at that time the head of Cottier & Co. He had fallen heir to the firm's traditional affection for the painter and seemed to share in it sincerely. But I think that Mr. Fearon himelf will probably admit now that a less practical avenue of approach to the hermit artist could not have been hit upon. Mr. Ryder may have been a prophet, but Mr. Fearon was by no means a St. John the Baptist. Not exteriorly, at least. On the contrary, like a self-respecting Englishman, he turned himself out very well indeed. He was all amiability, explained that Ryder was difficult, but promised to bring off the meeting.

That, however, was more easily promised than performed. From what I now know of Ryder I can see that the prospect of entertaining a constellation of dazzling personages probably frightened him. Certainly the interview did not occur. All sorts of things seemed to interfere.

Upon consulting my diary for March 11, 1911, I find the following staccatic references to my ineffectual attempts to meet Ryder:

"He speaks of Ryder with great kindness, even affection, yet with something of amused patronage, such as a keeper of a trained bear might indulge in."

"Ryder was charmed at the idea of meeting a friend

of Mr. Fearon's, but wished a few days in which to arrange for it. Mr. Fearon explained that the artist lived in great disorder, and probably wished to fix up his room a bit."

"Two days later a messenger reported that Ryder was no longer at home. 'Probably ambling around the country roads in New Jersey,' explained Mr. Fearon, 'taking advantage of the springlike weather.' "

"Two days later than that the messenger reported finding Ryder at home, but the room appalling. Floor piled high with ashes and all kinds of debris. 'You know more than once,' said Mr. Fearon, 'the Board of Health has got after him. Once when Ryder was ill the Reillys, who live on the floor below, managed to get in and gave the place a thoroughly good housecleaning, but that is the only such event on record.' "

"Last Saturday Ryder called on Fearon and said that he would appoint a day soon for the interview."

"Mr. King said last night that he had called once on Ryder and Ryder had given him one of his rooms. 'You know his brother owns the Hotel Albert. He named the hotel after Ryder.' "

"Called at the Hotel Albert to-day. Mr. Ryder not at home. Clerk said Mr. Ryder was a traveling salesman. Didn't think he had ever owned that hotel. A Mr. Rosenbaum had owned the Hotel Albert for years."

I think it was Ernest Lawson who finally put me au courant, told me the sort Ryder was, the simplicity of his character and the style of life. As soon as I learned the facts I gave up the idea of an article, as I did not wish to assist in starting a pilgrimage of busybodies and idlers to the retreat of the aged and picturesque painter; besides, I knew that after such a terrific amount of preparation the interview would be so stiff and artificial that it would be useless for my purpose.

However, I did subsequently meet him. A year later a second entry in my diary records the event:

"At Montross's, where I had gone to get the photos of Bryson Burroughs for his forthcoming show, I met Albert P. Ryder for the first time. There was a show in the galleries by a Syrian artist, Gibran, who paints mystic pictures. I had written in THE SUN that they were confusedly felt and confusedly expressed, and every other New York critic made similar observations. Apparently the public for once agreed

with the critics, for Ryder was alone in the gallery. The clerk at Montross's told me who he was.

"I took my courage in my deux mains and spoke to him. I reminded him of our correspondence and of my wish to call upon him. He seemed to recall my name and made some explanations of his inability to be at home to me last year — explanations that were like the Gibran pictures, rather vague. We talked about his famous two paintings on the one wooden panel that were separated by some marvel of engineering, and, talking to me, he seemed to decide to himself that he might trust me. He said that I had his address, but he had another place where he would receive me, at 252 West Fourteenth street. It had been given to him, he explained. There was a man who had taken it, and finding it unsuited to his use, offered it to Ryder. Ryder asked Miller the painter if he would take the room if it were he, and Miller said, certainly he would, so, said Ryder, ending his tale, 'I took it.'

"How do you like these?" I asked, waving toward the Gibrans? "He seems to be after something mysterious. All of them are the same."

"He seems to mean it, at any rate," said R. "That's the main thing."

The Sun, April 1, 1917

OPENING OF THE INDEPENDENTS

UNLIKE THE Rowe's Wharf street car line in Boston, which Henry B. Fuller says "starts everywhere and goes nowhere," the chance visitor to the exhibition of the Independent Artists who starts anywhere will go everywhere.

Thanks to the new system of hanging the pictures ac-

cording to the alphabetical order of the contributors' names, there is no opportunity for the wily student to economize his time by skipping certain rooms, and one is forced to at least glance at all of the 2,400 works of art on display, not all of which, you understand, are gems of purest ray serene, lest one miss the real jewels that sparkle from Mr. Lothrop's extraordinary Venus or the neat manner in which Miss Marjorie Wood demonstrates by means of tactile values how certain brands of soap actually float on the waters.

These and the numerous other wonders of the great show – which perhaps should not be mentioned by name so early in a serious review such as this until the reader has been properly prepared for them by a few generalities – these wonders are sprinkled along the walls with an almost uncanny regularity, if one considers the entirely accidental nature of the hanging arrangements, and are actually enhanced by the sedate rows of nice, good, quiet, academical productions that seem to lead up, as it were, to these explosions of the underworld.

The proportion of inoffensive to offensive works is about ten to one, and offensive is meant in the complimentary sense of being challenging. The leaders of the "spring offensive," as they say, in modern warfare, are but one in ten, but even so they are a good many, and they seem to have the enemy at their mercy. Just when you have been flung into a drowsy state by eight or ten soporifically correct pictures of the sort that are usually rejected even by the academy, and you are wondering whether deep down in your heart you really care a pin for art, suddenly you stumble upon that stupendous production by Miss Dorothy Rice, the portrait of the "Claire Twins," and are waked up so effectually that you find yourself forgiving the neighboring half dozen commonplaces before you realize that you shouldn't forgive them. So it is all the time – you are led on and on, into the remotest corners of the building, and are led everywhere except out.

It requires, in fact, strategy to get out. The ground plan of the new salon is ingeniously contrived with a labyrinth of alcoves. The front gates of the Grand Central Palace seem to lead one into the show quite simply and naturally, but when one exits one must depart from somewhere near the middle of the exposition. On the night of the gorgeous and gay private view, after I had seen everything and everybody, I made about

four circuits of the building before I found the way out. Each time I went round I met young Arthur Craven, the lecturer, boxer and poet from Paris. The third time we met he said:

"I am glad I do not owe you money. What an awful place this would be in which to escape from a creditor. When you turn these corners you don't know what you're getting into."

The rooms, however, look very well. The massy pillars have been somewhat reduced in volume by the partitions that have been built against them, and the show as a whole has the look of a real salon. It was especially effective at the private view, when a truly Parisian mob of artistic notables assembled as by magic. The scene was very like the foyer of the Opera in Paris on a Ballet Russe night — except, of course, that Miss Frances Stevens would never in the world have been allowed to take her dog Sacha to a Ballet Russe. Miss Stevens explained to a group of young men of noble countenances but odd attire — leading members of the Washington Square Players, it was whispered — that Sacha, being of a retiring disposition, was at first reluctant to come, but on its being explained that in times like these one should put thoughts of self aside and live only for the public, had consented. Sacha, however, did not appear to be entirely happy and emitted low growls from time to time, especially when people approached too closely the "Bride and Groom," carved and painted wooden figures by Miss Stevens, that were evidently old friends of his. The "Bride" bears a distinct resemblance to the fair sculptress of the work, but this is quite by accident, the carvings being purely imaginative, Miss Stevens says.

Miss Stevens's friend, Miss Mina Loy, was one of those upon whom the whirligig of fate, I mean, of course, the alphabetical hanging system, had played a scurvy trick. Her "Making Lampshades," which is clever with a European kind of cleverness, had the misfortune to be placed next to Mr. Lothrop's gem studded Venus, and there was a continual mob struggling around that work, to the total eclipse of Miss Loy's painting.

"How can you stand this?" said some one to her. "Why do you not take those extraordinary and beautiful gold earrings from your ears and pin them to your chef d'œuvre, since that is what seems to go here?"

Miss Loy's sad eyes flashed with opaline brilliancy for an instant and then as quickly dimmed.

"No, I could not do that," she replied. "It would be pla-
giarism."

William J. Glackens, president of the new organization,
was another of the unfortunate ones, and Robert Henri,
George Bellows and John Sloan, who mind misfortunes that
happen to Glackens a great deal more than they mind the mis-
fortunes that happen to themselves, tried loyally to cheer him
up, but the Glackens pictures were hidden away in the most
remote corner of the whole two miles of pictures, and even
when found could not really be viewed by the most zealous
of friends.

But Glackens laughed again when he saw the "Claire
Twins" by Miss Dorothy Rice. Everybody laughs when they
see those twins. Even the Baron de Meyer laughed. Marius de
Zayas of the Modern Gallery seemed positively glued to the
floor in front of them.

"You'll be having that down in your gallery next," I
bantered him.

"I should be only too proud," he returned. "I can't believe
a woman did that. It's strong."

"She asks but $5,000 for it," said Mr. Montross, examin-
ing the little white card beside the picture.

"Mon Dieu, c'est pas cher," interrupted the Baron de
Meyer, laughingly, and he fairly ran into the next alcove,
where the Baroness de Meyer was critically examining her
own portrait bust in red sandstone, to tell her of the $5,000
"Claire Twins."

The bust of the Baroness is by Renée Prahar, and is
astonishingly like, although cubistic. Isn't it delightful that she
has decided to openly patronize modern art? It is the stand
that everybody has been hoping she would take for some time.
There are distinct social possibilities in cubism, and it seems
odd that the two or three people in town who dare to lead a
fashion have been so slow in recognizing the opportunity.

Marcel Duchamp, author of the famous "Nude Descend-
ing a "Staircase," which was such a great hit in the armory
show, says that Miss Rice's "Claire Twins" and a work called
"Supplication" by Louis Eilshemius are the two great paintings
which the exhibition has called forth. "Supplication" is valued
at $6,000. Can it be that Mr. Duchamp has been with us so
long that he has begun to estimate works of art by the price
marks? In regard to the "Claire Twins" there will be many

to agree with Mr. Duchamp in spite of the price mark, but no one that I have heard of yet agrees with him in regard to "Supplication" except Mr. Eilshemius. I have a vague recollection of having received many missives in times past from Mr. Eilshemius in which he seemed to be not unaware of his own merits as an artist, but I confess that "Supplication" was one of the thousand or two paintings that I merely glanced at in passing. Mr. Eilshemius is to be congratulated upon having found so powerful a friend. I will look at "Supplication" again, on Mr. Duchamp's account.

The Sun, April 15, 1917

MORE ON THE INDEPENDENTS

LAST SUNDAY when I was about to retire for the night, or rather for the morning, for newspaper people never retire for the night, and I was asking myself the usual question, "In what have I failed to-day?" I was astonished to hear a voice in reply. I was astonished, for to tell the truth I had asked the question perfunctorily.

"You have failed miserably to-day," said the voice as clearly and distinctly as a voice from a phonograph, indeed distincter than that; "you have failed not only to-day but every day for a month past to give your readers a real account of the exhibition of the Independents. You have failed to state plainly whether you think the exhibition as an exhibition is a success or not, a thing upon which your readers have a right to your opinion. You have failed to give an account of the problems of management which the committee in charge of the exhibition have had to face. And you have failed to list

the pictures, especially by new artists, that had points of interest to those of the public that wish to be kept abreast of the times we live in."

Reader, I knew that voice. It had been some time since I had heard it, but I knew it. It was Conscience that was speaking. Usually at this season of the year the inner spiritual existence of an art critic isn't worth two pence and the wrongs of Hecuba and the thirst for the adjustment of the eternal verities are swamped in the grand yearning for a complete silence, and really I knew no reason why I should not soundly sleep the day away as good art critics should. But such a tirade from a hitherto docile conscience indicates a situation that was grave, to say the least.

And the acrid accents continued. There was more of the same refrain. Sleep became impossible, and rising at the ungodly hour of 10 A.M. I resolved to square myself with the voice and my readers, if it be possible, and to add a post-scriptum to my history of the Independent exhibition that should include a few names of the newer artists who deserved a notice a month ago.

But first a short account of my experiences with the exhibition is in order. Not by way of excuse, you understand. No excuse is possible for conduct such as mine. An embarrasment of duties confronted me and I apportioned my energies among them. I see now that was wrong.

In a constructive age such as this I should have neglected everything for the supreme duty of aiding the reconstructionists. But wait! There'll be another year with plenty of reconstruction in it, and mistakes are not mortal if they are recognized as mistakes. And my experiences may be significant to the committees who are to plan next year's attack, since they are, as I believe, experiences that others have shared.

First of all, I should like to say that I regard the show as an artistic success; a success far beyond what I had thought possible for the first year of such an organization. It interested me beyond any other public exhibition of the season. In fact, it has been the only public exhibition of the year that has much interested me, that has made me think and that has forced me to recall that there are artists living in America who are confronted with American problems.

The very conglomeration of the show as a whole, with its strange admixtures of cubism and the Hudson River school

due to the alphabetical hanging of pictures, seemed to suggest the teeming mass of at present disunited ideals that go to make up the present stage of our civilization. Here and there, sticking out all over the exhibition, are little signals of aspirants who may later gain complete control of our melting pot to shape the national spirit into new forms.

Which way the forces will direct us no man knows, no more than he knows the exact form that our national life five years hence shall take; but it is something gained, at least, to put the principles at stake fairly before the public without the entanglements of politics, that the public itself may choose. In the end it is always the great public that chooses. By dispensing with the middlemen of the juries the public will economize, by saving whole generations of time. At least it has already done so in Europe.

But as an art critic I confess the exhibition was too much for me. In the limited time at my disposal it was impossible to get hold of the exhibition sufficiently for the purposes of an article. I saw it first the night of the private view and enjoyed the spectacle hugely, but the impression was made up of one-third pictures and two-thirds the picturesque mob.

A few days later I went again. There were very few in attendance, but among those few I found some friends. Each time, in fact, that I went I found friends, and although it is delightful to discuss amusing pictures with friends it is difficult to make classifications with them, and I estimated that a solid week's work would be necessary in which mentally to rehang and recatalogue the chaos of pictures before it would be possible to make a succinct report upon the proper modernity, that is to say the real spirit, of the exhibition. Although I am a reformed character and promise myself to do better next year, nevertheless I am already shuddering at my prospects if the ruling powers insist upon continuing the system of the alphabetical hanging, for of course all the trouble was due to that; to that and to the fact that there was no press view.

I went twice again, on the last Saturday and Sunday of the exhibition. The attendance had much increased, and I liked the look of the people I saw there. They seemed to be people with histories. A percentage of them clearly bore the look of having come from a distance; they seemed to have the aspect of the "new people" that the art world has been longing to annex, and they were unmistakably enjoying themselves.

As for my own experiences, I found that I made fresh discoveries on each visit, and on the last Sunday night decided that if I could have a day or two longer of the show I could compile a respectable list of new people who deserve at least to be watched. I began there and then to make a little list, but about 9 P.M. the porters began rushing in to take the works of art down from the walls, and my scheme was only in part carried out.

I have been so handicapped myself by the alphabetical system of hanging these works of art and have met so many people who have spoken against the method that I was somewhat surprised on my last visit to the gallery to meet a group of exhibitors who were still keenly for the alphabetical system. Morton L. Schamberg of Philadelphia spoke so strongly in favor of it that I asked him to put his argument on paper for me. He does not convince me that the public is most benefited by the new way of hanging pictures, but all sides of the argument should be heard. He writes:

"Apropos of our conversation I am sending you my argument in favor of alphabetical hanging. I hope I have been able to make my points reasonably clear.

"Was the system of alphabetical hanging used in the first independent exhibition a success? There appears to be a difference of opinion. The abstract principle of justice — that is, the elimination of any possible inequality of opportunity due to favoritism or bad judgment on the part of a hanging committee — is pretty generally accepted. The difference of opinion is usually based upon other considerations.

"I find that most of the exhibitors favor the used system of hanging as regards their own works, and that the opposition mostly comes from those who are concerned with the effect only upon the public. Though an exhibitor myself, I am inclined to think that the later consideration is the more important one, and my reasons for favoring alphabetical hanging I base largely upon that very consideration; that is, the effect upon the public.

"The most frequent criticism of this system, which ignores the inevitable schools or groups into which most of the works fall, is that of the resulting bewilderment to the untrained observer. I entirely agree that the effect is bewilderment, but instead of finding in that bewilderment a fault I find in it the greatest virtue; not that I find it an undiluted

virtue. There is probably, as in most other things, both good and bad. Nor is it even necessary to establish my opinion that the good outweighs the bad.

"All that I wish to point out is, first, that the grouping system is to be found in practically every other exhibition, so that the good in it is not endangered, that the public has plenty of opportunities to follow the various evolutions and tendencies; second, that the system which ignores grouping is more consistent with the aims of this particular exhibition.

"There is, of course, a difference between the effect of such a system upon the artist or on the trained observer, that is the specialist from that on the average visitor, but I believe that is more a matter of degree than is usually supposed. But whether the bewilderment is almost nil or whether it is overwhelming, to me in either case it is healthy. I consider it of the greatest value that in at least one exhibition, and this seems to be the logical one, all works should be withdrawn from their accustomed environment and made to stand alone.

"It is so easy to confuse the environment which the grouping system has made inevitable with the work itself. A perhaps less important benefit lies in forcing the visitor to at least give himself the opportunity of looking at every work shown instead of concentrating upon those he has decided beforehand he is going to like.

"The general effect of the exhibition, as a whole, I consider, in this instance at least to be an even less important consideration, but even at that the independent exhibition just closed seemed to me most beautifully presented. However, that is a matter of personal taste rather than judgment. Very sincerely yours, MORTON L. SCHAMBERG."

The Sun, May 13, 1917

THE STRENGTH of the late Thomas Eakins as a painter, it is safe to promise, will come as a revelation to most of the students and connoisseurs who will visit the memorial exhibition of his work that will open to-morrow to invited guests and on Tuesday to the general public in the Metropolitan Museum of Art.

The name of Eakins is unfamiliar to the present art public, is practically unknown to our great collectors and is strangely absent from the lists of the so-called honors meted out by artist juries at the time of public exhibitions. Nevertheless Eakins is one of the three or four greatest artists this country has produced, and his masterpiece, the portrait of Dr. Gross, is not only one of the greatest pictures to have been produced in America but one of the greatest pictures of modern times anywhere.

Under the circumstances it can be seen that the Metropolitan Museum has undertaken an enterprise of importance — nothing more nor less than the crowning with honors of one of our most neglected geniuses. It will place the fame of Thomas Eakins. It will make more history, although it will not be more important, than the memorial exhibition to Albert P. Ryder, which is to take place later in the season at the museum, for in a way Ryder has long since found his audience and his place. Consequently in the most emphatic manner possible the public is urged to begin at once the study of the Eakins pictures and to study them long.

I say "study them long," for it is possible that the timid portion of the population unless held sternly in check will imitate the silliness of the timid people of years ago, who were stampeded from the "Portrait of Dr. Gross" by the cry, "It is brutal."

The picture is brutal, if you will, but it is brutal as nature sometimes is and science always is.

It is a stupendous painting nevertheless. It is great from

every point of view, impeccably composed, wonderfully drawn, vividly real and so intensely charged with Eakins's sense of the majesty of modern science as personified by Dr. Gross that the elevation of the artist's spirit is communicated to the beholder, and the ghastly blood stains — for Dr. Gross is shown in the clinic, pausing in the midst of an operation — are forgotten. It is not the blood that makes the painting great, any more than it is the blood that makes "Macbeth" great. However, the public will probably wish to dilate upon this blood, and it is welcome to the theme, providing it does not allow itself to be hoodwinked into vulgarizing the painting. I once knew a dear old lady who assured me that "Macbeth" was a poor play, basing her contention upon the undoubtedly correct plea that *Lady Macbeth* was "horrid."

But before taking up the study of the pictures something should be said about the painter and his career.

The long continued neglect under which the artist struggled — he died without tasting a real public success — is puzzling. He was a modest man, without guile, and quite ignorant of modern methods of self-exploitation, yet it is singular that such excellent works of art could remain hidden from public knowledge for such a length of years. With the exception of the great canvases, the portraits of Dr. Gross and Dr. Agnew, which are owned by the medical institutions in which these surgeons labored, the bulk of the paintings in the memorial exhibition are still owned by the widow of the artist. That is a startling fact and a sufficiently distrubing accusation against the taste of our collectors, both public and private.

I have often wished to make a study of the possibility of "art making its own reclame," of pictures succeeding upon their merit alone and because of their merit alone, and when I first visited the house of Thomas Eakins in Philadelphia after the death of the artist and saw the superb canvases lining the walls of the house from cellar to roof and piled against one another in corners of the rooms, pictures that had constantly been rejected at the academical exhibitions and were far finer than those that had been accepted for these exhibitions, I felt that should I attempt the essay I could find instances sufficient for my argument in the life story of Thomas Eakins.

For I confess that in moments of discouragement, when contemplating at too close range the activities of the success-

ful, money making artists of the present era, I have sometimes acknowledged to myself that ninety-nine-one-hundredths of the character of these men is made up of the quality known as "push." Thomas Eakins, on the contrary, was ninety-nine-one-hundredths artist, so Fame held aloof from him until after his death.

I don't wish to intimate that Eakins was totally without artistic recognition for a few artists of prominence valued his performance. M. Humphrey Moore and William Sartain, who were fellow students of Eakins in Paris, were close friends. William M. Chase was an admirer and formerly owned one of the pictures in the present exhibition. But none of these men were able to obtain honors for Eakins or even an adequate hearing for such a serious painter. It is doubtful if they really realized the full power of Eakins or they would have blazed aloft their enthusiasm for him upon the rooftops and forced attention.

The "Portrait of Dr. Gross," as I have said, was found brutal by the artists of the day at the time that it was painted. The same objection was held for the "Portrait of Dr. Agnew." It was rejected by the jury of that year at the Philadelphia Academy. It had been sent in the collection from this city, and when the New Yorkers threatened to withdraw the whole New York group unless it were hung it was reluctantly accepted.

Eakins's history is full of similar rejections. The important portrait of Prof. Barker was offered to the university to which he was attached and was not accepted. Eakins wished to exhibit the portrait of Prof. Rowland in the Johns Hopkins University, but the generous offer was looked upon with suspicion and he was discouraged in the attempt to show it in Baltimore. Eakins was not even spared the ignominy of having portraits that he wished to give to certain sitters refused. The Carnegie Institute refused for its international exhibition the portrait of Miss Coffin, which now finds an honored place in the memorial exhibition along with the other formerly rejected pictures. Still more recently the Panama-Pacific Exposition in San Francisco refused to honor Eakins and itself; but that is so very recent an affair that I shall be accused of talking scandal if I don't watch out.

But nothing in the way of enthusiastic appreciation came to Eakins from the public during his lifetime. For this sustain-

ing sympathy thought to be so necessary this artist relied upon the members of his family and a small group of his pupils and scientific friends. I asked Mrs. Eakins what she considered the most comforting experience of the artist's career, and she replied unhesitatingly: "The reception given to him in the city of Lancashire in 1912. It was arranged by two gentlemen of that place, one of whom had been once a student of Mr. Eakins, and the 'Portrait of Dr. Agnew' was shown in the exhibition. They were very kind to him and he always spoke afterward of the pleasure they had given him."

That was the only honor of the kind that fell to Thomas Eakins's lot. That little provincial reception becomes pathetic in retrospect when one now studies the achievement of the artist as displayed so tellingly in our museum. It is enough to make one weep when one contrasts it with the recognition so generously given out to the favorites of the hour.

However, I dare say it was a very nice party.

Thomas Eakins was born July 25, 1844. His father's father came from the north of Ireland and upon the mother's side his forebears were from England and Holland. His father was a caligrapher of prominence, writing diplomas and important governmental documents upon parchment.

After a little study at the Academy in Philadelphia Eakins went abroad and studied with Gérôme and Bonnat. Apparently he was not a facile student, and a remark of Gérôme's at that time was quoted about the student quarter and is still current. Gérôme said, "Eakins will never learn to paint, or he will become a very great painter."

Mrs. Eakins says of this period of her husband's history:

"I know from what my husband said and wrote of his early studies that he floundered about in his struggle to understand, unwilling to do clever or smart work or deceive himself by dash. Finally he wrote to his father, 'I know now I can paint, and if I can keep my health, I will push forward.' He writes of the great advantage of studying in the school from the naked model and with so great an artist as Gérôme to criticise, also perceives the advantage of making memory studies and studying by himself in his room between school hours. He was then 24 years old and had been in Gérôme's school two years, always independent, yet admiring and anxious to profit by the advice and example of the good painters.

"He was in Spain seven or eight months previous to his return home in the summer of 1870. While in Spain he painted his first picture, that of the little gypsy, Carmencita Requina, dancing, also a portrait of her and some other studies."

The bent of Thomas Eakins's mind was strongly scientific, and science and scientists held great sway over him all of his life. The study of anatomy, so essentially part of an artist's training, led him to the clinics of the surgeons, that he might glean information at first hand, and to his studies in this direction, may be traced the two great pictures of Dr. Gross and Dr. Agnew.

The scientists in their turn were afterward impressed by the closeness of observation betrayed in Eakins in some of his pictures of animals in action, and a brochure by the artist on the subject, "The differential action of certain muscles passing more than one joint," was listened to with respect at the Academy of Natural Sciences in Philadelphia in 1894.

Eakins's enthusiasm, however, was not confined wholly to the surgeons, and the series of chemists and physicists that we owe to him are impressive to a degree. Each one may be said to have received so religious a celebration at his hands that the result in effect for each is an apotheosis.

The second interest of the painter was athletics, and his boxers, swimmers and oarsmen pictures are scarcely less important than the great portraits.

I have called the portrait of Dr. Gross Eakins's masterpiece. So little has been written of Eakins of an authoritative nature that it becomes necessary to rate a few of the most significant successes, so that our public, which likes to have serious painters made easy for digestion may not in its haste make mistakes of too glaring a nature.

I am aware that hitherto the "Dr. Agnew" in a private way has been called number one, but now that the paintings hang in the same gallery the extraordinary power of the "Dr. Gross" will probably pass unquestioned.

The "Dr. Agnew" is full of the impassioned painting that is characteristic of all of our artist's work, and the attitudes of the personages are as unconscious and the realism of the operation that is proceeding before us is as terrifying as that in the first named work, but the grouping is not so happily arranged and the picture does not rise to an overpowering climax in the central figure as in "Dr. Gross." Besides, the students on the

arena benches in the background are confusedly placed and distracting.

In the "Dr. Gross," on the contrary, every actor in the drama is first rate in his part, and every detail of the picture has the highest distinction as painting.

There is a danger at this time with the question of surgery again so prominent in the public consciousness because of the war that there will be a difficulty in gaining public attention for the study of the style in these two important pictures, so absorbed and perhaps so shocked will the layman be by the spectacle.

It has been so many years, in fact, since any of our artists have thought it worth while to work over their pictures, or have had sufficient concentration to carry a complicated theme to a conclusion that the vast canvases, with their many figures, will be in themselves a surprise. Add to that the realism of the operation, the businesslike haste of the surgeons, the intensity of the assistants, the spattering blood, the total lack of modern hygienic appliances — and one must be pardoned if one thinks more at first of subject than of manner.

Although I intend to scold the public if I find it lays the wrong emphasis upon these two pictures, I confess that I had to overcome by force of will a confusion into which I fell myself at the first sight of the "Dr. Gross Clinic." My excuse is that I have not been in good health this autumn, and on the day of my visit to the gallery I was particularly unwell. In the Dr. Gross picture there is a figure at one side, of a new student who weakens at the sight of the operation and covers his face shudderingly that he may not see blood. I looked at him and at the thing he could not look at — and then suddenly I was compelled to leave the gallery.

I went back again, however. The "Dr. Gross" is one of the great pictures of modern times. It is the duty of every art lover to see it. But heaven grant that there be not too much silliness uttered upon the subject.

A safer theme for general discussion is the "William Rush Studio," a delightful picture that challenges in a vague way the work of the great German, Menzel. I saw this painting first a year or so ago at the retrospective exhibition of American art held in the Brooklyn Museum. I stated then that it was the finest work in the exhibition and urged that museum to acquire it for its permanent collection. The painting is indeed a regular

little gem. There is the most loving sort of brush work in every part of the canvas. Evidently the artist himself felt rather satisfied with it.

Another picture of the greatest importance is the "Katherine," a study of a young woman seated in a chair and teasing a cat.

But the clock strikes — the hour for going to press arrives. I find I have not allowed myself time to describe the feminine portraits, portraits of peculiar distinction and charm. There is much to be said about Eakins's method of painting, its merits and its defects — for it has its defects. It will also be found worth while to explain to the general public how the portrait of the female singer in trailing skirts of pink damask, is a fine portrait, even though her slippers do peep out from her skirts at the wrong places.

There is, indeed, much to be said of Thomas Eakins. This tale, therefore, is "to be continued."

The Sun, November 4, 1917

THOMAS EAKINS II

> *I depend greatly upon that which I do not yet know.*
>
> MAX WEBER.

> *You know our bargain; you are to write me uncorrected letters, just as the words come, so let me have them — I like coin from the mint — though it may be a little rough at the edges; clipping is penal according to our statute.*
>
> PERCY BYSSHE SHELLEY.

UPON THE whole, I am content that there should have been a stop of one full week between what I said last Sunday of the work of the late Thomas Eakins and what I have to say now,

for there are certain divergencies of style in the paintings in the Memorial Exhibition that fascinate me, but that, perhaps, will not fascinate those who followed me last week easily enough in praise of Eakins's concrete and monumental successes.

The fact is that Eakins made successes for the public and successes for artists. That the public will ever rise en masse to an appreciation of pure style in painting I doubt, but wherever and whenever a community becomes seriously interested and influenced by the arts there the abstract qualities of painting become more generally legible. It is for that reason that the "modern" movement makes such slow progress into the public consciousness. Its appeal must necessarily be to the few, to the few to whom the brush stroke is as pregnant with meaning as the poet's word. But these few we always have with us, and they will always remain the most staunch and inflexible defenders of that vestibule of style through which all pass who gain a secure refuge in the Hall of Fame.

In the series of Eakins's portraits the "Dr. Gross" and the "Dr. Agnew" take a preeminence that probably will pass undisputed. There remains a series that includes "The Thinker," "Prof. Rand," "Prof. Barker," "Dr. Horatio Wood" and "Prof. Rowland," works in which the characterization and finish have been carried to a degree unprecedented in the history of American art. In none of these has sincerity been sacrificed to finish. They are not in the least perfunctory or academic. They are lively and intense.

If public and artists alike were to join in a voting contest to choose one of these portraits for a public museum the choice, it is almost certain, would fall upon "The Thinker." This is the most restrained, most classic of all of the Eakins canvases. It is so restrained that it is almost more like sculpture than painting. Only the other day when talking of Eakins to a group of friends a sculptor who was present said he had seen an Eakins portrait years ago of a man lost in thought, with hands plunged deep into his pockets, and he matched his action to his words by assuming the identical pose of Eakins's "Thinker" for us.

It is indeed a memorable, unforgetable picture. Were it chosen by a museum, by our museum let us say for the sake of argument, there would be no quarrel about the choice with THE SUN. Were any of the other professors or doctors chosen

there would still be no quarrel here, for all of them are excellent.

But, and here comes the rub, I feel decidedly that were an individual to know the soul of Thomas Eakins solely by "The Thinker" he would miss much of extremest value from that painter's contribution. Furthermore, were the museum my private property and the collection controlled by my private taste — don't be alarmed, dear reader, this is only an argument — and in my typical museum poverty were I still restricted to but one example, my choice would not fall upon "The Thinker" nor upon any of the portraits named! For my private solitary King Ludwiggian delectation rather would I choose one of the so-called Eakins's "failures."

"Failure," of course, isn't the word, for in the strict sense there is no such thing as an Eakins failure, but I haven't a term ready at my hand for a second series of portraits, including those of "Mrs. Frishmuth," "Mrs. Talcott Williams," "Ruth," "Monsignor Falconio" and "Gen. E. Burd Grubb," which gave Eakins, the artist, a rude struggle. In them Eakins gained, and I am not sure he knew it himself, a rude triumph; and in them I take a rude joy.

He must have worked desperately upon these pictures, and most of them had the usual failure with the sitter. The "Mrs. Frishmuth" was loaned to the institution to which that lady had bequeathed her collection of musical instruments, and when the artist asked to have the canvas back to lend it to an exhibition he was told that he need not trouble to return the picture to the institution! Institutions are institutions, you know.

Mrs. Talcott Williams posed many times for her portrait and finally, growing discouraged, refused to pose any more. Probably the lady's relatives will agree that the likeness is not photographic, but, on the other hand, how much finer than a photograph it is. It is a great piece of painting, worthy to hang side by side on equal terms with the greatest things of Degas or Whistler. Mgr. Falconio also refused to continue the poses when he saw the sort of effigy that was growing between the painter's brushes. Who can blame Mgr. Falconio? Let him without vanity throw the first stone! Do you, reader, imagine that just because you take unholy pleasure in Mgr. Falconio's portrait you yourself would have had firmer courage when con-

fronted by the pitilessly dissecting eyes of Thomas Eakins, painter? I am afraid you flatter yourself.

I fear I never shall convince Mrs. Talcott Williams, and I know I never shall convince Mgr. Falconio, that their portraits are fine human documents, worthy of the salons d'honneur in any of our museums. It will be easier to persuade artists of it, however.

In the "Mrs. Frishmuth" there is a large and awkward circle of musical instruments on the floor about the lady's feet. I never look at it without laughing to myself, yet I admire the work immensely and will be vexed if our museum allows some other museum to acquire it. The roughness of the decorative arrangement reminds me of a certain decoration of Goya's that I saw in Madrid and which has the same big lines and savage grace.

The "Miss Parker" betrays the same desperation of workmanship that marks the "Mrs. Talcott Williams," and will be found almost equally attractive to painters. Like several of the other feminine portraits, it bears a strange and haunting suggestion of the work of Bronzino.

How long Eakins worked on these pictures I, of course, do not know, but I imagine he spent vast energies upon them. I was reminded of Vollard's story of his countless poses to Cézanne, who always insisted that the portrait was but just begun. Like Cézanne, Eakins often got most when he thought he had least succeeded.

In great art the means are concealed in the end, so it is said. In "The Thinker" they certainly are. In it Eakins hides all his effort and withdraws from the scene utterly. In the "Mrs. Talcott Williams" there is almost a more vivid sense of life because the artist is still there. The creation is still proceeding. The spectacle assists. The lady trembles with the unwillingness to become bronze like "The Thinker." It is, and I scarcely dare to say this, lest you become angry, a "modern" picture.

The Sun, November 11, 1917

CORRECTION

ON EAKINS'S "THE GROSS CLINIC"

AND EAKINS'S "THE RUSH STUDIO"

<p style="text-align:right">"The Philadelphia Inquirer,
"Editorial Rooms, Nov. 6.</p>

"MY DEAR MR. MCBRIDE: I feel I should like to thank you personally for the page about Thomas Eakins in Sunday's SUN. . . .

"There is one thing, however, that I do not understand—the allusion to the figure covering its head in horror in the Gross portrait. This figure is the mother of the boy undergoing the operation. In those days such things were allowed, of course, or Eakins, with his regard for truth, would never have put her in. He took a course of anatomy and surgery under Gross in order to paint the picture and it is better than the Agnew because Gross never posed. Eakins made his study in the clinic. Mrs. Eakins retains the original head of the Gross, which is a great work.

"Yours very sincerely,

"HELEN W. HENDERSON."

You are right, of course. Mr. Burroughs of the Metropolitan Museum reminded me instantly that the shuddering figure in shadow in the Gross portrait was the mother and not a frightened student as I in my haste thought. It was not so much the figure that I felt as the shudder.

I fear I am rather weak upon the story part of pictures anyway and could tell you many amusing scrapes that I have got into in consequence. One will suffice.

Many years ago when I was directing a big State art school somewhere in the State of New Jersey a Dürer print hung upon the walls of my office. One day a member of the board of directors happened to be loafing in the room and idly fell to examining the pictures. Suddenly he called out "What is this?"

"A Dürer," I replied.

"But what is it? What's going on in the picture?" he persisted.

Would you believe it, dear Miss Henderson, although I had owned that Dürer for years and was very fond of it, I was compelled to rise from my seat at the desk and reexamine my

print with the matter of fact eyes of a director. I saw instantly what my committeeman could have seen as well as I, that it was one of the Stations of the Cross, and I told him so, and he was content. But the real beauty of the print I could not explain to him, for he was not of the kind that could understand beauty.

In regard to "The Rush Studio," one of the most beautiful of the Eakins pictures in the memorial exhibition at the Metropolitan Museum, a description of the picture by the artist has come to light. It is not only a charming description, but it contains certain points that will interest the students of early Philadelphia history. He wrote:

"William Rush was a celebrated sculptor and ship carver of Philadelphia. His works were finished in wood, and consisted of figureheads and scrolls for vessels, ornamental statues and tobacco signs, called Pompeys. When after the Revolution American ships began to go to London crowds visited the wharves there to see the works of this sculptor. When Philadelphia established its water works to supply Schuylkill water to its inhabitants, William Rush, then a member of the water committee of Councils, was asked to carve a suitable statue to commemorate the inauguration of the system. He made a female figure of wood to adorn Centre Square at Broad street and Market, the site of the water works, the Schuylkill water coming to that place through wooden logs. The figure was afterward removed to the forebay at Fairmount, where it still stands. Some years ago a bronze copy was made and placed in old Fairmount near the Callowhill street bridge. This copy enables the present generation to see the elegance and beauty of the statue, for the wooden original had been painted and sanded each year to preserve it. The bronze founders burned and removed the accumulation of paint before moulding. This done, and the bronze successfully poured, the original was again painted and restored to the forebay.

"Rush chose for his model the daughter of his friend and colleague in the water committee, Mr. James Vanuxem, an esteemed merchant.

"The statue is an allegorical representation of the Schuylkill River. The woman holds aloft a bittern, a bird loving and much frequenting the quiet, dark wooded river of those days. A withe of willow encircles her head, and willow binds her waist, and the wavelets of the wind sheltered stream are shown

in the delicate thin drapery much after the manner of the French artists of that day whose influence was powerful in America. The idle and unobserving have called this statue Leda and the Swan, and it is now generally so miscalled.

"The shop of William Rush was on Front street just below Callowhill, and I found several old people who still remembered it and described it. The scrolls and the drawings on the wall are from sketches in an original sketch book of William Rush preserved by an apprentice and left to another ship carver.

"The figure of Washington seen in the background is in Independence Hall. Rush was a personal friend of Washington and served in the Revolution.

"Another figure of Rush's in the background now adorns the wheel house at Fairmount. It also is allegorical. A female figure seated on a piece of machinery turns with her hand a water wheel, and a pipe behind her pours water into a Greek vase."

The Sun, November 27, 1917

LUNCHEON IN PARIS WITH

RAOUL DUFY

MY MEETING with Raoul Dufy in Paris a year after the war had begun had an amusing touch of surprise.

I had asked young Lieut. Malye, one of James Stephens' friends, to dinner, and when I came home at 7 the domestique said a soldier had just been calling for me who had said that he would return for me in a few minutes. Thinking of course that it had been Malye, I sauntered out on the avenue to seek

him. Just in front of the house under the trees an officer had propped a rebellious motorcyclette upon a rack and it was racing away like mad although standing still. The explosions were terrific. M. Malye not being visible, I joined the little crowd around the exploding bicycle.

Suddenly a young soldier who had been assisting the Lieutenant of the bicycle stepped forward and said, "Is this Mr. McBride?" and when I had replied "yes," explained that he was Raoul Dufy. He had just learned that I was in Paris and had come at once to thank me for the kind things I had written about him in THE SUN the year before.

The people in my house and in the neighboring houses, brought to the window by the noise, appeared to be vastly astonished at my share in this military manœuvre, which was increased by the arrival of my dinner guest, whom the simple soldiers in the throng, including Dufy, had to salute. The troublesome motorcyclette finally became adjusted and bore its Lieutenant away. Dufy could not dine with me, as his wife would be alarmed at his absence on the day of his "perme" (all the soldiers, young and old, having immediately shortened the word "permission" to "perme") so I agreed to lunch with him and Mme. Dufy on July 14. Dufy's depot is not far from Paris. He is in a bicycle corps, he explained, and that was how he happened to assit the military cyclist in distress in front of my house. He had an afternoon off once in two weeks.

His studio is in Montmartre, in the neighborhood of the Place Pigalle, and it is full of works that America has not yet seen, but would profit by seeing; but before looking at them we ate an excellent luncheon. The plat was a work of art in itself, a roast surrounded by four vegetables of harmonious colors. The dish was decidedly worthy of being painted by M. Dufy. It struck me afterward as strange that M. Dufy, who is fond of still lifes, had never painted such a plat. Being devoted to food myself, I imagined that in the presence of such a piece de resistance the primitive artist's emotions — M. Dufy is a primitive — are so aroused that there is no withstanding the imperative desire to "kill the thing one loves" and so every perfect steak surrounded by vegetables gets immediately eaten instead of painted. Certainly none of the modern primitives paints them. They all paint lemons and bananas.

There was a bottle of red wine on the table, but as we

were about to sit down M. Dufy said: "Perhaps Monsieur McBride would like white wine; we have some specially good white wine," and without waiting to hear from me he immediately arose and returned with a bottle of cobwebby white. Now I have always noticed that when every work of an artist contains something that is personally pleasant I am sure to find the artist himself simpatico. Once again it proved true. How did he know I liked white wine and always drank it in preference. Simply by intuition lui et moi being simpatico.

In the atelier were stacks of canvases, some of them very large. All that I liked best had been painted in the Midi, gardens and balconies in the cavalier method of the moderns, but recognizable as gardens and balconies just the same. Dufy's color is always good, design good, and it can be felt that he could be realistic if he wished. He is not a primitif because he doesn't know how to paint, but for quite the contrary reason, because he does know how to paint.

He asked me how I stood on the question of Picasso and Matisse and was not horrified at my reply that I never found their work completely successful, though always completely interesting. (We were talking of the abstract performances by these men. Afterward I found abstractions by them that to me were completely successful.) M. Dufy said there were no new names to place beside theirs. For him Matisse has awakened a new interest in painting, which was a great thing. Apparently everything had been said, but Matisse found new ways to say it. Picasso was trying for problems that were perhaps insolvable, but his experiments had that interest.

He showed me a box of silks and damasks printed from his designs, most of them from the "Bestiare," the book of wood prints with text by Apollinaire. Apollinaire, full of fantasy and an amusing fellow, both M. and Mme. Dufy agreed. Dufy had designed stuffs for Poiret. Both Poiret and he felt that the war would not sidetrack modern art. Never could go back to the old, at least. For his part, if he did war things they would be allegorical. Gave me a silk pochette of his design, with all the Allies mounted upon white horses. He said Braque had become a soldier, had found himself in the vie militaire. M. and Mme. Dufy said that last year in the first week in September there was an anxious moment. "Heard the cannon, you know," most impressively. "We heard the cannon of the Germans, and in the papers, next day, not a word! We

looked to see what had happened – nothing!" Dufy comes from Normandy, his ancestors being originally Irish, hence the name. There had also been a German intermarriage among his progenitors, nevertheless, with a smile and a military salute: "J'espère que je suis un bon français!"

The Sun, December 30, 1917

WOODROW WILSON BY SARGENT

TIME – Friday.
THE PLACE – The chilly, jaillike salon d'hon-
neur of American art in the Metropolitan
Museum. In the central position on the wall
hangs the recently painted portrait of Presi-
dent Wilson by John Singer Sargent. It is
hedged in by an altar rail at which the devout,
if so inclined, may offer up their praise.

A MOB OF about eight people are assembled near the altar rail talking in barely audible whispers. In the next room, through the wide portal, can be seen a young man disdainfully copying Regnault's "Salome." Two young ladies in painter aprons, not so disdainful, consent to join the tourists in studying the Sargent. Uniformed attendants pass and repass with the nervously detached air of hotel detectives.

To these enter M. d'Hervilly of the department of painting and myself, talking French. That Mr. d'Hervilly, who himself is really French, should talk French with me, who am not really French, struck me at the time as something bodeful, ominous. He is as intense as the house attendants and doesn't know he is talking French.

"Vous allez voir le Sargent-Wilson, n'est-ce pas? C'est par ici," said he when we encountered each other by chance in the Silver Spoon section of the balcony, where we always used to

go to get the best view of the healthy Venuses of Hans Makart, which have now, alas! mysteriously disappeared.

"Yes, but I know where it is, thanks."

"But I'll show you the way. Let me carry your parcel for you. J'insiste!"

"Jamais. You are terribly kind. I am used to carrying parcels, or at least I am used to this parcel. No, no, monsieur, I'll carry it. And I mustn't trouble you. Really I know the way."

"But I wish to go with you," returned M. d'Hervilly, linking my free arm with his, and then whispering as we drew near the proud young man who was copying the Regnault "Salome," "I want to know what you think."

"Vous me flattez, monsieur."

"No, I honestly want to know what you think of it."

"Very well, then," returned I, and with that we rounded the corner into the Presence Chamber.

The mob of eight were extremely furtive in their attentions to the new Sargent. Although actually in front of it they kept looking about in worried fashion at the other things in the room and then returning in an attempt to meet the troubled gaze of the President, for the eyes of this Sargent do not follow you about as the eyes in some portraits do, but on the contrary appear to evade one. The portrait, in fact, seemed to catch some of the embarrassment that was thick in the room. I certainly had caught it, and the attendants had caught it. I had an alarmed sense that all the museum was perturbed. Why? Why, in Heaven's name?

And there was M. d'Hervilly still talking French to me, who had never talked French to me before!

"Dites. Qu'est-ce que vous penser, hein?"

"It's – it's a Sargent, you know," I faltered.

"I should think I ought to know that myself. Tell me, do you like it?"

"You know, Sargent hasn't been painting portraits much of late. He had retired from portrait painting. Circumstances compelled him to do this work."

"I know. But is it like him? Did you ever see him?"

"Wilson? I did not think him so pale, three months ago, as Sargent thinks him. But Sargent evidently tried hard to earn the money –"

"Money? How much money?" interrupted two gentlemen in fur coats. "What did he get for it?"

"Nothing," I replied; "but the Red Cross Fund got $50,000 for it."

"Fifty thousand dollars! Gee whiz, say, that's going some, Bill!" said one fur coat to the other fur coat.

"Who are they?" I whispered to M. d'Hervilly.

"Out of town museum directors probably," said he.

"Great piece of work," said one of the museum directors to the other, "all except the coat. I don't like the way it fits him. Looks like the kind that Einstein, Schwartzkoeffer & Schnaz supply to college boys."

"Why, that's just the part I liked," returned the other museum director, "and besides I like Einstein, Schwartzkoeffer & Schnaz's things. It was from them I got this fur coat."

"They say he has psychic powers," said a large lady with a poetic cast of countenance and with the air of having just escaped from Boston.

"Everybody knows that, my dearest Amy," returned her companion. "His mediumisitic susceptibility is truly extraordinary. In Boston there are people who profess to know the very spirit that controls Sargent. It's 'Bonaventura,' if I remember rightly. And if the rapport is established, perfectly wonderful revelations appear upon the canvas, and if there is no rapport, why, nothing happens at all. It really isn't poor, dear Sargent's fault, you see, if the picture turns out badly."

"Do you mean to insinuate, madam, that this portrait turned out badly?"

"I — I —" gasped the lady addressed, "I beg your pardon, I don't believe I have the honor of your acquaintance."

"Schucks, Schmittie," impatiently exclaimed one of the young lady art students to the other young lady art student. "Aren't they the limit?"

"For two cents," returned Miss "Schmittie," "I'd tell 'em what I think of it."

"Amy, dear, I think we might be going," said one of the ladies from Boston.

"Psychic powers! Psychic fiddlesticks!" exclaimed Miss Schmittie loudly. "I'd like to see where you get soul revelations out of that awful picture."

"She said 'awful,' Amy. What a dreadful young woman she seems to be!"

"Permettez moi de vous aider, monsieur," said M. d'Hervilly to me, "it's slipping."

"No, I can manage it, thank you."

"But your parcel is slipping. Why, what is in it? What have you in that bag? How it squirms! Is it alive?"

"It is. M. d'Hervilly, can I take you into my confidence? You have always been such a good friend of mine. . . . It's our cat. Yes, it's THE SUN's famous office cat. Ever since the recent cold snap it's been unwell. In spite of the forty-eight oilstoves that assisted the steampipes in the editorial rooms our cat took a severe chill upon that awful Saturday night when the thermometer went 13 below. Perhaps she imbibed some of the oil. She took a great fancy to those stoves. . . . So to-day when I found that I had to come up here I decided to give her a little airing in the park. She so seldom has the . . ."

"I tell you that picture is n. g.," the young person by the name of Schmittie was exclaiming, "and, what's more, Sargent is a flubdub. Why, Irving Wiles could beat it. It's only skin deep. It has no color. It has no interpretation, no style. Sargent was afraid when he painted that picture. He was afraid of the Schwartzkoeffer clothes and the Schwartzkoeffer chair and afraid of what the people would say. In a committee meeting room it would never be distinguished from the other portraits there. In a museum you would never know it to be a Sargent without the label. Bonaventura has given Sargent the go-by. He quit portraits once, he should have stayed quit."

Upon hearing these dreadful sentiments from the mouth of one so young (and so fair, for Schmittie has nice candid pale blue eyes like Bastien-Lepage's Joan of Arc), M. d'Hervilly and I in our agitation allowed the parcel to drop, and out sprang a frightened cat. It was such a strange place and such a curious situation in which a well bred cat should find herself that — and is it any wonder? — she immediately had a crise-des-nerfs.

Round and round the room she went. Never a glance gave she at "The Cremorne Gardens" of Whistler nor at Mr. Ranger's "High Bridge," though doubtless she well knew the difference between the two paintings. "What is it, a mouse?" gasped the psychic lady from Boston, pushing away her friend Amy in the effort to mount first upon the upholstered divan.

"It's a coyote from the zoo," said the fur coated man named Bill, making for the door.

"Oh, my, here's Dr. Robinson," exclaimed M. d'Hervilly, trying to escape.

"What reprehensible proceedings are these?" demanded the astonished director of the museum. "Animals? In the museum? Who is responsible for this outrage?" eying with instant and instinctive suspicion the two fur coated museum directors from out of town. "Officers! Are there no officers here? Officers, do your duty. Arrest these people!"

"I had nothing to do with it," replied the fur coat named Bill. "I think it was her," pointing to Schmittie.

" 'She,' you mean," returned Schmittie sweetly. "Come kittie, nice kittie, come come to your muzzer," but the innocent cause of the disturbance had by this time mounted upon the altar rail before the Sargent portrait and was in no condition to be mollified by soft words. She let out alternate meows and hisses that resounded throughout the museum. The meows were prayers for safe deliverance from this scrape, the sincerest prayers doubtless that had been uttered upon that altar, and the hisses were for the attendants who were fast closing in upon her.

"Throw your coat over her, that's the only way to catch her," said the large lady named Amy, to the fur coat museum director named Bill. "Throw your own coat over her," returned that gentleman rudely. "Ain't been introduced to you yet," and he leaned so heavily against a pillar that the bronze "Frog Fountain" by Janet Scudder that surmounted the pillar fell to the floor with a reverberating crash.

"This is too much," murmured Dr. Robinson.

"This is too much," echoed the disdainful young man who had been assiduously copying the Regnault "Salome" in the next gallery. "What's the row?" said he from the doorway, appealing to Amy Lowell, for yes, 'twas she, the large lady mounted upon the divan. "What's up?" he insisted.

"The cat," returned Amy Lowell, pointing to Schmittie. "SHE LET THE CAT OUT OF THE BAG."

The Sun, January 20, 1918

GASTON LACHAISE

THE BOURGEOIS Galleries may be congratulated upon discovering a new young sculptor of talent. The bronzes and sculptures of Gaston Lachaise, now on view in these galleries, disclose a personality that is likely to greatly interest our public, and is sure to deeply impress the younger members of the population.

Mr. Lachaise is a young Frenchman who has been in America twelve years. The astonishing and encouraging feature of his work is its essential Frenchiness despite the twelve years of exile from the capital of Light. I do not mean of course that to be French is necessarily to be right in art, but I pin great faith upon an individual who keeps a firm clutch upon his native traits and upon his own ideals, when launched at a tender age upon a community like this, where every atom of the social fabric is aligned in an effort to standardize character.

Mr. Lachaise being French has been impressed by our recently enfranchised ladies. His attention so far has been almost exclusievly focussed upon our feminine voters. He feels, he says, and his work shows that he feels, something extraordinary and powerful in our women. They seem to be energy incarnate. There is a force in the air here that the sculptor felt when he first breathed it. There is energy stamped upon the faces of our men and upon their gigantic engineering achievements.

But these goddesses, the American women of 1914–1918, are the true equals of the men. (To look at the sculptures is to fear they excel men.) Aspiration and achievement are one with them, as Madame Nellie Melba recently said. They are full of the je ne sais quoi. The sculptor, who speaks excellent English, could not find words to define the emotion suggested by our superwomen. He dropped off into French, but in his native tongue also was continually saying "comment dirai-je?" This is as it should be.

There is nothing I like better to hear from a sculptor describing his aspiration than: "Comment dirai-je?" If he knew how to say it in words, doubtless he could not say it through

sculpture. The most sacred things carry us beyond words, beyond definitions.

The first thing in a work of art is a feeling, and it cannot be defined if it be immense; and it is immense in the nude figure called "Elevation."

I like this figure immensely. It is as strange a piece of sculpture as any that has happened in America in recent years, but it is real and vibrant with the sculptor's emotion. Americans will I hope be properly impressed by the fact that this statue is a tribute by an ardent Frenchman to the women of this country. If the ribald laugh at it and call it a fat woman they may. What the idle think of a genuine work of art is unimportant. The main thing is that a sufficient number of intelligent art lovers signify their interest in the work emphatically enough to encourage the sculptor.

I believe, however, that this new artist has sufficient force to survive temporary non-comprehension. A worse thing for a young artist than neglect is a too vehement and fashionable appreciation.

The Sun, February 17, 1918

FLORINE STETTHEIMER

AT THE INDEPENDENTS

I AGREE with Mr. Walkowitz that one of the most joyous of the paintings is the "Birthday Party," by Mrs. [sic] Florine Stettheimer. Mr. Walkowitz assures me that the picture was done from the life and that there actually was such a birthday party, the birthday being in fact for no less a person than the great

Mr. Duchamp, author of the famous "Nude Descending a Stair-way." All the people at the party, Mr. Walkowitz says, are ex-tremely well known in the most advanced Greenwich Village circles. He mentioned them over to me, and I blushed at not having heard of them. Not to know the fair artist of the picture is to argue oneself unknown, I dare say, yet I cannot recall having heard of Mrs. Stettheimer before. I say "fair" advisedly, for the lady has painted herself into the party and she has some rather good things to say for herself. One of the gentle-men at the fete is lying face downward on the turf, and yet his toes point skyward. I believe it is Mr. Duchamp. At any rate he is very clever and could do it.

One of the trees is painted scarlet and one a bright blue. The shadows are such colors as pleased the artist, and that is the reason, I think, they now please others. Under the trees the refreshments were served. Mrs. Stettheimer appears to be a good provider. The more I think of it the more miffed I am that I wasn't asked to that party.

The Sun, April 28, 1918

1920–1928

CHARLES SHEELER'S

BUCKS COUNTY BARNS

THE WORK of Charles Sheeler now on view in the De Zayas Gallery is an exhibition for the progressive element in the community. Mr. Sheeler is an out and out modernist, and there is very little in the past history of art that will assist the amateur to appreciate his. Only the sophisticated amateurs who love exploring will go along with Mr. Sheeler, who will be forced to rely for sympathy, probably, upon his fellow modernists.

Mr. Sheeler's subjects are Bucks county barns, flowers and still lifes, and these have been worked out both in photography and water color. It is of course possible that the artist may win some applause from totally uninstructed persons, who will see that Mr. Sheeler's barns are genuine Bucks county barns in spite of something in the work that the instructed will call "cubism," but these same uninstructed persons, while admitting that Mr. Sheeler's barns are barns, will doubtless sigh for a few more vulgar details, so that upon the whole their sympathy will not amount to much; and Mr. Sheeler's future as an artist will depend upon winning a few more converts among the instructed.

What will operate against a swift fame is a certain coolness in the work. Mr. Sheeler makes compositions that are as compact as Picasso's out of the various parts of a barn without destroying, as has been hinted, the barn resemblance; but his procedures are as taut and tight as Van Der Weyden's pictures of crucifixions and there is little plasticity in them to entice the nibbling picture-lover onward. In his art Mr. Sheeler is as ascetic as the early Dutch painters, but the Dutch painters flourished upon the fact that their asceticism was good form. They had the people and the patrons with them. Here in America asceticism is not good form. Not just at present, at least.

But all of Mr. Sheeler's fellow artists will see that he composes very well and that he contrives to make certain surfaces

155

tell realistically, and without seeming to borrow too much from the famous innovator, Picasso.

In the photographs Mr. Sheeler is more dominating. He has a relentless eye, it seems, when it comes to focussing; a personal feeling toward textures and values, and is even more Van Der Weydenish than ever in his compositions. All who look on photography as a means of expression should see these photographs of barns. They rank among the most interesting productions of the kind that have been seen here, and are all the more important as this artist never forgets for a moment that the camera is a machine, and he emphasizes the things a machine can do better than hands, instead of blurring them into so-called artistic effects, as so many photographers do.

The Sun and New York Herald, February 22, 1920

THE WALTER ARENSBERGS

"WALTER ARENSBERG is quite mad. Mrs. Arensberg is mad, too." The remark ended a conversation. There was a finality about it that would have ended any conversation.

My friend – one of the most reasonable and most educated of men – admitted that the Arensbergs were delightful, but raving lunacy was to him the only explanation for the possession of the works of art that adorned the Arensberg salon. The Arensbergs' big studio on West 67th Street is exclusively modern. The big panel by Matisse of a woman perched upon a stool and with most of the curved lines of the figure indefinitely extended to the confines of the canvas – it proved very trying to the public when shown in an exhibition in the Montross Galleries – is an item upon one of the vast white walls. The shiny brass "Portrait" of the Princesse Buona-

parte by Brancusi that almost got rejected from this year's Salon des Indépendents in Paris upon the ground of immorality, is another item. Things by Gris, Braque, and Metzinger in vivid colours so pull the eye of him who enters the door that the big, and still uncompleted, chef-d'oeuvre in glass by Marcel Duchamp that is posed near the entrance is sobriety itself by contrast and assumes all the reticence of a piece of furniture or of a Rembrandt in the Metropolitan Museum of Art. Furthermore there is one of Picasso's "reasoned derangements" in paint, some particularly dynamic African fetish carvings, and plenty of the latest local outpourings in cubism. Some of the works individually verge towards violence, but they have been so carefully placed by the mad owners of the establishment that not only a perfect balance but a genuine if hitherto unheard of harmony has been attained.

However, my most educated friend saw only craziness and not harmony in the room. His education had been, perhaps it is necessary to explain, confined to the pictures of the past, and of life as it is lived at present he knew little. Doubtless, too, the Arensbergs played a little up to him. The temptation to *épater les bourgeois* is something nobody resists."

"Do you want to see Marcel's latest work of art?" Walter Arensberg asked me, upon the occasion of my first visit to the studio and after we had had a long and easy conversation without a word of reference to the Matisse, the Brancusi, and the other marvels, all of which I had seen perfectly without looking at them. From the grin upon his face I knew Marcel's latest was something larky. When Arensberg lifted a glass bulb with a curious tail to it from the protecting cottons of a wooden box I saw that my premonitions had not played me false.

"It's air from Paris," said my host, "hermetically sealed at a particular street corner in that city."

I'm not a bourgeois, so I didn't have a fit; I didn't even inquire the name of the street on which the air had been caught. Like Arensberg, I laughed. As a work of art "Marcel's latest" seemed pleasant and droll. Perhaps I instantly saw that the joke did not apply to me so much as to my educated friend. That's the advantage in not being a bourgeois yourself. And sure enough when I asked my friend if he had seen the Air from Paris by the famous Monsieur Duchamp, he replied drily:

"Do you suppose it's still air from Paris? Science tells us that air tightly sealed in that fashion quickly rots and changes its character," and before I could interpose an objection he wound me up with his contention of the day before.

The only drawback to *épaté*-ing the bourgeois is that half the time they don't know when they are *épaté*-ed. If my friend chances to read these lines he'll know. I'll squander a copy on him.

The Arensbergs are at home a great deal, and it may surprise the owners of J. Francis Murphys to know that they are seldom at home alone. People seem to like to come to see them. In particular the new poets and the newest artists flock to the studio. In addition to the pleasure that young people evince in merely being together there is always the further excitation that comes from a consciousness of being in the van of a movement.

But apropos of the Arensbergs I mustn't drag in a plea for modern art. I feel almost as though I were giving away a state secret in even hinting that they and their friends are having a mediaevally good time with it. But people have been so extraordinarily scary and silly on the subject here in New York that it seems only Christian to give this belated warning that there are social possibilities in the new things that the Horace Walpoles of this period ought to look into. The world is presumably to go on again with enough approximation to the old life to permit the arts to exist – at this moment this is indeed a presumption – and in this case people who have money to spend might just as well as not get the Arensbergs to explain to them how it is that one gets in contact with the creating talents in the world. If they can't or won't consent to mount Parnassus hand-in-hand with new geniuses, they will never get there. Looking at old genius already at the top through spy-glasses will not assist. One might just as well be – in fact, one is – a dealer in second-hand goods. Patrons must be as hardy intellectually as artists to register – as they say in the movies – as genuine patrons.

My own recommendation to those in doubt upon this point is – to know a "modern" artist. Mothers or fathers, for instance, whose sons or daughters happen to turn out to be cubists are usually as pleased as Punch after they get over the initial shock. Nothing ever delights me so much as to hear a prim old New England lady or a hard-headed Keokuk

tram-car manipulator expatiating upon the qualities of their offspring's cubism. (It doesn't have to be cubism — I merely use that term as it still happens to be anathema to most.) The wittiest study of the modern forms that has yet appeared was an essay by C. R. W. Nevinson's father in the Atlantic Monthly of some years ago in which he frankly confessed that he had found he had to take up the subject to keep pace with his son. And indeed, to drop into plain English, cubists are not so bad. Some of them are cubists for moral reasons. Was it Trelawney or one of the Gisbornes who met a young man at the house of a friend in Italy who seemed to be all goodness and purity but who bore the dreaded name of Percy Bysshe Shelley, and who left the house demanding inwardly, "Can this innocent creature really be the monster that is horrifying all Europe?"

The Dial, July 1920

CHARLES BURCHFIELD

ALSO LATE in the spring a collection of pictures by Mr. Charles Burchfield was shown in the Kevorkian Galleries, and this was the most interesting "first appearances" of the winter. Mr. Burchfield had the great good fortune to pass his young life — he is but twenty-six — in the loathsome town of Salem, Ohio, and his pictures grew out of his detestation for this place. No German hated England so hardly as Mr. Burchfield hated, and I hope hates, Salem! for what would become of Mr. Burchfield's art if Salem should reform or if he should move to some likable place? Salem is a place of shanties, so Mr. Burchfield says, dreadful, wobbly shanties that seem positively to leer with invitation at the passing cyclones, which,

however, disdain them. It is one of those places which are cut through by the straight and terrible line of a railway and Mr. Burchfield has drawn this railway and the switchman's little hut with the sarcasm of a Swift. Mr. Burchfield is, of course, extremely young to be a Swift, so his case presents problems. There is almost nothing in his work but this hatred, and if he lived to be sixty he could not be a more vehement hater. What is to provide him with material if he progresses along this line? Salem cannot hold out all that time. He might come to New York. There is much in New York that is certainly worth hating, but somehow I feel it in my bones that Mr. Burchfield is not the man to hate it. Besides it's been done already. Nobody could hate New York so well as Lafcadio Hearn hated it, and that has gone on the records.

The Dial, August 1920

PHOTOGRAPHS BY STIEGLITZ

———————————

THERE IS SUCH a thing as loyalty in America, Alfred Stieglitz is now thinking, or ought to be thinking, for all of his old friends and disciples and many new ones turned out on Sunday and Monday afternoons to see his life work in photography, on view in the Anderson Galleries, and to shake the master photographer's hand and tell him how much they had missed him.

For Stieglitz had been in a state of eclipse ever since he closed the little gallery at "291" Fifth avenue – a gallery that occupied a share of the public regard wholly incommensurate with its size – and although even in the palmy days of that institution there had always been suspicions in the bosoms

of its adherents that there was an injustice in allowing Stieglitz to sacrifice his career as a photographer to his service there in behalf of modern art, nevertheless the actual parting had been something of a wrench, a wrench that time had accented rather than healed, since it had become only too evident that no one had appeared to replace him. Where Stieglitz had been there was a distinct void.

So the meeting again with him was something of a fete. All the photographs were there that he had been doing, and about which there had been so much private conjecture, but greater than the photographs was Alfred, and greater than Alfred was his talk — as copious, continuous and revolutionary as ever — and no sooner was this recognized than the well re-membered look — a look compounded of comfort and exalta-tion — began to appear upon the faces of John Marin, George Of, Marius De Zayas, Marsden Hartley, Oscar Bluemmer, Walt Kuhn and Abram Walkowitz, for to them it seemed that "291" was operating as usual and that this long hiatus had been a dream. There was a slight change of background, considerable red plush instead of the inconsiderate gray paint, but the main thing, Alfred, was there and they were happy.

Alfred had fortified himself in advance for the meeting with a statement. It runs as follows:

"This exhibition is the sharp focussing of an idea. The 145 prints constituting it represent my photographic develop-ment covering nearly forty years. They are the quintessence of that development. One hundred and twenty-eight of the prints have never before been seen in public. Of these seventy-eight are the work since July, 1918. Some important prints of this period are not being shown as I feel that the general public is not quite ready to receive them. The fifty other prints never shown before were produced between the years 1908–1919. Of the earlier work I show but a few significant examples. With more the exhibition would become needlessly large.

"The exhibition is photographic throughout. My teachers have been life — work — continuous experiment. Incidentally a great deal of hard thinking. Any one can build on this ex-perience with means available to all.

"Many of my prints exist in one example only. Negatives of the early work have nearly all been lost or destroyed. There are but few of my early prints still in existence. Every print I make, even from one negative, is a new experience, a new

problem. For, unless I am able to vary — add — I am not interested. There is no mechanicization, but always photography.

"My ideal is to achieve the ability to produce numberless prints from each negative, prints all significantly alive, yet indistinguishably alike, and to be able to circulate them at a price not higher than that of a popular magazine, or even a daily paper. To gain that ability there has been no choice but to follow the road I have chosen.

"I was born in Hoboken. I am an American. Photography is my passion. To search for truth my obsession."

By way of postscript he added:

"Please Note — In the above statement the following, fast becoming 'obsolete' terms do not appear: Art, science, beauty, religion, every ism, abstraction, form, plasticity, objectivity, subjectivity, old masters, modern art, psychoanalysis, æsthetics, pictorial photography, democracy, Cézanne, '291' prohibition.

"The term Truth did creep in, but may be kicked out by any one."

Just why "prohibition" should be regarded as an obsolete word is not quite clear. I find it an invaluable term myself in describing certain present day effects, also I shall find it difficult to say anything about the photographs without using the word "art." The most astonishing of them, my favorite I almost think, represents a typical, bourgeois American sitting room. The room must have been thoroughly comfortable and "homey," but there is scarcely one of the far too numerous pieces of furniture but would require apologies from the member of the family that pretended to æsthetic sensibilities. In other words, it is a humdrum example of our civil war style of decoration. Nevertheless, the photograph is beautiful. The play of the late afternoon shadows among the furnishings is delightful and takes hold of one's fancy. The picture would not tire one quickly, I think, although the room from which it was taken might have been a bore. Now the camera itself is a mere machine and is incapable of seeing beauties in a stupid thing. In using the machine, Alfred, I think, must have searched. In other words, he expressed himself stylistically and became an artist.

I admit that I myself drew away from photography about the time the so-called "art photography" came in. I could not stand photography that, through tricky manipulation of the

plates, aped painting. To me photography was one thing and painting another, and the foggy, blurred enlargements that to many of our experimenters seemed "artistic" were to me merely vulgar. I shrink from photographs that are too large anyway, just as I shrink from Brangwynnian etchings. There was a time when our "working classes" (Stieglitz will say that term is obsolete also) indulged themselves in a pathetic fancy for crayon enlargements of photos of their dead. They were rather horrible, but only a trifle more so than the gaudy silver framed affairs that now adorn the homes of our rich. I like straight photography and thought the profession had severed itself from art rather early in the game — that is to say, shortly after the daguerreotypes were relinquished. But Alfred Stieglitz reestablishes the link. He is a photographer, pure though not simple.

His prints include landscapes and city views, still life, portraits and studies from the nude, and in each of these divisions memorable work has been accomplished. Stieglitz's reputation is already so secure that it goes without saying that all who are interested in photography will see this exhibition. That it will have marked results upon the other members of the profession is certain.

The New York Herald, February 13, 1921

AMERICAN ART IS "LOOKING UP"

AT THIS season of the year it is impossible to resist a feeling of hopefulness in regard to the prospects for the art season, although to tell the honest truth no change in the world situation is visible to the anxious watchers in the tower, and without a

better world – that is, a world more at ease with itself – there cannot be better art.

But last winter was particularly ghastly from the point of view of accomplishment, and when it had finished every one connected with it breathed a sigh of relief, feeling that whatever more might happen the worst was over and that things must mend.

It is the cheerfulness perhaps of a convalescent, but that is not a bad kind of cheerfulness to have, and it is with that that we totter to the shutters, let in the light, rearrange our wares and prepare to keep peace between the artists and the public for another winter.

As a writer and an American, the straw that we clutched at when adrift in that sea of gloom last winter was the fact, patent to us at least, that native wares were looking up. They are not so profuse yet as the French or English, nor do we yet pretend to a worldwide authority that would appear to be in keeping with our brilliant financial position, but not only have we more living painters who are taking their inspiration directly from the soil than we had in 1914 but we have an immensely wider public that has learned to demand the native flavor in native goods. A group of clever but misguided artists of a generation ago had carefully drilled our public into the notion that to be good, art must be foreign, or at least foreign looking, and it has been no easy task to supplant this monstrous teaching with the theory – obviously true at the first glance – that is now gaining ground. Mr. Guy Pene du Bois, in a recent *International Studio,* made an accusation in rather vague terms that the present writer is Francophile. The accusation might have been less vague without giving offense in this quarter.

The fact is that this critic, up until about 1914, was a citizen of the world, perforce, in order to keep going as a critic. He was about nine-tenths French because nine-tenths of the art world were French. The Rodins, the Cézannes, the Rousseaus, the Matisses, with their live stuff, were compelling our eyes to Paris and obliging us to neglect the pathetic Blashfields. Coxes and Dewings, with their ineffectual echoes of the scholastic past. To be contemporary, then, we were obliged to go abroad.

But events have changed all that. The advantage that France had is now not so overwhelming as it was. It still

leads – and we are still Francophile enough to admit that – but it would require subtler mathematics than we possess to figure out by what percentage. It moves by previously acquired momentum rather than by actual force.

If momentum can do so much, think what it will do for us, with our great weight, once we start, and that we have started is now the general feeling. The real dramatic interest for us Americans begins to be here. There are some who will tell you that a death is just as captivating as a birth, but it is hard to convince young papas and mammas of that.

Communities all over the United States are, to use the old fashioned phrase, in an interesting condition. We have just fallen heir to the proud position of world supremacy that was Spain's at the time she produced Velásquez. We, too, can now afford to produce expensive geniuses, and we intend to do so – in fact have commenced. The general opinion is that they are to be as lusty as those that Walt Whitman prophesied for us. Is it any wonder, then, in these crisp October days, that we are undismayed as we peer into the immediate future? After all, the "cheerfulness of a convalescent" is too mild a metaphor.

Quite a few significant ripples upon the surface of the waters that sufficiently indicate the direction of the winds are the publications that celebrate the performances of the innovating artists.

The Picabia number of the *Little Review*, issued during the summer, was the most daringly modern review that has yet appeared in the States, and the fact that the issue was still nine-tenths French does not conflict with the assertions made above concerning our future, since the review concerned itself with actual attainments, with the period just over, but which still lights up the path we are now to tread.

The Dial, too, is all for modernity and seems so avid for American productions that it is now unlikely that our revolutionary thinkers will be kept waiting long at the gates.

A publication just announced that ought to help considerably is Albert E. Gallatin's new book about the American water colorists, for the work has been sumptuously printed under the eye of the famous Mr. Bruce Rogers and contains not only enthusiastic appreciations of the work of John Marin, Charles Demuth and Charles Burchfield, but careful reproductions in color of some of their things. To place Marin, Demuth

and Burchfield, firmly beside the fixed star, Winslow Homer, in a serious critical estimate is, to say the least, going some. It will not only be sure to affect the ideas of collectors but will put heart into the entire younger school.

The New York Herald, October 15, 1922

GEORGIA O'KEEFFE

GEORGIA O'KEEFFE is what they probably will be calling in a few years a B.F., since all of her inhibitions seem to have been removed before the Freudian recommendations were preached upon this side of the Atlantic. She became free without the aid of Freud. But she had aid. There was another who took the place of Freud. His success with her would give him fame at once had not his previous successes with John Marin and Marsden Hartley already placed him upon a pinnacle from which he could gaze down comfortably upon Coué and the other Great Emancipators. It is of course Alfred Stieglitz that is referred to. He is responsible for the O'Keeffe exhibition in the Anderson Galleries. Miss O'Keeffe says so herself, and it is reasonably sure that he is responsible for Miss O'Keeffe, the artist.

Her progress toward freedom may be gauged from a confession of hers printed in the catalogue. She says that seven years ago she found she couldn't live where she wanted to, couldn't go where she wanted to go, couldn't do nor say what she wanted to; and she decided that it was stupid not at least to say what she wanted to say. So now she says anything without fear. She says that she did say at first that she didn't

wish this exhibition, and adds that she guesses she was lying, for she consents to this exhibition of her own newly acquired free will.

For a lady to admit she lied represents the topmost quality of freedom. After that the fences may be said to be completely down. And as nothing that happened in San Francisco for two or three years after the earthquake seemed to matter much, so the final confession that she is not indifferent to what people say about her pictures nor even what they don't say about them is relatively unimportant. The outstanding fact is that she is unafraid. She is interested but not frightened at what you will say, dear reader, and in what I do not say. It represents a great stride, particularly for an American.

The result is a calmness. Younger critics than myself speak of the "punch," but I am not particularly interested in the punch unless there should be a knockout, when of course I must take notice. What I prefer is style, which occurs all along the line and makes the whole encounter interesting from start to finish. There was for me more of knockout in one of Miss O'Keeffe's former exhibitions – the one that occurred in, I think, the Bourgeois Galleries shortly after she had burst the shackles. That was the exhibition that made O'Keeffe (I think I must drop the "Miss" since everybody else does). I do not know if there were many sales, or any, nor if there was much attendance from the outside world. But certainly all the inside world went, and came away and whispered.

To be whispered about in America is practically to be famous. A whisper travels faster and further than a shout, and eventually registers upon every New York ear. The art crowd did not know that O'Keeffe had formerly had inhibitions, but saw that she was without them in the Bourgeois Galleries. Such a scuffing about for draperies there never was since the premiere of Monna Vanna. Even many advanced art lovers felt a distinct moral shiver. And, incidentally, it was one of the first great triumphs for abstract art, since everybody got it.

To this day those paintings are whispered about when they are referred to at all. Even Marsden Hartley, who is a fine writer with many colorful words in his possession, whispers. He says, "Georgia O'Keeffe has had her feet scorched in the laval effusiveness of terrible experience; she has walked on fire and listened to the hissing of vapors round her person." And in another place he says: "She has seen hell, one

might say, and is the Sphinxian sniffer at the value of a secret. What these quests for truth are worth no one can precisely say, but the tendency would be to say, at least by one who has gone far to find them out, that they are not worthy of the earth or sky they are written on."

But they were worthy of the earth and sky they were written upon. This second exhibition makes it plain. If all those vapors had not been shattered by an electrical bolt from the blue, O'Keeffe would have undoubtedly suffocated from the fumes of self. There would have been no O'Keeffe. In definitely unbosoming her soul she not only finds her own release but advances the cause of art in her country. And the curious and instructive part of the history is that O'Keeffe after venturing with bare feet upon a bridge of naked sword blades into the land of abstract truth now finds herself a moralist. She is a sort of a modern Margaret Fuller sneered at by Nathaniel Hawthorne for a too great tolerance of sin and finally prayed to by all the super-respectable women of the country for receipts that would keep them from the madhouse. O'Keeffe's next great test, probably, will be in the same genre. She will be besieged by all her sisters for advice — which will be a supreme danger for her. She is, after all, an artist, and owes more to art than morality. My own advice to her — and I being more moralist than artist can afford advice — is, immediately after the show, to get herself to a nunnery.

And in the meantime, after the storm in the Bourgeois Gallery, we have peace in the present collection of pictures. There is a great deal of clear, precise, unworried painting in them. Alfred Stieglitz calls it color music, which is true enough. It sings almost as audibly as the birds in the "Cherry Orchard" do when the Russian actress opens that window to breathe in the morning air. That it will have the usual Stieglitz success goes without saying. Claggett Wilson told me that he rushed home from the show to put the emotions roused by it into literature and George Grey Barnard telephoned me in the midst of this writing to tell me of an extraordinary sunset picture of O'Keeffe's in which there were vast evolving forms as at an earth creation, interrupted by a darting line of yellow that had been the artist's color response to the massed cries of cattle heard in her youth upon the plains of Texas. His communication materially changed the tenor of this article. I had been upon the point of telling him some of the O'Keeffe

things but saw there was no use in telling him what he had already got.

The New York Herald, February 4, 1923

A PREDICTION ON MARIN

NOTHING BUT trouble at the Montross Galleries. The Max Weber paintings come down from the walls and the John Marin water colors go up. No respite for the weak at heart. The pace is terrific. People are obliged to watch each step they take. And this in America!

Considering feeling was aroused last year by the Marin exhibition in these same galleries, and some were so cross that they implied that they were going "to do something" if this sort of thing didn't quit. Well, it hasn't quit. John Marin is as bad as ever, if not more so. Ninety percent of the water colors in the exhibition are calculated to make Kenyon Cox turn over in his grave. And some people have the audacity to claim that these things are great. I myself am among the number.

How am I to prove it? I cannot, I fear, except to the small band who have spirit, who respond to spirit and who judge works of art by their spiritual content. This small band, however, forms the court in which the ultimate values are appealed — "the six friends for whom the poet Shelley wrote" — so after all there is nothing to worry about. The million opposed will pass away hugging the delusion that Marin is a bluff — just as the million of the previous generation passed away firm in the notion that Walt Whitman was a bluff; but

the young million now sprouted, who are to rule things twenty years from now, will all agree with the six friends of Shelley or, I mean, the six friends of Marin.

To them — these six — he is the most considerable artist in these States at present. He has great natural gifts and seems to exploit them unhampered. He is a water colorist, and contrary to the general experience has attained an extraordinary breadth of vision and sweep in execution, all in developing himself in this medium.

It is usually held that water color is a restricting medium and that knowledge sufficient to give it a style must be acquired by the artist in some more plastic method of expression, but Marin has not found it so. He is more plastic than Winslow Homer ever was, and indeed more plastic, than any artist I can think of, past or present. Without departing from the confines of true water color he gets all that any painter can ask for in oils. The way to this astonishing richness and power in expression has been opened for him perhaps by the modern revolt from literalness. There are so many things that a Winslow Homer thought he had to do that are now no longer required of any one, and indeed are not permitted of any one — and the immense resultant release of energy allows a human volcano like John Marin to simply explode with feeling.

Last year it was remarked that a streak of something somber, savage, sinister, ran through all the work. It was said to be a "late Beethoven" feeling. It continues again this year. It happened that I went from the Montross collection to an exhibition in the Daniel Gallery, where there are some early Marins that seemed so simple, innocent and youthful Mozartian (one goes for one's comparisons to music, naturally) that it amounted to a shock. Marin is a poet always, but once he was a young one. Now he thunders — and people, as I said, have to watch out.

There is a set of ocean pieces in this collection that seems deliberately mournful. Marin sought the mystery, the aloofness, the restlessness, of the sea and plays it almost in monotones. These are difficult. They are profoundly moving to "the six," but it is evident they are dedicated to the future. The possible candidate for entrance into the Marin Society is recommended, on the contrary, to go first of all to the picture marked No. 25, "Study on Sand Island, 2," and if this won't

do for him or her, then nothing in this year's output will. It is a picture that is soaked with the moisture of the sea, lovely as to color, and a masterpiece of handling.

Then there is No. 20, "Camden Mountain Across the Bay," just two or three amazing splashes of color and a wafer sun against the white paper. This, too, is not for beginners, but for the initiated what fun! No. 21, a different version of the same theme, is glorious. There are a dozen works that ought to overwhelm those for whom color has meaning. They have the splendor of stained glass with an inflection of passion foreign to the older workmen.

There are also three pictures relating to downtown New York, part of the series begun with such distinction last year. The subjects have not aroused the artist to the extent that the Woolworth Building did, but this is possibly a matter in proportion, since the Woolworth Building is supreme of its kind. There are just two pictorial phases of the city that to the rest of the world seem unique — downtown skyscrapers and the crush in upper Broadway at night after the theaters. Foreigners, they say, have a sort of yearning interest in the activities of Wall Street and the things that go on inside of Mr. Morgan's banking establishment, but if these items linger on in history it will probably be the psycho-analyists who will put them there. Artists will get more from the two subjects preferred above.

Mr. Marin, by the way, might try what he might get from the night scene on Broadway. I don't think he has attempted much in the way of night things anywhere. He leaves the moon so severely alone that one suspects he shares Mr. Llewelyn Powys's hatred of the earth's hitherto admired satellite. Before quitting Mr. Marin for a while, I suppose I ought to mention that an unknown young lady who ventured by mistake into the press view of the Marin pictures and smoked one of the cigarettes that are only provided in the Montross establishment upon the occasion of press views announced that she loved the "Down Town View, No. 3," above all other water colors of this year. I preferred the sea view, No. 25, already mentioned, but I think an opposing opinion, such as this, should be considered. She was a remarkably prepossessing young woman, with clear, crisp speech, and rows of handsome, small teeth, like Herman Melville's young Tahitian friend, Fayaway, in "Typee." It may be that she swells the list

of Marin admirers to seven, which would be wonderful if
true.

The New York Herald, March 11, 1923

JOSEPH STELLA AND MAX WEBER

SO FAR, more people have asked me what I thought of
Joseph Stella's new work at the Société Anonyme than have
inquired into any other event of the season; and I have been
more puzzled by the inquiries and have been more evasive in
my replies than usual. I had set myself, upon first seeing the
pictures, to the task of having a clear opinion of them, but
without first-rate results; and it occurred to me that others had
some uncertainties, too, and hence the questioning. There was
no insinuation anywhere of opposition. Upon the contrary,
Joseph Stella has already been adopted into the general affec-
tion, everyone wishes him well and everyone feels that some-
thing will come out of him that will credit all of us. The mere
fact that he was standing up to New York, doing us, "the big
city," predisposed the public – I mean, of course, the small
public that follows the younger men – in his favour; but in
spite of all this yearning, no loud shout of joy reached the
heavens when the pictures were shown. They were impres-
sive, they were interesting, they were undoubtedly sincere,
but – were they what we were all waiting for?

Maybe they were. Perhaps we'll simply have to get used
to them. But part of the yearning, when we heard that Stella
was doing a big New York picture, was that it might be a
crashing success; and this it cannot truthfully be said to have
been. When asked, I have generally said, I liked them very

much. There is an enormous amount of aspiration, an enormous amount of intellectual energy in them and generalship in the execution – but also a lot that offends.

The thing has a ferocious amount of parallelism. The tall towers appearing behind each other are razor-edged. I get the effect that Stella's New York is all strung upon wires. My friend usually replies, "Yes, I feel all that too; but don't you think New York is like that?"

Perhaps it is. Certainly no city on earth seems so cruel to the individual who is not a part of it. Even the dyed-in-the-wool New Yorker returning from a month or two's touring in Europe is invariably seized by panic as he gazes at the relentless structures that loom over the waters at Battery Park. Once ensconced at his city desk the feeling promptly disappears; but even the most boastful New Yorker, if approached tactfully, will admit having been crushed at moments. However, there is nothing in all that that unfits the city for art. Nobody will blame Stella if he makes us terrible. In fact, we rather like being terrible. The fear is, at least my fear is, that he has made us ineffectual and thin. There is not the robustiousness that made his first Brooklyn Bridge so acceptable, nor the ingratiating suggestiveness of so many of his landscape abstractions. If he intended his New York to be so very wiry, then why not have done it in wires à la Marcel Duchamp? But I see I am venturing into criticism, which was not my intention, for, as I meant to have explained earlier, I feel that criticism should wait until these panels are shown elsewhere. The Société Anonyme's rooms are thoroughly charming, and generally helpful to all modern manifestations, but this time Mr. Stella is quite out of scale. His immense compositions quite swamp the Société Anonyme and are not only too close together, but too close to the spectator.

Undoubtedly, too, there has been considerable debate upon the merits of Max Weber's newer paintings, shown in the Montross Gallery, but unfortunately I have heard none of it. My lines, during the past few weeks, have been cast in exclusively with the Philistines and they, of course, detest Max Weber, but their detestations, at this late date, are not particularly amusing. As far as I can make out, they unite in thinking that Mr. Weber's nymphs' feet are too big – and perhaps they are in the right as to that – but since it was evident that they were blind to the authority of Weber's com-

position and the extraordinary richness of his colour, I did
not attempt to combat their prejudices.

It seems that this artist has been in retirement for some
time, has shunned the public places and the disputes in the
studios, and has been living alone in the country. The new
pictures prove the wisdom of the course. Weber is not unsus-
ceptible to influences and years ago when he first came back
from Paris fresh from the contact with Rousseau le Douanier
and Henri Matisse there was evidence of those encounters in
his work and he was criticized for it. But not by me. In his
first big exhibition he included his Woman and Tents, Chinese
Restaurant, and another large panel, the title of which I
forget, that portrayed a man wading in a stream; at St. Christo-
pher or St. John the Baptist, perhaps. There were six or eight
canvases so fine that I instantly forgot the forty that were
of the École Rousseau and proclaimed Weber the best of the
American moderns. Since then, and some years have elapsed,
he has done nothing to justify the estimate, until the present
exhibition, and now again he emerges strong, and more con-
secutively himself than before. However, in the meantime,
John Marin, Charles Demuth, and Joseph Stella have also
been emerging, and it is now more difficult to give precise
ratings than it was; and unnecessary, since each individual of
the quartette is significant, and, as they say of Vesuvius, "in
active eruption."

In retirement, Weber's art has become Jewish. In an-
other publication I already so qualified it hesitatingly, not be-
cause of any uncertainty of my feeling in regard to the
work — that was clear and profound — but because of an appre-
hension that the term might be misunderstood. There was a
danger that others might not regard it as the triumph that I
insist it is, and there was the possibility (not important to my
theory, however) that Weber himself might not be a Jew. The
new quality is not based upon the lugubriousness of Weber's
themes, nor the long beards of the Jews who wail upon the
housetops after the manner of the prophets, but rather it
comes to me in an abstract way and from the colour chiefly.
It is the richest, most distinguished, most eloquent use of
colour I have seen this winter. In a way I scarcely know how
to define, it seems to have come straight from the Old Testa-
ment to Weber. It is sombre and with something in each tone
that seems to crystallize a human experience. The faded reds

are the stains dripping from the wine press, the blues are dull turquoise; and onyx and lapis and alabaster and such terms spring to the mind in recalling them, in preference to the prosaic qualifications of the palette. The pictures may be said to reek with melancholy, but it is a melancholy more than made supportable by this colour. Even such a work as Meditation in which all the personae including the dog beneath the table seem steeped in woe, the general authority of the composition combined with the lovely colour make a noble, and, upon the whole, exhilarating appeal. It would be a fortifying possession for a Christian collector, and for a Jewish, wonderful. But I have a horrid scepticism as to all the collectors of the present, both Jew and Gentile, and fear the worst in regard to Weber's selling possibilities. . . . To be sure, there are the museums! !

The Dial, April 1923

THE BANQUET BY PASCIN

HAD I arrived two days sooner in Paris I should have seen the décor that Juan Gris made for the Ballet Russe charity performance in the Salle des Glaces at Versailles. Gertrude Stein had a card to see it privately in the afternoon and could have taken me. Gertrude liked it very much. From the description it certainly was new in idea — quantities of tin being used, covering the floor, I believe, and the steps to the platform, and gilt joining in — but startling only to those capable of being startled by ideas, for the passionately fashionable charitable folk who paid immense sums to attend seemed unaware that there was décor there at all, taking the setting casually as a part of

the original salle. Alice Toklas said it was not objectionable to walk upon – though anyone who has ever attempted to walk upon a tin roof would recoil from dancing upon tin. But those Russians really are very expert and recoil from nothing.

That Juan Gris should be known to Diaghilev and that Braque, Picasso, and he should do décors for him is merely one hint that the pre-war receptivity is still on. Indeed the receptivity is almost frantic, but beyond the admittance of our own Man Ray to the ranks of the magicians there seems to be no new name to be learned. The Parisians are just dying to have an affair with some new artist, but the boldness of the blandishments they offer seems to frighten rather than attract, and young geniuses, if they exist, are incredibly coy. One does not hear of them even at the Café du Dôme. Speaking of blandishments, the Ballet Russe projects one of Molière's pieces with musique by Gounod re-arranged by· Erik Satie and with a décor by Juan Gris. It is a project and not a certainty, but merely to think of such a combination is going some in the way of liberality; is it not?

Pascin gave me a miniature banquet – moi qui vous parle. That is, there were at least twenty at table and that, I think, entitles it to be called a banquet. I had supposed I was dining seul, but when I reached the top of the almost endless series of stairs on the Boulevard de Clichy I found ladies, exuberant children, a solid bourgeois who had been rendered more distingué by the loss of one eye at the front – and a measurable family atmosphere that was a distinct surprise *chez* Pascin. In a minute we all descended to the street made more than usually noisy by the Fêtes de Montmartre then in progress and I did my share in marshalling the exuberant children among whom and the most so, was a young mulatress of about ten. As it couldn't possibly be a French party without somebody getting lost we promptly discovered that three or four of us were missing. But we soon found them. The one-eyed gentleman – whose name I never mastered – and several of the children were discovered astride the shiny fat pigs of the merry-go-round whirling in the air above our heads. Then we were re-united only to be separated again into different taxis for it seemed we were to go to the Café du Dôme for the apéritifs. The ride across town was extremely gay, made so by the children who were continually crying and waving to each other from the various vehicles and inciting the chauf-

feurs to race. Pascin and I had the young mulatress with us and she was enchanted that we won the race. We made a distinct sensation arriving at the Café du Dôme, and without in the least meaning to boast I think I may say that I shared the honours with the mulatress. People did look at us. If there is receptivity for art in Paris there seems even to be plenty of this commodity for art critics and there was a constant stream of persons coming up to claim acquaintance not only with Pascin, but with me. So much so that we scarcely had a moment actually to sit and Mahonri Young who had thought perhaps he might be of service to a newcomer retired abashed after one curious glance at the young coloured person. The café terrasse was crowded with the usual early Saturday evening crowd of students, oh, so much more gaunt and hollow-cheeked than they had been two years before; or so they did seem to me, comfortable in the knowledge that I certainly was to have a dinner. This festivity took place finally in a restaurant over near the Bal Bullier and the eats and the spiritual uplift were quite all right though the one-eyed gentleman took the host to task for allowing the men to be seated at one end of the table solidly and the ladies at the other; "If there is any possible way to bungle it trust Pascin," said he, with affectionate wrath. It was this gentleman who owned the large touring car that awaited without and into which about ten of us were whisked to the Café Suédois later on, standing up or clinging to side-steps as best we could, college boy style. Of the children who had gaily started out from Montmartre with us only the young mulatress was left and she was still maintaining a social status when I retreated from the Café Suédois at the discreet hour of minuit. At this party I met among others MacOrlan the writer and Laborde the artist, both of them keen and delightful, with worldly success apparently staring them in the face and André Salmon, the critic, equally delightful, but not so certain to get on in this life; and renewed acquaintance with Madame Pascin, one of the most remarkable women in Paris, which is saying much, and Mina Loy, the poetess.

At the banquet I asked Pascin when I could have a second look at his drawings and he suggested coming to lunch the Monday following. Galanis was there when I arrived and two young women who seemed not enthusiastic over my advent. Afterward I learned that Pascin had forgotten having

asked them for Monday or had forgotten having asked me and they were promptly chased away. However they said bon jour with the calmness of duchesses and will have had it made up to them by Pascin later, doubtless. Then after Galanis left I was allowed to look through piles of drawings, including all the ones made in Tunis and which I like particularly, and the series of mocking allegories in which "offrandes to Venus" and hitherto suppressed details in the life of Scheherazade are lightly sketched. From the débris on the table I turned up two books, both of them inscribed. One was Paul Morand's Fermé la Nuit which contained on the fly-leaf the author's wish that Pascin might illustrate the work sometime. Morand is about to have his wish, I understand, Pascin having undertaken to do the drawings. The other book was by Cocteau also with compliments upon the fly-leaf. Then too, Meier-Graefe is to do a Pascin album; so here is one artist at least who cannot complain of an indifferent press.

We lunched at the Café Manière. At the café we found MacOrlan and Laborde, both of whom were charming as usual and full of curiosity in regard to America. When I told Mac-Orlan that I had dined at Brancusi's and that Brancusi himself had acted as *chef* and had énormément de talent comme cuisinier, he said that to cook was quite à la mode now.

The dinner was wonderful — but gracious heavens — I see I have not left myself space enough in which to describe it. Believe me it would require space!

The Dial, November 1923

TZARA AT THE THÉÂTRE MICHEL

I HAVE a suspicion now that gendarmes were dotted more thickly about the entrance of the little Théâtre Michel the night of the modern art "evening" than the apparently innocent programme of music and recitations warranted. Certainly they were called for and were of great use just as soon as the proceedings got under way, but I wonder how they came to be so conveniently there. Did young Mr. Tzara, who was the author of several of the poems and also the little dramatic sketch a portion of which we almost heard later on, tip them off, thinking it might add to the fun? And did the commissioner of police in detailing his men for the job instruct them to go easy? The psychology of those police gets me. There was such an uproar, you see, and seething-mob stuff, and flashing police clubs, and villains carried struggling over the heads of the audience and forcibly propelled through the door, and yet when all was over, no one went to jail, and no one had been hurt, not even a scratch. I puzzle over this the more since Mr. Tzara threatens to translate the scene of his activities to New York and actually contemplates an "evening" here. Could our highly sensitized policemen stand it, do you suppose? And go away nicely at the end merely shrugging their shoulders at "these artists"? As Mrs. Asquith said when the reporters became too tumultuous with their questions, "I wonder!"

The Théâtre Michel evening failed a trifle I thought from being over managed. There must be an uproar, of course, and scandalized upholders of virtue must protest shriekingly against the licence that comes to them from the stage, but in arranging for this Mr. Tzara secured more shriekers than things to be shrieked at. His bravi were so impetuous and unrestrained that at the very first line of the very first poem they shrieked themselves, the police aiding, out of the theatre. Young Mr. de Massot had a tiny poem each line of which said that somebody died upon the field of honour. He began, "Madame Sarah Bernhardt est morte sur le champ d'honneur,"

and immediately the bravi shouted "Thank God" and otherwise misbehaved themselves. By the time two or three well-known people had died *sur le* champ d'honneur in Mr. de Massot's poem the whole house was standing upon its feet and two of the interrupters had actually mounted the stage to strike Mr. de Massot, the one with a fist upon the cheek and the other with a walking stick upon the shoulders. There was only time to get in about two resounding whacks before the agents de police bore the intruders, as I said, amid much flashing of police clubs, over the heads of the audience to the exit. Then the hale reader went on in absolute silence to tell us who the others were who had died upon the field of honour, and for half an hour or three-quarters, there was a boresome, respectable silence for everything on the programme, even for Man Ray's quite terribly-insulting-to-our-intelligence moving picture. But by the time the dramatic offering to Mr. Tzara was reached, the belligerent bravi had somehow crept back into the purlieus of the théâtre Michel and were there to shout and to mount upon the stage and to finally stop the performance. They were undoubtedly the same bravi and the query is to me, how did they fix it up with those gendarmes so to re-enter the arena like that? What took place between them and the police outside? Did the police say, "Now will you promise to be good if we let you go in again?" and did they promise, or what? At any rate it is possible to envy Paris her police system. We have nothing like it here. I had to explain to Mr. Tzara that we martyrize the first person who does anything in America and that our martyrdoms are not amusing and do not necessarily lead to much. I cited the Gorki incident for him — of the hectoring Gorki received because of the lady who came with him and who was not Madame Gorki. I explained that now half Greenwich Village lives with ladies who hate the term Madame with a Queen Victorian hatred and that at present Gorki could pass unmolested from Boston to Hollywood. Mr. Tzara seemed to think the amount of preparation our public requires for an idea formidable. He was somewhat sad and unsmiling as he talked of the evening at the Théâtre Michel. He appeared to be conscious that there had been something of a formula about it and that an effort in a new country and under new conditions might help the cause. I said as little about our police as I conscientiously could, but nevertheless I fear I said enough to disturb him. If Mr. Tzara

does not have an "evening" soon in the Sheridan Square Theatre I suppose I shall be to blame.

The Dial, December 1923

BELLOWS'S CRUCIFIXION

MR. FRANK CROWNINSHIELD was generally credited last year with having saved the life of the New Society of Artists and this year, with his strong right arm, he again admirably sustains it. The institution had been in a precarious condition for the first two or three years after its secession from the Academy. The reviews of the shows had been lukewarm, the attendance ordinary and the sales less than ordinary. Something had to be done, and quickly. Mr. Crowninshield, who was obliged to assume the role of an eleventh hour, emergency specialist, did it.

In the first place he assembled all the artists and told them what he firmly believes – that they are the best artists in America – they really are the best of the Academicians – and conjured them to make good his belief by sending of their very best to the show he intended "to put over." They all said that they would. Then, through a corps of private secretaries, he addressed his personal visiting list, the largest personal visiting list that the world has ever known – M. André de Fouquière's, in Paris, being nothing in comparison – and commanded them all under threat of his displeasure to appear in person at the first view of the New Society's incomparable paintings. So potent was the appeal that none addressed dared disobey. "All New York" saw and was seen at last year's vernissage, and this year, with much less urging, "all New York" again turned out, And besides there were a few outsiders.

Now when all New York genuinely turns out, an art exhibition is "made." Something is generated in the atmosphere when our nervous, impressionable fashionables are crushed together into two or three small galleries and the sense that there is something important somewhere is born. Some such amiability is always necessary when viewing pictures, but it is remarkable and significant that true receptivity springs from crowds. Visiting foreigners always have commented upon the good nature of our mobs — but mobs for art have seldom been brought off, though when they are brought off they are, naturally, all to the good.

By this time the psychology of the maneuver is pretty well understood. Mr. Crowninshield, for instance, will be obliged to do what he did this year again next year. Foreigners are quite right in thinking the New York mob good natured, but they are not here long enough to also note that it is faithless. We lack the dutifulness and habitualness of London behavior that takes the polite mob year after year to Burlington House just because it was established by some strenuous, English Mr. Crowninshield of long ago, that it was the thing to do so.

Also it would be a great mistake to assume that just because the rooms at Anderson's were uncomfortably crowded for this show that the New Society ought instantly to seek larger and more ostentatious quarters. Psychology teaches that mobs love discomfort and go only where it can be had.

In such a hubbub, of course, criticism ran to extremes. I heard one lady say, for instance, that Mr. George Bellows's big "Crucifixion" was "the greatest picture ever produced by an American." If she really thought that she should have sold all that she had and straightway purchased it, for "the greatest picture ever painted by an American" is a very good buy and bound to go up. Mr. Bellows's picture was the rallying point all the afternoon for those who love to argue, and doubtless will be the most talked of painting in the collection.

As in all of Mr. Bellows's painting there is something to be said for it and something to be said against it. The points in its favor may be stated first. It is vigorous and ambitious. An artist who has his living to make doesn't undertake a religious picture in these days without considerable preliminary thought, and that Mr. Bellows finally decided to risk all the necessary time and energy is a high testimony to his courage. That religious pictures have, so to speak, "gone out"

would provide a startling sidelight upon the times we live in were not the clergy daily presenting us with still more startling food for thought. If the lady already quoted does not beat them to it I certainly would counsel some of these Modernistic leaders to acquire the new "Crucifixion" for one of their churches. There is no sin, not even a taint, in advertising, and this picture ought to do considerable in the way of advertising. The most careless, at least, would look at it.

Failing the lady and the churches, Mr. Bellows's picture is still sure of the most practical issue of success — it will pay for itself. It will, if allowed, travel around the country and sooner or later will win money prizes in the various exhibitions that offer them and finally can wind up in a museum for a good round purchase price. All that is success of a sort, and it is a success that other painters will envy and strive to emulate; so we may expect more and still more strenuous religious pictures in the near future.

But there is a reverse to the medal and there will always be those to look at both sides of the coin.

Is Mr. Bellows's picture truly great, either in feeling or in workmanship? Ah, there we get down to business. I cannot feel religious ecstasy anywhere in it, but on the contrary a continual reaching out for theatrical effects. All of the dramatic personae seem to be Broadway headliners instead of simple village folk overwhelmed with disaster. The Mary Magdalen of the hideous gesture could easily be Miss Olga Nethersole, and the "other Mary" kneels at the foot of the cross much as Mrs. Leslie Carter might. All the characters, in fact, are swayed by artifice rather than feeling.

In color, draughtsmanship and composition the painting is the reverse of commendable. Color always has been a trial to Mr. Bellows and he does not seem to improve. The blacks and whites out in the corridor show how much more the artist he is in lithography than when he wields the brush. Such feelings as I indicate would not be fatal to an artist who gave himself up unrestrainedly to his own muse. Am I not always lauding the work of Ryder, who knew nothing of technique but had poetry to express? And there is the case of the French Carrière, who had no color and achieved at least a style of his own.

Mr. Bellows has the prevailing American fault of self-consciousness, and if he dropped all thought of color, all

thought of composition, all thought of drawing and yielded himself unreservedly to the subject at hand he would be infinitely better off. As it is he cannot detach himself enough from the masters to be one himself. At the reception the ominous word "Goya" was continually rising above the choruses of praise, but to me there was far more Greco than Goya in the picture.

The New York Herald, January 6, 1924

DECORATIONS BY J. M. SERT

THE MOST millionairish works of art that ever I have seen are the decorative panels by J. M. Sert, now being shown in the Wildenstein Galleries. I should say they are distinctly multi. The main, big galleries at Wildenstein's, which always used to appear so sumptuous to us, now seem rather paltry and are indeed inadequate as backgrounds for the immense Cosden decorations. Tons of black marble and oceans of crimson velvet are needed to chime in with the gorgeous black and gold version of Sinbad the Sailor, and doubtless these will be provided in the latest of the Palm Beach palaces when M. Sert's decorations are finally installed in it.

M. Sert's art is staggering. Mere words cannot describe it, and so you are counselled to go and see for yourselves. The Queen of Sheba never dreamed of such things, even after her return from the court of Solomon. George Washington in his most optimistic flight never conceived a time would come when such grandeurs would descend upon a simple American citizen. For M. Sert is a modern Veronese. Veronese? Pouh! Veronese pales in comparison. The famous Marriage at Cana

in the Louvre looks faded and washed out beside these daz-
zling panels for the King of Spain and these others for his
Majesty's brilliant contemporary who lives at Palm Beach.

The advent of M. Sert to New York — Sheriff Bob Chan-
ler's home town — is wonderful but disturbing. One simply
cannot take these extraordinary panels and talk in the usual
way about chiaroscuro and all that rot. In spite of oneself
one thinks millionaire thoughts. How precarious it is to be
very rich! What extraordinary devoirs confront one! How
inevitably we approach the Louis Quatorze stuff.

And how necessary it is that we should be secret about it.
If the populace only had some sense, which of course it never
has, it would see that all these things in the end are for it.
The King and Queen do not keep a gilt rococo carriage with
silver haired lackeys on the back step for their own pleasure
by any manner of means, but just the moment that the price
of bread advances then all the barbarians begin shouting out
about the gilt carriage. But heavens, where am I? I think,
upon the whole, that it will be much safer to take up the
chiaroscuro aspect of M. Sert's art.

M. Sert's panels for the King of Spain were intended to
serve two purposes, to be designs for tapestries and to be
murals in themselves. The subjects glorify the market fairs of
Spain and nothing so opulent in the way of painting has come
out of Spain in recent years. The colors have a Ruben's clarity
that gives every indication of lasting intact, and our artists
will be sure to inspect them closely.

The maquettes of some of the most talked of of Mr.
Sert's European rooms, will also be closely inspected; and here
another fear unveils itself. We have an almost unconquerable
impulse in this country to do things in quantity. Now the ball-
room of Sir Philip Sassoon is quite safe in London, but not at
all safe here. We have such institutions as the movies. We
have the Follies and we have extravagant dance halls that can
get up startling imitations of things. How wrong it would be
were a dozen duplicate Sassoon ballrooms to confront us at
every turn. And what is to be done to prevent such a catastro-
phe? I ask you.

The ballroom of Sir Philip Sassoon must be M. Sert's
masterpiece. In it he destroys architecture by means of mir-
rors at the corners of the walls and ceilings and in various
places, and the romantic scene of his fancy erects itself

against these space enhancing glasses. It is quite in King Ludwig's best vein. Indeed that monarch never managed to lay his hands upon anything half so fairylike. The maquette that displays this tour de force in decoration is sure to impress our designers profoundly. But must it be imitated?

The New York Herald, February 3, 1924

LITHOGRAPHS BY BELLOWS

THIRD IN the sequence of recent exhibitions of the work of Mr. George Bellows, and by far the best, is the present collection of this artist's lithographs in the gallery of Mrs. Albert Sterner. In this medium Mr. Bellows's uncertain muse seems to feel more at home and to move about in it with greater ease and more frequent success than in any other that he employs. One is tempted to put this production at the head of the American black and white work of the period, and one would do so unhesitatingly and with a sense that it is a once for all rating were it not for the challenge that Mr. Boardman Robinson makes for this first position. But there is no denying that Mr. Bellows is the harder worker of the two and by far the more secure in popular favor.

Mr. Robinson is seldom in difficulties with the critics, however, while Mr. Bellows almost always is. The reason is that Mr. Robinson relegates technic to the second plan – or rather has mastered technic sufficiently to relegate it to the second plan – and the spectator is confronted instantly with the idea; whereas Mr. Bellows's technic sticks right out in front and the most willing admirer is obliged to wave aside certain awkwardnesses and confusions before arriving at the part that pleases.

By "the most willing admirer," of course, I refer to myself. I am an easy admirer. I do not demand the impossible nor expect perfection, and often accept works of art only one-third of which may be said to be illuminated by the divine spark. But some touch of rapture, however slight, I must have.

So even in the new Bellows lithograph of the Firpo-Dempsey fight, which I mean to recommend to collectors, there are things which I have to brush aside and which I wish were not there. This print, which was issued a short time ago at $40, is already selling for $65 and is bound to go higher. Why shouldn't it? It is a stirring account of the most lively prize fight that ever occurred, and even were it by a less capable draftsman than it is it would still be a wonderful souvenir of a historic occasion. Money "values" are so distinct from artistic "values" that though Mr. Bellows has achieved more completely successful prize fights than this the "Firpo-Dempsey," for the association's sake, must take precedence of them.

Were sporting gentlemen aware of its existence they would doubtless exhaust the edition instantly, and it's a pity they cannot be first in on it, but the chances are that the investment seekers on the spot will get there before them. By way of solace I can at least print a reproduction on this page and will have a great curiosity myself to know what fight experts think of it. In particular, I hope the Messrs. McGeehan and Trumbull of the *New York Herald*'s staff will cast their eyes upon it and report.

Sportsmen in general, I suppose, will yearn for a little more precision in the likenesses, but Mr. Bellows's evasions in that line do not disturb me, for in the startling moment he chose to represent — that moment in which the fistic idol of Americans went crashing through the ropes — there was no time to observe eyelashes. There is no doubt, however, as to which is which. Firpo stands erect, conqueringly, with legs far apart upon a true Hambidgian triangle.

Firpo, artistically speaking, is eminently satisfactory, and so is Mr. Bellows's arrangement of the ringside ropes, and so is the point from which he chose to view the "disaster." But Dempsey, still from the point of view of art, could be ever so much better; and so could be the referee and the bystanders.

In fact Mr. Bellows was quite confused about the champion. Betting men will think, of course, that if the artist got flustered about Dempsey it must simply have been that he had

money on him, but I prefer to believe that it was merely be-
cause those cursed rules of Hambidge got in the way again of
the composition. Mr. Dempsey is over modeled. The shadows
on his body are not transparent enough. I did not see the
actual fight. I was hundreds of miles away in the wilds of
Pennsylvania listening to a befuddled radio man's frenzied ac-
cents, but I know enough of fights to know that Mr. Dempsey
must have seemed a dazzling mass of white suddenly flung
down on those black coats by the ringside. And if he weren't
at least he should have been in the picture, for pictures have
rules of their own, and Mr. Dempsey, though knocked through
the ropes, is still of the highest importance. Some of the prints
vary. In some Dempsey is quite in shadow, though even in the
clearest versions he does not count as he should in the com-
position.

Then the gesture of the referee is quite silly, I think.
Whether he is issuing commands or counting time, I do not
know, but it is inconceivable that he should be giving orders
already since it is still in the infinitesimal fraction of time in
which Dempsey is falling, as is indicated by the champion's
lifted leg. Although by all accounts "pandemonium reigned,"
I'm sure that referee had at least half a second of complete
petrifaction. At any rate, I don't like that gesture. And I don't
like the man who supports Dempsey. He seems to turn his
head away as though doing a simple gymnastic feat. He must
have been quite huddled against Dempsey to have rendered him
service. But there again the artist refused to allow his imagina-
tion to work in order to apply his rules for composing. As a
matter of fact, there are too many lines curving in the same
direction in just that part of the picture. And all the bystanders
seem to be saying, "Oh." Friends of mine who were there say
they said all sorts of things.

These few strictures upon an admittedly successful print
are to be understood as good natured. A print is not much good
that does not make people talk, and mine is just part of the
talk. The lithograph as a whole is a highly commendable un-
dertaking, and collectors who ignore it, in my opinion, will not
be wise.

The New York Herald, February 17, 1924

REAPPEARANCE OF DUCHAMP'S

"NUDE DESCENDING A STAIRCASE"

A PAINTING which perhaps more than any other has caused Americans to spill ink is again visible in our midst. This is the famous "Nude Descending the Staircase," by Marcel Duchamp, and it reappears in the Whitney Studio Club exhibition arranged by Mr. Charles Sheeler from the works of Marcel Duchamp, Pablo Picasso, Georges Braque and Marius de Zayas.

This picture was undoubtedly the star piece in the historic and sensational "Armory" exhibition of long ago. It was very well placed in the collection that set the entire United States once by the ears. Everywhere in the vast galleries were works of art that were calculated to start the placid and the sluggish to thinking, and the cumulative effects of so many cerebral shocks become unbearable at the far end of the Armory where Mr. Duchamp's painting hung.

A sort of locomotor ataxia developed and people could not or would not go further. They crowded about the picture shrieking for help. "What does it mean?" cried they, and the voices of those who tried to answer were drowned in loud choruses of "Noes." More "Noes" than anything else were heard. "No, I refuse to admit —" "This is too much," &c., &c.

To add to the confusion certain clergymen were found who declared that this picture, which purported to render the sensations of an individual descending a stairway conveyed a great moral lesson, and certain other clergymen were found who declared that the painting conveyed just the opposite effect. The wits reveled in this supposed challenge to their powers, and for two or three months there were endless bon mots on the subject. About the best, it was generally agreed, was somebody's definition that the picture represented "an explosion in a shingle factory."

This was repeated to one so often that finally it became unbearable and had as much to do as anything else with the shelving of this particular discussion. But long before the dis-

pute grew cold the picture was sold at a gratifying price to some one in the West, it was rumored, and after a tour to Chicago and other places retired to private life.

And now it comes again. And strangely enough, considering the uproar that once there was, it comes quietly and will be viewed quietly. This picture and the others by Picasso, Braque and De Zayas already have the air of classics. They are painted in reticent grays and browns and the whole atmosphere of the rooms has become thoughtful and serious.

So much for the processes of time! It is strange how dreadful a mere idea can be to those unaccustomed to ideas, and it is strange also how innocent the monster may become when robbed of unfamiliarity. The timid, or the perverse, may immediately jump to the thought that monsters, as such, are recommended. Not at all. The occasion merely serves once again to illustrate how fatal a bad prejudice is to the arts. It is not that the startling thing is necessarily good but that the startling thing is not necessarily bad.

The "crime" that the Messrs. Picasso, Braque and Duchamp committed was to speak to the imagination in the terms of the painter's language. No one ever supposed that the book and the bell and the candle, or the lemon, banana and peach, of the former generation's still lifes, had anything sacred in themselves — it was merely the style of the painter who happened to see something in them that counted. The new men merely put into practice the theory that Whistler preached and added a few new angles from their own experiences and the text books of the scientists — and scandalized the world.

The fact that this revulsion from the subject occurred at the time of the great war gives it a significance that it might not have had in times of peace, and we may be sure that the psychologists of the future will be most illuminating in their efforts to coordinate it with the other soul manifestations of the period.

In the meantime, as I said, it is most quiet and reposeful; and the average student of to-day who has already discounted the fierce attacks with which abstract art was greeted at first, will accept it easily enough for its decorative and other qualities.

The New York Herald, March 9, 1924

BURCHFIELD

"Then to the real artist in humanity what are
called bad manners are often the most
picturesque and significant of all."
—WALT WHITMAN *in "Specimen Days & Collect."*

FROM THE trooping throng of attractions that the art galleries
have let loose this week upon an expectant city the water
color drawings of Charles Burchfield at Montross's seem most
potent in enchaining the eye, for Mr. Burchfield speaks
through the eye to the new patriotism that some of us feel
expanding in our midst.

Patriotism, I trust, is no new thing, and especially not
to readers, of THE SUN (to whom my salutations), but it can
scarcely be denied that an awakening has been brought about
among the young people by the great war and that their in-
stinctive detachment from the ideals of Europe has caused
them to look with a certain freshness of vision upon our own
assets that shall be realizable in art.

In this sudden closing in of horizons the coast lines, for
the first time in our history, lost themselves in mist, and a
fierce spotlight, directed by some one in Chicago, it is sus-
pected, called attention to the marvelous possibilities in the
soils of Illinois, Nebraska and the other middle States. The
writers, led by Mr. Sherwood Anderson, made frantic rush to
embalm the vegetations of those parts – some scoffers in the
East still call them weeds – in literature, but so feverish were
they that oftentimes the outlines in their studies became
blurred.

It is a pleasure to state that in the art of Mr. Burchfield –
the first artist to take an authoritative position in the mid-
Americas – the outlines are now blurred. Oh, look at these
drawings, Mr. Sherwood Anderson, Mr. Carl Sandburg and
Mr. Edgar Lee Masters, and take heart of courage. Here is
what you have been after. Are they not you all over? Whole
volumes in each one, complete, unflinching, wonderful, hor-
rible and very good art.

Mr. Burchfield is the sort of genius that communities
usually massacre and then afterward revere. He tells the truth

until it hurts. He is less careful of our feelings than was the late J. N. Synge of those of the people of the Aran Islands. We might as well be the bones and shreds of the extinct Aztecs for all he cares. But how splendidly he lays out the remains! After all, it's art! Vive art! And vive America, for Mr. Burchfield is one of us. The phenomenon of a genius at work is to be observed in these States. "Take notice Europe," as Ralph Waldo approximately said years ago upon a similar occasion, "Unto Us a Man Is Born."

Mr. Burchfield is the artist who burst upon us some seasons ago with drawings that seemed to publish an extraordinary distaste for life as it is lived in Salem, Ohio. Mr. Burchfield seethed with rebellion or allowed himself to become the mouthpiece of those who did seethe with rebellion, at the miserable shanties and unlovely conditions in the small town where he lived. He mocked with a venom and a ferocity that Dean Swift himself might have envied, at the decay of the machine made dwellings, at the hideous corrugated iron shops, and above all at the terrible railway which drove relentlessly and implacably ahead and provided no escape from the hell that was Salem, Ohio.

These drawings were songs of hate. Furthermore they violated all the rules of polite water colorers. Water color is a medium that is supposed to have, like all other nice mediums, certain well defined limitations. Mr. Burchfield ignored these rules. He used gouache indecently. He drew in sizes that almost compared with the spring circus posters in the town he despised. But, que voulez vous? The man had genius. We squirmed in anguish for a while at the mirror thus held up to nature, and for a while we were tempted to shout, "Kill him! Crucify him!" but in the end, que voulez vous, art is stronger even than human nature, and we succumbed; and so strange is the psychology of admiration that instantly we began searching about for a pedestal for the artist, realizing that he is one of the great people of the land. Also a peculiar but secret relish for the horrors of Salem, Ohio, developed. The gigantic anything, even a gigantic horror, has its interest for Americans.

But, naturally, the place became too hot for Mr. Burchfield. He moved to Buffalo, N.Y. From the point of view of art, this seemed a tragic necessity. Mr. Burchfield's art was founded upon hate. Could he loathe increasingly Buffalo, and

later on New York City, thus having a career? Or had his bolt been shot at Salem, Ohio? No one could say. Time alone could tell.

One glance at the new set of drawings now exposed in the Montross Galleries and we are reassured. The Burchfield talent is intact; nay, more undeniable than before. The ferocity and mockery are undiminished, and in addition there is a hint of a developing macabre along Poesque lines. In the way of treatment some of these water colors have been varnished. Isn't that terrible? No, it isn't. We had that out with Mr. Burchfield once before and Mr. Burchfield won. Henceforth, he can do as he likes. He can violate the old medium all he wants to as far as I am concerned. I intend to stay with him to the end.

But it is grand to think he hates Buffalo, N.Y., and is unfussed by fame. That was the great danger in capitulating to him that other time. Advice and adulation pour in upon a painter once he is publicly praised and often corrupt him. It appears this man is not that sort. Doubtless, like Turner, he doesn't read art criticisms; and at any rate hoping he doesn't, I have ventured this time to give way to my enthusiasm, for I don't wish to be the one to spoil him.

The Sun, March 22, 1924

JACOB EPSTEIN AND SINCERITY

IN THE very latest best selling type of satirical romance to reach these shores from London, called "Seacoasts of Bohemia," one of the heroes changes his name from Bloggs to Czkvmzl and immediately achieves the fierce light of publicity.

" 'It's the "z," I think,' said Brawn, 'which is the keynote

of his name. There's something about it which is . . . I can only describe it as teleological, you know, culminant. Cézanne never would have happened without it. Then there's Gaudier-Brzeska, what? And Zadkine.' "

" 'What about Epstein, then?' somebody murmured interestedly.

" 'Exactly,' said Brawn. 'That's just what's wrong with Epstein. There's always an unappeased aspiration in Epstein. It's the ghost of the "z" haunting him. Haven't I always said that Epstein lacks — how can I put it? — teleology; culminance, if you like.' "

To the hard boiled American, Epstein lacks several things besides the unappeased aspirate, and among them is the faculty for being sincere. Sincerity may be out of date in London, but it still goes here — and reputations may be founded upon it alone. Without it the individual himself must put in an appearance and perform antics for us. The London gestures of Epstein have never quite taken on meaning at this great distance, nor, in consequence, have his works of art.

The present show of his carvings in the Scott & Fowles Galleries provokes the query as to the form this talent would have assumed had it developed in New York rather than in London. It is positively certain that it would have been unrecognizedly different. Epstein is undoubtedly clever. He knows form and how to manipulate clay, but his inner urge is merely to supply a demand. London likes to be astonished and is easily astonished, so in every exhibition in London, this sculptor puts forward a cheeky portrait of a duchess or an archaistic Christ, and immediately brings down the house. Catering to cheap applause has finally produced a style that is ruinously fatuous.

Whether Epstein could ever have been great is a matter that is ready for investigation. Doubtless the individual that would sell out to the wrong set in London would have sold out to the wrong set in New York. What in the mean time "makes the judicious grieve," as the phrase goes, is the fact that several pieces in his present display prove the talent that has already been admitted, and point the way to the greater success that might have been this sculptor's.

These are the bronze heads of Muirhead Bone and the late Lieut. T. E. Hulme, and to a lesser degree the heads of Augustus John and Lord Fisher. The Muirhead Bone head is

really excellent, with a relentless, Roman tendency to squeeze every inch of the modeling into character. It is entirely worthy of the man who did the etchings and seems to insist that he had the inner, essential type of greatness that would have been fine in any form of expression. Much of the same kind of force radiates from the Lieut. Hulme head, but the effigy of Lord Fisher leaves one doubting, just as the splurgy, gaseous individual himself did. It is unquestionably, however, something to be preserved, if for nothing else then as an aid to historians in solving the riddle that this curious war lord posed. But who is to preserve the distorted, affected portraits of the duchesses? Not I.

The Sun, April 19, 1924

A SARGENT RETROSPECTIVE

TWO SHOWS have attracted crowds; the John Singer Sargent retrospective in the Grand Central Galleries and the J. M. Sert decorations at Wildenstein's. The Sargent crowds I take on hearsay, having been permitted an early private view of the paintings and so not having been obliged to be one of the ten thousand at the *vernissage;* but the Sert crowds I saw with my own eyes and I can certify that they were indeed immense, richly apparelled, and awaited without by motors, but in the end as completely flabbergasted by M. Sert's art as though they had not been awaited without by motors. I mean to go again, of course, to the Sargent rooms, just as soon as I get my breath, for next to seeing how I take pictures myself I dearly love to see how others take them. I had taken the Sargents, the new John Marin water-colours at Montross', the

recently imported Maillol bronzes and Henri Rousseau paint-
ings, all in one afternoon and found it somewhat of a gulp,
consoling myself with the reflection that after all my pace in
New York could have been no swifter than the late King Ed-
ward's in Paris on the famous occasion of his doing both
salons on the same day with a state luncheon between. How-
ever, of course, King Edward was not obliged to deduce morals.
Well, I shall not deduce many.

Sargent has been out of the public eye for such a long
time that he seems like a new thing. The present collection,
chosen in the main, by the artist himself from his available
works, lacks certain noisily acclaimed portraits, such as the
Wertheimer series now in the National Gallery, the Car-
mencita, now in the Luxembourg, and the little Beatrice
Goelet, but on the whole makes the case as strong for Sargent
as it can be done upon this side of the water.

And will it have all of its old-time effect? Hardly. The
times and manners have changed once again. There is nothing
in the atmosphere of the age to back Sargent up. The fabric
he created for us still dazzles here and there, but in places
it has been worn thin. Perhaps some of the survivors among
the former enthusiasts of twenty years ago may catch again
at the thrill that comes from seeing a gentleman's gold watch-
chain made manifest by three dabs of a brush — but not all. In
the long run tricks tire and it is only the soul that counts, in
art as in life.

In the pre-Sargent era, throughout all our land there was
a craze for technique as such — born of the sudden realization
that our cherished Hudson River school of landscapists lacked
style — and it was supposed that certain masters in Europe,
and only those of Europe, could impart the secrets of true
painting. The crush of the 'eighties and 'nineties to acquire *ton*
now seems pathetic, for though the trans-Atlantic lines con-
tinue to flourish, the attitude of the travellers has undergone
a change. Then artists were humble, submissive, and dutiful;
and Bouguereau, Gérôme, and Bonnat were listened to, and as
far as possible, imitated. Now, students go to France for the
Quat z'Arts ball, for the Café du Dôme, and perhaps, though
not necessarily, for a glance at the Louvre. They have no
definite master in view and no longer hope to join the trade
union that used to sign in the catalogues with pride, "pupil
of Juliens," "pupil of Piloty," et cetera. To be a pupil of any-

body now damns rather than crowns. But in Sargent's day it was different. He had the supreme advantage of having parents who had undertaken the grand tour, and was actually born abroad upon one of their quests — and hence, came into the world upon the ground floor, so to speak, of cosmopolitanism. This gave him an advantage over the Henry James of thirty years ago that only the Henry Jameses could appreciate. When he had finished his studies with that archmountebank, Carolus Duran, Sargent was prepared to astonish the world, and did. Never, in my time, has an artist been so petted as he. You see, his public was being educated for him by the others, and from the apparition of that startling but dubious Mme X, down to the appearance of the tall, thin "Stokeses," there was never a question but that with him we had reached the apogee of the arts. I shall never forget the excitements of those early first appearances. For days before the public exhibitions rumours that had leaked out from the jury rooms whetted the appetites of amateurs and when the chefs-d' oeuvre were finally disclosed the public undissentingly rose to them. The little Beatrice Goelet was "far and away beyond the Velásquez Infanta in the Louvre," which it vaguely resembled; the Carmencita completely "put the kybosh" — I believe that was the term — "upon anything that Frans Hals ever did"; et cetera, et cetera. For the tall, thin Stokeses, doubts leavened the praise; for at that time the terrific tallnesses and thinnesses of El Greco had not so fully been recognized as great art as later they were, and the only thought that occurred to the innocents of the 'nineties was that perhaps Mr. Sargent didn't like the Stokeses and was exaggerating on purpose. However the public still clung to him. There was a great desire to be done. To be painted by Sargent distinctly helped socially and when this was realized the final débâcle could have been foretold had clever clairvoyants been consulted. There was a rumour one autumn that Sargent had dashed over from London to do sixteen portraits in sixteen weeks for five thousand dollars each. Whether hands were included for the five thousand I do not know, but I suppose not, for hands were a trial to this artist and he had frequent agonies over them. Even in the present exhibition hand trouble is everywhere in evidence — and that is one of the things that makes one smile in thinking of the old-time boast that at last we had excelled Frans Hals!

But that remark brings me with a jump to the present-day aspects of Mr. Sargent's art and — as the space at my command has a tendency to evaporate — I fear I must postpone a consideration of them for another occasion. The present exhibition undoubtedly invites appraisals, and as a hint of my feeling, which I may elaborate later, I must confess that Sargent, though not exactly a God, is secure enough of a place in the American heaven.

The Dial, April 1924

MORE ON THE SARGENT

RETROSPECTIVE

AS NEARLY as one may dissect the pleasure that a portion of the community takes in the Sargent exhibition, which is still charming dollars from pockets unaccustomed to paying dollars for art exhibitions, it lies in a pleased surprise at the good appearance we make. We are, or we were in the 'nineties, in better form than we suspected. At the present day form, as far as I can make out, is not much of a preoccupation with many people — the war seems to have dissolved form — yet even in the hilarity of our new prosperity it is apparent that the tradition of "quality" is not quite so dead but that surviving members of the former cult may réchauffer themselves at such embers of it as Mr. Sargent's art provides.

We have all, of course, with great readiness, accustomed ourselves to the *rôles* that fate has recently thrust upon us. We not only submit to, but enjoy, being grandees; and, recalling some of our experiences of a dozen years ago, rather think

we have improved upon the model then extant in the way of world leaders. We seldom betray impatience at the importunate princes and lesser nobles that now besiege our doors; and as a rule we are uncritically willing to know and to feed them. In the rush of accommodation to the new life, there is little chance to indulge in our old vice of introspection; but occasionally at odd moments we do recall the time when any European had it in him to make us feel second-class. Between the Daisy Miller who had the "tournure of a princess" and was so pitiably unable to cope with a hotel courier, and the Newport ladies in The International Episode who so unaccountably crumbled in the presence of a duchess, there is not now, we recollect with astonishment, so very much to choose. Indeed the average citizen of to-day is altogether likely to agree with Mr. Howells in thinking Daisy Miller a "supreme effect of the American attitude towards womanhood" and in considering the Newport ladies cheap. Their failure certainly was a less bearable kind than Daisy Miller's. Some of the stain left by this and all of Henry James' later accusations against us is what the current exhibition dissipates.

I don't suppose the gratification is a deep one — how could it be in the intoxication that sweeps New York at present? — but it nevertheless soothes in the midst of so many new distractions to discover that even a generation ago we were not so bad. It is as though a *parvenu* were to be unexpectedly blessed with a grandfather. In this case one should say grandmother, since it is the elderly women in the show who do us proud. The men, with the single exception of Mr. Joseph Pulitzer, all go to pieces as human beings, but several of the old ladies are to be seen spiritually intact, and, as though that were not enough, nicely costumed. The Victorian and Second Empire dowagers really had nothing on Mr. Sargent's examples whatsoever; and seeing this, it is all the more surprising that the daughters, several of whom are prettily indicated by the artist, should have undergone the European abasements that Henry James said they did. It is as a sort of social register that Mr. Sargent succeeds. His sensitiveness to scale is amusingly illustrated in his portrait of dear Ada Rehan, who it now appears, was not — how shall I say it? — not quite a lady — and not being a lady therefore not interesting, or at least, not to Mr. Sargent. He scarcely considered her

worth drawing properly, and the less said about the arms that hold the immense fan the better. A social register, however, is a not unuseful achievement. It has been remarked that the historians who accuse Horace Walpole of light-mindedness quote more steadily from him than from any other Englishman of his time. Without pretending that Mr. Sargent spoke for his 'nineties with the authority of a Walpole — for Horace occasionally looked below the surface and plumbed depths — nevertheless the record he accomplished makes a vivacious accompaniment to the histories of the two decades — the 'eighties and 'nineties — that are now being rounded out by the recent critics into an appreciable period.

It is not deep work. It is not finished work. In one technical feature, and in only one, it is first-rate. The "values" everywhere are unerring and superb. The colour used in the interiors is acceptable but undistinguished. The colour in the outdoor things is commonplace; in fact Mr. Sargent's whole point of view towards landscape is commonplace in the extreme. And finally, the drawing is uncertain. Everywhere in the New York exhibition we see arms that are awkwardly attached to torsos, and torsos that lack the support of legs. Even the Higginson ears lapse out of construction! In a loftier form of arm, errors of hand can easily be overlooked; but here where everything is passionless and superficial, the very great brush dexterity that is held out to us as a recompense is not enough. Not enough at least to enchain permanent interest.

I ought to add, I suppose, for those who like concrete statements, that I infinitely prefer Sargent to Sir Thomas Lawrence, but that I rate him well below Manet, Cézanne, Reynolds, and Gainsborough.

The Dial, May 1924

HOPPER'S WATERCOLORS

THE STUDENT who not only weighs positive achievement but the possibilities for future achievement must have looked upon the etched work of Edward Hopper with respect from the beginning. It had its crudities but it was always honest. Mr. Hopper never succeeded in uniting himself as with hoops of steel to the life of the poor people upon whom he gazed from his studio windows — studios in Washington Square are admirably placed to induce broadmindedness upon the part of their occupants — but there was no question as to the sympathy he expended upon them. He was not a Millet agonizing over the injustices of the peasants, but he was sincerely sorry for their lot and incidentally noted that it had its picturesque moments.

The something that turns an honest recorder into an inspired one had not occurred to him. The assurance that can be felt in a first rate Seymour-Haden etching was not Mr. Hopper's, neither in the identification with the subject nor in an abandonment to the eloquence of the etched line. But this undeniable honesty of his, if not the whole of genius, is at least a long step toward it and predisposed most of the critics to be his friend.

All of these latter will now be gratified by a little exploit of Mr. Hopper's in another medium, water color, in which he appears to plunge forward. He doesn't plunge quite to absolute greatness, but he advances to a position where others than hopeful critics must consider him. In other words, he engages the attention of collectors and the public in general. In the F. K. M. Rehn Galleries the group of studies made by Mr. Hopper last summer in Gloucester, Mass., have not only aroused Mr. Rehn to a pitch beyond his usual enthusiasm, which is always considerable, but has so excited his clients that at this writing more than half the water colors have been sold.

These purchasers may think my own enthusiasm, which is also considerable, is, in spite of its quantity, coolish in quality, due to the fact that I insist on absolute greatness.

But that would merely be impatience upon their part. There is lots of time yet for greatness, and in the meantime I think it pretty fine that Mr. Hopper should be interesting.

It is impossible, for instance, for the observer who views everything to ignore the fact that Mr. Hopper in his new drawings enrolls himself in a school that appears to be in process of developing and of which at present Mr. Charles Burchfield seems to be the head. It has been pointed out already that in the etchings this artist noted that however squalid the slums might be they still had the power to suggest beauty to an artist. He was not, however, stirred to passion or noble thinking by this discovery. In the present series of water colors the same feeling enables him to be forcefully eloquent upon the hitherto concealed beauty of some supposedly hideous buildings built during the Garfield administration. The dwellings, in fact, are hideous, and people of sensibility were quite justified in shuddering when they passed these relics of a dark era in American history upon the streets of Gloucester, although now that an artist has known how to extract beauty from them there will no doubt be a temptation to view them with affection.

Mr. Hopper is not as savage to Gloucester as Mr. Burchfield was to Salem, Ohio. He does not mock. He does not rant. He merely joins, and with more vehemence than most, in the cult that has restored the mid-Victorian forms to our hearts. The painted Windsor chairs, the New England hook rugs — the cruder the better — are part of the general movement. The first bitter drawings that Mr. Burchfield showed here had the appearance of having been torn from the bosom of a man suffering past endurance, lost to all sense of shame, indifferent to the opinions of bystanders. It is quite possible that Mr. Hopper has never seen Mr. Burchfield's drawings, for from the very beginning his attitude to life has been that he now discloses with increased freedom in his water colors; but on the other hand the shocks that have been received from Mr. Burchfield's ruder work and that compelled a frightened public to think have blazed a way for all sorts of freedoms — and in particular have presented our starving artists with a lot of new themes.

The chief matter for congratulation in all this is the broadening out that our collectors have been forced to take. We arrive at the point where we dare to make fun of our

past. We glory in the excesses of our ancestors, even in their orgies of bad taste. Soon we shall be allowed to laugh at our present. Then, intellectually, we shall have arrived and satire will be possible. At present is is a penitentiary offense.

The Sun, October 25, 1924

MATISSE AND MESTROVIC

MATISSE ASCENDS the social scale in New York. That is to say he ascends the financial scale, the social and financial circles being so closely allied that the terms used in both are practically synonymous. The exhibition of his recent paintings in the Fearon Galleries indicates that his work now has marketable value. This quite apart from the actual prices that are asked and which are said not to be excessive — to be, in fact, French prices. For the Fearon Galleries aim for the Duveen, Knoedler, Scott and Fowles standards and eschew the experimental. In other words, Matisse approaches being considered "safe." Well, it is high time. In Europe he is no longer an argument. The irritation that existed in the early years against a recognized draughtsman who appeared to throw draughtsmanship overboard vanished as it gradually dawned upon the scandalized that, so far from throwing anything overboard he had actually added ballast to his equipment as an artist. To see freshly was the aim, and it must be allowed that there was disturbing consciousness in the early efforts to become as a little child. New York Philistines in considerable numbers, ten years behind their French brethren, are still shrieking "insincere," which is all nonsense. The consciousness, which was slight anyway, has long since disappeared, as well as the

intellectualism which was also in evidence. Instead there is to be found the most delightful ease in painting to be encountered anywhere in the modern world. Young people say he is our Rubens and I find nothing objectionable in the phrase, particularly since I am one of those to whom the painting only in Rubens appeals. Rubens as a searcher of the soul, or even as historian, leaves me cold. Matisse, in spite of his famous casualness as to subject, holds the mirror much more firmly up to nature. I don't think he plunges to the depths, however. He is not of the École Rembrandt. The soul is not much more to him than it is to Rubens. But he at least gives you its cadre. He is French, so very French. As French as Chardin. A Chardin up-to-date. He dares to give you the bad taste of the contemporary French scene. A positive smell of chicory emanates from his canvases. The small-minded at first thought this a treachery, but it is not. It is purest patriotism. Only when faults are loved is the genuine affection reached. These stuffy interiors of Matisse are killingly funny and at the same time ineffably dear to those who know the bourgeoisie upon which French civilization rests. And how superbly are they rendered! Really, after all, the association of names is a compliment to Rubens. Where in his work can you find things so smashingly presented? And where anywhere is such amazing energy attuned to such equally amazing delicacy? I have no words with which to express my contentment with the new kind of precision in values to be observed in one of the interiors now shown. The room in nature must have been a scream. A red and white striped table cover which comes into terrific collision with a frightfully red rug and turned, in this picture, into captivating wit by the adroit brush of the artist! The stripes on the table-cloth alone vindicate the doctrine elucidated from St. Matthew, 18:3. The scholastic would carefully rule such lines and have them exactly meet the down stripes at the edge of the table. But not so Matisse. With an infant's wild abandon he lets the meeting of the stripes occur as they will, and miraculously an emphatic effect of nature comes to pass. The edge of that table is masterly. Go see it, Philistines, and repent ye, ere it is too late.

The exhibition of Mestrovic sculptures in the Brooklyn Museum is stupendous in at least one thing — size. There was a widespread desire to inspect these carvings at the time of

their London success in 1915, but the getting to America of
heavy sculptures, always a hazardous matter, was doubly so
in war times, and no one was willing to undertake the affair.
Now that they are come and duly installed in a museum gal-
lery one must wonder that there was enterprise enough in a
public institution to induce these works of art in this direction,
for there are over one hundred pieces and many of them are
very large. In a vague way one hopes that all monies expended in
the cause of art will not be expended in vain even when ex-
pended in causes with which one is not wholly in sympathy, and
one trusts that the Brooklyn Museum will be recompensed for
the present severe strain upon its purse. But how? Only the Lord
in Heaven knows. The public, I think, can be persuaded to
visit the show in large numbers. I have done my best in the
columns of the daily press to encourage an exodus from New
York to Brooklyn and Brooklyn itself always turns out well
for its own shows no matter what they are; so the public, I
think, will see them. But will they buy? Ah, that's the rub.
How can they? They really are so big, these sculptures! We
have no church anywhere that could support Mr. Mestrovic's
big figure of Christ in wood. An enthusiast said, "Well then,
we should build a church that would hold it." I regret that I
cannot share in that feeling. It is charming to have enthusi-
asms, but the populace doesn't have to justify itself for its
furores and I do. I think, however, though we needn't build
a cathedral for Mr. Mestrovic — we are having a slow enough
time, as it is, Heaven knows, building St. John's — we might
purchase a few of his things, and since private citizens cannot
possibly get them into the sitting-rooms of the tiny apartments
in which they are obliged to live, it seems to be up to the
several museums to purchase a few. Also the various Jugoslav
Societies in the various cities might help, as anything that
happens in this line redounds to the glory of the new state. If
I seem to take a light tone in this matter it is in perverse reac-
tion, no doubt, to the too extravagant claims. Something had
been said about Michael Angelo. Mr. Mestrovic is by no means
a Michael Angelo, though he is Michael Angelesque. He is a
good sculptor, one of the best of the exotic band to come here
since the war, and he is serious. He is serious, but not pro-
found. How could he be, working at that speed? Sculptures do
not make themselves even in these days of mechanical aid and
that a man of forty should already have carved 240 ideas into

permanent material is the most disconcerting fact that his biographers have supplied.

The Dial, January 1925

SEURAT

THE BEST exhibition in town passes unnoticed. A percentage of the connoisseurs, those most closely allied with current affairs in Paris, have seen the Seurat paintings in the Joseph Brummer Galleries, but the public has been unaware. Four of the more important canvases are lent by the estate of the late John Quinn, but most of the works have been brought from France. They are for sale, but in the third week of the show Mr. Brummer reports that not a single individual has inquired a price. In a land were money speaks, so deep a silence is significant of much. Mr. Brummer is a shrewd man, shrewd in judging pictures and shrewd in judging men, yet he is frankly puzzled – as well he may be. Seurat, now, is an acknowledged European master and a rare one. The total number of paintings is not large and the first American exhibition of the work might reasonably have been imagined creating a flurry, yet the Hudson River was never for a moment in danger of conflagration. If anything, it froze.

Looking at the matter now with hind-sight, I find that our public, after all, ran true to form. The pictures are small, they are not new, they are quiet. How raise a sensation over things so essentially unsensational? Who is there here who buys a picture as a woman does a hat in a shop, because it has suddenly become a soul-necessity? No one. We buy because "the others" are buying or because some unevadable salesman has

talked us into it. Seurat didn't murder anyone nor run off with somebody's wife. He is not a figure of romance. All he did was to paint studiously a few good pictures and die young. And good pictures in America do not make their own réclame.

I can see why two classes of society "failed" with Seurat. Even to the students who acclaim him he is not a subject of debate. He is not only twenty years dead, but twenty years known. He pops up casually in studio conversations, just as Blake, Redon, or Delacroix do, to illustrate a point, but like them, he is indubitably of the past. He is not in present-day politics. He may prove, for historians, the line of succession from Cézanne to Picasso and Braque, but what our talkers desire to know is who is to do the bridging out from Picasso and Braque into the future. They hustled up quickly enough last year to Wildenstein's to see the Greek Picassos, for it seemed likely, then, that they would all have to turn Greek, for they know quite definitely that when they do turn it will not be for a mere matter of twenty years backward. So much for our students.

The other reason is more delicate. Perhaps I shouldn't mention it. I have a disturbing fear it was given me by one of our great picture dealers in strictest confidence. But on my life I cannot recollect which art-dealer! So I'll chance it. Besides, sooner or later, you'd have to know it anyway. It seems that great classic art is no longer sold in public in America. Everything is done secretly. When the picture has been surreptitiously acquired then the great millionaires are let in singly to view it. If persuaded that no other millionaire has cast eyes upon the chef-d'oeuvre in question he buys it instantly. If not so persuaded, everything is off, the millionaire departs in a huff, and the Rembrandt, or whatever it is, is taboo. It is either deposited in the ash-can or presented, with the dealer's compliments, to some western museum. Why this should be so I cannot fathom. It is millionaire psychology, however, and it is only because I am not a millionaire that I do not understand it. But with such a state of affairs in this country you can see why nobody asked the price of the Seurats. Seurat is not a fresh discovery of the long-haired students, to be gobbled up instantly by the half-dozen who like to be in on the first of everything, and he must appeal, if he is to appeal at all, to the wealthy acquirers of classic art — and how could these formal connoisseurs violate their own

code by actually picking canvases off the wall of a public gallery? You see the difficulty.

Mr. Brummer smiled at himself sub-acidly, I fancied, as he recounted his lack of success with this show, but there are some failures that are more honourable than some successes. In the end I think he will have added to his prestige with the adventure.

I ought to add, to be honest, that my own pleasure in the work is quiet. With the best will in the world I see nothing over which to make a pertinent hullabaloo. And it is the first time, too, that I have encountered a thorough exposition of the Seurat *principe*, with its rise in the quiet but good student work to the quiet masterpieces of the later years. The pleasure is that which one takes in a sober, well-made book by a real person, the sort of book one goes back to continually for steady entertainment, but which never bowls one over. Even the satire of Seurat is quiet. It is satire, of course, though the Seurat enthusiasts of my acquaintance do not dwell upon it much. They are all for the workmanship – and in Mr. Pach's case, chiefly for the link in the chain of history. The distinctly plump young woman engaged in powdering herself is seen with humour, but with the correct satirical humour that Baudelaire insists upon, that is more than half sympathy. It is indeed amazing that so enduring and architectural an arrangement can have been evolved from such contorted furniture as the young woman owns and surrounds herself with; and that the effect is not arrived at impetuously is self-evident. Every touch is calm and unhurriedly exact. In the final, best work, the Circus, which now, by the will of Mr. Quinn, goes back to the Louvre, the wit struggles through the Seurat repression to a point that is almost bitter. The Mephisto touch re-appears like a Wagnerian motif all over the canvas, not only in the moustache of the ring-master, but in the chignon of the *equestrienne* and the traits of those attending sprites, the people of the audience. One suspects the scene to be an outside attraction at a not-too-cruel modern inferno, but those of us who are hipped on the subject of good painting are not permitted to suspect too much. We are soon seduced by the perfect balance achieved between unlikely lines and the freshness of a colour which is as much a testimony to Seurat's old-fashioned thoroughness of method as anything he puts

forth, being apparently as lively now as on the day it was applied.

The Dial, February 1925

MANSHIP'S SCULPTURE

THE SCULPTURES by Paul Manship are having their usual success in the Scott & Fowles Galleries. People like them and go in numbers to see them. This is an encouraging or discouraging fact, according to your viewpoint. I occupy a middle ground which approaches indifference, but which permits me to look at the work from two angles.

In the first place, it is always interesting to know what people like. You may pooh-hooh best sellers as much as you please, but they always indicate something. We are said as a nation to be at the present time, hard, unimaginative and lacking in subtlety. All these are outstanding traits of Mr. Manship's art, too. The parallel looks as though Mr. Manship had been holding the mirror up to nature, but that is one thing, decidedly, he doesn't do.

He is frankly archaistic. He doesn't go to life for his subjects, but to the libraries. Contemporary life or contemporary feeling, apparently, doesn't interest him in the least. The small version of "Actaeon Pursued by his Dogs" is the sort of thing our grandmothers put under glass cases and kept on the parlor table. Mr. Manship, in fact, is a modern Josiah Wedgwood. He has, I think, carried his Wedgwoodism to a higher degree of finish than the original, but that is about all. The spirit is not more animated.

The workmanship is mechanically exact. I think that is the quality that really appeals to the public. They have always felt, for instance, that in impressionism they were not getting their money's worth. To do Mr. Manship's carvings justice it must be allowed that they are never slighted. They seem to have been created by machines and finished by machines. This, too, fits in with our modern system of living, and when the terms are applied to Mr. Manship's art it implies both reproach and commendation. Fifty years hence, if these sculptures still persist, people will say "they were hard people in those days and those carvings are as hard as they were." And others will say: "They were terrible people and those sculptures are terrible." But the truly discerning, of whom there are always a few in any age, will say: "Those things are imitations of other artists' work, and have no connection with any period."

The portraits in the collection are amazing — they are so stilted. They lack all sense of human connivance. There is no flow in them, no motion, no vitality. They seem like curious emanations from the studio of a spirit medium, a spirit medium working, be it understood, with first class machinery. That of Dean Keppell of Columbia has a slight approach to geniality, due possibly to the warm color of the stone from which it is carved, but the effigies of Miss Carey-Thomas and Lady Cholmondeley are simply ghastly. At the same time the carefully delineated threads of individual hairs upon the heads combined with the razor edged profiles are most distinctly to the public taste. Therefore, should Mr. Manship worry? I think not.

The Sun, February 7, 1925

LÉGER

DIFFERENT AS is Fernand Léger's art from Bourdelle's, the two men have this in common, both might or should have been produced by New York had not New York been so furiously engaged in living art rather than in producing it. Léger is some sort of a cubist, Bourdelle is some sort of an academician. Bourdelle is energetic enough and scientific enough to fit a sculptural ornament to the façade of the Woolworth Building; Léger speaks through a use of symbols that ought to be legible indeed to Americans, since these symbols consist for the most part of machines, the things upon which American civilization rests.

That he, a Frenchman, living in a land where machinery is still in its infancy, should so insist upon the closeness of machines to life is curious. It merely means that if we have the machines France has the artists. Here, in a town where wire ropes and pulleys cross the vision at every turn, where steam dredgers and derricks pull down and erect with incredible speed, and where automobile sirens assault the ear incessantly, you could probably still find many to oppose the notion that machines affect the soul in any way; but on the other side of the water, being subtler in expression than we are, there are scores who seem willing to speak for us, to prophesy for us and to explain us. Why, the very best thing that has ever been written on the subject, the "Love Among the Machines," by Samuel Butler, was conceived in a flash by that sensitive thinker when machines first came among us, and now that they dominate the world there remains nothing to be said save that Butler was right.

Butler's discovery didn't depress him. There is nothing depressing in the idea of machines. America, the land of machines, is not a depressing country to live in, is it? Of course not. Youth who drive motors with great speed, heads of families who tune their radios with extreme nicety and housewives who sweep their rooms with electric sweepers, are not to be commiserated, are they? Not much. But at the same

time not many among us apparently relish having the artists hold the mirror up to nature, and art, we appear to think, is something that relates to another period than this. And machines are so nice too; so neat, especially when new and hygienic.

Fernand Léger's first big exhibition in America is now taking place in the Anderson Galleries under the auspices of the Société Anonyme. The private view proved to be the first rally of the season for the advance guard, and they seemed more numerous than heretofore. The occasion was unlike some in the past for no one was heard to ask what the pictures meant. All seemed to know what the pictures meant. This indicates either that more people now understand cubism or that cubism itself has become clarified. Rumors have persisted of late that cubism is completely forgotten in Paris and that no one practices it anywhere any more. The Léger exhibition quashes that rumor.

Fernand Léger, so most of those in attendance at the first view said, genuinely feels his cubism. He means it. His pictures have the conviction of an artist with a message. He confesses himself that in exploring the modern world and trying to interpret it in current terms he feels just like a primitive. Certainly his immense decorations have the vigor and freshness of the earliest works.

The N. Y. Sun, November 21, 1925

THE QUINN COLLECTION

A DRAMA is now being enacted in New York that vividly recalls the closing chapters of Balzac's Cousin Pons and though the *dénouement* may be reached before these lines appear in

print, nobody at present knows what is to become of the John Quinn collection of modern art. There are no rascals in the story. I don't mean that. But a horde of people with varying interests are pulling strings in all directions in an effort to sway the heirs and executors of the estate, and these latter, who appear to know nothing of art, are in as fine a state of confusion as you could wish to see. The chances are, therefore, that exactly those things will be done to the collection that its late owner would not have wished.

The perfectly obvious procedure would have been to have sold the pictures and carvings at public auction last winter in New York City. The times were ripe for it and the stage was set. Mr. Quinn's library had already been sold with immense success and the prestige of that event would have extended over to the sale of the objects of art. It is well known to students of auctions that the excitements of them are cumulative and the atmosphere of a big sale breeds a frenzy of buying that ensures success. The dealers, when consulted, invariably deny this. They say that to unload a vast quantity of pictures upon an innocent public is to invite disaster. As a matter of fact, what they dread is the effort that is necessary "to protect themselves" at the sale, for the modern dealer who has been selling certain artists for certain figures thinks it extremely compromising if the said artist fetches less at the auction than at the shop. This is an error both in fact and in judgment. What they ignore is that the details of a great sale linger in the public memory but for a few days and that chance bargains to connoisseurs do not interfere with the prices of staple goods. The records not only prove this but also that the dealers seldom do have to protect themselves in great sales. On the contrary the orgy of buying that ensues on such occasions brings a crowd of customers to the shops as well.

So of course there were dealers to advise the executors of the Quinn Estate against a sale last winter. There were other experts who thought certain works in the collection could only be sold in Paris. It is true that the late Mr. Quinn's taste was far in advance of the crowd and in particular that the cult for certain fine artists such as Derain and Brancusi, whom he affected, has not developed impressively as yet in New York; but the *réclame* of a famous auction reaches as far as Paris and the competition of European collectors would be

effective in preventing the sacrifice of the newer men. . . .
Then some of the newer American artists opposed the sale,
needlessly fearing the public test of an auction – but after all
what could they lose in figuring in such a famous event? . . .
And, finally, there were some ladies. Just who they were and
what were their claims upon the estate I have not heard but
I did hear that they assumed sentimental attitudes. They were
largely responsible for vetoing the auction last winter, holding
that the pictures should be kept together as a memorial to
Mr. Quinn; which was a fatuous notion, for, interesting as is
the collection, it was too unedited to warrant being kept intact.
Mr. Quinn himself was continually editing it and would have
thinned it still more had he lived. His action in regard to his
library is a fairly good clue to his plans for his pictures, and
so I think it a safe bet he would have auctioned them off, for
he was sufficiently shrewd to have known that if he brought it
off successfully, "the historical event" would provide a fine
enough memorial for any man.

To date, the sentimentalists have had their way, and a
"memorial," and temporary exhibition of the collection has
been arranged for to take place during January in the rooms
of the Art Center. This will of course draw many visitors but
when the fine fever of curiosity has abated, do you suppose it
can be re-kindled later on to provide the excitements upon
which auctions flourish? Mr. Quinn, himself, would have
known better than to deliberately invite, in this fashion, an
anti-climax.

The Dial, February 1926

THE QUINN Collection, at this writing, is still the topic du jour. In a case of general interest, such as this, the newspapers may be relied upon to publish the cold facts to the world and so it scarcely can be regarded now as news to state that the cold facts are that finally it was decided to place the selling in the hands of Joseph Brummer, one of our most able dealers, and to exhibit certain chosen pieces in the galleries of the Art Center by way of a memorial to the late owner.

These, I consider, are exceedingly cold facts, for the procedure resolves the Quinn Collection into money and nothing else. It leaves the modern art situation in America precisely where it was and Mr. Quinn might just as well have dabbled in stocks or drygoods as in art. A public auction, on the other hand, would have been a magnificent gesture, compelling professional attention, and awakening the public conscience as nothing else that can be thought of. It would have been as much of an eye-opener as the celebrated Mary J. Morgan sale of years ago which first taught the American public what a peachbloom vase was, only this time the lessons would have concerned themselves with Henri Rousseau, Picasso, and Derain. Since Europe has been so quick to buy examples of these men — the pick of the collection, it is said, having been made by a Parisian dealer — it is absurd to contend that Europe would not have competed in the auction; but had that even occurred, you may be sure those connoisseurs would have had competition from unexpected sources. It is a discouraging thought that I have harboured for a long time that it takes a dramatic occasion to fix the eye of our lethargic noblesse; and to realize that we have missed our great educational chance in the Quinn affair is doubly tragic for nowhere on the horizon is there another collection that could do so effectually the job. It is part of the immense advantage that Paris has, and which I continually resent, that there, periodically, the Hôtel Druot clears the air. The Quinn Collection contained many sure-fire hits but much also that

was debatable, and a public instead of a private appraisal
of it would have been a great help.

It is the part of philosophy to accept what benefits accrue
even from mishaps, so it is time to acknowledge that the por-
tion of the Quinn Collection that was shown had all the old
electrifying powers and drew a steady attendance of the "best
people" who made valiant efforts "to understand." No doubt
some of them succeeded. An immense amount of water has
passed beneath the Brooklyn Bridge since the days of the
Armory Show when aspiring amateurs shocked by such as-
pects of modern life as they caught from the mirrors being
held aloft by the new painters could think of nothing better
to shriek than the words "degenerate" and "imposture." The
attitude now is certainly calmer, though here and there an
unregenerate still thinks it necessary to insult an artist for
being truthful. I have, for instance, just finished reading a
rather dull satire by Mr. Hilaire Belloc who attempts to
burlesque the modern frenzy for quick finance and tells of a
lady who made a dubious *coup* on the Stock Exchange and
was thereby enabled to repaper her Georgian house and hang
her drawing-room with pictures painted apparently "by lu-
natics in hell." This is the only witty phrase, I hasten to say,
in a book I have no desire to recommend. Mr. Belloc spends
all his energy in contriving a picture of modern society that
any visitor from Mars would consider hellish, but turns in a
fury to rend the artists who are saying the same thing he does.
The wonderful difference between the two points of view is
simply that Mr. Belloc looks on life with scorn and our paint-
ers with sympathy.

My finest moment in Mr. Quinn's Inferno – for I don't
care what Mr. Belloc calls it, modern life is the only life I
have known and the only kind I enjoy – came with the dis-
covery of his amazing Henri Rousseau, La Bohémienne En-
dormie. This certainly must be one of the great imaginative
pictures of the era. How explain it, how measure its peculiarly
psychic force? Luckily there are no vulgar chemicals to rob
it of its secret, which will mystify, I hope, for many years to
come. Like music it may be interpreted variously and all inter-
pretations shall be correct. Is it a dream lion more terrible than
a real one? Is it a dream gypsy sleeping in a desert that never
was? You can take your choice but in either choice there is
the same stab at your vitals or you are not susceptible to

poetry. I am always quoting Emily Dickinson's definition of poetry but it has not yet staled in repetition: "If I read a book and it makes my whole body so cold no fire can ever warm me, I know that is poetry. If I feel physically as if the top of my head were taken off, I know that is poetry. These are the only ways I know it. Is there any other way?" . . . In this picture, as in most works that seem struck straight from the soul without any intermediary parleyings with the intellect, I am thrilled again by such details as the moon and stars which shimmer fatefully but positively as they never do in the night-scenes of the so-called realists. This Bohémienne, I understand, is part of the immense loot from the Quinn Collection that Mr. Rosenberg is taking back to Paris, but the circumstance to me is not sad. I am resigned, also, to the departure of Seurat's Cirque. In fact, I am more and more persuaded, as time goes on, that the correct lodging for a masterpiece is the country that produced it.

The Dial, March 1926

DEMUTH

NO GREATER contrast to the art of John Marin could be asked for than that that is supplied by Charles Demuth and which is exhibited now in the Intimate Gallery where Marin lately held forth. Marin grows more and more passionate, more tempestuous and nervous. The opposing currents of modern life seem to beat in upon his spirit relentlessly. He feels each jerky, jazzlike force that comes along and, to the death, must translate it into rhythms. He is another melancholy Dane who says "Oh cursed spite," but always in the end accepts

the challenge and wars it out with nature to tragic though triumphant conclusions.

Demuth, with the aid of science, doubtless wraps himself in some sort of a transparent cloak and shields himself from the contrary winds. He is like these deep sea experts who sink beneath the wave incased in glass, to come back when the supply of oxygen has been exhausted with reports of wonders. Not a ripple from the upper airs is allowed to disturb the intensity of his study. If a storm rages he will hear about it from Marin afterward. But this scientifically induced calm is by no means stagnation. There is life to be observed from the spot where he has taken up his station and, since science secures you from fogs, he gets it straight.

Physicists, consequently, will block the entrance to the Intimate Gallery, struggling to get at the color facts of the matter. Demuth is the one who hands them out. To me he is more reliable than Chevreul. But, then, Chevreul is dead and science always going marching along. Chevreul was not so much interested in those faint plum colored tones on the carrots or the carroty rust on the plums. He would have preferred those clearer tones that sometimes leap at you out of Demuth drawings like the healing rays recommended by our more expensive physicians.

I should think, indeed, these watercolors might have curative properties. You hear of stranger things. I can testify myself to having a slight relapse in health after being accidentally separated from one of my Demuths. Slight twinges of rheumatism developed, and that's a fact. One of my drawings, lent to a friend, got locked up in storage with all his things when he went to Europe, and it will be a year before he returns with the key and I can attempt to prove my theory and cure my pains with an application of pure color.

But can Demuth be modern, you ask, if Marin is? Why not? The oddest fallacy amid all those that persist is that there must be a formula for modern art. Both men connect with the times, though they connect differently. The submerged, inner life of Marin revolts at science and fights it. But the science that kills Marin keeps Demuth alive. Demuth chants the Hymn Intellectual, as Walt Whitman would say.

In addition to the watercolors that have made Demuth one of the half dozen best known artists in the land there are some oils. One of them is a vigorously drawn Calla sprouting

from a handsome sea shell. Just what it is that makes the Calla so esteemed in these days, other than the fact that it was considered vulgar a generation ago, I cannot say, but possibly that in itself is sufficient reason. The present seems determined to call the lie to everything in the past.

I have heard, though the rumor has not been affirmed, that this Bronzino-like portrait of a particularly robust Calla was intended by the artist as a tribute to the memory of a strange, erratic figure in the theatrical world who recently passed, as they say, to his reward. This is as it should be. I believe in "homages" and sometimes wonder that the artists, who are supposed to be so desperately searching for subjects, do not indulge in them oftener. Here, where the streets are not very often named after painters and sculptors, other pictures, at least, may be. Mr. Demuth, to do him justice, has painted several such tributes to contemporary artists — among them John Marin, Arthur Dove and Georgia O'Keeffe — and includes them in his present show.

The N. Y. Sun, April 10, 1926

EILSHEMIUS

"JUNE 13TH, 1826, called early on Blake. He was as wild as ever, with no great novelty. He talked, as usual, of the spirits, asserted that he had committed many murders, that reason is the only evil or sin, and that careless people are better than those who," &c. From the "Reminiscences of Henry Crabb Robinson."

It will always be a mystery to superior, intellectual people how the unclever, modest, well behaved Crabb Robinson

came to investigate and finally to appreciate the essential qual-
ity of William Blake during the lifetime of that unfortunate
artist. Perhaps like the Boswell who has recently been made
great in order to excuse the perpetual interest of his writings
he was not so unclever after all! In running after greatness, as
he avowedly did, he made too many "finds" to permit his
success to be explained away upon the score of luck. It is
doubtful if another human being since history began achieved
such a long list of famous friends as he did, and since lion
hunting as a sport is by no means obsolete it may serve a
practical end to point out that the chief secret of Crabb Robin-
son's "method" lay in the fact that, having no genius himself,
he "believed easily" in the genius of others. He was not so
much, in other words, a rejecter as an accepter.

He succeeded in the way that great business men suc-
ceed, by being continually on the try. To change the old
adage slightly, he put his eggs in many baskets and watched
all the baskets. It is something for collectors who would fore-
stall posterity to remember. To bank one's entire fortune upon
one bet is not the policy, I am told, of the best gamblers.

These curious remarks must be leading up to something,
you are thinking. You are right. They are leading up to the
announcement that there is a Louis Eilshemius exhibition
in the Valentine Dudensing Gallery at 43 East Fifty-seventh
street, and that all the Crabb Robinsons of the community
should look into the matter. It would be too annoying after
Louis Eilshemius's death to discover that we had had an ex-
cellent painter in our midst without knowing it.

The name of Louis Eilshemius cannot be unknown to
readers of THE SUN. It used to be signed quite often to letters
that appeared on the editorial page of this journal. No matter
what the topic of the day happened to be Mr. Eilshemius would
write a letter asserting that he knew all about the matter and
was, in fact, a past master at everything. Were he writing to-
day, for instance, I wouldn't put it past him to declare, like
Blake, "I have committed many murders." This sublime con-
fidence was thought by certain of our editors to be mad but
amusing, and it is true that many readers came to believe that
there must be something seriously wrong with the world when
the daily letter from Eilshemius failed to appear for some
reason. But I suppose that those editors and those readers

will now be the most surprised people in the city to learn that Eilshemius really is a master painter.

Like Blake, this artist paints and writes, but whereas Blake's soul was always visibly burning "like a white flame" through any medium he employed. Eilshemius, or so it seems to this bourgeois, only really lights up when he has a paint brush in hand. It is that faculty that makes him. I cannot say that he plunges as deeply into the mysteries of heaven and hell as does the great English seer, but his paintings "sing," and Blake, were he here, would be the first to acknowledge it, though deploring, of course, the lack of prophecy and religious teaching. Eilshemius is not in the least pious, but is gay like a pagan.

The opinion that the Eilshemius muse is an undoubted muse, though light, is founded upon a study of only two small groups of his paintings, and further exploration may develop that she has more weight than at present. During the years of his unrecognition Eilshemius painted 3,000 pictures! That is formidable! I am always uneasy when I hear of artists who spread themselves out over innumerable canvases and know of no worse charge against Renoir than the interminable catalogue of his works.

The N. Y. Sun, November 27, 1926

BRANCUSI

EVERY ONCE in a while some half educated person in government employ mistakes himself for the whole government and commits an act of great foolishness. This time it is an under-

ling in the New York bureau of the United States Customs who insists that Brancusi shall pay several hundred dollars of extra tariff upon his famous Bird in Flight on the plea that is is not a work of art. The official definition of sculpture with which this worthy fortifies his position, runs as follows:

"A work of art is not necessarily sculpture because artistic and beautiful and fashioned by a sculptor from solid marble. Sculpture as an art is that branch of the free fine arts which chisels or carves out of stone or other solid substance, for subsequent reproduction by carving or casting, imitations of natural objects, chiefly the human form, and represents such objects in their true proportions of length, breadth, and thickness, or of length and breadth only."

The wily concocters of this fiat doubtless thought they had constructed a definition that was, as we say, "fool-proof"; but, it seems, they were mistaken. No law is or can be fool-proof and the best safe-guard to justice is, as a celebrated English jurist pointed out long ago, a sense of fair play in the community. A frivolous editorial writer on The New York World, citing the session of the United States Customs Court that was held to consider "whether Christmas trees were toys, timber or fresh vegetables," opines that there is an irrepressible joker concealed somewhere in the Customs Bureau who occasionally "must have his fun." Official incompetence is, of course, highly amusing to unimplicated bystanders, but the decision that attempts to fine heavily the superb Brancusi and to rob him of his standing as an artist, is a joke that the visiting Roumanian sculpor may not see.

The affair, however, is not grave, and the intended slight, I am sure, will have been circumvented in some fashion before these lines appear in print, but in the mean time, one must register one's distaste for the episode. As for definitions they are, as I said before, futile. Definitions of life, art, poetry, style, and justice are often diverting to those who already know much about life, art, poetry, style, and justice, but they cannot guide infallibly the inexperienced. I doubt, for instance, if the ignoramus who fined Brancusi would be much helped in judging poetry by Shelley's famous description of it. "A poem is the very image of life expressed in its eternal truth. . . . Time, which destroys the beauty and the use of the story of particular facts, stripped of the poetry which should invest them, augments that of poetry, and forever develops

new and wonderful applications of the eternal truth which it contains. Hence epitomes have been called the moths of history; they eat out the poetry of it. A story of particular facts is as a mirror which obscures and distorts that which should be beautiful: poetry is a mirror which makes beautiful that which is distorted."

But in what Utopia will a custom-house official know anything of the eternal truths in which a Shelley and a Brancusi specialize?

Quite unconscious of the humiliating farce being enacted behind the scenes, the intellectual portion of the public flocked in greater numbers than ever before to the Brummer Galleries where the Brancusi carvings were exposed and where they had a real success. For my part, I felt that those who saw this sculpture only in the Brummer Galleries saw but the half of which these subtle and sensitive works of art were capable. They need the co-operation of the changing outdoor lights; or, indoors, some friendly shadows to which they may be tied. This is illustrated well enough in the truly excellent photographs with which the "Brancusi" number of The Little Review was illustrated. The exuberant Mr. Ezra Pound, who shares my aversion to definitions, said in that issue, that "it is impossible to give an exact sculptural idea in either words or photography," and while he is quite right, the photographs by which his text is surrounded go as far as photographs can to defeat the argument. They at least definitely show what the right surroundings can do for a Brancusi. Who wielded the camera is not stated, but the various versions of Mlle Pogany are entirely worthy of Mr. Man Ray. In the pitiless light of the Brummer Gallery the Portrait of Mlle Buonaparte swam for the first time into the ken of certain Philistines and got much whispered about. I met no artists but those who took it for what it is — a work of art — but the misunderstanding in regard to it doubtless was at the base of the confusion in regard to Brancusi in the Customs House.

The Dial, February 1927

THE PIONEER WOMAN

MRS. SHAMEFOOT "used always to say it would be at Versailles, or Vallombrosa, or Verona, or Venice. Somewhere with a V." I think if that highly modern but fragile lady were still extant she might now agree that it could begin with a P. At least Ponca City in Oklahoma has become the captivating though not quite realizable (perhaps it's for that very reason) city of my dreams. It used to be Samarkand, which was followed by a nostalgic interest in the eighteen-century cure at Lucca, and I even succumbed to a pre-Gauguin feeling for the Marquesas Islands (due to Melville's Typee) which dwindled, however, almost to the vanishing point before Gauguin arrived to give it the coup de grâce. As a rule it is wiser to restrict one's commerce with such places to the dream-world. To touch them is fatal. I made that mistake with New Orleans, the only city in the United States that had, in the generation just past, an appeal. I adored it a dozen or so years ago, worshipped at all the shrines, and came home to read in the newspapers of the destruction of the old Hotel St. Louis, the most romantic and satisfactory building on the continent, and the burning of the heavenly opera house. New Orleans immediately receded farther into the distance even than Tahiti. So, considering everything, I don't think I shall go to Ponca City, Oklahoma.

I had never heard of the place until the night of the Marland banquet in the Hotel Plaza to the competing sculptors. Mr. Marland had come on from the West with certain friends and business associates to view the submitted sketches for the monument that is to glorify the hitherto unhonoured Pioneer Woman of the Plains, and a little conviviality was considered necessary to put us and him in the mood. It was the lady who sat next to me at this dinner (pearls, white satin, and a calmly youthful face that in itself I thought distinguished — so rarely is calmness associated with youth nowadays in the eastern part of the country) who mentioned Ponca City. She came from there, she explained. "From where?" I

enquired, thoroughly mystified. "Why, from Ponca City," she repeated, "the place where this statue is to be put up. I should think you would know where Ponca City is," and she eyed me doubtfully, as though suspecting a joke that through repetition had grown tiresome. Disavowing any intention of being funny and deploring my ignorance, I was able, after a while, to elicit the picture of Ponca City that still fascinates me.

It centres, it seems, about this Mr. Marland who made all the money for himself and the others so quickly, and who gives the statue. He it was, so my neighbour with the pearls informed me, who first of the new community became interested in art. "Indeed, he keeps us all stirred up," she continued. "He is interested in many things and likes us to share in his enthusiasms. For instance, he loves hunting, keeps a great stable, and on the day of the hunt any one at all decent in the town can go to his place and have a mount free. His home is a fine villa in the Spanish style. He entertains a great deal. We all came east in his private car — it is most comfortable. He took Mr. Davidson, who came to Ponca City to do portrait busts of Mr. Marland's family, out to the coast in this car upon a little excursion. Then there is the golf-course which is certainly handsome, and due, I believe, to his initiative. And, oh, so many things. He doesn't seem to think of himself but of the general life in Ponca City. You know this Pioneer Woman is but the beginning. He has other ideas for the advancement of the community. . . ." But she had said enough to make me think that pioneering must be, upon my word, vastly different now from what it was in the old days, and, take it all in all, a mighty attractive life for those who have the vocation. It was with the arrival of this thought that it occurred to me that there was, after all, no longer a necessity for me to go to Avilà, Spain, to spend my declining years, a plan that I had hitherto held to; Ponca City would do as well. Not that I altogether fancied dwelling in the shadow of a fifty-foot bronze Pioneer Woman by, possibly J. Bryant Baker, but I could have, I hoped, a little bungalow facing in another direction, with an outlook upon the inspiring activities of the place, and possible glimpses of all the sculptors going to and coming from the Spanish villa, and all that sort of thing. . . . Mr. Marland who just then arose to do a tiny after-dinner speech, looked the part that had just been given to him — an essentially modest man, markedly idealistic, and

one to whom the possession of millions would be but the starting point. What I marvelled most at was the lack in his features of any trace of strain or hardness. There was nothing in him of Rockefeller asceticism or of Ford sternness. I had always thought that the quick accession to riches could only be managed at the expense of soul — an idea probably acquired from a reading of the novels by Sinclair Lewis and Booth Tarkington — but studying Mr. Marland and his associates, all of them young and uncrushed, I saw that I and the novelists would have to readjust our conceptions of American millionaires. Apparently a new type has arrived, a type we artists can have something to do with.

And apparently there is in this first arrival the makings of a most amenable art patron. It was reported, for instance, that after his inspection of the twelve sketches by the twelve sculptors, he expressed satisfaction in all of them and said that he would be content with any one. That is decidedly the proper spirit. A scheme of popular voting for the best of these models has been inaugurated and it has already had lovely results in publicity and will doubtless eclipse anything in that line that we have experienced. Which is all to the good! The public actually seems willing to think over the problem as to which is the best of these twelve sketches. It is a little exercise in connoisseurship that we ought to follow up quickly, if we are to have educational profit, with another pleasing problem of the same sort and only a shade more difficult. And by and by we might have an art public. But that is looking far ahead. Just at present, I believe, nobody in his senses, would agree to letting the public have its way, even with this Marland Pioneer Woman. The public would inevitably choose the least of the twelve. Out of the million but very few, obviously, would recognize the best bid for the permanently bearable. Mr. Marland has wisely decided to cast the deciding vote himself.

Not but that he'll have his difficulties. There is no easy way out in these matters. Already what is called "human nature" has manifested itself in this competition. The twelve little sculptors, it appears, are not just so many little lambs. Already Arthur Lee, one of the little sculptors, has misbehaved himself in the actual presence of Mr. Marland. Something, I believe, about Maurice Sterne's innocent error in making his sketch four feet high instead of the three feet to which the others adhered. The cry arose that the larger model gave

Mr. Sterne an unfair advantage. And then there was the epi-
sode of Paul Manship. Mr. Manship, upon hearing that Jo
Davidson was already on the spot in Oklahoma doing por-
traits busts of members of the Marland family, refused to have
anything to do with the affair. "Call that a competition!" said
he, with withering sarcasm. . . . But such things are trifles and
every great art patron must realize sooner or later, and prefer-
ably sooner, that artists are after all human; and subject to
all the wayward impulses the mind is heir to. The Great
Michael Angelo himself had more than one sharp encounter
with his pope and Benvenuto Cellini said things to his duke
that he afterwards apologized for. The little fable about the
puppies by Epictetus — "See how they love each other, but
throw a bone among 'em" — is thought by some to be malicious
but it is not; it is merely practical. Throw a commission for a
five-hundred-thousand-dollar bronze statue among a group of
sculptors and you may expect politics. That this should be so,
will not I hope disillusion Mr. Marland. In fact the difficulties
in doing good are part of the attractiveness of doing good.

The Dial, May 1927

LACHAISE

ALTHOUGH Gaston Lachaise has been widely recognized as a
sculptor of importance these ten years past it is still the
"might have been" aspect of his career that fastens the atten-
tion. Those who first made acquaintance with his talent in the
Bourgeois Galleries in 1918 saw possibilities in the public use
of it that are not yet realized. They already saw, those early
connoisseurs, that the "public use," depending as it usually

does upon committees, would be difficult, but they little sus-
pected how difficult it was to be. Lachaise's art is not the
kind that pleases committees. There is nothing pretty about
it, nothing light nor reminiscent of the fashions of recent
years. On the contrary it makes an unusual demand upon the
spectator. Lachaise's sculpture, as much as the painting of
Braque, requires the party of the second part to have a sensi-
tive feeling for beauty in the abstract. At least I think it is
abstract beauty that makes the appeal when the student is
swayed by an ideal astonishingly different from his own.
Lachaise's own feeling in the matter is far from being ab-
stract, it's concrete enough. His ideal female of the species,
to come to the point at once, is fat. He is so innocent about it,
however, so intense and certain of his conviction, that I sup-
pose it must surprise him fully as much to see the models of
the day, dictated by the rue de la Paix, as it surprises commit-
tees to see what he puts forth himself. The actual creative
feeling back of his art can be explained interestingly enough,
I suppose, by Freud, but not Freud nor any other scientist can
explain away the right of an artist to express beauty upon his
own terms, nor minimize the positive achievements of La-
chaise in that line. The two big Venuses that I saw in 1918
and 1920, and which have never yet been put into stone or
bronze, seemed fat only in the first minute or two of inspec-
tion. After that they became, and have remained, immensely
satisfactory works of art, alive and beautiful. In fact I say
"fat" only because that is the word opposing critics have used.
I feel sure that if actual measurements were taken they would
not be found to be revoltingly larger than most of the Venuses
that have won the world's renown – including that one from
Milo. That one from Milo, I believe I have already said else-
where, would not herself stand much chance with the officials
of to-day, being more, I am persuaded, a product of the fields
than of the town, and committees are exclusively town. It is
not anyway so much a question of bulk, with Lachaise, as a
certain largeness in scale. There was something in those two
Venuses that started most of Lachaise's friends to imagining
the new Statues to Liberty that he would be doing, the statues
in scale to the new architecture. Here, at last, they all thought,
is the man for the New York job – but the nearest he ever
came to it was the design for the allegorical figure in the new
Telephone Building, a design afterward rejected, it was said,

because it was thought the public would fear "that" was the reason for the increase in the cost of telephone calls. A hideous charge against New Yorkers, if true. But of course it is not true – merely bad psychology – for even the dullest New Yorkers know that one statue in a vestibule would not appreciably affect telephone charges. But the failure of the telephone people to see the chance to do a really gracious act for their subscribers was only a minor tragedy compared with the packing away into store-houses of the two plaster Venuses and the halting of Lachaise in the production of things on the grand scale. That is the real accusation against the times we live in and against the state of art-patronage in America in particular. There is no rich person, apparently, with sufficient feeling for serious art to wish to do something handsome for the age in the way of monumental sculpture. There is no public place in New York that the people themselves yearn to see decorated. What is the use in attempting an ornament for a "place" or a public square that is always in process of change? Were there one spot in the Metropolis that positively called for sculpture, one of the usual "publicity campaigns" might be undertaken for Lachaise and "the people," always docile in the long run, might be induced to subscribe the necessary funds. But since there is no such spot the only alternative is to wait as patiently as possible for the miracle that is to produce it – city control of architecture must arrive sometime – and to keep Lachaise groomed against the day.

But I prolong the lugubrious note unduly. The grooming process has in itself produced a series of noble portraits, an imposing piece of garden sculpture, and a host of small bronzes, and when these things were recently shown in the Intimate Gallery, none marvelled at them more greatly than Lachaise's fellow sculptors. The voice of criticism was not raised at all. There was nothing but praise; and gratification for the way in which the sculptures explained each other. There had been some astonishment expressed at the first portraits, shown singly, for in them, as in everything else, Lachaise had shown a largeness of spirit that suggested he had been thinking inwardly of niches in the Escorial or some other such vast edifice, and that again patrons would have to do some tearing down and re-building – as for the two regretted Venuses – before the busts could be employed. But

owing merely to a little matter of sympathy in the arrange-
ment, the Intimate Gallery was able to dissipate this fear, and
to relate all the busts and ornamental pieces so perfectly that
all thought of sizes vanished. If miracles have been slow in
coming to Lachaise, this at least was one, for the Intimate
Gallery is as tiny as its title implies, and an acceptable instal-
lation of Lachaise's wilful carvings had not been anticipated.
It may augur that at length the season for miracles has been
ushered in.

The Dial, June 1927

COVARRUBIAS IN HARLEM

CARICATURE MUST depend upon an inner urge! It is rewarded
hugely and, generally, at once. In the long list of art's mar-
tyrs there are few caricaturists. Yet comparatively few, in
America at least, take it up for what there is in it. This is,
perhaps, lucky for us. We are spared the vast army of pre-
tenders that choke the vestibules of the galleries where the
more orthodox, more dignified forms of expression prevail.
The men of genius in caricature stand out clearly, and it is
usual that the idle public that merely loves to laugh unex-
pectedly finds itself in agreement with the severest critics.

Miguel Covarrubias is one of the gifted caricaturists who
pleases all the governors in a world that is now thought to be
even madder than it was in Shakespeare's time. He came up
from Mexico an untaught boy, so Frank Crowinshield says,
but the first drawings he showed to us convinced everybody
that he was a real genius. There was no fumbling around
either for the idea or for the method, but an adult assurance
that was as startling as it was pleasing.

He contented himself at first with the newspaper celebrities of the day, and one by one he "showed them up" in his drawings in a manner wonderful to behold and yet in a manner that left no trail of rancor. His "victims" were just as pleased and flattered as the victim's friends were amused. This, of course, is the genuine test for caricature, as Baudelaire long ago pointed out. It doesn't get very far unless founded upon sympathy. "If you say that, smile." The smile, according to the famous Western code, offsets everything, and implies a complimentary opposite.

By the time Covarrubias had reached Carl Van Vechten in his list of celebrities he had also, and naturally, made acquaintance with the elite of the colored population in the northern part of town. In Harlem he found a society perfectly suited to his pencil. He at once proceeded to make a marvelous series of drawings. He has missed nothing, apparently, in the well-known list of types. He gives you the "Jazz Baby," the negro "Preacher," the chocolate-hued "Sheik," the heavily jowled negro financier, the impassioned "Blues Singer." Even the now classic "Cakewalk" inspires him to a masterpiece.

All these extraordinary people and their equally extraordinary activities have been recorded very exactly in the art of Covarrubias, and the book of these drawings, recently issued by the house of Knopf, proves convincingly enough that in the young Mexican we have a caricaturist comparable in talent to the Frenchman Caran d'Ache. In the course of time he may go beyond Caran d'Ache, but to reach that degree of skill is in itself already astonishing. He is in the first, youthful, rapturous stage of recognizing lovely and too unbelievably amusing things in life. When he gets a little deeper into the puzzling maze of human existence and gets constructive impulses he may become a Daumier. He certainly has skill enough to be anything.

How he came to be such a phenomenon has not as yet been explained, and may never be. Mr. Crowinshield probably hits it off as well as it can be hit off when he asserts that the young man "mastered his metier solely by virtue of close observation and hard work." If it be true that he is self-taught, then the artist's instincts for form must be sound. In all the playfulness of exaggeration in the negraic heads there is always the suggestion of underlying knowledge of the true formation of the skull. The massive teeth close upon each other

with the precision of expensive machinery, and the lips that fold them in, especially when seen in profile, are inexorably right in drawing.

The N. Y. Sun, December 24, 1927

THE BRANCUSI CASE

SEATED ON the benches in the court-room awaiting our turns to testify in the Brancusi case, I noticed an unusual ring upon Jacob Epstein's finger. The reporters in attendance appeared deeply impressed by Mr. Epstein's sartorial splendour and did full justice to it in their accounts in the daily press, but I don't think any of them noticed the ring. "What is it?" I enquired. "A ruby," he replied. "An Indian prince gave it me." It was, in effect, sufficiently Indian. The large ruby had been embedded heavily into the gold which had been carved into the semblance of a snake.

I had forgotten it temporarily but it came to mind when I had progressed but a little into the New York exhibition of Mr. Epstein's bronzes, at Ferargil's. The bronzes were so excessively Indian, so forcefully Indian! — so very different, indeed, from the sort of thing encountered in Dr. Katherine Mayo's new and sensational book, Mother India. The Indian Madonna and Child, in particular, were so aggressive that they might be supposed to have emanated in direct reply to Dr. Mayo's awful accusation. No wonder the Indian prince gave Jacob Epstein that ring. He should have given him a lac of rupees, as well, and a white elephant, and a half-dozen nautch-girls, and — but I am forgetting again; those bronzes were achieved long before Dr. Mayo thought of her book. The

Indian prince after all could only have been a disinterested art lover. Or do you suppose he could have foreseen Dr. Katherine Mayo and the havoc she was to make of American sympathy with the Far East, and was preparing against the day?

In truth, I have a wretched memory, and another thing I completely forget, though I should know it, for I must have been told, is how Jacob Epstein became so Indian. The psychologists say that this sort of forgetting is due to indifference, which is something I'm sorry for, if true; and anyway, if I should be proved guilty of indifference to the Indianization, as such, of Jacob Epstein, I certainly am not indifferent to the process of his becoming so. Processes are always interesting. Why, I wonder, did he take it on? When he might just as well, like Ralph Rackstraw in Pinafore, have remained an Eng-lish-mun!

Mr. Epstein made an awfully good witness for Brancusi. He has immense social skill, and with distinct leanings toward the histrionic. He will be a great success in America, just as he has been in England. Jacob Epstein couldn't fail anywhere. His charm of manner was just as certain in the spacious court-room as when produced for short-range effects across a dinner-table. He was grandly patronizing to the presiding judge and to the opposition lawyer, speaking to them from a height — as though to little children — and, with the greatest virtuosity, screening his amusement from them though getting it to us on the back seats perfectly. Just the same, and this will illustrate to him what he is up against in his return to America after twenty-five years of burial in England, neither this judge nor that lawyer ever seemed to have heard of Mr. Epstein before! It is always the legal game, I suppose, to discredit expert testimony, and all of Brancusi's well-wishers and witnesses were forced to reply to dull enquiries into their right to speak authoritatively upon questions of art. "Well, did you study anywhere?" asked the lawyer sceptically, when Jacob Epstein avowed himself to be a sculptor. "Yes, at the Art Students' League in New York, four years at Julien's, in Paris; and also at Carlorossi's, in Paris." "Well, have you anything to show for it?" "What do you mean?" "Any paper? Wouldn't they give you a diploma?" "Art schools are not like colleges . . ." began Mr. Epstein incredulously, as though scarcely trusting his ears. "Did you or did you not secure a diploma? Yes or No?" thundered the attorney hammering his

desk, in the approved lawyer manner. "I never heard of such a thing," said the sculptor, still smiling broadly. "Answer the question," said the judge, wearily. "No," replied Epstein meekly; and the opposing lawyer glared triumphantly around the room as though requesting the reporters to note especially that point.

But in the end, the bored judge, who looked as though he had never in his life had a job less to his taste than this task of deciding whether or no the Bird of Brancusi was a work of art or a dutiable object of utility, appeared to be impressed, in spite of himself, by Mr. Epstein's enthusiasm for it; and gave out the official pronouncement that the title of a work of art did not necessarily describe it and consequently that, though the object in dispute did not represent a bird literally it could very well embody certain impressions in the artist's mind that had been aroused by the flight of a bird. He immediately quelled, though, the mounting rapture on the back benches, by murmuring to himself, sotto voce, that personally he thought all this sort of thing nonsense, and had he to choose himself, between Michael Angelo and Brancusi, he would choose Michael Angelo every time. Those were not his exact words, of course, but approximately the burden of his refrain. In spite of this chilling lack of modernism, the little Brancusi coterie thought him a most excellent judge – far better than they had dared to hope for – and that in deciding the Bird not to be an object of utility, he had decided everything as far as the courts of law were concerned. . . . The amusing farce cannot end just yet, however. A legally necessary deposition from the author of the Bird – Brancusi is in Paris – delays the final verdict another six weeks. It cannot affect critical opinion whichever way it goes.

In the meantime the Epstein exhibition is attended by crowds of people who are vaguely but visibly impressed. No instances of outraged opinion have as yet been recorded. A foreign-looking Madonna astonishes nobody. In fact the idea long since became general that She was not American. So that is that. The other sculptors all admit him to be a sculptor. So do I – in spite of his lack of a diploma. He is not as deep as Michael Angelo, it is true, nor so suggestive as Brancusi, but he knows how to do what he sets out to do. There is a touch of sameness in the work that invites the suspicion that Mr. Epstein confines himself *to* the things he knows how to do.

He doesn't clutch at the stars like Blake. He never fails gloriously but succeeds methodically. Such extraordinary ease in execution is in fact rather tiresome. The immense collection of bronzes he displays gives a suggestion of rankness as though it had grown up over night in some most tropical forest. But the American public unquestionably likes free-flowering geniuses. Sert, for instance. They like him.

<div align="right">The Dial, January 1928</div>

O'KEEFFE'S RECENT WORK

THE ANNUAL exhibition of the work of Georgia O'Keeffe is now open to the public in the Intimate Gallery. An annual exhibition is a severe test upon any artist's powers, and, as a rule, is not to be recommended, for it implies that something new in the artist's experience has been recorded, and it is not ever year that presents such new experiences.

Miss O'Keeffe, however, is better suited, temperamentally, to this open progress toward fame than certain others who might be mentioned. She seems to be unflustered by talk, to be unaware of much of the talk, and to pursue her way in calmness toward the ideal she clearly indicated for herself at the beginning of her career.

She comes nearer to it this year than ever before. She is an imaginative painter, not so much interested in facts as in the extraordinary relationships that may be established between facts. She is in love with long lines, with simple, smooth surfaces that change so slowly in tone that it sometimes appears as though a whole earth would be required to make them go all the way round; and she yearns so for purity of color that the

impure pigments supplied by the shops must often appal her and it would not surprise her annual critics too much to find, a few years hence, that she was carrying out her designs in colored glass rather than in paint.

There are two or three themes that haunt Miss O'Keeffe in the same way that Mlle. Pogany haunts Brancusi. One is the "Red Hill with the Sun." She got the theme in Texas, where she was born, or lived, or went once, I forget which. But the plain with the glaring sun impressed her psychologically, and until she gives out all that she got from it, she will go right on painting that terrific theme. This year's version does, however, seem complete to at least one outsider. The blazing sun on the red, red hills is as good as it can possibly be. It probably, in consequence, is the last of that series.

Another theme is the Shelton Hotel. Miss O'Keeffe lives there – by choice. It has long lines, long surfaces – it has everything. At night it looks as though it reached to the stars, and the searchlights that cut across the sky back of it do appear to carry messages to other worlds. Miss O'Keeffe has painted several versions of the Shelton and has been praised for them, but her increased plasticity, increased mysticity and increased certainty in intention have enabled her this time to achieve one of the best skyscraper pictures that I have seen anywhere. It combines fact and fancy admirably and ought to be easily accepted even by those who still stumbled over Miss O'Keeffe's petunia pictures.

Petunias are a third absorption of Miss O'Keeffe's. Or rather there is a group of flowers on which she dwells lingeringly. They can be taken just as decoration or as essays in pure color. There is the "Dark Iris, No. 1," which began as a simple study of an innocent flower, but which now presents abysses of blackness into which the timid scarcely dare peer. Or there is the "White Rose – Abstraction," in which there are rows upon rows of filmy transparencies, like one of Pavlova's best ballet skirts. These and similar paintings, content those who respond to the painter's touch and to her clarity of color – and mean just what the spectator is able to get from them and nothing more. To overload them with Freudian implications is not particularly necessary.

The New York Sun, January 14, 1928

DE CHIRICO

AND NOW it is De Chirico that is brought forward by that temple of modernism, the Valentine Gallery. De Chirico is not an unknown name. Samples of the work have been seen here from time to time. It always commanded a certain interest. But when the phrase "brought forward" was used it was used intentionally. De Chirico is distinctly brought forward by the present exhibition in the Valentine Gallery. It is something to be seen.

It is something to be seen and something to be remembered. De Chirico's earliest examples were slightly dry. They had wit and a curiously self-conscious and wholly modern way of looking at the heritage of art from the past that still encumbers the shelves of the picture dealers. He might or might not become a leader among artists, so it was felt some years ago, but at any rate was certain to have a definite place in the affections of those who must be modern at all costs.

Well, he now emerges as a leader among the new people. He escapes from the clutches of the "advance guard" and becomes the property of collectors. This is because he has become a vastly improved painter. He preserves his wit, even adds to it, and achieves a largeness of style and a certainty in painting that are highly gratifying to behold. At this distance from Paris, where we take French pictures on their "absolute" qualities, and without study of the various causes that contribute to their invention, it is impossible to decide immediately upon the origin of certain tricks of expression, but these "origins" are always discovered, sooner or later, and credit duely given for them.

So it is not quite possible to decide at present whether De Chirico, in his pseudo-Greek passages, has been helping himself to a little of Picasso, or "vice versa," as Fluther Good says in that marvelous play, "The Plough and the Stars." Some say the one thing, others say the contrary. It doesn't seem to matter much, whichever way it is, since all that De Chirico now has seems so indubitably his own.

It is an essential part of that wit that was his from the beginning that he should be pseudo-Greek. And there never was a pseudo-Greek that was quite so pseudo as his. The "Annunciation," for instance, which is expressed by a composition of two obviously antique carvings, might be thought impious were the times not so ribald. Voltaire had to fly from France and hide in foreign parts until the noise from utterances much less "free" than this had subsided. Now it will be merely considered a wonderfully fine bit of painting.

Shocked pietists who take their precepts literally may be consoled by the reflection that many other human aspirations are mocked by this De Chirico. Poets and scientists, especially scientists, come in for considerable bludgeoning at his hands.

There is a strange jumble in his work of past and present. All the prized emblems of our civilization, such as the cannon which thunder out our beliefs to the world and the railways that pander to our thirst for speed, are posed against relics from the ancients that suggest immemorial time. You may read them as you like. In "La Conquête du Philosophe," which contains railway trains, clocks, factory towers, cannon and two enormous artichokes in the foreground, it may be time that confounds the philosopher or it may be the pleasures of the table, as indicated by the artichokes. Most likely it is the latter.

In "Les Plaisirs du Poète" a tiny little poet is seen sauntering out into a formidably empty and repelling square before a railway station and at first you think, "What chance has a poet in a place like that, or, indeed, what chance has he anywhere in modern life?" but as you look longer you see that the clear sky is unfathomable and that the vast, lonely spaces of the picture are of the kind that do truly trouble poets, and in fact that the whole argument of the picture is that your genuine poet squeezes poetry from the most unlikely themes, and, furthermore, that poetry is unquenchable and must always persist as long as there are human beings to "yearn," as Bunthorne put it, for the unattainable.

The New York Sun, January 28, 1928

A KUNIYOSHI RETROSPECTIVE

THE DANIEL Gallery has opened a retrospective exhibition of Yasuo Kuniyoshi's work. This artist is one of the most outstanding of the younger group of Americans and the one who, because of a certain strangeness in the style, would be most likely to attract critical attention in Europe, but who – and just because of this strangeness – gets less backing from American collectors than he deserves. A sequence of paintings illustrating all parts of Kuniyoshi's comparatively short career is, therefore, something to be looked into.

It happens to Kuniyoshi, as it happens to many other modern artists, that the very traits that are acclaimed by his friends are the ones that set him back with timid connoisseurs. He is original, and probably unconsciously so. Originality is an excellent quality in an artist, in fact, a necessary one if he is to achieve great fame, but the great fame has to be paid for by a struggle. The public yields unwillingly and sometimes slowly to the painter who appears to defy the rules.

Kuniyoshi's originality is, in my opinion, unpremeditated and native to him. He was born as his name implies, in Japan, but was brought here at such an early age that all his education, including his artistic schooling, was obtained here. But all the Americanisms that have been imposed upon him fail to stop the flow in him, once he starts to paint a picture, of influences that can only be explained upon the score that they are pre-natal. His art is curiously atavistic. On the surface, it is taken straight from Kuniyoshi's experience as boy and man in America, but in the background of each picture, is something that is not only Japanese, but Japanese of the middle-ages.

Also his art is often light enough on the surface, but underneath it is always profound and serious. The Orient may have its triflers, but most of the great paintings we get from there awaken moods of solemnity in the beholder. The Chinese and Japanese connoisseurs frequently laugh when examining their own masterpieces, but it is at the ingenious and un-

expected way in which the artist has introduced a flower or an animal into the composition, which itself is usually concerned, and in the loftiest way, with man's relationship to nature.

Kuniyoshi disturbs conventional art lovers in two ways; first, by the liberties he takes with the proportions of the human figure, and second, by a reversal of the usual color values. Kuniyoshi is quite capable of indicating the color of a flower by a rich black, but in a way that is quite inimitable and which would make serious Chinese art patrons laugh with pleasure. He manages to make it stand out from the background and to have an unmistakable feeling of air in the picture. Stodgy people who are fixed in their notions take one look at a Kuniyoshi flower and fly the room, outraged to their souls; but if they could only outstay their first consternation they would soon see that Kuniyoshi is not taking away anything from art but adding to it, and that all his work is full of vivacity and life.

The matter of the proportions can be illustrated by the well-known "Boy Stealing Fruit," which has been lent to this show by Ferdinand Howald. Every one who looks at infants sympathetically must often have been struck, even in the case of the healthiest of them, with the preponderantly large heads and tiny hands. On first acquaintance with the naughty little boy who is stealing fruit in this picture, the largeness of his head does seem excessively insisted upon, but the furtiveness of the gesture is so natural and the design of the painting is of such masterly sureness that in the end what was at first questionable acquires the added charm of quaintness.

The recent paintings by Kuniyoshi can easily be picked out in this exhibition by those who have already studied his work. They all have an added richness of painting and profit by an extension to the artist's palette. A study of an interior with a window looking out upon the sea can be placed unhesitatingly among Kuniyoshi's best things. There is also in the second gallery a group of Kuniyoshi lithographs not previously shown, and these have all the decorative qualities and all the skill in handling blacks that will be expected.

The New York Sun, February 11, 1928

McBRIDE'S PORTRAIT BY LACHAISE

THAT I AM not myself a person to flinch at the word "vain-glory" is proved sufficiently by the fact that I did pose for a portrait by Gaston Lachaise, the sculptor. When Lachaise first suggested the idea I said what I honestly thought, that it couldn't be done, that I was not a type for artists, that never in my life had a painter wished to do me, and that I was enough of an artist myself to see precisely why they didn't. I was wrong, Lachaise insisted, looking at me with that curiously appraising glance that is so disconcerting to some people, "there was something," he had felt it for some time, he knew definitely what he wished to do, et cetera, and in short – to boil the argument of half an hour into one sentence – I finally consented. This was last spring, at the close of the season, when all New Yorkers and especially the critics who had been compelled to study thirty to forty thousand pictures during the winter, were at the lowest ebb of vitality. If posterity were to peep at one, one might have preferred another moment. One might have been more there in the autumn, for instance. "But after all," I reflected, mounting waves of satisfaction completely engulfing me, "the affair is Lachaise's, not mine. Why should a mere sitter choose the moment, or choose the pose, or choose anything," and I remembered the famous nonchalance of Walt Whitman when getting photographed, and his explanation that he never "dressed up" for portraits and that their invariable success was due to his refusal to be fussed by a camera; and I resolved to keep calm.

So the posing began. It was very pleasant. There was something peculiarly soothing in the thought that Lachaise had it to do and not I. Lachaise "had been studying me for some time." He had "an idea of me." Gained from my writings, no doubt, for, after all, we had never had many talks! The green wax that sculptors use nowadays took form rapidly. Somewhat to my surprise it took on heroic proportions. So that was what Lachaise thought of me! Well, it's gratifying, say what you like, to have someone look on your bright side. By

two or three sittings there was a definite character indicated. Oh, very heroic. But very heroic. Mussolini! Yes! Even more so. I had moments of compunction, feeling perhaps I was taking an unfair advantage of the sculptor. I thought of confessing that I was not, habitually, a Mussolini. Then I remembered Walt Whitman and decided to keep mum. Even so, I felt I ought to die at once before the truth came out. Besides, I argued, I *am* a hero — at times. I am one of those persons who when alone in their sanctums are unafraid of the truth. In public it may be a different matter. Face to face with one of those artists who have the bad taste to haunt their own one-man exhibitions, I have been known to reply to his enquiry with a "Yes, very interesting indeed," and then rush right home and scribble a review beginning with "These are positively the world's worst pictures."

But I did not die at once. Heroism for heroism I had not quite enough for that. The sittings went on. On certain days the green wax appeared to remain stationary. At other times the sculptor flung himself furiously at the work just as sculptors do in novels and in the autobiography of Benvenuto which is practically a novel. After one of these paroxysms, rather more prolonged than usual, Lachaise, in a small voice and almost apologetically, said, "Well, it is finished. I won't do any more," and I took a look. Mussolini had vanished almost completely! There was still a faint trace of him. But the subconscious part of Lachaise, the part that does the work, evidently thought I was but a modified form of hero. Well, I hastily decided, it was perhaps just as well. It would be fatiguing, at my time of life, to try to outshine Mussolini. Also, there were compensations. I was more refined than he. Refined and at the same time chastened. The refinement was due, no doubt, to suffering. I was glad to see that I had got something, after all, from what I had gone through. That person in the green wax might weep but he would march straight through to Calvary, nevertheless. Not totally unlike the famous Judd so recently and rightly electrocuted by the State authorities at Sing Sing. But refined! That was the main thing. On the whole I thought I came out of it very well. I was quite content with my experience as a poseur. I will recommend the idea, henceforth, with more courage to others.

The Dial, March 1928

MIRÓ

THERE ARE certain art lovers who suffer, rather than en-
courage, art to progress, and one of these who has at last,
though somewhat painfully, adjusted himself to present-day
manifestations, permitted himself to say the other day that
now that he understood it modern art was not so bad, but he
was glad just the same that the worst was over and that art
connoisseurs had reached a period of comparative calm.

It depends upon what you mean by "worst." I took it that
what my friend really meant by the word was "difficult." In
that sense, we are by no means over the worst. There is never
any rest for the dilettante. There are always new phases pop-
ping up, and the new phases are always difficult.

Take the art of Joan Miró, for instance. It is something to
be considered just because so much consideration has already
been given to it in France. He is probably the most outstand-
ing of the present group of rebels in Paris. The young people
praise him extravagantly, and the old people, who have already
stood an awful lot from the young people, positively refuse to
go to Pierre's, where the Mirós are to be seen, at all. There, of
course, they are wrong. Everything should be given a chance.

Miró is a Surrealist. That is to say, he disdains realism.
He has certainly written over the door of his studio the word
"Whim"; which, you recollect, is the word that Emerson wished
to write over the door of his library. He gives full sway to his
pencil and carte blanche to his soul. He must sometimes,
when he has recovered from the trances in which he paints, be
vastly surprised himself at what he has achieved. The paint
pots which Whistler emptied into the faces of his public are
simply nothing to the splashing effects of which Miró is
capable.

Sometimes there is the splash and not much besides. The
terrific gesture alone contents Miró's young friends. The great
world, however insists upon more than gesture. It demands
the goods. These, it begins to be apparent, it has discovered in
two or three enormous paintings by the young artist, which are

still enchained in Paris. These contain the splashes, if you will, but also an undeniable mystic quality. One of them that attracted much attention was called "The Dog Barking at the Moon." The moon was not precisely the literal moon and the dog was far from being a literal dog, but the two together exerted a powerful effect comparable to that that would envelop scientists who had just received an authentic message from Mars.

Any work from such an innovator would, in consequence, be worthy of study, but "The Signature" by Miró, which is now being shown by the Gallery of Living Art, at the New York University Building on Washington Square, happens to be the most significant of his paintings, after the "Dog Barking at the Moon" and the "Spanish Landscape."

It is really difficult. It will be mentally accessible, I fear, only to those who lean readily toward the mystical. It is cabalistic. It looks, at first glance, like the writings upon a cobalt canvas of a particularly lazy Indian. But the laziest Indian never paints a picture without putting himself in communion with the unseen powers, and so it is with Miró. There is more to be discerned in his work upon acquaintance; and it is fortunate to be able to make this acquaintance in the first flush of the artist's contact with the world.

The New York Sun, December 8, 1928

PETER ARNO

THE INEVITABLE has happened. Peter Arno has been discovered by the high brows. There is an exhibition of his original drawings in a bona-fide, Fifty-seventh street gallery — the

SOME OF HENRY MCBRIDE'S FAVORITES

1 Marcel Duchamp: Nude Descending a Staircase, oil, 1912
 Courtesy: Philadelphia Museum of Art, Arensberg Collection

2 Florine Stettheimer: Cathedrals of Fifth Avenue, oil, ca. 1921
 Courtesy: Whitney Museum of American Art, New York

3 George Bellows: Gramercy Park, oil
 Courtesy: Mrs. Leonard Franklin McCollum

4 George Bellows: Stag at Sharkey's, oil, 1916
 *Courtesy: Philadelphia Museum of Art, Gift of Mr. and Mrs.
 George Sharp Munson*

5 Charles Demuth: Nana Seated Left, and Satin at Laura's
 Restaurant, watercolor, 1916
 Courtesy: Museum of Modern Art, New York

6 Charles Demuth: Modern Conveniences, watercolor
 Courtesy: Museum of Modern Art, New York

7 Gaston Lachaise: John Marin, plaster
 Existence and ownership in question

8 Gaston Lachaise: Nude, pencil drawing
 Courtesy: Whitney Museum of American Art, New York

9 Gaston Lachaise: Nude, pencil drawing
 Courtesy: The Lachaise Foundation, Boston

10 Louis Eilshemius: War, oil
 Present ownership unknown

11 Charles Burchfield: Ice Glare, watercolor, 1933
 Courtesy: Whitney Museum of American Art, New York

12 Albert Pinkham Ryder: Jonah, oil, ca. 1885
 *Courtesy: National Collection of Fine Arts, Smithsonian
 Institution, Washington, D.C.*

13 Albert Pinkham Ryder: Siegfried and the Rhine Maidens, oil, 1888–91
 Courtesy: National Gallery, Washington, D.C.

14 Thomas Eakins: The Pathetic Song, oil, 1881
 Courtesy: The Corcoran Gallery, Washington, D.C.

15 Thomas Eakins: Mrs. William D. Frischmuth, oil, 1900
 Courtesy: Philadelphia Museum of Art

16 John Marin: Mid-Manhattan I, oil, 1932
 Courtesy: Museum of Modern Art, New York

17 Georgia O'Keefe: Cross by the Sea, watercolor, 1932
 Courtesy: Currier Gallery of Art, Manchester, N.H.

18 John Marin: Camden Across the Bay, watercolor, 1922
 Courtesy: Museum of Modern Art, New York

19 Charles Scheeler: Pennsylvania Landscape, watercolor, 1920
 Courtesy: Philadelphia Museum of Art

20 Pierre Bonnard: Harbor at Cannes, oil, 1920
 Present ownership unknown

21 Henri Matisse: The Musicians, oil
 Courtesy: Mrs. Leigh B. Block

22 Chaim Soutine: At the Gate, oil
 Present ownership unknown

23 Henri Rousseau: The Repast of the Lion, oil, 1904
 Courtesy: Metropolitan Museum of Art, New York

24 Paul Cézanne: Nudes in Landscape, oil
 Courtesy: Barnes Foundation, Merion, Pa.

25 Paul Cézanne: Self-Portrait in Strawhat, oil, ca. 1875
 Courtesy: Collection of Mr. & Mrs. William S. Daley

26 Jackson Pollock: The She-Wolf, mixed media, 1963
 Courtesy: Museum of Modern Art, New York

27 Elie Nadelman: Gazelle, bronze
 Courtesy: Metropolitan Museum of Art, New York

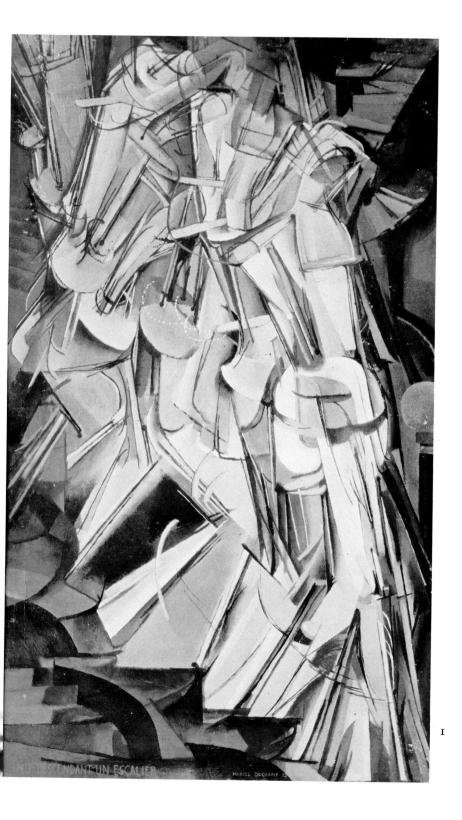

NU DESCENDANT UN ESCALIER MARCEL DUCHAMP

I

2

3

4

5

6

7

8

9

10

11

17

18

19

20

21

22

23

24

25

26

27

HENRY MCBRIDE BY HIS PEERS

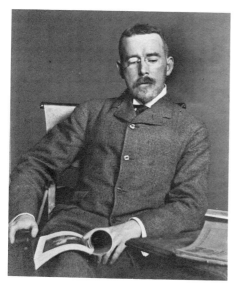

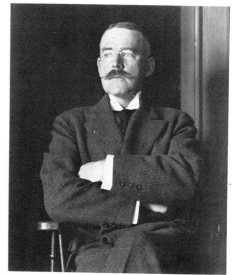

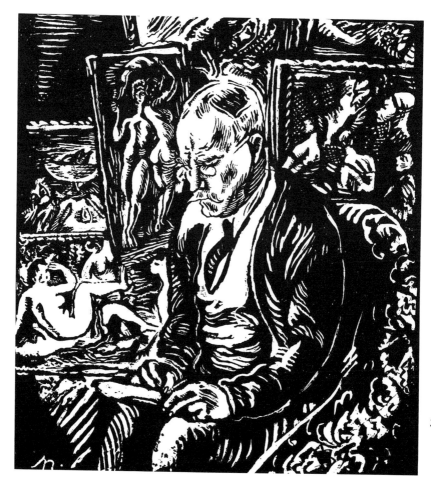

31

32

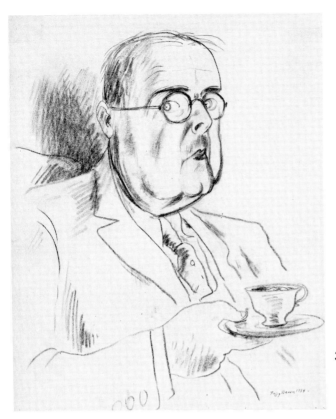

33

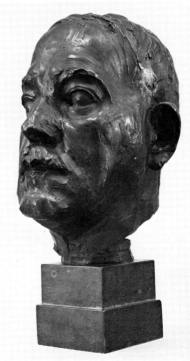

34

Henry McBride

35

May 9 1951. nyc

36

37

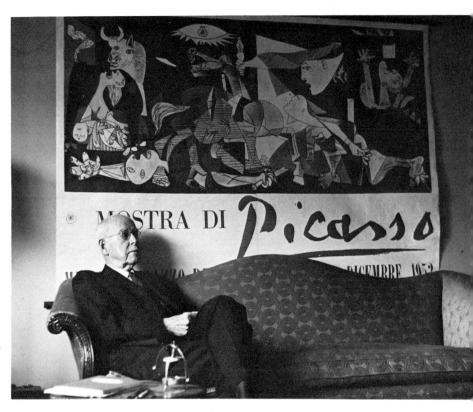

39

Valentine Gallery, to be precise. They'll probably now be finding out his real name, too; for it has been whispered about for some time that in reality he is a member of the genuine haute noblesse who disguised himself as "Peter Arno" in order to evade issues with the Soviets who are increasingly prevalent, it is also said, in our midst.

But be that as it may, there can be no doubt but that he is the darling child of this period. He made this a period, some think, and probably they are right. We didn't know ourselves until he came along and stamped the hall mark "New Yorker," upon all the new types we have created and which are to give the age a distinct claim upon posterity. Now we see "Peter Arno" every time we take a stroll on Park avenue, and certainly every time we go out to dinner.

Only last night in a house the most respectable of the respectables, the lady on my left was bemoaning the treachery of her bootlegger upon the occasion of the coming-out party for her niece. The champagne didn't arrive. At the last moment a charitable neighbor supplied them with the miserable half dozen cases that they happened to have — a pathetically inadequate amount, naturally.

What was to be done? As it was a young people's party the hostess decided to take a chance. She commanded a champagne punch, mixing the real thing with White Rock or other effervescing fluids, and though she said she heard no actual complaints, there was certainly a marked lack of the inebriety that distinguishes a really successful coming-out party in these days.

That, of course, was Peter Arno stuff, though he, being a genius, would have expressed in three bold words what I have to mumble in a long paragraph. Even the little children in the Peter Arno drawings utter bold words. "By gad, officer, you'll answer for this," cries the small tot being ordered off the grass in Central Park by a policeman. By the time you reach the misses' age the tone becomes still more emancipated. "I'm sorry the Mater's out, Mrs. Marshall," remarks a young person to an immense dowager who has penetrated into the reception room of a gaudy modern mansion, "Shall I tell her you barged in?"

When Mr. Arno turns his relentless eye upon us adults then incredible things happen. That is, they would be incredible if we could disprove them; which we can't. None of us,

for instance, has ever read a tabloid, yet in public gatherings we cannot escape catching glimpses of the headlines, can we? Consequently, "Here y'are. Read about yer red hot popper caught in love queen's kiss nest," doesn't seem so much of an exaggeration as it should. And the movie actors! What does not Mr. Arno do to them? There is a study of an impassioned love scene – in a bed, of course – with the hardest boiled of directors shouting "Feel-thee pictures," to the scared hero and heroine whilst a bunch of repellent camera men hover within arm's length for the "close-up." So cruel an exposure of the new art's technic would finish it as a business, one would think, in any other age than this.

Consequently, since we seem to be convicted of sin, shall we droop our heads in shame? No, hardly that. Sin, it appears, is fashionable. That's this artist's great discovery. And since fashion in America has more of the wherewithal to expend upon its draperies than it has anywhere else on earth, it follows that the mise-en-scene that Mr. Arno so faithfully records is the envy of those former citadels of chic that line the banks of the Thames and the Seine. London and Paris at last are copying us and since there is an undoubted exhilaration in escaping from provincialism after all these years of thralldom to it, why should we worry, even though our moralities, for the moment, be slightly askew?

As for the drawings, as drawings; – make no mistake; they are masterly. Peter Arno is our Constantin Guys; a Guys with a dynamic touch, and a wider range of outlook. His collection makes a superb effect, so fresh and vigorous it is. If nothing else, of so memorable a nature occurs this year, at least we shall be grateful to a season that permitted us to make our salaams to Peter Arno.

The New York Sun, December 15, 1928

DEATH OF ARTHUR B. DAVIES

THE NEWS of the death of Arthur B. Davies last October in a remote mountain district of Italy shocked the entire art world inexpressibly. That so prominent an artist could die unnoticed and alone anywhere on earth seemed more than strange to those unacquainted with the man: but not so strange to those who knew him. The fact is that of late he had become excessively furtive. Expansive enough, probably, with a few chosen intimates, nevertheless he increasingly dreaded contacts with the public at large.

I began to notice the trait at least ten years ago. Having written reams of commendation of the artist's work in the early stages of his career, I had a moment's surprise on encountering Davies in an art gallery and noticing that he palpably avoided me. I supposed I had inadvertently given offense, but when I mentioned the episode to a mutual friend my explanation of it was discounted. "Oh, no," said my friend. "There are times when he simply doesn't care to meet any one."

Being somewhat furtive myself I was quite willing to humor the quality in others, so after that, when chancing upon Davies in the galleries about town, I pretended not to notice him. Almost invariably on such occasions, after realizing that I had no intention of attacking him with talk, he would relent and would edge up to me, and at first shyly and stiffly, and afterward very frankly, converse at length.

My most curious experience with him occurred only last winter. Intending to go uptown to attend the funeral of the late Frederick James Gregg, I boarded a crowded subway train. The only vacant seat, I saw at a glance, was next to Arthur Davies, who sat there most unseeingly. He gave no indication of recognizing me, but I noticed that the irises of his eyes had dwindled to pin-points, as they do often in neurotics who are undergoing strain. Without any ado I took the seat and we both sat there stiffly for a moment or two.

Knowing that it was up to me to break the silence I sud-

denly turned upon him point blank and said, "How do." Mr.
Davies gave an effect of being awakened from a dream, but a
pleased look crossed his face. He held out his hand and began
at once to talk. Finally his talk became so enthusiastic that it
practically resolved into a monologue upon his part. When we
reached the chapel he said, "Let's sit together, will you?" and
I said, "Of course." Going up the aisle he talked, and all the
while we sat there in the otherwise silent chapel, and even
after the priest began reading the service for the dead, he
talked. I believe I was finally reduced to saying "Ssh." It really
seemed as though some hidden spring in his personality had to
be touched before he could communicate with his fellow men,
and when once started another secret spring had to be touched
to shut him off.

Such mannerisms are easily explained in modern psy-
chology. Davies's brain teemed with ideas and he wished to
give himself up to realizing them. Society, on the other hand,
seems specially organized at present to come between the
artist and his work. Too much friendship can be just as fatal
to self-expression as anything else. The similarity of the Davies
"case" and the frantic search by Eugene O'Neill for repose in
Shanghai, China, must be noted. It begins to be apparent that
we must establish asylums for our great producing talents.

Davies certainly was a great producer. It was his fecun-
dity, in fact, that sometimes made me doubt him. No man, I
am persuaded, can produce several thousand masterpieces.
He was always pleasing, always had a definite thought and
never was perfunctory. But I used to find it difficult when
arguing for him to those who were as yet unconvinced of his
talent to fix upon a definite canvas that summed up his genius.
I always required half a dozen, or even a dozen, paintings
to evoke the Davies idea. So many of the early, pleasing can-
vases contained a flash of a poetic thought but not the com-
plete expression of it. The effect was that of a study of a paint-
ing rather than the painting itself.

When the series devoted to the glories of the California
scene arrived this reproach was hushed. They were certainly
complete, poetic and important. To this day I suspect them to
be of Davies's best. It is too soon, of course, to try to make up
posterity's mind in regard to Davies, and, anyway, posterity
has a trick of making up its mind for itself. But Davies cer-
tainly secured a definite place. Under the circumstances there

is sure to be a desire for a memorial exhibition of the dead artist's work, and this must be consummated. So many of his best things have been sequestered for years in private collections that the mere bringing together publicly of all of his work will do much toward clarifying opinion in regard to it.

Another phase of the man that makes his untimely cutting off regrettable was his unmistakable gift for connoisseurship. His instinct for the talents of others was truly remarkable. It was he more than any other who was responsible for the amazing success of the famous Armory Show of modern art, and he lived to see many of his early and daring judgments confirmed by the best minds of the world. He was an inveterate collector himself, and aided many of his friends to collect. Altogether he was a great power in the modern world, and it is impossible to think of any moving factor behind the scenes – for it was characteristic of him that his most important moves were secret – who could be so illy spared.

The New York Sun, December 22, 1928

MIRÓ

THE CHIEF question on my mind when sailing for France last summer was that of Miró. Was he worth bothering about? No other name, during the winter, had come across the seas with such insistence, and nothing came across with the name – no pictures. If he really were worth bothering about it would be necessary, it seemed, to make another of those fatiguing trips to Paris in order to do it there. A traversée "was clearly indicated," as the fortune-tellers say, and so, being essentially dutiful, I went.

I did not meet the young man though. M. Miró had him-
self felt the inclination to travel and had hied himself to his
native Spain. I very seldom meet the artists. I prefer not to.
They sometimes are so personally fascinating that they preju-
dice you in favour of their works and that complicates things.
Two of M. Miró's works, on the other hand prejudiced me in
favour of *him*. No matter what he might be like – and I heard
he was odd – the two pictures had answered my question and
I knew that the artist was worthy of bother. They were at the
new gallery, Pierre's, on the rue de Seine. They were not for
sale. (Instantly I had decided that either or both pictures
would do admirably for the New York Luxembourg, a mythical
institution for which, in my mind's eye, I am always making
purchases.) But they were not for sale. They were to adorn
M. Pierre's private collection, or the artist's own private collec-
tion, I forget which. That is the latest thing in Paris! The deal-
ers have become collectors. All the desirable objects of art are
not for sale. It is certainly the case, and with a vengeance, at
M. Paul Guillaume's. M. Guillaume looks positively offended if
you ask a price. It almost seems to be superfluous, under the new
system, to have a gallery. I have a vague notion, for instance,
that there were pictures at M. Paul Guillaume's gallery on
the rise de la Boëtie but recollect perfectly all the masterpieces
of the private collection and can even tell you their positions
on the walls if you insist upon it. I remember *them* very pre-
cisely. One of the members of New York's advance-guard was
calling upon Guillaume while I was there, and agreed with me
in thinking the collection excellently representative of the push
and urge of current feeling and that it would be a handsome
act upon the part of somebody to acquire the whole thing for
New York. When one or other of us voiced this opinion to
M. Guillaume he smiled at us incredulously and unhumor-
ously. The pictures, it seemed, were not for sale. Nevertheless
some people do seem to know how to get things away from
French dealers, even under the new system. I myself have
great faith in the efficacy of prayer. I pray, for instance, for
the two big Mirós to come to the Gallery of Living Art, or at
least to some New York collection, and preferably a public one.
For the three big Mirós, I should say, for there is another one,
The Dog Barking at the Moon, which I have only seen in photo
but which I am now persuaded is also swell. Before going
down the crooked little rue de Seine to Pierre's I asked one of

the younger French modernists of my acquaintance if he agreed that Miró were great and I got a dubious and unconvinced shrug of the shoulders by way of reply. After a moment of reflection, however, my friend twinkled his eyes and said, "Well, I must admit that there is something great about that Dog Barking at the Moon."

M. Pierre, when showing me a big Miró canvas which divided itself practically into two bold tones of red and was called A Landscape, said — seeing that I was impressed and would probably stand for it — "It has the feeling of Rousseau's Egyptienne." I did stand for it. I really thought so too. This landscape has the same mysterious spooky quality that made the Henri Rousseau evocation so thrilling. Later I was shown another large canvas that had been touched in with the same spectral brushes. There was something that looked like a dog, too, in this composition and that helped me to realize how effective the Dog Barking at the Moon must be. "Very like a whale," I suppose you'll be saying if you are sceptical of all this. M. Miró, in truth, does very little for the dog that appears so frequently to him in dreams. The new art, you understand, is simple. It is almost like a Caran d'Ache dog, or like one of those stylized toy animals that advanced parents now give to their children. But all the same, the symbol has the power of something genuinely imagined and is painted as though to the order of Don Quixote himself. Accepting definitely three such pictures as these mentioned is something, and so I now feel committed to M. Miró.

The Dial, December 1928

1929–1938

AMERICAN EXPATRIATES IN PARIS

ARTHUR SYMONDS once defined vulgarity as the state of un-regenerateness that prevails in the social circle immediately below your own; and by the same token sin may also be defined, I should think, as that state of morality that is immediately below your own. At any rate, just because I have gone abroad myself at intervals, I shall not be deterred from shying a stone at those others who go abroad too often and stay too long when they do go. Whizzing around the corner of the Boul' Raspail into the Boul' Montparnasse one evening last summer on my way to a dinner engagement I was thoroughly scandalized at the size of the student mob that crowded the sidewalks, the roadway, and in fact all the intervening space between the two notorious cafés that face each other at that point. It was not a fête-day nor anything of that sort but just a plain Saturday night, yet five hundred or more young people — my countrymen, I could see, in spite of the speed of the taxi — hovered about the spot waiting to seize upon any chair that might be vacated upon the densely populated terrasse. The effect, to the aroused moralist in the taxi, was that of a swarm of weak-willed insects drawn to a trap craftily baited with poisoned sugar. "Fools," cried he to the night air, "don't they know that one taste of that stuff is death? Won't somebody tell 'em?" but at that moment the taxi drew up to Miss Stein's door, and the general good cheer, including the extraordinarily good food, that Gertrude always knows how to provide, dissipated, for the moment, the hastily formed intention of shooing all those insects back to America where they belonged, and where, whether they knew it or not, they would have been so much better off.

That frustrated intention has recurred to mind often enough since then. One by one the cigales recollected that there was not un seul petit morceau de mouche ou de vermisseau in the larder and came knocking at the door of America petitioning supplies. There has been a constant stream of them all winter long. Doles have been handed out, it is true — for no one had quite the cruelty to say "Eh bien! dansez" —

but, and mark this, the doles were less in quantity than ever
before, and more begrudgingly given. It was not the critics'
fault, I do assure you. They covered up the nakedness of the
stricken exiles as long as they consistently could, but the public
itself, enraptured almost to the point of ecstasy with its new
sense of world-authority has grown intolerant of diluted pa-
triotism. "American artists who live in France"; the very phrase
is condemnation. A fiat seems to have gone forth. At any rate
cold shoulders in solid phalanges were turned in succession
this year on the works of William Yarrow, Marsden Hartley,
Paul Burlin, Guy Pène du Bois, Leon Kroll, and a long list of
other expatriates.

The times, as a matter of fact, have changed. There is no
longer the necessity (if there ever was) to study art abroad.
The African savages whose carvings M. Paul Guillaume now
sells for such exalted prices did not form themselves in Mont-
martre. Nor did Hokusai and Korin of Japan. Art is not a cloak
that an artist borrows from someone else but a fabric he im-
provises for himself. I wish to make no rules. I know that at
times strange distillations go to the making of a style but the
younger Americans in search of one are herewith gratuitously
advised that the chances of acquiring one in cosmopolitanism
are noticeably less than they were a generation ago. The rea-
son for this, to put it in a nutshell, is that the centre of the
world has shifted. Paris is no longer the capital of Cosmopolis.
All the intelligence of the world is focused on New York; it has
become the battleground of modern civilization; all the roads
now lead in this direction, and all the world knows this save the
misguided artists who are jeopardizing their careers for the
dubious consommations of the Café de la Rotonde.

As this is above all others the place of destiny, it follows
that those who absent themselves from it, do it merely for
reasons of self-indulgence. Indeed all the sinners whom I met
in person this winter confessed as much. "We had a charming,
eigteenth-century villa in the south of France, with two ser-
vants, for fifty dollars a month." "I must have wine. I won't
live in a country where you are obliged to bootleg for it." Vari-
ations on those two themes were encountered ad lib. One man
actually said, "I married a wife and my wife loves Italy." Com-
ment on such remarks, you will agree, is almost superfluous.
What is to be gained by talking sense to people who have al-
ready compromised with it to that extent? Nevertheless, I am

tempted to quote an exceedingly apt passage from a book that has recently come to hand. It is the tenth-century Pillow-Book of Sei Shonagon which Mr. Arthur Waley has newly translated as a pendant to Lady Murasaki's marvellous Tale of Genji, of the same period. Many readers have wondered why it was that of this great age in Japan there were but these two women authorities. Mr. Waley answers the question thus:

"As far as the production of literature went, women did not, in fact, enjoy so complete a monopoly as European accounts of the period would suggest. But convention obliged men to write in Chinese, and not merely to use the Chinese language, but to compose essays and poems the whole attitude and content of which were derived from China. It may be objected that a potentially great writer would not have submitted to these restrictions – that he would have broken out into the vernacular, like Dante or Paracelsus. But this is to demand that a literary genius should also possess the many qualities essential to a successful reformer. The use of the native kana (the only form of character in which the Japanese language could be written with reasonable facility) was considered unmanly, and to use it would have made a writer as self-conscious as a London clubman would feel if he were to walk down Bond Street in skirts."

This statement ought to be sufficient in itself, I think, to fetch all the truant artists home from foreign parts. Of course, the moment the facts in it are digested there will be a cry of exceptions, but to them I shall reply, as before, that the times have changed. The only exception I make myself is in favour of Miss Stein and that is partly because she dates from that different period of before the war. But even she, I understand, is coming home. Young Mr. Virgil Thomson who has made an opera from one of her poems, The Four Saints In Three Acts, and who has been enchanting us lately with extracts from it, hopes to get the whole work performed in New York, and if he succeeds, he has Miss Stein's word, he says, that she will come on for the première. In that case the entire prop of the European invasion will have been withdrawn; and obviously, the riff-raff had better scuttle home at once before that disaster occurs; for if Miss Stein once gets here, believe me, she'll stay. She's too great an artist to be able to resist us.

The Dial, April 1929

OPENING OF THE
MUSEUM OF MODERN ART

HISTORY AT times makes the effect of being swift and inexorable. A thought comes to a man of genius that seems to give a new color, a new aspect to life. Just because it requires the spectator to make a readjustment in his point of view, to listen searchingly with his ears to a new set of harmonies, to seek confirmation with his eyes for the new color combinations, the lazy and above all things comfortable Old World, denies at once the truth of the new thought and very often succeeds in destroying the discoverer physically.

Then all at once without anything apparently having happened a change comes over the scene. The bones of Edgar Allan Poe, Paul Cézanne, Charles Baudelaire or whoever it happens to be, are disinterred and put in consecrated ground. People actually whisper prayers for the repose of the souls they had been trying to damn but a short time before. Léon Daudet now says that the "Fleurs du Mal," which was reviled as heartily at the time of its first appearance as anything ever written, represents the summit of the French spirit, and Vollard, the champion of Cézanne, takes a pride in the insults that were hurled at his hero, and gives up perhaps too large a chapter in his biography to recounting them.

In reality, of course, these characteristic reversals of public opinion are not so quick – they only seem quick. All the time quiet forces had been busy sowing the seed of the new opinion, usually in the minds of the younger generation, and in reality it is the coming of age of these young people and their prompt usurpation of the world, that convicts their predecessors of sin and gives the effect of inexorable judgment upon them already mentioned. Even in these swiftly moving times it still requires two decades before the harvest of new poesy and art can be reaped.

These ideas, not so free from smugness as I could wish, apply equally to the institution of the new Museum of Modern

Art and to the first of its exhibitions, now open in its temporary galleries in the Heckscher Building, at Fifty-seventh street and Fifth avenue. This enterprise, so long and so devoutly wished, is so large in its promises and so positive in its present attainments, that it seems to have come full-blown upon us over night. It truly makes us rub our eyes now that we have gone such a journey to see that we have arrived at the destination.

And the exhibition itself is so incontestably serious and so impressively alive that the astonishment will now be general that so many fences had been erected to keep this art from the public. What was the insidious danger of it twenty years ago, or even ten years ago? Nothing other than that, that it was alive. The Philistine dwells in formulas, and formulas apply to the past, and that is why, I suppose, the born Philistine is always at sea when brought face to face with the art of the present.

The new museum wisely chose to give its first exhibition to the works of the four pillars of the modern movement, Cézanne, Seurat, Van Gogh and Gauguin, and by each of these artists it does nobly. It is not an exaggeration to say that no such showing of modern art has hitherto been made in America. The paintings fortify each other. Some of the most important of them, such as the Cézanne self-portrait from the Phillips Memorial Gallery, the still life of the Chester Dales and the still life anonymously loaned, have previously been shown, but never to such advantage as on the present occasion, when practically every item on the walls emanates greatness.

Seurat and Van Gogh, however, are the two painters who get increased auras out of the event, for both have been ill-understood in America, and both are now beautifully represented. The landscapes of both men are particularly revealing. We have known how to take the rugged Van Gogh figure pieces such as the "Facteur Roulin" and "La Mousme," but it is a fresh astonishment to come upon such an essay in pure music as "The Ravine," lent by Keith McLeod of Boston. In the same way, we have already been prepared for the endiablée "Parade" by Seurat, which the Knoedlers lend, but gaze with all eyes upon the sure serenity of such landscapes as the "Lighthouse at Honfleur."

From the moment the Museum of Modern Art loomed upon the horizon the question has recurred at intervals as to the possibility of collision between the new institution and the

Metropolitan Museum. From a bulletin issued by the new society the following excerpt may be taken as a reply to the query:

"Experience has shown that the best way of giving to modern art a fair representation is to establish a gallery devoted frankly to the work of artists who most truly reflect the taste, feeling and tendencies of the day. The Louvre, the National Gallery of England and the Kaiser Friedrich Museum, to mention only three national museums, follow a policy similar to that of our Metropolitan. But they are comparatively free of criticism because there are in Paris, London and Berlin – in addition to and distinct from these great historical collections – museums devoted entirely to the exhibition of modern art. There can be no rivalry between these institutions because they supplement each other and are at times in close co-operation. The Museum of Modern Art will in no way conflict with the Metropolitan Museum of Art, but will seek rather to supplement the older institution."

The New York Sun, November, 9, 1929

O'KEEFFE IN TAOS

GEORGIA O'KEEFFE went to Taos, New Mexico, to visit Mabel Dodge and spent most of the summer down there. Naturally something would come from such a contact as that. But not what you would think. Religion came of it. Georgia O'Keeffe got religion. What Mabel Dodge got I have not yet heard. But Georgia O'Keeffe painted a series of canvases with enormous crosses booming across ascetic landscapes. Some of them black crosses!

These matters are to be observed in the new Stieglitz Galleries, which have lately been housing the Marin water colors. The piercingly white walls of the new rooms, which so became the Marins, are not so fortunate for the O'Keeffes. They do not interfere with the new pieties of the artist, though they frustrate appreciably a work that I saw a few weeks ago in another place and which I then thought a chef-d'oeuvre of mysticism. I can go into that later, perhaps, but new religions, of course, come under the head of "news" and take precedence over everything else. Hence, like Georgia O'Keeffe herself, we must take up the crosses.

"Any one who doesn't feel the crosses," said Miss O'Keeffe, whom I fortunately encountered at the private view, "simply doesn't get that country." This reminds one of Maurice Barrès, who began his "Du Sang, de la Volupté et la Mort" with the statement that anyone who had once glanced at the forbidding, sunsered banks of the Tagus at Toledo had no need for the philosophies of Pascal. So much is brought back to us of the frivolities of the tourist colony at Taos, so much is said of the added pulse-beats that are caused by the high-powered ozones of that locality, that it is intellectually thrilling to find Miss O'Keeffe adopting so quickly the Spanish idea that where life manifests itself in greatest ebullience there too is death most formidable.

Her "Crosses" are something less and something more than painting. It is the fashion of the moment in critical circles to say that Miss O'Keeffe doesn't paint, but this is the subtlest compliment imaginable, since it is incontestable that she has her way with her public. None of the devoted band would think for a moment of inquiring whether Derain also painted like that, or whether anything in Matisse justified Miss O'Keeffe's methods. It suffices for them that they get the vibrations. Some of them will be cured of their lumbagoes and arthritic knees at this show — or I miss my guess completely. Since that cemetery in Massachusetts was closed by the police this new exhibition will be the only place of pilgrimage remaining open for business.

The "Crosses" run through several sets of chromatics and emotions. There is the "St. Francis of Assisi" in pale blues and turquoise, for those who have given over the world completely and live or attempt to live on the spiritual heights. There are several crosses for those who have dabbled slightly both in

sin and virtue and are not yet certain which way they are going; and finally there is the great "Parsifal!" cross posed blackly and ponderously against a sky of molten crimsons and vermilions, and with purple velvet mountains in the distance. The mind pauses in contemplation of this picture. In fact, it is distinctly not for the mind but for the "subconscious." A gallery is no place for it. It ought to be viewed in church. I should like Mae West to see it. It can only be properly understood, one feels, by someone who knows life thoroughly. On second thought I should like Mae West not to see it. It might disarrange her views of play-writing — which would be a public calamity. But one yearns instinctively to see this picture do its work, just as one turns occasionally at the opera to see the thought of the proffered forgiveness for too much knowledge stealing over the wrought-up Wagnerians.

The New York Sun, January 8, 1930

MODERN ART

SOME PEOPLE would rather argue than eat. As for me I am precisely the contrary. Occasionally one is obliged to combine the two activities. Quite recently an energetic hostess, seating her guests at the dinner table, mentioned to the lady who was to sit next to me that I was one who could "tell her all about modern art," and the lady in question dutifully said: "Oh, yes, do tell me." I stole a look at her. She appeared to be serious. In fact, she was evidently a serious lady, with a clearly chiseled face and grim lines to the lips that indicated she had definite and decided views upon life and all that concerned it.

Not the type, you would think, since she was unquestionably American, that would go in heavily for art of any kind, but she said again, seeing my hesitation: "Do tell me about modern art. I so want to know."

There seemed no way out of it, so I told her. I did my best. I had at first no great enthusiasm for my task, for it seemed a bit hard at this late date to have to tell anyone about a movement that had already been so well advertised. Twenty years ago I used to begin each review of each new artist as he came along, with a description of what he was attempting to do — but that was twenty years ago. One hates to stick always at the same point and to remain always at the beginnings of things, and if new inquirers happen along one is tempted to abandon them to the new writers, and to confine oneself to the initiated, to presume upon a few readers who know their abc's. In social intercourse I more or less follow the same plan and avoid altercatious academicians and side-step "explanatory" conversations. But in this case I was in for it. And my neighbor proved to be a disputant. Practically everything I said met with a counterstatement. Early in the dinner she said: "But modern art is so unspeakably vulgar," and shortly after that she queried: "But don't you then care at all for Beauty?" We were in the middle of the fish course. There was an enticing arrangement of shad but the bones were still in it and had to be attended to. Nevertheless I managed to insist that I did care for Beauty (we both said it with a big B) but I didn't go so far as to say that the vulgarity in modern art was entirely in the eye of the beholder. I wanted to say this but I didn't quite dare. Instead I trotted out all my favorite theories about the imperious necessity of each generation to discover its own formula of expression — about the wonders of present-day life, especially here in marvelous New York, and the total inadequacy of Grecian or early-Florentine systems to compass the tumultuous mental experiences we were now undergoing but all this was without avail. The more I talked the more "set" and adamantine did my neighbor's face become. Finally the hostess gave the signal for the ladies to depart, for an interval, to a smoking room of their own, and as my companion arose she said, acridly: "It all sounds to me like the arguments that spiritualists use who wish to convert you to their belief." "You mean, you must

have 'faith'?" "Yes," said she, sweeping triumphantly on her
way. (These new long gowns again permit the women to
make effective exists.)

 Still oppressed by this crushing defeat, I fear I can only
half-heartedly attempt an answer to several inquiries that
have come to me in regard to Miss Wilborg's *Seated Woman*
by Picasso — the star picture in the recent show of French art
at the Modern Museum. One of these writers, who enclosed
a stamped envelope for reply mistaking me for a man of
leisure, said that he was a young art-student and would like
to know why it was that all the art-critics made such a fuss
over the *Seated Woman* for he could see nothing in it at all.
The surprising thing about this inquiry is that it came from a
young person. As a rule young people do not have to be told
about modern art. They understand it instinctively. A thou-
sand things, including the very advertisements in the news-
papers, have taught them its language. I took advantage of
this fact rather slyly at the time of the Brancusi Trial. After
the first session of the court, the then commissioner of cus-
toms asked Mr. Duchamp, Mr. Steichen and myself, all three
of us being witnesses for the defense, into his private office
for a confab. He was not the judge in the case, but for his
own private satisfaction he wished to know why we thought
the disputed *Bird In Flight* was a work of art. He quite evi-
dently accepted Mr. Duchamp, Mr. Steichen and myself as
honest men but failed to follow us in our admiration for
Brancusi's carvings. In the little talk we had, he mentioned
that his daughter was an art-student. That was the point I
seized on. I told him I was willing to wager that his daughter
would be sympathetic to Brancusi's work simply because she
was young. This commissioner died before the verdict for
Brancusi was reached and so I never saw him again to learn
if he had an "art insurgent" in his own family though I still
think it likely in spite of the apparition of this new young
unbelieving correspondent of mine.
 To him, I would say, that the whole thing depends upon
your attitude toward abstract art. If you can conceive that a
noble or a forceful or in fact any kind of a personality can be
expressed in abstract art then you are in need of no explana-
tions from anyone. If you violently and flatly refuse to be-

lieve that abstract art can be anything but trickery then you might as well go your way and give up the study. That is the rock on which we all split. The lady at the dinner party admitted that she could see nobility in handwriting irrespective of the words, that ancient Cufic script had undoubted handsomeness, that early Chinese painting had grandeur of style even when employed on subjects that meant nothing to her, but she refused to see handsomeness, power, or nobility in anything that Pablo Picasso did. There are other attirbutes to modern art but the ability to feel the abstract is the real test. An odd thing is that most objectors, in a vague way, feel that this form of art is impregnated with sin, and this, too, in spite of the fact that the most respectable critics who have ever flourished, including Walter Pater and Ruskin, have put themselves on record, and at considerable length, as yearning for a form of art that would have the purity and fluency of music. It is true, of course, that neither Pater nor Ruskin, could they have survived to this day, would have recognized his child of their dreams — or should we say grandchild? — for without the extraordinary educational forces of today, including that most persuasive one of all, The Movies, how could they have had the clue? Poor Ruskin stumbled even upon Whistler whose "art for art's sake" was in line with his own theories but whose application of it was "so unspeakably vulgar."

That it will go on forever is scarcely likely. No art movement ever does. But that it has been the ruling power in the art world for twenty years is enough in itself to give it historic significance. No artist who lives henceforth will be in ignorance of what can be done in abstract art nor will remain unaffected by it.

To bring this unavoidably repetitious essay to a close, I may add that modern art is a flower that came into full bloom in Paris where it seemed and still seems remarkably in accord with its habitat. It is exactly like all the other things that are going there, and by that, believe me, I do not mean "sin"; and fits in perfectly with the period. To middle-aged Americans not deeply interested in painting but suddenly confronted with such a defiant emanation as the recent "Painting In Paris" exhibition at the Modern Museum, the whole thing could

readily seem "spooky." But it is tangible enough to those who would give it the same amount of attention that they would bestow upon any other form of expression. For my own part, I find the language so legible — I accept so easily its conventions — that when I first saw Miss Wilborg's *Seated Woman* I read realism into it, in addition to its marvelous design and color. There was a majestic spaciousness to the mysterious figure in the alcove that fed the mind exactly as fine music does; and could be as illy spared, once known, as the Fifth Symphony. However, I had had, as I have said, twenty years of preparation for this acquaintance.

Creative Art VI No 3 (March Supplement I) (1930)

MATISSE IN NEW YORK

THE MOST surprising event of this week has been the arrival of Henri Matisse, the great French modernist. This arrival was unheralded and unexpected. The artist, who had heard something of the prowess of New York reporters, had decided to travel incognito, but he was recognized on the Ile de France by some of his fellow passengers and the incognito was completely ruined. In consequence Mr. Matisse has been steadily entertained during the few days of his stay in New York. He is expected to leave today for Chicago, San Francisco, the South Seas and possibly a world tour.

M. Matisse has been enchanted by New York. He is one of the most enthusiastic visitors that the city has yet enchained. He finds words quite inadequate to express his astonishment, but "incredible" is the one most frequently on his

lips. He says he was quite unprepared for it, that photographs and the cinema had given him no idea of the wonders he was to see.

He arrived in the evening, in time to see the twinkling lights in the great downtown towers, and then went straightway to rooms that had been held for him on the thirty-first floor of one of our new great hotels. He said the next day that he had slept perfectly in the lifegiving, invigorating air of New York (the enthusiastic adjectives are all quoted from M. Matisse), but awoke at sunrise to "assist" in that magnificent spectacle. He would have been quite content, he said, to have spent the entire morning looking at the views from his windows, but friends arrived to take him sightseeing. To show how much he had reacted to the energy in the New York atmosphere M. Matisse added that before 8 o'clock he had breakfasted and written two letters.

The first visit was, naturally, to the Metropolitan Museum of Art, where the artist spent three hours. By special indulgence he was admitted to the preview of the great Havemeyer collection that had been arranged for the critics, and he was filled with admiration for what he saw. Later he was taken to see the typical show places, such as Wall Street, the Brooklyn Bridge, one of the great cinemas, Harlem and the theater crowds of Broadway at night. It was all "incredibly" interesting.

M. Matisse is in excellent health and spirits. It is ten years since my previous meeting with him and I could not see that he had changed in any particular. Naturally at this moment his chief interest lies in his present experiences and it is difficult to engage him upon the subject of his own work. I did try to sound him upon the always delicate theme as to which was his best painting to date, but we did not come to terms. In my opinion this picture is the "Seated Odalisque," which was shown here some years ago in the Valentine Gallery and which remains in the artist's possession.

He said he retained it, with several others, in order to remind himself of the path he had previously trod. He said he remembered the mood and the outward "face" of his pictures always, but that he occasionally liked to look again at the details of certain effects much as a novelist might reread some of his published books. He did not, however, positively dissent

from the notion that the "Seated Odalisque" occupies an important place in his production; so we did not come into collision upon this point.

The New York Sun, March 8, 1930

ROUAULT

FOR MANY years Georges Rouault has been known to the few as a daring and original painter. By "the few," I mean collectors who lean in tendency toward the moderns. He was not, it was apparent at once, a painter who made concessions toward collectors, not even toward modern collectors. It could be suspected that, as a man, he was difficult. Nevertheless, he was given a sort of reluctant fame. Even so, he had to wait thirty-five years for his first one-man show, and that occurs now in New York in the Joseph Brummer Galleries.

In order to stave off at once the avalanche of sentimental correspondence that usually comes to me whenever I mention the case of a great painter who has had justice rendered to him only after death or too late in life to do him any fleshly good, I may say that this time there is no particular injustice, and that Georges Rouault is not to be pitied half so much as some of the rest of us. Georges Rouault is still in life, living quietly in the way he likes and in the manner best suited to his type of genius.

He could have had exhibitions forty times over had he wished, or had Vollard, his merchant, wished. Heavens, how difficult has it not been to see his work in the recent years and what ennuis have not the collectors undergone in order to obtain his paintings! Hardships? Believe me, it's the collectors

this time who have undergone, the hardships and not the artist.

Before going on to say something about the man I must put in a word about the pictures, which are remarkable and quite capable of exciting the collectors into unseemly rivalries. There is something ferocious about them, and has been from the start. The very titles of the pictures indicate that the painter lives a terrific inner life that would naturally disable him in the contacts on the market place. Among them are these: "Qui dira j'ignore encore?" "Tu gagneras ton pain par le sueur de ton front," "Le Clown," "La Crucifixion" and "Le Déménagement au Château en Espagne."

The gloomy thoughts that so frequently overwhelmed Rouault were reflected in the palette and most of the pictures that we first saw were somber in the extreme. The feeling in them was genuine and profound, but tortured. To this day, even now that I am convinced of the man's essential genius, I am repelled as well as attracted by the early work. Fortunately something happened of a clarifying nature. Rouault loses nothing of his integrity — such a man couldn't — but he looks into the abysses of life as from a height. The light shines through his colors as though it came undiluted from the mountain tops. He has a blue, and a use of the blue, that is dazzling. It is so obviously comparable with stained glass that one longs to test it out, at Chartres, in the Sainte Chapelle, or at St. Denis. One imagines that it would hold its own, not only in color, but in massiveness of design.

When I said that Rouault was not to be pitied I did not mean to imply that he did not know what trouble was. Probably his early steps were sufficiently hazardous; or how else could he have so quickly seen that life was terrible as well as beautiful? But when I first heard of him, now many years since, he was already under the wing of Vollard. Vollard had launched the Cézanne cult and was guarding Rouault, it was said, and grooming him to be Cézanne's successor. Then it did not seem long until I heard that the artist had become conservator of the Gustave Moreau Museum in Paris. This job was one of those little sinecures that seem to fall so frequently, in Europe, into the right hands. Thus Rouault had sufficient income for his modest needs, and could paint when and as he pleased. It may be that the clear blue tones that are now so wonderful in the pictures, date from the moment his posi-

tion was secure -- but in saying that I am merely guessing.

He is "both timid and bold," he says himself, when describing his inner life. "I had the nostalgic and naive sentiment of a little apprentice of the faubourg; I loved the ancient tunes and the Barbary organs of those times; I was not made to be so terrible as they all say." Almost the first line in his recently issued "Souvenirs Intimes" contains the assertion that the artist should not stiffen himself with worries, but should above all things, "live in inner peace, without trembling at realities." It is clear that Rouault always held to this, both in his painting and in his writings. The "Souvenirs Intimes," I should add, is a delightful book, not at all literary, but full of heroic sincerities that put faith into other artists as well.

The New York Sun, April 5, 1930

MIRÓ AND MATISSE

RETURNING VISITORS from Paris are always met with the question: "What is brewing now on the Left Bank?" and for ten years or so the answers have been confusing and evasive. Of late there has been a little clearing up of the mists. A few names get mentioned in addition to the everlasting Picasso, Braque and Matisse. A name that recurs oftener than most is that of Jean Miró, and now at last a lot of pictures signed with his name are shown in the Valentine Gallery; and we can attempt to see what it is all about.

Henri Matisse is one of those who mentioned the name, but apparently against his will. Matisse is now, of course, a definitely arrived personage. He has seen himself increasingly successful during many years. He enjoys the peace and secu-

rity that are now his, and sees no cause to interrupt them. He is not belligerent by nature anyhow. He goes out of his way to avoid the disputes of the argumentative.

One night, at dinner, during Matisse's recent visit to this country, I asked him what he thought of the new young crowd of artists in Paris? At once the barriers were up. He was loath to be drawn into such a debatable region as that. At the same time, he is far from being reticent, and in fact is a fluent and brilliant talker, and before long he was explaining that he was old and not a proper person to appraise the young people, and besides had lived so remote from the streams of modern influences that he was scarcely aware of the new tendencies, and as for this young Miró, and Matisse gave a shrug of his shoulders to indicate an unwillingness to be responsible in that direction. He went on charmingly excusing himself for some time before I interrupted him to say: "But you did mention the name Miró."

Matisse looked as though he had been caught in a trap. Then we both laughed and changed the subject.

Miró is represented permanently in the Gallery of Living Art by his "Dog Barking at the Moon," a picture that is a sure test of mental old age. Young people do not mind it at all, and some of them like it very much, but people who have settled upon fixed principles for their guidance during life are apt to shudder at the barking of this dog. It is a bit of mystic symbolism, however, that ought not to frighten anybody. It is weird, fantastic and likely to give you dreams, but that, after all, is one of the chief businesses of a picture.

The new pictures show that Miró has more dreams than one at his command. He is weird and uncanny practically always, but he speaks in beauty, as an artist should. His color is invariably rich and evocative. He has the faculty of making color do unexpected things and yet seem right. The big panel called "Portrait de la Fornarina" is strangely decorative in subdued colors, and has a far-off relationship to the grotesqueries of Aubrey Beardsley. If our collectors were persuaded that this work were by Beardsley it would not seem difficult at all. It is, it seems, after all, merely the new name "Miró" that is frightening.

Certain other pieces, such as the "Interieur Hollandais" and the "Pommes des Terres" are really more difficult, but on the other hand have more sting to them. Miró's fancy fol-

lows more intricate paths in these two pictures than in most of his work, but he gives himself up to his fancy without reserve and records his findings with the precision of an early Dutch master. The vision and the execution is startling, even in a period that has grown used to Picasso's abstraction, but in the end both are equally authentic. The new Museum of Modern Art, therefore, should see that these works remain on this side.

The New York Sun, October 25, 1930

SUMMING UP WALT KUHN

THERE IS great embarrassment to the critic in the necessity that sometimes arises to blow hot and cold with one breath. A sharp repulsion from the work of an artist is unpleasant, but at least it is a distinct feeling that can be measured. A glowing enthusiasm is equally easy to put into words; but a "yes" and a "no" applied to the same thing are confusing to critic, reader and artist alike. The Walt Kuhn exhibition in the Marie Harriman Galleries puts me in this predicament. I shall wriggle out of it as best I may.

I have been for and against Mr. Kuhn during all his career, which now at last begins to be successful — from the selling point of view at least — so I suppose he scarcely numbers me among the most helpful of his friends — yet I would be one — to the very innermost limits of my conscience.

My earliest difficulty was a lack of patience with his long search for a style, which he thought to find in the paintings of others. I am always opposed to that. I hold that style should come about unconsciously and should result from a

personal feeling about life that can only be expressed in a personal way. One gets it by living rather than by going to school. Just about the time that I was renouncing Mr. Kuhn permanently he exhibited a lot of paintings in which the quotations from Derain, Pascin and the others, were so minimized that they were no longer the whole thing. Mr. Kuhn was being himself.

That was last year, I think. The subject matter was excellent. It was matter well calculated to send any artist off on voyages of mental discovery. Mr. Kuhn had occupied himself with the humbler people of the stage — chorus girls from the East Side music halls, acrobats from traveling circuses, and the like. What impels a hearty, buxom girl who might have made an admirable wife for one of our better "working men" to take up the precarious career of a chorus girl is in itself a mystery. What leads to the final choice of the particular tawdriness she affects for a costume is another mystery.

The possibilities of her being "straight," or really caring for her profession, her deportment in the petty squabbles back-stage, her resemblances to the Balzacian creatures that are now known as "gold diggers"; all these suggestions flit across the brain whenever she is contemplated by a complete outsider, but Mr. Kuhn helps you to few conclusions in regard to the specimens he selects. He disrobes them more or less but by no means unvails them. Compared with the researches of Toulouse-Lautrec in a similar field, his work seems halting and wooden.

Nevertheless last year the artist had "a good press." Most of the critics, including this one, felt that he had gone ahead, and when an artist goes ahead it is an item of news. There was no question but that Mr. Kuhn knew those chorus girls and with just a little more frankness and freedom in the painting it was thought we would have something to match the European output. But this frankness has not come about in one year. The chorus girls are as they were, posing on the model stand and as reluctant with their secrets as though they were posing for Mr. Whalen in a Rothstein case investigation.

In spite of this, Mr. Kuhn achieved last year, and still maintains it, a definite place in American art. He must be included in any of the "twenty best Americans" that our new museums may decide to bring forward. A private collector who goes in for Americana cannot ignore him. This is a comfort-

able position for any artist to find himself in, but in order to get world fame a still greater effort is indicated.

The New York Sun, November 8, 1930

MEMORIAL EXHIBITION OF PASCIN

IT IS fitting that New York should give a memorial show to the late Jules Pascin, for of all the internationally known painters of this period, he was the one most tied by bonds of sentiment to the city's life. This was more than the mere accident of his American citizenship, which was one of the exigencies of the late war, and was undertaken, paradoxically enough, so that he could the more quickly get out of the country and return to France, the land of his adoption.

But in spite of the fact that he was only nominally an American, he had an undoubted affection for the New World, its pictorial aspects and its people. Some of his most ardent friendships were contracted here and he remained faithful to them, in his fashion, to the end. He had one or two ennuis, naturally, at the beginning of his stay, due to a suddenly restricted income, to an unfamiliarity with the language, and to some of the war fears that he brought with him. But after a while he made friends, chiefly among the artists — for as Mr. Crowinshield has pointed out, he was essentially an artist's artist — and then he was happy.

They surrounded him with the atmosphere of belief and interest that go so far to fortify an artist. It is this atmosphere of "belief" that is so readily obtainable by all artists in Paris and which is the real secret of that city's supremacy in the arts. Pascin was the most modest and unselfish individual

in the world, but nevertheless he could not but feel flattered and comforted by the open-eyed admiration that met him everywhere. He was a hero, of course, in Paris, but he was a hero among ten others. Here he was elevated to the chief position, the only unmistakable hero we had — of international fame, that is.

We also paid him the dubious compliment of imitation. That is the one chapter in the history of our relationship with Pascin that we shall have to live down. Too many of our susceptible artists copied the Pascin style. It got them practically nowhere, so the individual sinners need not be mentioned. Besides, everybody knows them.

It is likely that Pascin dreamed of Havana and New Orleans before crossing the Atlantic, but it was the realization that the New York winter can be formidable that quickly drove him South. New Orleans, oddly enough, was something of a disappointment to our artist. Possibly because it was too completely artistic in itself; "ready made" as Matisse felt Tahiti was. The artist always wishes to get in his word, you know; but neither Pascin in New Orleans nor Matisse in Tahiti could get in a word edgewise.

In Key West and Miami Pascin "connected." He simply adored the free, animalistic movements of the colored natives. In Havana, where he was to go later, his rapture continued. He had the delight of a discoverer, and he recorded the doings of the halfbreeds in clear-cut and rhapsodic lines. It was after his second visit South, I think, that I called upon him to see his work, and was amazed to find that Pascin had a steamer trunk full of extraordinary drawings. There was matter for several large exhibitions, and I foresaw a sensational Parisian success if they could be shown in the City of Light.

I am not aware that this ever occurred. There were of course plenty of Pascin exhibitions in Paris later on, but I do not recall one exclusively of Cuban subjects. I still hope that this may be managed some day. In the meantime it is pleasant to see some of them again in the memorial show that is now open to the public in the Downtown Gallery.

This memorial has been surprisingly well managed. That is, it surprises to see so many important paintings by Pascin in this country. At the time of his stay in America he had accomplished but few of them, most of his energy having been spent upon the delectable drawings. Although the themes

of these paintings are not greatly varied, the moods are; and so the exhibition gives you an excellent idea of Pascin's power as a painter. It is not likely that a better collection will be made, nor that they can be more sympathetically shown.

The charm of the pictures is the dream-like quality that seems to surround youth. Adolescence had a peculiar fascination for this painter, and he never tired of its poetry. The pale, delicate tones are far from being evasive, and they answer to all the tests that are put upon works of art, in a masterly fashion. For instance, though they seem sometimes to have been blown upon the canvas with a delicate breath, they photograph unerringly well, and in the shadows of dusk, the forms still hold true. The drawing is about the most sensitive drawing of modern times. It has the quality of great calligraphy. From the beginning of Pascin's career, this was so. His style truly seems to have been born in him. It was himself. And it will live.

The New York Sun, January 3, 1931

CONTEMPORARY GERMAN ART

THE GERMAN show at the Museum of Modern Art is a difficult task well done. No one who has not tried to send a typical collection of American art to Europe will quite realize what the modern museum and the Germans have now accomplished in reversing the process. What the living Germans take seriously in their current production is here intelligently put before us. It is up to us to take it or leave it.

My advice, founded upon an experience of only two or three years, to those who would "leave it," is — not to leave it too abruptly. If your first impulse is to reject it — forbear. There

really is matter here for your consideration, and which you will be obliged to consider sooner or later, so why not begin the study now, open mindedly? You will, for one thing, almost instantly discover that this new effort of the Germans to secure a place in the sun is only our own problem all over again, for we, too, have been barred from world recognition in the congress of arts and any effort of another nation to seek a new path up Parnassus is bound to be interesting to us — is bound to suggest ideas to us.

I say "forbear" because I didn't do it myself, at first. Until quite recently I had a distaste for German art that was quite too much for me. There was a certain grossness and hardness that I instinctively sidestepped. It was not a sufficient recompense, I felt, for the vigor, which was undeniable. Then I began making exceptions. I fell in love with the work of Paul Klee, who seemed to me a Chopin in paint. Later I began to see things in Camperdonck that I had not seen at first. Now I think him an excellent artist and the "White Tree," which is lent to the present show by Miss Dreier, is certainly a prize.

Then I began acknowledging, perhaps a little reluctantly, the undoubted power of Max Beckmann, Karl Hofer and Oscar Kokoschka. On the present occasion, I am distinctly tempted by George Grosz, and to a lesser degree by Ernst Kirchner. Of course, all along, I have accepted Georg Kolbe as a conspicuously successful sculptor; and in fact have regarded the Germans generally as able in sculpture. And so, when an American who started out with a prejudice against Teutonic art accepts Paul Klee, Camperdonck, Max Beckmann and Georg Kolbe, it begins to be apparent that the Germans are in a position to engage in international talk. I wish that the Germans would as frankly accept four living American artists. I do not, however, hold this remark over them as a threat. If they don't see us it's their loss.

Max Beckmann's paintings are the most dominant in the present collection and there will be many new people to concede that the style is sharply distinct. His pictures rely more upon power than upon charm. In that they follow a recent trend in Paris. Picasso, the most dynamic personality in contemporary art, has been minimizing charm, too, but however powerfully he speaks he always says something. In the great world, a forceful proclamation always takes the lead. It's the old story of Caruso and Clement. Many connoisseurs thought

the delicate Clement the finer singer of the two, but the vast
public was never able to hear him. They all heard Caruso,
however. In Beckmann's case there is still a suspicion that he
is more concerned in making a noise than in saying some-
thing. He does, however, unquestionably make a noise.

The impressiveness of the sculpture leads one to believe
that this is an art that lies well within the German grasp.
Kolbe, De Fiori, Barlach, Sintenis, Belling, Marcks; all are
able. The thing to be noticed by our struggling younger sculp-
tors is the way these Germans define their basic ideas before
starting to work. There is no fumbling. It is all definite, and
in the end, easily read. De Fiori's clever portrait of Marlene
Dietrich arrives at an opportune moment to share in the ap-
plause that is everywhere given to this actress; and the same
sculptor's portrait of Jack Dempsey recalls once more the
strange apathy of our own sculptors toward the superb ma-
terial the boxing ring presents to them unavailingly. They're
already beginning to say that Jack's marvelous legs are no
longer what they were, and soon this opportunity to rival the
ancient Greeks will have completely passed. However, as far as
sculptors are concerned, Young Stribling, Ernie Schaaf and
Chester Matan are almost as good.

The New York Sun, March 14, 1931

OPENING OF THE WHITNEY MUSEUM

THE STARS in their courses conspired to favor the Whitney
Museum of American Art. The sign was right. The fates, from
the very beginning, were amiably disposed. The grand opening
was grand even beyond expectation. President Hoover sent a
hopeful letter, ex-Gov. Al Smith, in person, confessed to a

distinct partiality for native art, and the great Otto Kahn looked in on the affair and saw that it was good.

There were about five thousand others in attendance who cheered to the echo every hint of patriotism. The entire five thousand came in automobiles. The crush of motors was beyond belief. West Eighth street was, in the words of Henry Schnakenberg, an old resident, "as it never was before." The merchants on the street gave up all thought of business and joined the throngs on the sidewalks to gaze at the unwonted spectacle. It was grand, all right.

The five thousand, naturally, didn't see the pictures very well, but they saw each other and expressed enthusiasm unanimously for "the idea." At present the idea is more important than the pictures. Mrs. Force, the director of the new institution, in a frank little speech at the preliminary banquet that was given to the art critics of the nation, spoke of the enterprise as a "gesture," and added that the true test of the gesure could be made about twenty-five years hence.

Neither this remark nor this banquet were propitiatory. Propitiations, in this case, were unnecessary. The art critics and the public at large were completely won at the first announcement of the museum that was to be. The announcement was like a battle cry to which the only answer could be another hurrah. The only alternative, to the unthinkable minority, was a trip to Leavenworth, but so far no traitors have been unearthed. We have been as solidly knit into one party by this occasion as the British were at their last election.

This party-spirit smoldered all summer long only to burst into flame at the beginning of this season. The number of dealers who intend to handle the native production increased over night astonishingly and the word "American" has become, über alles," the word to conjure with. Of course it wouldn't be a party-movement without some exaggerations. I heard one reputedly intelligent young man exclaim, heatedly, "I'd rather have a poor American picture than a good foreign one," but the cool weather which the experts are now promising us definitely will doubtless bring this young man and his friends to a truer sense of proportion. The fact is, we all desire a place in the sun but not the sun itself, which will be permitted to shine as heretofore on such territories as the League of Nations approves of. The main thing is we've got our place in the general scheme at last.

Mrs. Whitney, with a generosity unsurpassed in history, has supplied "the works," but it is up to us to keep them going. If, on the day of judgment twenty-five years hence, this museum shall be found wanting, it will not be Mrs. Whitney who has failed but we, for it is generally agreed that a nation and a period get the kind of art they deserve. We shall even be responsible for the choice of artists, since the times have greatly changed since the days of Mrs. Whitney's great predecessor, Lorenzo. We are no longer docile and we dictate even the benefactions we receive.

"The works," if I may be permitted so affectionate a term for such an impressive machine, are exactly calculated to our present need. They are easy to enter. They are right on the street, without lofty porticos and chilling entrance halls. The installation is rich, but not too rich. There is a comfortable feeling of prosperity about the rooms that will no doubt aid many people to trust the pictures more completely than heretofore, and this is very fortunate since many of the pictures are of the sort that nice people have not as yet sufficiently trusted.

In fact, the first phase of the Whitney Museum of American Art's "gesture" seems to be in the direction of our lesser known man. The collection has been greatly augmented and strengthened during the year of preparation, but the bulk of these works of art were acquired by Mrs. Whitney during the years of the Whitney Studio Club's activities, and were acquired as much for the promise as for the performance that lay in them. In the strict sense of the term many of them are not museum pieces. But it is altogether excellent that they were purchased when they were purchased and it is altogether excellent that they are shown now. If one were to wait until an artist becomes an acknowledged master there would be no sense in making the purchase at all — at least for such a museum as this, whose business is to make reputations, not to embalm them.

So the comfortable and enticing conditions under which the work of a whole horde of promising young artists can now be seen are achievements already to be thankful for. The unthinking demand "old masters" at once, but the unthinking are not aware that masters are never isolated and unattached, but are the choicest specimens from a whole forest of endeavor. Much art is necessary, and all kinds of it, to the com-

munity that produces geniuses. The freedom and lack of convention that has guided these purchases are the greatest possible auguries for the future liveliness of the museum. A contemporary museum that is stilted and pedantic is — well, it is not a museum but a morgue.

Some of the most advertised of our present celebrities are not represented by outstanding examples of their work. Eventually they will be — or it will be their own fault. There will be plenty of time later on in which to discover "holes" in the representation, if there be any, and to make suggestions for remedying them, but, in the meantime, and even in the crowded attendance of these opening sessions, it was possible to notice a few men who stood out exceptionally well from the walls.

Among these who already better their reputations by this event are Edward Hopper, Niles Spencer, Stuart Davis, Louis Eilshemius, Joseph Pollet, Henry McFee, Reginald Marsh, Charles Rosen, Vincent Canadé, Bernard Karfiol, Gaston Lachaise and Cecil Howard.

By way of background to the work of living men a group of paintings by artists whose careers have ended has been included. It is scarcely likely that much of this museum's energy will be spent on backgrounds, but the inclusion of two works by George Bellows and Arthur B. Davies will be generally thought appropriate. The Bellows is the well-known "Dempsey-Firpo Fight." It is a picture that is destined to interest posterity because of the event but not aesthetically. It can be accepted, with many reservations in regard to the color and the composition, because of the reflection it gives of the forceful personality who painted it — a personality that is still potent in our midst.

The New York Sun, November 21, 1931

AMERICAN PRIMITIVES

THEY TELL me that the younger artists are taking great comfort in the collection of early American paintings now being shown by the Folk-Art Gallery at 113 West Thirteenth street. They acknowledge the little-known painters to be their great-grandfathers and great-grandmothers and seem to relish the fact that at last they have an ancestry.

This feeling is comprehensible enough. Somehow it recalls a remark I once heard back in the period of the late Mrs. Jack Gardner, for I am a survivor from that epoch. Mrs. Gardner, however, was not the one who said it. She who did was a radiant beauty of the type that used to be known as a "society belle." On being asked, on a particular occasion, why she felt so gay, she replied: "I am happy to be a woman. It gives me great satisfaction to know that men like me just for that." At the time I thought that this was one of the most brazen remarks I had ever heard uttered, but as time goes on, and pure womanliness becomes scarcer than it used to be, the fleshly philosophy of the lady seems less reprehensible.

At any rate, her principle applies nicely to ancestors. We don't ask anything of them but that — to be ancestors. Their little sins and shortcomings are immaterial. They are our forebears and that is enough.

In all the extraordinary emancipation of the present era, with illusions dropping from us at every step, ancestors still persist. In fact they seem more necessary than ever they were. So, doubtless, our younger painters are quite right in thus hitching on to history. Conscious that they have a definite background they may make more confident gestures.

But they might go farther into the matter than that. They might see that these early and little-taught artists had ideas, convictions and above all, distinct points of view. The great error of modern art instruction is that it erects a barrier between the student and life. It teaches so many "musts" that the pupil is never afterward certain of the "cans." Our grandparents had no such embarrassments. Life was not then so

completely organized in these States that the experiences of one were common to all. They each had things of moment to tell. Today the individual has to go farther in the search for things to tell, but, even so, individuality is still a thing that may be achieved.

All the early pictures in the present display invite smiles and affection both. The portraits are always vital and assured, and if the painter was unembarrassed by not knowing precisely how to draw a foot, neither should we regard the predicament as fatal. Beauty depends upon larger matters, and all these painters had ideas of beauty.

Joseph Pickett, who, in his "Manchester Valley," shows the first railroad train entering New Hope, Pa., gives the railroad engine an intrepid look as though it were a gazelle leaping from rock to rock, yet nevertheless has such earnestness in his account that you unhesitatingly accept his version of the affair. Edward Hicks, author of "The Peaceable Kingdom," a picture in which the lion and the lamb and a lot of other animals lie down side by side, and William Penn and the Indians converse amiably in the distance, is another who has so much conviction that your own weak doubts are swept ruthlessly aside. These pictures, if they teach anything, certainly teach the importance of being earnest.

The Gallery of Folk Art in its researches is endeavoring to classify and place the early practitioners of the arts, and among the others has been doing some work on the subject of Raphaelle Peale. This disregarded member of a well-known family of artists signs an early still-life of a bath towel with bits of the bather showing here and there, which is thought to be one of the earliest still-lifes painted in this country. It is so well realized, or at least the towel part is, that all the "primitive minded" will look upon it with extreme interest. In fact, even those who are not as yet "primitive minded" ought to concede that it contains good work.

The New York Sun, November 19, 1931

PORTRAITS BY ORPEN

DAT OLE debbil Vainglory has a lot to do with the art of portraiture, but on the other hand, if Ecclesiasticus is to be believed, Vainglory has a lot to do with everything. Sins in which we all share are venial. Vanity, after all, is not a penitentiary offense, and only he who has never sat for a portrait can afford to scoff at him who hath enjoyed seeing his flesh exactly rendered.

So whatever else it may be, the present occasion of an exhibition of portraits in the Knoedler Galleries by the late Sir William Orpen, is not one on which to pin a mockery of the rich and important Americans who succumbed to the insidious flattery of an immortalization on canvas by the most precise portraitist of this generation; though one cannot resist surmising what they thought of their experiences after Sir William had finished with them. One can only surmise; one will never know.

Portraiture, it has been said, is a competition in willpower between the painter and the sitter, the painter striving to glorify himself and the sitter insisting on being himself the protagonist. Others say, especially when the picture turns out to be a real success, that it is a matter of cooperation between the two parties to the affair. No doubt every cultured person, on mounting the model-stand, fully intends to cooperate, but those secret, inner forces, about which we all now know so much, tend to develop in the gentle sitter only too often what the artist must regard as — misbehavior. Was it not John Sargent, the most petted and indulged of all our recent artists, who defined a portrait as "a painting in which there is always something wrong with the mouth?"

In a Sir William Orpen portrait there is never anything wrong with the mouth. There is never anything wrong with anything. Of course, that is the trouble with them. The sitter is so tremendously pleased with the result that nobody else is pleased at all.

And yet, in all these instances spread out before us so

impressively on the walls of the Knoedler Galleries, who wins the competition, the sitter or the painter? I vow I am scarcely prepared as yet to settle this matter even to my own private satisfaction. I am not in possession of all the facts. One thing, at least, stands out quite clearly: Sir William was not a human being at all, but a machine. In a way, that exonerates the sitters, don't you think? You can't hypnotize a machine so you can't say that they put themselves over on Sir William.

Machines, on the other hand, are not choosers, and there was one slight element of choice in Sir William's work that was not quite biased enough to enable us to classify him among frail humans like the rest of us, and yet not pronounced enough to imply that he had a weakness as a machine. I refer to his apparent predilection for power in persons. He did seem to relish what are known as human dynamos. I mention this apologetically, as I wish to make out as good a case for Sir William as I can.

James Stephens, the Irish poet, used to say years ago that Sir William had the best eye in the world for seeing but what he saw wasn't worth seeing. If James Stephens were here now I think he would be the first to modify this statement, for at the time he made it Orpen had not seen all these wonderful Americans, and unquestionably they were worth seeing. Going about in the Knoedler Galleries from one effigy to another one cannot resist the thought that these are the very people who made this period what it is. If not all of it, they were at least a large part of it.

Hard, relentless, dominant perhaps. One needs such qualities in these days not only to get anywhere but even to guard what one has already got. Is it a reproach? Is it a reproach to be a success? Nonsense. You wouldn't consider it a reproach to be thought another Lorenzo the Magnificent, I am sure; and the busts of the early members of the Medici family show them to have been as like our great men of affairs as peas from the same pod.

The New York Sun, January 23, 1932

COMEBACK

FOR THE HUDSON RIVER SCHOOL

IT WAS inevitable, after Holger Cahill's fine work in convincing the public that there was genuine aesthetic interest in the productions of the early American primitives, that something should be done in the way of restudying the despised Hudson River School. The present exhibition in the Macbeth Galleries is a step in that direction. There must be more of it before scholars can come to definite conclusions, but already there are clews.

The term "aesthetic interest" which has been applied to the American primitives does not commit one too much and can be used with equal justice on the Hudson River men. There is no suspicion as yet that any of them can be ranked among the great landscapists of the world, but even without supreme merit of that kind it is apparent that some of them — not all — can claim "aesthetic interest," and besides that, help us to know ourselves. They are an essential link in the historic chain which it seems has never been completely without "aesthetic interest."

Just why we threw the entire Hudson River School out, bag and baggage, about forty years ago, is a matter for psychologists to bother about. It seems rather funny now. We suddenly grew ashamed of them. It was not that we realized that no one of them was a Ruysdael or a Claude Lorraine, but merely that we had discovered them to be insular. They lacked a fashionable touch, they lacked what the French call "chic." The first great excursions of artists to Paris had begun and when Chase and Weir and Whistler and Sargent began to show their modish wares we hastily swept the Hudson River landscapes into our closets and denied that we had ever been like that.

We were very susceptible to criticism in those days, which shows that we were not quite sure of ourselves. We foamed with fury when Charles Dickens found a few flaws in our

social system and were still able to be annoyed many years later when young Rudyard Kipling again took exception to our way of doing things. It is only comparatively recently that we have learned to keep cool under criticism, and now when Bernard Shaw and Aldous Huxley make unkind remarks about us we simply say, "Oh, yeah?" and let it go at that. It was the last great war that taught us our true position in the world. Whatever else that war did to Americans it at least gave them a keener sense of the word "home" and a keener appreciation of everything that led up to our having a home.

Now that we are at last willing to stand upon our own feet, it is to be noted that the very expressions we once feared were provincial have become dear to us. This phase can be noted in literature as well and explains the prominence that is given to Sherwood Anderson's work, which is not only not chic but appears to studiously shun the chic.

In taking up again with our past, however, it does not follow that we take up all the past. Time is an editor. Freed from the contemporary prejudices of a former period we look at it in a detached way and accept only the livelier items. There is agreeable drama in the "Conway Valley" and "The Valley" by John F. Kensett in the present exhibition, as well as in the "Storm Clouds" and "Harvest Scene" by Jasper F. Cropsey and the "Foothills of the Catskills" by William M. Hart, but I think that most people who share the taste of today will remain cool to such things as Albert Bierstadt's "Rocky Mountain Scene." George H. Smillie's "Wood Interior" and Thomas Cole's "West Point."

The point is that no subsequent and amiable generation can put life into the work of a former period if it did not have it in the first place. A work that is stodgy in the beginning remains stodgy. A rigorous division can be made between perfunctory painting and painting that has drama in it, and as time goes on, the division becomes more and more rigorous. There is, to be sure, a second chance for certain inexpert artists when their subject matter becomes quaint, but even this implies an original and personal outlook. The one deadly sin is perfunctoriness.

The present exhibition seems to invite some critic with a constructive turn of mind to go into the Hudson River School more deeply. It is time the sheep that abounded in that pasture were separated completely from the goats. The fact

that Mr. Macbeth was obliged to borrow many of his specimens from public collections implies that the museums are already upon the trail. They can do more about it, however. A roomful of pictures by John F. Kensett, Jasper F. Cropsey, Jervis McEntee, William M. Hart and David Johnson would not be a handicap to any American gallery.

The New York Sun, February 6, 1932

EILSHEMIUS AS A CULT

READERS OF The New York Sun are not unaware of the name of Louis M. Eilshemius. In fact, readers of The New York Sun know the name better than most people. But they associate it with literature. They think of Mr. Eilshemius as a letter writer. He has been The Sun's most assiduous correspondent for years. He wrote on all sorts of subjects, but chiefly on the supremacy of Mr. Eilshemius as an artist.

These letters had such a curious tone and made such astounding claims that I think they bewildered even The Sun's editors at times. Just who had the courage to accept them first for publication I have never learned, but I suspect it to have been Mr. Kingsbury, who was on The Sun in the early days, and who had a subtle feeling for humor and literature. At any rate, The Sun was vastly entertained by its novel correspondent for some years and then, possibly thinking that enough of even a good thing was enough, decided to drop him. Somehow this was not so easy. A newspaper's readers are its emperors and their will is law; and The Sun's readers had acquired the Eilshemius habit. The letters, as you must

have noticed, have recently reappeared and, the tone of them is as unabashed as ever.

But all this is mere prelude to as curious a story as you would care to read. There was no indication that the admirers of the letters took the claims that were made in them for Mr. Eilshemius's art seriously. I never heard that Mr. Kingsbury ever bought one of the pictures or walked half a block out of his way to see one. That, it now appears, is where Mr. Kingsbury made a mistake, for many people, at this late date, begin to say that the pictures are very good indeed and that the artist is quite justified in refusing to assume hypocritical airs of modesty in speaking of his work. The letters are just as quaint as ever and it is still all right to laugh at them, but unconsciously one laughs with them instead of against them when one learns that the artist really is a good artist and that the letters, all these years, have been a sort of an antic disposition assumed to pierce the skin of an indifferent public.

Why the pictures of Mr. Eilshemius were rejected for an entire generation is easily enough explained. The artist's ideas, feelings and manners were helplessly American, and they were brought forward in a period when it was fashionable not to be American, when the painters were all struggling to be European and when Henry James, Whistler and Sargent preferred having London residences rather than New York ones. There was not a touch anywhere in poor Mr. Eilshemius's paintings that was fashionable – there is not to this day – but there was much that was poetic. In fact, the despised Mr. Eilshemius is that rare thing – a genuine lyric painter.

In the dozen years or so since Marcel Duchamp and the Societe Anonyme discovered the true worth of Eilshemius in the exhibitions at the Independents, there has been a steadily increasing band of converts, and lately there is evidence that some of the young people are making a political cult out of the affair, all of which may help the cause of the artist and incidentally the young people engaged in it. However, young people dearly love "a cause" and, once persuaded themselves, like to make it as difficult as possible for the enemy – i.e., those not yet converted. These outsiders, hearing so much noise, are sure to inquire into the matter and, as like as not, will be confronted at first with the less-acceptable paintings, for Mr. Eilshemius, in a long life time, has painted an enor-

mous number of pictures, not all of which are equally suscept-
ible to fame.

Consequently, these honest outsiders who may some day
be converts might as well be told at once that Mr. Eilshemius
is a simple man who evolved a delightful way of painting all
by himself, in the course of which he made one or two obvious
challenges to pictures that were being acclaimed at the time
when he was being rejected by officialdom. Curiously enough,
Ryder, the artist with whom Eilshemius is most akin, was the
object of his envy, and so there is no occasion to make much
of the discrepancies between the "Flying Dutchman" and the
picture in the Whitney Museum which Eilshemius painted
in emulation of it, and in the "Macbeth and the Witches,"
which derives from the same competition.

Instead the seeker should go at once to the long series
of mellowtoned pictures that record the artist's adventures
in the South Seas. These works please lastingly. They are not
intellectual, like the performances of Mr. La Farge in the same
region, nor erotic, like the canvases of the recent Mr. Gauguin,
but simple and youthful ecstasies that have an unmistakable
singing quality though expressed in paint. The pictures have
so little "side" to them that one suspects that these are just
the sort of pictures the Samoans might have painted of them-
selves had they been versed in this particular medium. But
with all their simplicities of painting, the color has a peculiar
and vital vibrancy, and the tone of the work impresses you
more each time you encounter it. The chances are, once you
have accepted these South Sea pictures, you will go on to ac-
quire a special affection for all the works of the artist, for there
is a rusticity to them that is especially attractive in these days
of our first rebound from "the culte de Europe."

The Eilshemius paintings are now being shown in the
Valentine Galleries and the present group will be replaced by
another set a little later on, as the Valentine Galleries are
eager to put the whole "oeuvre" before the public.

The New York Sun, February 27, 1932

BEN SHAHN'S THE PASSION

OF SACCO AND VANZETTI

GOOD SHOWMANSHIP must be accredited the Downtown Galleries for putting on the "Passion of Sacco and Vanzetti," by Ben Shahn. Mr. Shahn himself must be allowed one of the genuine hits of the season. It is not often in these days that an artist has the sense of speaking directly to the people. Rivera did it in Mexico, and now Shahn does it in New York. It must be a great satisfaction to him.

The exhibition has been largely attended, and by unusual people. They behave before the drawings as though they were in church, and when, on the occasion of my visit, I indulged in a little light conversation with Mrs. Halpert over by the desk some of the visitors turned upon us reproachfully as though we were misbehaving in a sacred edifice. We promptly subsided into awed silence, for, after all, the seriousness of the students merited respect.

All this is certainly a triumph for Mr. Shahn. I am not a communist myself, and I thought the Sacco and Vanzetti trial was conducted fairly, but that does not prevent me from taking an unholy joy in Mr. Shahn's violent arguments to the contrary. It is rather amazing to see how he makes his effects. He has depended upon photographs, naturally, and he reflects the photographic feeling in a way that is practically burlesque and at the same time attains to extraordinary sincerity. As an artist he half laughs at his distortions, and yet the feeling back of the work is that of the zealot.

It is this feeling that gets over "to the people." The partisans are so persuaded that Mr. Shahn is on their side of the argument that their first impulse, being partisans, is to deny that there is any distortion or burlesque anywhere in these water colors, and no doubt they will say that the dreadful portrait of Judge Webster Thayer is entirely too good for him. Well, Boston is going to have a grand time with these novel works of art, for I hear they are to be shown there.

The New York Sun, April 16, 1932

MOTORIZED CALDER

WITHOUT IN the faintest degree intending it as a reproach to my country, I say that Alexander Calder's sculpture, now being shown at the Julien Levy Gallery, could scarcely have been brought to its present state of detachment from life here. In spite of the fact that this sculpture looks like machinery and moves like machinery, it is scarcely the sort of thing that we Americans would be likely to encourage.

It needed the dark, dull afternoons of a Paris winter for its inception, and needed them also, once the work has been finished, for its appreciation. We really have too much sunshine in New York during the season. There are so many more interesting facts presented to us than we can cope with, that we have no energy left for chimeras. Not even for chimeras that resemble instruments of precision in a laboratory built for Prof. Einstein. But I insist this is not a reproach to us. Every country has its specialties, and if the livid atmosphere of Hollywood gives our cinema a special cachet, then we won't moan because the murky air of Paris also has its uses. If we find that we need these moving sculptures of Mr. Calder for the betterment of our souls, then we'll import them. There'll be no harm in that.

But first we must be sure Mr. Calder is serious. It is too bad that Marcel Duchamp is not in this country. He would have been just the parson to preach Mr. Calder's kind of truth. When Marcel was here we almost got to the point of thinking that art consists of things rather than the painted reflection of them, but he went away and all of us but Walter Arensberg of Los Angeles and Katherine Dreier of Connecticut backslided. Now, it seems, we shall have to begin all over again.

At any rate, we can be fascinated at once by the cute little motors that run these disks and wires and small planets. They are no bigger than your fist. And the Saturns and Jupiters, if that is what they are, move so lazily on their orbits, that, too, is fun. You see, I too was in Paris once and

somewhat get the idea. The extraordinary remoteness of this small power that has been translated into motion reminds me of a Stravinsky piece I once heard played by the Lange Quartet, a piece so pianissimo it could scarcely be heard, yet, for all that, with a recognizable purpose that finally breathed out its design. It suggested the quiet business of a fish in deep water, or the ardent but noiseless activity of a spider. With such things, these abstract sculptures, I am sure, have affiliations. Not that they imply fish or spiders, but they suggest a set of values borrowed from some other world than this.

"Slight," will be the hard-boiled, native art-appraiser's comment on this, "very slight"; and possibly in the final analysis young Calder's work may turn out to be so. For all that it is well to remember that one cannot have cake and eat it, too; and if one must be hard-boiled and estimate everything in dollars and cents then one must expect to lose a great deal that is playful. Paris still has the capacity to play with art and the things that fringe upon art, and it is that that makes her so comforting and comfortable for artists.

As for young Mr. Calder, we don't have to do anything in particular for him, since Paris has quite adopted him, much as she adopted Man Ray some time previously. There is no sense in lamenting these two artists as expatriates, since we cannot provide them with the sustenance necessary to their mental existences; and Paris can. Both have become as complete Parisians as Picasso, and it is to be noted that the loud acclaim for their inventions does not come from American friends but from the French themselves. This is quite as it should be; for there are always these two sides to expatriatism. If an American artist must live in Paris for his soul's good, that's his affair; but in doing so he automatically becomes French and must gain French support rather than live, parasitically, upon funds from home.

The New York Sun, May 21, 1932

KANDINSKY'S FIRST ONE MAN

EXHIBIT IN AMERICA

ALTHOUGH KANDINSKY'S work became known in this country twenty years ago, making one of the outstanding successes with the connoisseurs at the time of the famous Armory Exhibition, it has never been exploited by the dealers and consequently has never achieved the publicity it deserves. The exhibition given him this week in the Valentine Gallery is the first one-man show he has had in America.

Yet during all these years Kandinsky has been a constantly increasing influence upon artists of the modern school, and all those who deal in abstract art yield him high praise. The remarks of Diego Rivera, quoted in the catalogue, are both touching and typical: "One day Kandinsky will be the most familiar and the best loved by men. I know of nothing more real than his painting – nothing more true and nothing more beautiful. The painting of Kandinsky gives the maximum of possibility for the dream and for the enjoyment of matter." The slight tinge of foreignness in Rivera's language makes the tribute all the more appropriate to an art that also has its foreignness.

For Kandinsky deals in the abstract. He is a genuine painter – any one can see that who is sensitive to what painting is – and he is a gorgeous colorist, but he is so imaginative that he long ago left the world of commonplace ideals behind him and now speaks in symbols that can be understood by the sympathetic but which sometimes baffle the lazy.

Kandinsky's work is serious, in fact, solemn. He seems to seek for a pure beauty that is part of light itself, and will be understood consequently wherever light penetrates. It is a language, he hopes, suitable for conversations between the stars; suitable even for prayers. That is why he is solemn. He apparently gives no thought to the ultimate use of his pictures, as the Parisian painters do who live in the gay world and see their works, even in the midst of creating them, already adorn-

ing the boudoirs of the fashionable. So when the day comes that Rivera speaks of, when all will love Kandinsky, it will mean that we are living in a better world.

The New York Sun, November 12, 1932

THOMAS BENTON'S MURALS

AT THE WHITNEY MUSEUM

WITHOUT BEING much carried away, personally, by the Thomas Benton decorations for the Whitney Museum's library, I can nevertheless discount my personal tastes sufficiently to see very definitely that these murals are the most important outcome, to date, of the Whitney Museum enterprises.

They are going to horrify the refined portion of the community, for they are pure "tabloid" — if a tabloid, from any viewpoint, may ever be thought "pure" — and they are going to rejoice the souls of those restless illiterates who "march on Washington," bomb judges and otherwise annoy the government — if restless illiterates, from any viewpoint, may ever be thought to have "souls." In short, these mural decorations of Thomas Benton are "red."

This atmosphere of rebellion is produced, not by any direct reference to the proceedings in the law courts, but by a caricaturish insistence upon everything that is hectic and rowdyish in the American system of living. There isn't a single reference to the rewards of virtue or the charm in ordered living. There is no order whatever in Mr. Benton's America. It is all discord, temporary excitement, roughness,

and vulgarity. He even paints into his panels the words of certain songs that are broadcast, such as: "Ain't gonna let no one woman make a fat mouth out of me" and "I'll shoot poor Selma just to see her jump and fall"; and adds by way of benediction: "And it's all good enough for me."

There you have the weak spot in Mr. Benton's philosophy. There is no denying the fact that vulgarity is a part of life and even has a necessary place in life, but it is by no means the whole of life. Quite evidently the artist thought, in all this, that he was being broadminded, like the Walt Whitman who accepted everything, who was the poet for "the foolish as much as the wise," who was "stuff'd with the stuff that is course and stuff'd with the stuff that is fine"; but, alas, in accepting only the vulgarity of life one is far from being broadminded. If Mr. Benton will take another look at the "Leaves of Grass" he must discover that Whitman balances every ugly thing with a beauty, every ignoble thing with something that is noble; that, in short, he keeps the balance.

The painting of these panels is quite as raw and uncouth as the subject matter. Any one who has been educated to what has heretofore been considered "style" in painting must shudder at Mr. Benton's cheap colors and the unnice manner in which they have been banged upon canvas. By style I mean the sensitiveness in the use of the pigment that is seen to perfection in the works of such masters as Frans Halls, Velásquez and El Greco, a sensitiveness that results in making each square inch of a picture pleasant in its own right and merely as texture. Mr. Benton disdains, or perhaps is incapable of, such graces. He is as remote, in painting, from Frans Hals as Theodore Dreiser is in his use of English from Walter Pater.

In spite of all this the choice of Thomas Benton to do the murals for the library is the wisest thing Mrs. Whitney has done since she has been running a public museum. Vulgar as are the subjects the artist has chosen to depict, and caricaturish as is his manner of depicting them, there will not be lacking those to whom both subject and manner will be acceptable in a way that a Frans Hals subject and manner never could be. The times, in other words, have changed.

The Sir Philip Sidney type, who was all grace, has definitely vanished. So why should we be surprised that grace has disappeared from modern painting? I hate to add that "the

gentleman" is also obsolete, for the word "gentleman" is still frequently upon our lips and is, at intervals, still potent as a tradition, but there is no escaping the fact that the entire civilized world is busily engaged in the effort to understand and cope with the vast submerged portion of the populace that used to be inarticulate but is now anything but. I mean, of course, the working classes.

To attempt to bottle up these protesting rebels with their grievances is bad politics. To make martyrs of them is, after all, to make martyrs of them. It is far better to invite them to "free speech," and it is highly practical to encourage them to affiche their ideals in public places so that they themselves, in the course of nature, may tire of them. Unrelieved vulgarity without the presence in the picture of a gentleman villain is, after all, monotonous.

The mere fact that I go on like this shows that the artist has hitched his muse to at least one of our band wagons. He may retort that it is too much to expect one muse to propel the entire circus. That may be granted. Even grasping at one phase of our many colored life is something, however, and suggests that the artist, if he chooses, can still have his say. That Mr. Benton's "say" will attract attention and acrimonious discussion is its best point. Other artists, envying this desirable publicity, may be encouraged to say something, too.

The New York Sun, December 10, 1932

MAURICE STERNE IN RETROSPECT

MAURICE STERNE was born at Libau on the Baltic in 1878. In 1889 he came to New York. In 1904 he went back to Europe

for a few years of study. In 1908 to Greece and the monastery at Mount Hymettos. In 1911 to Egypt. In 1912 to Burma and Java. In 1914 back to the U.S.A. In 1917 to New Mexico. In 1918 to Anticoli, Italy. From 1918 to 1933 alternating between New York and Anticoli.

All this represents the struggle of an artist to find himself. It is a rather sad story, and Maurice Sterne is a sad person and there is a great deal of gloom and black paint in his pictures.

Consequently one must be kind. We must all be kind to Maurice Sterne. Worse than the not having a country is the not knowing what country one would like to have. On the occasion of the unveiling of his monument to the Early Settlers at Worcester, Mass., a lot of us New Yorkers went up to see it. As we filed in procession toward the big allegory in stone and bronze, my companion – a great friend of Maurice Sterne's, – said, on first catching sight of the monument, "How Italian!" I looked at him quickly to see in what sense he meant it. He meant it as a compliment. I immediately suppressed my wish to know if the Italians themselves would think it Italian. I immediately resolved to be as kind as possible to Maurice Sterne and to look on the bright side of everything. But sometimes the act of being kind involves nonthinking.

So I positively refuse to decide upon the nationality of Maurice Sterne. Many people, anyway, in the mental confusions following the great war, have begun to deplore nationality – to look upon it as a sin. In case such people have their way, in the future, then Maurice Sterne may ultimately become a great saint. I, on the other hand, intend to be a villain of the rankest description. I intend to be hundred per cent Yankee. So if that be treason to the new Utopia, make the most of it. In spite of Muriel Draper and Maurice Sterne I think America is just grand!

So, in looking on the bright side of Maurice Sterne, I'll say he is intellectual. Consequently, the part of his work that most attracts me is his drawing. Consequently, that portion of his exhibition that most impresses me is the section upstairs that is devoted to the studies for the pictures.

I have said frequently that nobody in America has a greater command over the mechanics of drawing than he, but, oddly enough, I've never been able to convince many young people of this. I hold that no matter what turn we may give to our expression it is useful to have possession of an adequate

technic. I think it is better to articulate a truth distinctly rather than to stutter it forth. Of course it is the truth that is the essential, and a stuttered truth is infinitely preferable to a perfect manner that contains no truth, yet for all that, I'm for good articulation when possible.

I said all this once to a young friend who was contemplating going in for art and recommended Maurice Sterne as a teacher of drawing. Instead of hearkening to me, however, my young friend joined up with Kenneth Hayes Miller and has had a heavenly time studying but has not as yet learned how to draw. Of course, one may be the best draftsman in the world and not be able to tell others how to do it. Or, it may simply be that Maurice Sterne, as a teacher, lacks what doctors call "the bedside manner." Not having seen him in action, I cannot say. But it remains a mystery to me why young people do not follow him in droves in order to see how a figure is constructed in true proportion.

But I never try to force public opinion; and particularly not when it is young. Instead of that, when the mass of youngsters say they simply won't study drawing with Maurice Sterne I begin to inquire as to what they may possibly have on their side of the argument. All that I have been able to gather, to date, is that a style that is perfectly adapted to Piera della Francescan subjects may, after all, embarrass a young person who is intent on doing cabaret scenes. I can see that a tragedy in a speakeasy, expressed in the idiom of Pollaiuolo, might unintentionally be comic. It seems to be a case of "O tempora; O mores."

The New York Sun, February 18, 1933

MORE PAINTINGS BY PICASSO

THERE HAVE been so few French exhibitions this year, of a challenging nature, that the sudden appearance in the Valentine Galleries of a group of hitherto unseen Picassos, together with the Roy exhibition at Brummer's, the Derains at Knoedler's and the show at the Marie Harriman Gallery, give this one very much the appearance of being a "French Week."

Apparently starved for a little news from the City of Light, the students have crowded all these exhibitions, and the rather acrid discussions that may be heard remind one of the old times. The Picasso show, as it happens, is difficult. Picasso always was difficult, and, I suppose, always will be. Certainly he shows no disposition, as the years creep upon him, to begin his reminiscences, and steadily and alarmingly explores new territories. The fact that the very early Picassos no longer seem to threaten us with the immediate dissolution of the world, seems to afford no assurance that the new works which we are now called upon to judge, will not bring down fire and brimstone upon us. We are that timid.

The fact is, to keep up with Picasso, one must be upon the spot. He snatches things from the Parisian atmosphere like a prestidigitator and arranges them into his compositions with an authority that impresses – Parisians; but baffles inhabitants of remotely outlying nations who do not recognize the things snatched nor approve of virtuosity applied to material that seems to them so foreign to art. There is a small group in every community to whom the things of the spirit are an open book, and to these the manifestations of Picasso are in no way frightening, but these blithe beings are in the minority. Their friends and neighbors overwhelmingly say that they do not understand Picasso in the least, yet insist nevertheless that Picasso is a bad man and his art a menace to polite society. All this is really just because they do not understand.

And for "those who do not understand" the only thing I can prescribe is a short residence in Paris itself, a thing that is becoming more and more difficult to accomplish, the times

being what they are; yet in Paris there is so much art in the air, as it were, that you breathe it in unconsciously, and the first thing you know you look upon technic itself as a language and comprehend what an artist means when he plays one brilliant color off against another without deigning to fool you at the same time with a rather stupid anecdote.

Elegance, beauty, style and power are distilled so plentifully in Paris that they are appreciated even when distilled — that is to say, "in the abstract." Stories are still told in Paris — I don't mean that the anecdote is obsolete — but certainly it is no longer permissible to tell an obvious story in an obvious way — the out-and-out bores have at last been done away with. But the main "article de Paris" of this period, the thing you have to go to Paris to get, is the natural interest and sympathy with technic itself, for unless you are able to enter wholeheartedly into the game that the artist plays, you are bound to miss most of the significant things of this time. It is possibly a handicap under which the art of this day labors, but on the other hand, the comprehending connoisseurs in every period have been few; few but influential. In the end they win.

So, as it becomes more and more expensive to go to Paris, I advise those earnest citizens who fail "to get" Picasso not to bother about him. It's too bad that they do not get him, but then, on the other hand, these same citizens in an earlier generation would have been indifferent to Herman Melville, and, still earlier, to William Blake and Beethoven and all other innovating artists. To appreciate the genius of the immediate present one must have a flexible mind, one must be able to recognize power when divested of its familiar trappings. As this willingness to meet life half way is rare most people forego the pleasure.

From such delinquents, therefore, I would hide the two or three very strange Picassos in the present collection, for they will be bothered by them to no purpose. Picasso is a strong painter, with strong whims and fancies, and when he sets out to depict some extraordinary dream-ladies on a beach, dream-ladies seen in a fabulous scheme of perspective, it is, as the phase goes, "just nobody's business" save the comparatively few who have already been won to Picasso's charm and take interest in any solution he makes to any problem.

On the other hand, the big abstract decoration seen on the wall as you enter can be recommended to the general

populace, or at least to that portion of it that takes delight, say, in the stained glass windows of Milan Cathedral. It has a stained glass quality. To be sure, there is no announced subject. But then the molten colors that are poured down on the cathedral floors tell no story, either, or at least every beholder gets a different story out of them.

The New York Sun, March 11, 1933

REGINALD MARSH'S BOWERY

THE REGINALD MARSH exhibition in the Frank K. M. Rehn Gallery deserves some kind of a medal. There is no Pulitzer Prize for the best exhibition of the year, but if there were this would win it. As there isn't, Mr. Marsh will have to be content with one of Walter Winchell's mythical orchids. I believe Mr. Winchell is the journalist who distributes orchids about promiscuously when pleased, and Mr. Winchell will surely be pleased with Mr. Marsh's work.

Mr. Marsh's work concerns itself with phases of the city life that are almost unknown to denizens of Broadway and the East Fifties. He extols (I'll explain that word "extol" later) the Bowery. Somehow the city is no longer Bowery-conscious as it used to be in the gay nineties when the youthful Harry Lehr took the aged Mrs. William Astor to a Houston street restaurant and shocked the "400" deliciously for a whole winter. Perhaps Mr. Marsh may revive the interest. His pictures, together with Mae West's film, "She Done Him Wrong," may again mass the limousines at vantage points along the Bowery where life may be observed in the raw. Apparently the Bowery is just as good – or perhaps I should say just as bad – as ever it was.

Anyway, it is good in art. And that brings me back to the word "extol." I'll tell you how Mr. Marsh extols the Bowery.

Mr. Marsh is perfectly unmoral about it. He doesn't attempt to high-hat the Bowery. By some miracle of adaptation he manages to see the customers of the tattooing parlor, the frequenters of the burlesque shows and other attractions in the lower part of the city, as just plain human beings. He did not go down there to hunt villains or "to find evidence" or to reform anybody. Apparently Mr. Marsh thinks the Boweryites just as good as the uptown folk and a whole lot more picturesque. By clairvoyance, or sympathy or long acquaintance he has even adopted their standards of physical excellence, and so he translates into paint the beauties of the young lady actresses in the music halls and the young lady swimmers at Coney Island so that all must be convinced. I call that extolling. The beauty was there but we didn't see it. Now, thanks to Mr. Marsh, we see it.

It is, it is true, essentially innocent. Nothing very dreadful happens in any of the pictures. Mr. Marsh may arrive at a murder later on but as yet he has no inclination in that direction. Mae West, you may remember, did an almost-murder in "She Done Him Wrong" and lived to have a romance with the gentleman of her choice. Sooner or later on the Bowery things happen, and if Mr. Marsh lingers down there much longer, he may come up with something gruesome, but as yet, like Dostoevski in "Crime and Punishment" he allows the possibilities in criminology to be overshadowed by the greater interest of the merely human. As you watch you finally forget you are on the Bowery, just as in Dostoevski's jail you finally forget you are in jail.

Mr. Marsh has made strides as an artist. He doesn't paint easily and sometimes I suspect he tortures himself to paint, but it is his inner vision that has improved and by means of it he arrives unmistakably at his objective. In that way, and although so different, he links up with Albert P. Ryder. If you lifted your eyebrows, gentle reader, when I matched Mr. Marsh with Dostoevksi, you will be now lifting them still higher. I dare say, at the mention of Albert P. Ryder – yet I guess you get what I mean. If you go to the show you certainly will. It is in fact the reason that I put a value upon Mr. Marsh's work – that he gets you past the technique of the profession to the essential matters that concern an artist.

I like best the "Tattoo & Haircut," the "Hotel Belmont"
and the "14th Street Window." The "Tattoo & Haircut" is very
far down on the Bowery. It is a bewilderment of signs and
electric lights and furtive derelicts yet it hangs together ad-
mirably and the details can be read without effort. Even the
bolts and beams of the Elevated Railway overhead have been
indicated affectionately. The "Hotel Belmont" is not the Hotel
Belmont you may suppose. It is, in fact, a hostelry for Negroes,
and the clients of the hotel provide a dramatic panorama on
the sidewalk. The "14th Street Window" pleases me, in spite
of my refusal to believe that Mr. Marsh is a facile painter, be-
cause of its accomplishment. It has quite a number of aes-
thetic charms although it exploits a shop-window in which
young lady models parade in costumes that are for sale at
incredibly reduced prices.

The New York Sun, April 8, 1933

PAUL MANSHIP'S SCULPTURE

AT AVERELL House, 142 East Fifty-third street, all the re-
cent work of Paul Manship, including his "Lincoln" and the
Memorial Gate for the Bronx Zoological Park, are on view this
week for the benefit of the relief fund of the unemployed
architects and draftsmen. From April 17 to May 15 the exhibi-
tion will be free to the public.

Before this I have frequently referred to Paul Manship's
sculpture as "hard" without in the least interfering with our
private friendship. Mr. Manship takes criticism nicely. He is
indifferent to it. That is as it should be. He has never found

that criticism has interfered in the slightest degree. His career marches along, gaining cumulative force as though it were a thing in nature — as indeed I begin to suspect it is — and now he has reached the point when he is acknowledged to be the most successful sculptor in the country — the sculptor to whom all the important jobs naturally gravitate.

If you were to ask Mr. Manship for a self-criticism he probably would not use the word "hard." Although he is frankly indifferent when others use it, he himself would probably say, "I like to have things right." And "right" in Mr. Manship's own sense his work indubitably is. It is implacably "right," relentlessly "right," so extraordinarily "right" that sensitive and frail human beings get scared when they see it. After they get over their first fright they are usually able to take pleasure in an art that is so exactly fitted to the requirements of the nation that produced it.

For the times and the people are hard too. The average man when he wishes to boast will say: "I'm hard boiled, I am," and I have even heard ladies who own necklaces of genuine pearls and have had their portraits painted by Philip de Lazlo smilingly avow it. They simply mean by it that they "know what's what," that they are well aware of the values of the commodities they traffic in, and they also mean that they can't be bothered with inconsequential things, with idle vagaries, with soul probings and things of that kind. In short, they know "what's what."

The elite of this generation almost instantly recognized Mr. Manship to be their sculptor. They get from him what they would get in surgery from the highest priced surgeon of the day, in engineering from the very best engineer, and so on. The best surgeons and the best engineers do fine jobs, and they achieve a kind of handsomeness in their work that subtle thinkers in Europe have for some time been hailing as art. But the American elite did not wait for European approbation before adopting Mr. Manship. They joined forces with him the moment he swam into their ken. It was a case of instinct, and instinct is always swifter and more unerring than intellect.

The present exhibition is indeed made up of handsome material, handsomely shown. Mary Fanton Roberts, who viewed the collection at the same time that I did, and who is intensely susceptible to success in the abstract (as I am, too), murmured, as her gaze swept the room: "Royal. It is positively

royal," and for a truth, the effect was that of the costliest beauty to be obtainable anywhere.

The new gates for the Bronx Zoo, built in memory of the late Paul J. Rainey, are going to be very grand. They are rugged and masculine, and therefore won't shock the populace, as too much filigree might. The animals that perch here and there in the correctly spaced intervals of the ornament have been so simply seen and modeled that the affectionate caresses of the children throughout the ages to come cannot do them anything but good. The gate, in fact, is so sturdy that it looks as though it can stand anything the future has to offer.

The "Lincoln," a white plaster cast of the bronze that was placed at Fort Wayne, Ind., is amazing as workmanship. I don't think any errors will be found in it. The accessories, such as the tree stump, the ax and the dog, are quite free from fussiness. Everything that is there relates tellingly to the effect as a whole, and is designed to be impressive from a distance. As to Lincoln himself, Mr. Manship has no new ideas, and that is just as well. We have had almost too many new ideas about Lincoln of late. And anyway, people of today have enough things bothering them without being bothered by the things that bothered Lincoln.

The New York Sun, April 15, 1933

WALT DISNEY, THE ARTIST

GERTRUDE STEIN's friend, Alice Toklas, says that she has met three geniuses in her lifetime and that each time a bell within her rang, and she was not mistaken. I am that way myself. Alice's three geniuses were Gertrude, Pablo Picasso and Alfred

Whitehead. My latest is Walt Disney. The moment I walked into the Kennedy Galleries, where the Mickey Mouse originals are shown, the bell rang sharp and clear.

Some people thought it was the fire engine passing by on the way to Union Square to sprinkle water on the communists – it was May 1 – but I knew better. I "was not mistaken." It was Walt Disney. He is a genius. Furthermore, he's the right kind of a genius. He's the people's genius. He's not telling any hard luck stories! He doesn't know anything about hard luck! The tsars of the cinema world fall all over themselves to get his productions because the tsars of the real world, the people, fall all over themselves to get into any movie where Mickey Mouse entertains. Since the decline of Charlie Chaplin as the people's favorite, he is It. Consequently, he has all the money he wants and doesn't know what you are talking about when you say the times are hard.

It reminds me of the remark of the tough young man to whom E. E. Cummings, in "Eimi," expressed surprise at the pleasant privileges that the "right" people now enjoy in Moscow, and who said: "Oh, if you're O.K. with the comrades, you can get anything you want – same as anywhere else."

All this ought to be food for thought for the disgruntled other artists who are forever complaining about the indifference of the great American public – only I am afraid it won't be. Those artists do not care for food for thought. They prefer other kind of food. Therefore they don't get any kind.

The idea is, all other news to the contrary, that this big public likes art and will lap it up as readily as a horse laps sugar from the hand; only, it knows what it wants and wants it when it wants it. The moment you try to bully the public, the moment you say, "Don't eat sugar. Sugar is vulgar. This is what you should eat," proffering still-life pictures of lemons and bananas in the style of Cézanne, the chances are the public will walk out on you, leaving you to eat your lemons and bananas yourself.

But don't imagine Walt Disney's cartoons are made of sugar. They are sugared but they are not all sugar. Underneath is the profoundest stuff of which poems and plays are made. They give you the drama of the eternal ego, the little hero and heroine with whom each member of the audience instantly identifies himself or herself. It is the same old psychology, of course, that used to be spent upon Charlie Chaplin. Charlie

didn't think of psychology, Walt Disney didn't think of it, nor did the great public; but the great public fell for it instinctively without knowing what it was; and later on, the deep thinkers pondered over the matter and found out what it all was about and why; but the point is, that the great public didn't have to be told; they just liked it.

A reassuring thing to notice in Mr. Disney's work is, that success does not seem to have gone to his head. His recent films are as vivacious and as vital as the earlier ones; in fact, they seem to get steadily better. According to Eleanor Lambert, who has written an excellent miniature biography of the artist, Mr. Disney is thoroughly absorbed in perfecting the arrangements of the big studio in which he and his many assistants work, and she makes it clear that those arrangements are as complicated as any other cinematic activities in Hollywood. The arrangements are complicated, the results are not. That is the marvel of it. It is not everyone who keeps a firm clutch upon his soul, in the midst of the mechanics of Hollywood, but Walt Disney does. He is distinctly and typically a child of this age.

The New York Sun, May 6, 1933

DIEGO RIVERA

AND THE RADIO CITY SCANDAL

THE EXPECTED has happened. From the moment that Diego Rivera was engaged to do an enormous mural at Radio City it was foreseen that political difficulties had been invited. On Tuesday, a week in advance of the completion of the work,

the artist was dismissed on the score of using his task to preach communism. Whatever else may attach to the event, there cannot be a surprise.

When politics come in at the door, art flies out at the window. It is a matter of regret that in the war of opinions thus unleashed, serious considerations of art will not be of the least avail. People who have not seen Mr. Rivera's painting and who know nothing at all about art will immediately defend it, and people who also have not seen it and who also know nothing about art will immediately attack it; and both parties, obviously, will be in the wrong; for those who know even a little about art know that you cannot judge a picture without seeing it and they know, too, that the picture may not be properly seen until it be finished.

So any consideration given to the affair at this time must necessarily confine itself to the practical aspects of the "case." The initial mistake, as has already been hinted, occurred a long time ago, when Rivera was engaged to do the job. He was certainly the last man in the world who should have been considered, although it is equally certain that he is one of the most important artists now alive. He is important, however, as a Mexican; and he is in no wise fitted to speak to or for the northern Americans. He knows singularly little about us and that little has been gained, not by experience, but by reading the inflamed publications of the communists.

When he came up to New York in 1931 to submit sample jobs to the consideration of Radio City authorities, it was plainly apparent then that his attitude of mind was accusatory and it was also evident that he was thinking in terms of politics rather than in terms of art. The murals in Mexico, on which his fame rests, are tinged with politics, too, it must be confessed, but they emphasize beauty so insistently that the politics drop by the way. Propaganda is always dangerous to an artist and sometimes, when it is allowed to go to the head (as in the case of Émile Zola) it is fatal. Rivera's impulse on coming north has been more and more to "show us up" as capitalists; to be, indeed, an evangel rather than an artist. As all this was plain enough for anyone to see in the Rivera exhibition at the Modern Museum, the Radio City people seem to have been singularly innocent and ill-advised in awarding the great mural commission to a propagandist so violently opposed to the ideals of this country.

However, two mistakes do not make a right, and once committed to the Rivera preachment, it seems a second error in tactics now to martyrize the artist by suppressing his work sensationally. They might have learned the proper procedure from the Modern Museum's other experience with mural decorators last year when some of the invited panels seemed to be insults deliberately aimed at the Rockefeller family. There must have been the temptation then to hide them, but the sportier influence finally prevailed and they were shown; and in the end it was the silly artists who were laughed at, for it was evident that half-baked mentalities are merely boresome and do not constitute a threat.

In the like fashion the Rivera panels, though probably not half-baked (one must do Mr. Rivera the justice to own that he, at least, has force), should have been shown. Of the two embarrassments that would have been the lesser. The communists, elated at the daring of planting their placards squarely in the faces of New York capitalists, would have made the most of the occasion, you may be sure, but the excitement would have been but a nine-day's wonder. If the murals proved to be good art, the good art would finally surmount all else that might be in the compositions, and would speak peacably to what Emerson called the "over-soul" of the community. If they proved not to be art then all the campaigning in the world could not make them so. To suppress them, however, plays right into the hands of the agitators. The howl that they will put up will now be tremendous. If there is anything that "they" know how to capitalize it is a supposed injustice – and they have needlessly been presented with one.

The New York Sun, May 13, 1933

"FOUR SAINTS IN THREE ACTS"

AT HARTFORD

THE EXCITEMENT was intense. The excitement, naturally, had been intense for months past in New York, but on Wednesday in Hartford, on the eve of the world premiere of Virgil and Gertrude's opera, it reached a point when it became practically unbearable. Although in Hartford it still seemed a New York excitement. Whether or no any Hartfordtonians had caught the afflatus I had not been informed.

But already at noon at the chateau of the Cooleys, where hundreds of people were eating superb food that appeared from nowhere, like the manna in Bible times, Mrs. Kirk Askew of New York was telling her experiences. Mrs. Askew had stoically refrained from seeing any of the dress rehearsals of the "Four Saints," wishing it to burst upon her in full perfection at the premiere, but that morning in the Wadsworth Atheneum she had opened a door by mistake and there before her were the two Saint Theresas, the Saint Ignatius and all their attendants arrayed in such extraordinary beauty that all her feelings surged up within her till she thought her heart would break and she had to retire precipitately from the scene. Telling us this she added that she was not at all sure she would be able to stand the entire performance, to which we were looking forward so impatiently.

This, you must admit, almost parallels the historic adventure of Mme. Malibran, who fell in convulsions at the world premiere of Beethoven's Fifth Symphony and had to be carried, unconscious, from the hall!

Most of the cosmopolitans present at the luncheon had been subjected to the strain of two days of hearty hospitality, having come up for the opening of the new Avery Memorial wing to the Wadsworth Atheneum, as well as for the opera, and were showing signs of wear and tear. Pleasure exhausts one more completely than toil. Both the Julien Levys seemed completely shattered. John Becker had become so etherialized

(he had seen a few rehearsals) that he appeared to float in the air. The only individual continuing in resolute self-possession was M. Paul Rosenberg, the great Parisian art dealer, whose contribution of Picassos to the museum's loan exhibition was making it the most important event of its kind anywhere in the world.

Asked if he had seen the startling news in the morning papers as to the fall of Paris at the very moment when Hartford, Conn., was rising above the horizons of the art world, he silently but dramatically produced a cablegram that he had just received from his family. It read as follows:

"Sois calme. Nouvelles beaucoup exagèrés. Nous sommes tout à fait bien."

THEN THERE was the story they were telling about young Mrs. Austin, the wife of the director of the museum. It seems that at one of the pre-previews, a dowager of great importance and influence in Hartford society, being somewhat dismayed by the unexpected quality of the great Picasso compositions, said to Mrs. Austin: "But you wouldn't care to live with them, would you?" and when Mrs. Austin said that she "would" decidedly, the dowager walked away, saying: "Every one to his taste!"

But that evening, at the reception, with all the youth and beauty and chivalry of Hartford crowding in to applaud the new manifestations in art, the dowager, who had had time to readjust herself to the situation, and seeing Mrs. Austin in the official receiving line went up to her, and with an embrace, said: "Dear, loyal little woman!"

Hartford, Conn., 3 P.M.

The inside of the new wing to the Wadsworth Atheneum really is a masterpiece of museum installation. The outside is O.K., as they say, but the inside is special. "At last," said M. Paul Rosenberg, "there is one genuinely modern museum in the world."

The big entrance court is a matter of plain surfaces and those horizontal lines with which the new architects are proving that skyscrapers shouldn't be Gothic. The Brancusi

"Kiss" at once looks like the work of genius that it is, before such a background.

The Picassos, however, are the whole thing of the occasion. And rightly. Who is there, more than he, who represents modernity? It is possible, of course, that they may be a bit difficult in Hartford to others, in addition to the great social leader who has already been quoted, and to such the only advice I have to offer is that that was proffered by M. Paul Rosenberg's family to him: "Sois calme."

The Picasso paintings sum up very completely all the successive mental atmospheres current in a sensitive capital in the period of disintegration following the great war. Those not conversant with the events may reasonably be bewildered by the new accents invented to describe them — and there is no shame attached to that — but the bewilderment need not necessarily be lasting, for only a slight degree of intelligence promptly dissipates it. Of a truth, the period just past is as unmistakably reflected in the work of Picasso as the Mme. Dubarry-Louis XV period is in the work of Fragonard.

A. Everett Austin Jr., the director of the Wadsworth Atheneum, and the guiding force behind these unexpected and novel developments, is so young a man that he may resent being reminded of his youth, but one of the influential connoisseurs of New York, expressing regret at his inability to be present at an event so certain to become historic, was inclined to attribute Mr. Austin's success in bringing it off to just that — his youth. "The whole thing," he continued, "shows the necessity of getting some fresh air into our museums. The elderly business men who direct most of them without in the least knowing what the whole thing is about, are completely shown up by the exhilaration that Mr. Austin has thrown into the art situation. The two episodes of the Picasso exhibition and the Stein-Thomson opera are easily the most brilliant events that have ever been pulled off in an American museum of art."

Hartford, Conn., 3:30 P.M.

Just then Virgil Thomson and Florine Stettheimer emerged from the doors of the museum's theater where they had been struggling with the final touches to the opera. It was sensational, to those who knew, to find Miss Stettheimer thus

abandoning a willfull seclusion of some years' duration to do the decors for her friend Virgil Thomson's opera. Both looked weary but happily confident. As a matter of fact, Virgil looked as though he had just been run over by an automobile truck in Taos in August (August being the dusty month down there).

Miss Stettheimer reported that the Negro singers were not only acting like saints, but like angels. Very little temperament was being shown in spite of the superhuman demands that were being made upon the artists. It was true that a prima donna had objected to a headdress that had been designed for her. It was even true that the prima donna had flung the head-dress at them when it was first presented to her, but Miss Stett-heimer had had a long conversation with the artiste, and every-thing was serene once more and the headdress was to be worn in the second act.

Hartford, Conn., 5:45 P.M.

Miss Stettheimer has just called me up at the Heublein Hotel to tell me she is quite exhausted and can do no more, and would I be good enough to go to the nearest Woolworth's and purchase two artificial roses for her, the best I could get. The whole fate of the opera was at stake. They were necessary to the second act. I said I would, and sallied forth.

Hartford looked gay, prosperous and attractive at that moment, with the electric lights all glowing in the skyscrapers (yes — there were skyscrapers) and the crowds of people hurry-ing home from work and animating the rather wide boulevard until it challenged comparison with the Cannebière of Mar-seilles. I think Hartford could be my favorite town, next to New York and Stockholm, if it wished. Indeed, if only the lower part of that little park in front of the Hotel Heublein could be flooded with water and made into a lagoon there would be no doubt about it. I would then give it Stockholm's second place.

I got the two roses. A very good buy. They were exceed-ingly handsome.

Hartford, Conn., 7:45 P.M.

The dining room of the Hotel Heublein seems to be en-tirely filled with New Yorkers. Parmi l'assistance one could

remark and did remark the following: Mrs. Muriel Draper, Mr. and Mrs. Alfred Barr, Philip Johnson and his sister, Miss Theodate Johnson; Mrs. Murray Crane, Carl van Vechten, Fania Marinof, Edward Wasserman, Frederick Amster, Mrs. William Averell Harriman, Mary Lawton, Mr. and Mrs. James Johnson Sweeney and Mr. and Mrs. William Lescaze.

Hartford, Conn., 11:30 P.M.

The opera was an overwhelming, an inescapable success. The Virgil Thomson music was not in the least difficult but always clear; witty, caressing, unexpected, dramatic, just as the composer wished. The Gertrude Stein words, always helped by being read aloud, are extraordinarily amplified by being sung. The Florine Stettheimer settings and costumes are simply sublime. If I could think of a more powerful adjective I would use it, but "sublime" will have to do for the present. The Negro singers and dancers are artists of the very first quality. One easily believes that the least of them is equal to anything. In addition, they are unbelievably handsome and wear their costumes with an air. Frederick Ashton, the choreographer, produced one tour de force after another, the whole evening through, and Maurice Grosser made a miracle of a scenario as a base for the shining fabric of Gertrude's exalted inspiration. All this sounds like extravagant praise, but believe me, I haven't told you the half of it. New York is in for a rare sensation when this show comes to town, and Broadway will get enough ideas from its scenic investiture to last it for ten years to come.

In order to round out this little narrative, I may as well confess that when my two artificial roses came on in the second act I never noticed them. I was so engrossed in a study of the two Saint Theresas dressed in ravishing white, with the most fetching of sun-hats, though adequately spiritual as well, that I quite forgot my own modest participation in the scene. I was told afterward that the two roses adorned the Commère, in the loge overlooking the garden party.

I also ought to add that Mrs. Askew survived the opera handsomely. She confessed to having been much refreshed by it. In fact it may well be that "Four Saints in Three Acts" has curative properties. Helen Appleton Reed of Brooklyn, who rose from a bed of pain to attend the premiere, said afterward

that her neuritis had completely left her. I myself had a head-ache before but none after taking. Would it be strange if the opera should become a place of pilgrimage? It would be stranger still to see the lobbies lined with votive offerings after a six-month run of steady cures.

The New York Sun, February 10, 1934

NEW YORK BY STUART DAVIS

THE SLOW progress of Stuart Davis toward being a best-seller is something to ponder over. It is either a reproach to him or to us. Which is it? His work is clever, fashionable (that is — it is in the fashion of the day) and widely known. Theoretically, we ought to relish such clear-cut, workmanlike statements with no nonsense about them. But do we?

Not to the extent of buying them in quantity, at any rate. There are probably fewer Stuart Davis pictures in private circulation than John Marins, and that is putting it pretty caustically. John Marin is the most acclaimed artist living in America today; and the least owned. The Davises and Marins that are owned are kept, for the most part (the Phillips Memorial Museum in Washington is a notable exception), in strictest intimicy. The brave collectors who ventured into modernism are not sufficiently brave, it seems, to come right out in the open and boast of their purchases.

We need a type like the late Mrs. Jack Gardner who thoroughly enjoyed blazing new trails and had enough social magnetism to draw all the weaker elements of society into line. But types like Mrs. Gardner are obsolete, and only this week a lady who might have assumed the Gardner mantle had she chosen, announced through the press that the day of the in-

dividual art patron is past, and that the recent activities in the way of Government purchases of art indicate the form that future art patronage is to take.

That may be as it may be. The future is something that I know little about, and in a time like this the present predicaments are sufficient to occupy one's entire attention. That the aristocratic patron is no longer care-free enough to do fancy buying is something we all have noticed and those who noticed it first are the artists who do explorative painting, like Mr. Davis and Mr. Marin. That we punish rather than reward the seekers after new truths in painting has been one of our characteristic traits, but it is a trait we must erase if we would attain worldwide prestige in the arts. It is the community with a sense of direction that dominates the rest of the world.

So, since the Government is not yet actively committed to art and the aristocratic patron has vanished entirely, the only hope remaining to Mr. Davis is to appeal to the consciences of the museum directors throughout the land. They are all engrossed in the acquisition of classic art, or in academic art, and most of them increase by way of bequests of pictures, but enough of them have funds to keep the conventional artists alive, and it is about time that they were made to realize that the innovators are essential to artisic progress. The Modern Museum will do wonders in the way of setting an example, once it gets under way, but in the meantime each of the many museums should have a little Luxembourg annex to its regular activities.

The present Stuart Davis exhibition in the Downtown Galleries shows him to be unfaltering in his allegiance to the abstract. He is the most resolute of our practitioners and the most expert. There isn't an item in the present collection that shows the least fumbling or uncertainty, and there isn't a picture that doesn't publish to the world the precise period in which it was done.

It is distinct in style, and after you grant that the original impulse to be abstract came from France, it is sufficiently American. Compared with the work of Léger, to which it comes nearest in manner, it diminishes in plastic qualities. Perhaps this is intentional. Certainly, if this be the machine age that they say it is, Mr. Davis has the right to be machinelike. The artist, however, also diminishes in humor, and that I deplore. A Stuart Davis of some years ago could be counted on every

time for some wise-cracks. None are to be had from him this
year. If the machine age is going to compel us to be solemn all
the time we should have been warned before going in for it
so heavily.

<div align="right">

The New York Sun, April 28, 1934

</div>

SALVADOR DALI

THE FASHIONABLE, very disputed and very difficult exhibition
of the week is the Salvador Dali show in the Julien Levy
Gallery. And it is not cubistic, either. It seems that perfectly
straight, highly finished, beautifully colored painting can have
its difficulty, too, for Señor Dali is psychoanalytic. He doesn't
paint you from the outside but from the inside.

This innovation made an instant hit with the carefully
chosen and extremely "advanced" assembly at the private view
on Tuesday, and this in spite of the fact that psychoanalysis
had been considered "out" as a dinner-table topic, these two
years past. But we had never had it in pictures, you see. In
pictures it is different. It has a fresh and unexpected note.
Or possibly Señor Dali is an unusually good "control." Isn't that
what they call it? A "control?" In spiritualistic circles, I mean.
For obviously, it is his own self that he is analyzing all the time.

This starts Señor Dali off to a new kind of reputation
with us. This is his third. He has been a psychoanalyst all the
time, only we didn't know that. At first, when the strange
pictures began to come over, we thought him more than a
little mad. That example in the present show at the Modern
Museum called "The Persistence of Memory" was one of them.

You remember it, no doubt, with the apparently melted watch bending at right angles over the ledge, crystal, dial, hands and all. That was at the time when some of our more profound counselors were urging us to be a little mad, like the Russians, so that we might be better artists. Señor Dali, we thought, was overenthusiastic, but just the same, he was in the proper school, and so he was taken right in by our collectors.

The year after that, however, when a new invoice of Dali pictures arrived in this country, there was considerable consternation just at first, for the new compositions were thought – there is no harm in telling it now – risqué. However, for one reason or another, all the pictures sold, and quickly. I know one gentleman who told me he had never bought oil paintings before in his life, but he had been so thrilled by the Dalis that he could not resist the temptation to acquire two. But for all that, he hung the two paintings high up in an obscure corner of his sitting room so that he would not be obliged to explain them to his female relatives when they came to visit him. He could not explain them, anyway. He just liked them.

But lately, I understand, he has taken the two pictures down from their obscurity and placed them prominently in his parlor with spotlights on them, and all the other Dali collectors have done the same, for in the light of the new revelations of the current exhibition this art is found to be entirely O.K. It is psychoanalytic. Do you see? Everything goes – in psychoanalysis. It's all a dream. Do you see? It's nothing you have done or will do, but, as far as I can make out, it's something you have repressed. Therefore it's altogether to your credit. Especially when it is so marvelously painted as Señor Dali does it.

I dare say if you were to look at some of these highly finished miniatures through a telescope you would see these landscapes receding to endless perspectives, with each little hillock behind every other little hillock, all in impeccable gradations, just as in nature. When these qualities in the Dali oeuvre shall have been well advertised, you will find all the oldtimers dashing, or perhaps, "hobbling" is the word, to the gallery, in order to feast with their own eyes upon, at last, the destruction of this cursed cubism which has occupied the public attention too long and has just swelled up again this week at the Modern Museum into historic proportions. But of

such, alas, the Dali clientele will not be formed. It's for the new people, I think, like the gentleman I told you of, who liked them spontaneously and didn't know why.

P. S. I think the work called "Javanese Manikin" is Salvador Dali at his best. I don't think he'll ever dig anything better out of his subconscious. It is extraordinarily weird and extraordinarily attuned to the scientifically deranged emotional life of the day.

The New York Sun, November 24, 1934

JAMES THURBER'S PSYCHIC ART

IF PETER ARNO may be said to have discovered the present city of New York, then with equal justice James Thurber may be said to have discovered Columbus, Ohio, and of the two discoveries the last named is by no means the least, since most New Yorkers are persuaded that New York would have been discovered anyhow and they are not at all certain that Columbus, Ohio, would ever have been heard of had not dear Mr. Thurber called attention to it.

Besides, in discovering Columbus, Ohio, Mr. Thurber discovered all the United States except New York city; all the "outlying districts" as it were. There are many cynics who claim that New York city is not America, and we who live here know what the cynics mean, even if we do not wholly agree with them, but no one has ever dared to say such a thing of Columbus, Ohio. Columbus, Ohio, in fact, is so 100 per cent, so precisely, in essence, what all the other towns west, north and south of Broadway, including Keokuk, Chicago, Spokane and Tulsa, aim to be, that it is simply uncanny – speaking of

discoveries and discoverers – that it should turn out to be called Columbus, Ohio.

But I see that this review – which is intended as a notice of the exhibition of the Thurber original drawings in the Valentine Gallery, if I ever get around to it – is already too literary; but then that is Mr. Thurber's fault, and how I got that way – just by looking at his drawings. He, too, is literary. I mean, of course, that when he discovered Columbus, Ohio, and incidentally all the rest of rural America, he discovered Columbus's soul, he found out what Columbus thinks – if you call it thinking.

That's rather a profound observation, that next to the last one, about the soul being what you think, but again the credit must be Mr. Thurber's. He plumbs the depths, and one can observe Columbus, Ohio, being turned inside out, as it is in his drawings, without becoming aware that he, too (or possible "she" – 'nay, probably she," as Noel Coward would say) has depths. That's how Mr. Thurber educates. He teaches us to recognize the Freudian fact that underneath the skin we are all alike! Even the difference between New York city and Columbus, Ohio – once you get underneath the skin – is not so great as you would have imagined.

Take, for instance, that midnight conversation from twin bed to twin bed, that out-eeries anything in that line in the poems of the late Thomas Hardy and in which the lady finally asks: "If they never found the husband's body could they do anything with the wife?" and watch the expressions on the faces of feminine art students as they take the full impact from the drawing. It's something too awful for the knowing and makes you want to put what is technically known as "the curse of Cromwell" upon Freud, who brought these thoughts to the surface instead of letting them rest in the depths where they belong. As it is every lady spectator instinctively recognizes the drama to be well within the limits of her own mental experiences. I, for my part, think the drawing should be entitled "The Mouse Trap," like the little play within the play that brought on all the trouble in Hamlet.

And there's that other one, of the young lady kneeling by her bed and concluding her exhortation with ". . . And keep me a healthy, normal, American girl." They say that that drawing stirred up considerable ennui for the publication in which it appeared and that conventional people from all over the

country wrote letters protesting against such sacrilege. But what sacrilege? I vow, I can't see it. That, of course, is the trouble with psychonalaysis. It releases so many bad thoughts that amateurs fall into the error of thinking that all thoughts are bad. This is so much the case that many practical people, "ravi" as they are with Mr. Thurber's drawings, are beginning to feel that it is a pity that Columbus, Ohio, ever started to think. It seems such a shame that a nice, innocent American city should have been thrown into such confusion by the machinations of a remote Austrian scientist. On the other hand we should then never have made acquaintance with the art of Mr. Thurber which is a contingency not to be thought on. On the whole, selfishly, we conclude, "Let Columbus, Ohio, take care of herself. She got herself into this mess. Let her get out of it by herself."

But you noticed my use of the little word "art." I suppose that was what you were waiting for. Yes, Mr. Thurber's little drawings are actually art and of a very fine order. He is one of the two or three artists in our whole vast land to have evolved a style for himself. He is as distinct in this country as Thomas Nast and in Europe as Felicien Rops; but happily he is unlike either. He is unlike anybody. That is his great secret and his great charm.

The New York Sun, December 22, 1934

PHILIP EVERGOOD

PHILIP EVERGOOD is the excellent name of the artist now exhibiting in the Montross Gallery and he is deservedly so named. At least, he's almost always good — the clock doesn't always

strike 12 for him, but in such cases it comes very near to it, 11:45 or something like that — and any one maintaining so high an average of marksmanship as that may wake up some morning to find his name changed into Philip Evergreat. Stranger things have happened.

For Philip Evergood is a keen observer, with a healthy sense of fun and a willingness to take the brave old world the way he finds it. He is still young — or so one imagines from the run of his subjects, which have a hallmark of Greenwich Village written all over them — and possibly he hasn't settled into a style that is to be permanent, but in the meantime the method of painting is so lackadaisical that it is positively calligraphic — like scribblings on a wall.

In that, of course, Mr. Evergood follows the trend of the times. Classicism died in this town with Kenyon Cox. Or possibly it is fairer to say that Mr. Cox killed classicism. Anyway, it is more fashionable at the moment to draw like George Grosz and the late Jules Pascin and Mr. Evergood is in the fashion. Perhaps he carries looseness of execution too far. Perhaps he ought to pull in his belt several notches. But that's for him to decide.

If he really likes looseness so much as all that and insists upon it, if he is willing to die for looseness, then he probably can eventually put it over on us. The world is like putty in the hands of a strong man. (Or a strong woman. Just see how the first line defenses crumbled at the mere approach of Gertrude Stein). We are willing to put up with all sorts of eccentricities upon the part of our great people, once we are compelled to accept them as great.

But the great Toulouse-Lautrec, who interested himself as an artist in much the same things that interest Mr. Evergood, was far from being so loose as that, and I should think a young artist of today, even if he were dying with laughter at the things he saw at the Marathon dancing contest, would like to have as much clarity and precision as Toulouse-Lautrec would have had, in describing such an event. Or perhaps not. Who knows what the future is to be? Or the taste of the connoisseurs of the future? People may become so floppy that spines, bones and structures of all kinds, may become obsolete. But what an idiotic artist that would be who would alter his style for so politic a reason as that! He wouldn't be an artist at all. The only possible excuse for any style is that it "had to

be." If Mr. Evergood just has to be loose, that's his own affair, and it's up to him to make us like it.

In the meantime, as I said before, he's having fun. It amuses him to startle straight-laced citizens, of whom, it seems, I am one, by flaunting his big picture of the Marathon dancers in our faces. With the entire universe going through the throes preliminary to the birth of "a higher morality," it seems incredible that such colossal inanities as the one depicted can have been permitted on the very eve of the "reformation." Yet having been, they remain on the record, and cannot be denied. Mr. Evergood spares us any accusations. He is not vitriolic like Toulouse-Lautrec. His silly boys and girls are not particularly vicious; they are just silly boys and girls.

Perhaps the Chicago Art Institute would care for the picture. It might give it a look at any rate. The Chicago Art Institute had the courage to acquire the "Moulin de la Galette" by Toulouse-Lautrec at a time when no other museum seemed to be interested, and it might be a steadying influence on young Mr. Evergood to see his picture subjected to the severe comparisons that neighborhood with such a materpiece would involve — and quite worth the small outlay necessary to the experiment.

The New York Sun, January 26, 1935

JOHN KANE'S MEMORIAL EXHIBITION

PITTSBURGH EVENTUALLY will be very proud of the paintings of John Kane, but perhaps not right away. It seems a bit soon for Pittsburgh to make a complete right-about-face, for,

all along, the Smoky City supposed John Kane's work a joke and the singling of it out for praise by the metropolitan critics was just a high-handed attempt, upon the part of these worthies, to bring shame upon the late Andrew Carnegie's home town.

John Kane was an ordinary house painter who took up painting late in life and without previous instruction. He was, I think, of Scotch-Irish descent, with the sturdiness of physique that that mixture of blood often presents, and a typical Scotch-Irish willingness to be "himself." In other words, he had character, plus a self-reliant and happy disposition. Apparently he loved the Pittsburgh that gave him a living and wholeheartedly adored the panorama that unrolled itself each day before his eyes. Finally there came the temptation to put down in paint the charms that had not often been noticed in a town that had not been much painted, and the results so gratified the house painter that he continued to paint pictures of Pittsburgh as long as he lived.

How the first one got into the Carnegie Institute's International Show of Paintings I have never learned, but I suspect it was due to the kindness of Edward Balken of the Institute's staff, who is the only Smoky City connoisseur that I know of, who owns a John Kane picture; but straightway the writers for the press picked the painting out for comment, and as time went on commented more and more about the house painter who had become a painter.

To do my confreres justice it was not so much the metamorphosis from house painter into artist that attracted their attention as it was the fact that the new man was, unquestionably, an artist. He was more than a painter, he was a poet in the use of paint. In the American section of the International Exhibition, where there were rows and rows of highly schooled paintings that contained little else than schooling, the meeting with the sweet feeling and novel approach of John Kane came upon one, as James Stephens, the Irish poet, once said, "like a breath of fresh air in a soap factory."

John Kane, of course, was unschooled in drawing, but he knew how to mix colors and apparently he was firmly convinced that Pittsburgh was just a piece of heaven on earth. He relished every bit of it, but particularly the activity of the river boats, the processions of railway trains, the smoky furnaces and the little cottages that dot the precipitous hill-

sides like a communist's dream of "better housing." It was odd that Pittsburgh didn't appreciate these sincere tributes, but it didn't. Only last year at the Carnegie International, which included a large and splendid John Kane landscape, I urged it be purchased for the permanent Pittsburgh collection, but was told, "Not a chance."

Well, the chances are still less now, and for another reason. With the death of John Kane, all the pictures he had painted but had not sold were sent on to New York, and the present memorial exhibition in the Valentine Galleries is meeting with a pronounced success with our connoisseurs. Fourteen of the pictures had been sold by the opening of the show, including several that ought, in all justice, to be owned by the Carnegie Institute. Among these are the "Prosperity's Increase," a river scene with cheerful activity going on in every direction, a view of furnaces by the river, called, I think, "Monongahela Valley," and an admirable row of small houses along a city street.

Pittsburgh, however, should not be judged too harshly for its behavior in the case of John Kane. Let the city that has not done the like throw the first stone. But the truth is we have all done the like. New York has only recently done the right thing by Louis Eilshemius, and that slowness in justice is only one of several black marks against us. And you all recall the behaviour of the good citizens of Aix when Paris finally sent down word that that crazy fool Cézanne was a genius. Why, the Cézanne landscapes had been lying around under all the bushes, ready for any taker. But once they became valuable there were no more to be found under the bushes.

The New York Sun, February 2, 1935

THE DEATH OF GASTON LACHAISE

THE TAWDRY, ineffective funeral I would not have had other-
wise. It was in the tradition. That's the way we buried Mel-
ville. That's the way we buried Poe. Greatness would not be
greatness if it could be understood generally. Nor do I blame
humanity for this poverty of vision nor cry out against God for
it. It is merely the way things are.

Yet the word "genius" was uttered. There in a Broadway
funeral "parlor" the word got uttered. Gilbert Seldes said it.
Gilbert improvised a few words and set them to a note of
bitterness. Yet the word "genius" was among them. That word
will be remembered later. A great man passed from among us
without the benefit of singing choir boys, without incense,
without processions. There was no "corruptible" putting on the
"incorruptible." There was no one even "weeping for Adonais."
A few of us who knew that Gaston Lachaise was great sat
there like wooden images in a Eugene O'Neill play and scut-
tled away the moment the crisp accents of Seldes ceased to be
heard, to ruminate on greatness in America — and its recom-
pense.

As far as Lachaise was concerned it might almost be said
that of recompenses there were none, for genius is not truly
paid with money but with comprehension. Not but that there
had been some admirers! There always had been a few. Per-
haps the most notable was E. E. Cummings, the poet; himself
so slightly acknowledged as to be practically of no use. Then
there was Gilbert Seldes and later on Lincoln Kirstein and Ed-
ward Warburg.

It was probably due to the influence of the two last
named that the astonishing one-man exhibition of the La-
chaise sculptures occurred in the Modern Museum last winter,
an exhibition so overwhelming in its appeal that you would
have thought that the whole world must have succumbed to
it; but there were no signs of such a submission. Nothing from

the collection was sold, and Lachaise told me himself that about all he got from the affair was my sympathetic account of it in The Sun. I do not repeat this boastfully but in despair. Were it not that I know that loftiness of feeling is never lost in this sluggish, unwieldly, careless but delightful old world of ours, and is invariably recognized in the end, I should forever abstain from serious art criticism.

But what a contrast there is between this icy reception of Lachaise's magnificent bronze goddess – I believe it was simply entitled "Standing Woman" – and the feverish interest of the Florentines in the productions of their sculptors in the days of the Renaissance. There was no quarrel here as to where the "Woman" should be publicly placed and worshiped as there was over the Michelangelo "David." There was no attendant mob of geniuses to instantly appraise and put a great value upon the work.

When the "David" was completed, so John Addington Symonds records, a solemn council of the most important artists then resident in Florence convened to consider where the statue should be placed. Opinions were offered by among others, Cosimo Rosselli, Sandro Botticelli, San Gallo, the architect; the illustrious Leonardo da Vinci, Salvestro, a jeweler; Filippino Lippi, David Ghirlandajo, the painter; Michelangelo, the father of Baccio Bandinelli, the sculptor; Giovanni, the father of Benvenuto Cellini; Giovanni delle Corniole, the gem cutter, and Piero di Cosimo, the painter and later on teacher of Andrea del Sarto.

What a society that was! They had their human frailties, of course, and the jealousies, back-bitings and political maneuverings that the flesh is heir to, but there was no possibility in a time when art was so important that any talent for it should be wasted.

Our Lachaise worked, for the most part, in isolation, continually beset with money difficulties that would have ended the career of any ordinary man before it had begun; and it was not until the present year that he received a commission for a public monument worthy of his immense ability. This was to be a group symbolizing the amalgamation of the races in America, and it was to be placed in Fairmount Park, Philadelphia. The accepted sketch clearly indicated that the work

when completed would rank among Lachaise's masterpieces — but the artist was not to live to see the idea realized. It was written that he was to be rejected of men, and so he was. Apparently the idea of the Philadelphia monument came nearer to the idea of "success" than the fates permitted, and so he was hastily snatched from the scene.

"In the 'David,' " so John Addington Symonds said, "Michelangelo first displayed that quality of 'terribilità,' of spirit-quailing, awe-inspiring force, for which he afterward became so famous. The statue imposes, not merely by its size and majesty and might, but by something vehement in the conception."

"Terribilità" is a good word and applicable to Lachaise. It was the thing in him that raised him to the heights. Lachaise alone among the sculptors of this generation is the one whom it is not ridiculous to cite in connection with Michelangelo. He was of that same giant breed. It was his terribilità that made him, if you must have a comparison, larger than the Frenchman Maillol. Maillol is a great sculptor and I admire him without reserve, but the beauty he evokes is pastoral, quiet, soothing, pagan. Lachaise, in the few pieces in which he rose to full stature, was more inflammatory. He was nearer, in class, to Rude than to Maillol. Comparisons are always insidious, and it may be even dangerous for a foreigner to rate Rude above Maillol, but, lovely as Maillol's carvings are, who is there who would exchange them for that one shattering relief of Rude's on the Arc de Triomphe?

Just a year ago, at the time of the Modern Museum's exhibition, Lincoln Kirstein wrote the following:

"One may hope that some really unselfish interests concerned with the fine arts will give Lachaise a commission for an even more important civic or public work. (Mr. Kirstein had been speaking of the Fairmount Park memorial.) Many possibilities suggest themselves. For example, there is no worthy memorial to Thomas Jefferson at the University of Virginia, a project which interests Lachaise intensely. There is no fitting monument to Herman Melville, or to Winslow Homer, or Thomas Eakins. John Reed is unhonored by Harvard College. There is no stone to the memory of Hart Crane, whom Lachaise knew and admired. Lachaise has twenty years

or more of work ahead which should be the crowning period of his life. Not to make the fullest use of such a talent would be heartless waste."

But T. S. Eliot dubbed the period "The Waste Land."

The New York Sun, October 26, 1935

WINSLOW HOMER'S WATERCOLORS

YEARS AGO I read, somewhere, of the Midwestern interviewers who surrounded the late Arnold Bennett when he arrived in Topeka in the course of his first lecture tour in America and who were astounded when he replied to one of their no doubt searchingly personal questions that the real reason he had come to this country was his desire "to see the Winslow Homer water colors."

This reply of his gave me untold pleasure and I was persuaded it was true, for none of the Topeka reporters in those days would have been capable of inventing such an original statement, and besides, none of them would ever have heard of Winslow Homer. The astonishing part of the affair, of course, was that Arnold Bennett had. It was the first case on record of a European acknowledging that there was such a thing in America as art, and the handsome extra flourish that "it was worth a trip across the ocean" made it doubly acceptable.

In those days Winslow Homer was my religion (and still is) and immediately I conjured up visions of the cultural balance to be established between us and Europe with hordes of Europeans coming over here to worship Winslow Homer in exchange for the hordes we were sending over to worship

Botticelli. But something stepped between the dream and its realization. Perhaps it was the great war. In any case, it didn't happen, and Arnold Bennett has never had a successor. There has been no other prominent European coming here to see our Winslow Homers, and I don't believe that even Arnold Bennett bought one, though they were not so expensive in his day as they are now.

But should we worry about that? Don't make me laugh. If you know the Winslow Homer water colors yourself, you know that the reproach in this story is altogether too leeward. And if you don't know them, you now have the opportunity in the Knoedler Galleries of getting acquainted, and realizing to the full, what Europe is missing.

It seems that Winslow Homer was born a century ago, and this exhibition is by way of being a centenary. How remote that makes him seem! Yet the work itself seems near; nearer now, in fact, than it used to be, for we have had several generations in which to live in intimacy with it, to test it out in every way, and finally to see in it a kind of Americanism of which we may be vastly proud.

Winslow Homer was the first of our painters to speak authoritatively in the native accent. Like Walt Whitman, he looked on this country and saw that it was good. Like Walt, he celebrated with enormous gusto the manly viewpoint toward this section of the universe. The liaison between the work of the two men has been often remarked, yet it is not likely that they knew each other, or that the painter had ever heard of the poet. Walt Whitman, during the active part of Homer's life, was looked upon by Henry James, Lafcadio Hearn and other accepted stylists of the day with even less approbation than is given by the same types in contemporary life to Gertrude Stein. Yet Homer, like Whitman, was a poet. It was that quality in him that made him so supremely great.

It was that quality in him, too, that threw some of his early critics into confusion. Pure poetry has a way of confusing the beholder on first contact, simply because it is pure creation; and purity of any kind is the thing human beings seem most afraid of; partly, I suppose, because it accuses us who are not poets of nonpurity. Not that Winslow had hardships. His bad criticisms were all minor, and he paid no attention to them. Some of the ladies — Miss Mechlin and Mrs. Van Rensselaer among them — were frightened by the trait that

was later on to be most admired in him – his robustness. His masculinity, naturally, was no offense to the men, and they rallied to him so heartily, and so quickly, that money troubles never came to him. A client seemed always in waiting for each picture to be finished.

Once definitely assured of his calling, Homer withdrew from the world and "hated to be bothered." His biographers assure us that he was invariably the gentleman, though certainly nonsocial. He saturated himself exclusively in the kind of life he was later to put on paper and canvas and went off for weeks at a time into the primeval forests with his brother. The wonder of the world was ever present to him, though he never said anything about this wonder. He put it all into his pictures. When he wrote letters he became the typical Yankee stoic. When he painted, however, the portals of heaven opened, and he saw nothing but beauty. His young hunters and old guides are marvelously beautiful and authentic as well. They are the real thing. They transfix you with their beauty and their intensity. It is not alone the scent of the woods that comes to you in such drawings as the "Adirondack, No. 7," and the "Canoeing in the Adirondacks, No. 17," but also there is the actual suspense of the hunt. No other painter before or since has had the courage so to sink his hunters into shadow, as Homer does in the "Canoeing," and at the same time keep them vital. It is a great masterpiece – and the European who doesn't know it doesn't know the half of it.

P. S. – I should like to go into the matter of the technic, if only to refute certain things Kenyon Cox said on this subject, but space limitations will not permit. Cox admired Homer greatly, but thought some exceptions could be taken to the drawing. This misapprehension resulted from not being an artist himself. Mechanical exactness is no help to an appreciation of the things of the spirit. Of this, perhaps, more anon.

P. S. No. 2 – Also I can't resist including in this too slight review a statement made by Winslow Homer late in life that has puzzled many. From Scarboro, Me., on July 4, 1907, he wrote this letter: "My dear Mister or Madam Leila Mechlin – I thank you sincerely for your interest in proposing an article on my work. Perhaps you think that I am still painting and interested in art. That is a mistake. I care nothing for

art. I no longer paint. I do not wish to see my name in print again. Yours very truly, Winslow Homer."

This matches the behavior of the aged and by the world forgot Herman Melville when a young enthusiast looked him up to tell him that "Moby Dick" was great and that something ought to be done about it. As gently as possible Melville assured the young man that he wasn't interested and that there was nothing to be done about it.

Homer, however, had never been forgot by the world, and had never suffered bitter disillusionment. He had, on the other hand, endured ill health for a number of years and had always been something of a recluse. He knew pretty accurately the merit of his work, and he knew it would last, but he knew also that his working days were over, that compliments in the situation in which he found himself had a hollow ring, and that when one had lived all one's life rigorously a special amount of seclusion befitted the ending of it.

The New York Sun, January 25, 1936

EXHIBITION OF ABSTRACT ART

AT THE MUSEUM OF MODERN ART

THE LONG-AWAITED Abstract Art Exhibition at the Modern Museum is now upon us. What will the public make of it? That's the question! Probably just what it makes out of all other problems involving complete wisdom and complete knowledge of contemporary affairs (including politics) — confusion! Complete self-knowledge is not available to the living and is only to be had, if then, in the obituaries; yet our ed-

ucators always will be attempting history while it's in the making!

For the new show is being historical about a thing that is not yet dead. Consequently, it is addressed to the professors and not to the impetuous, adorable, uninstructed public. It is very well done, I hasten to say, in so far as such a presentation can be well done. The sequences and derivations of the movement are very well indicated. The modern world has been effectively scoured for revealing examples and enough amazing productions have been recruited from the ends of the earth to keep the professors agog for several years to come and, incidentally, to assure alarmed citizens that the entire world is concerned in the matter. But though abstract art is here in plenty, "abstract beauty" is not placarded in a way to win new converts.

My contention is that the public is never concerned with statistics but with results. So a museum's business is always with the superlative successes in any chosen line, and with practically nothing else, leaving the sequences and the "lesser-examples-that-prove-things" to the schools for would-be professionals. It is for that reason that I have never been content with the Louvre since it abandoned that central Salon Carré that brought the people, before the war, face to face with its supreme possessions and really, more than anything else, gave world-wide fame to "Mona Lisa" and "The Man With the Glove." If you wish to educate the millions in art you must not confuse them at the beginning with lesser examples.

Being, however, one of the "professors" myself, I confess to taking both pleasure and instruction in the event, and even to admire the courage with which the directors of the museum smite the public in the eye on the very door-step, so to speak, of the show. Almost the first picture to be encountered is that terrific work by Picasso, called "The Dancer," painted almost thirty years ago, when the artist was trying to incorporate some of the demonic fury of the African carvings into his work, and succeeding so well that the picture is now likely to send any unsuspecting American lady who encounters it into what we call "the jitters." That, of course, is not the highest purpose in art, and perhaps it would have been more tactful to have prepared visitors for "The Dancer" by degrees. The initiated, it is true, who know that Picasso is the greatest figure in the modern movement, will look upon it as an

interesting step in the progress toward such masterpieces as "Les Trois Masques" and "The Seated Woman"; masterpieces, unfortunately, not included in the show and which would have been enough in themselves for a Salon Carré, had there been a Salon Carré.

By way of partial recompense for this brusqueness in presentation, the museum does very nicely by the Boccioni bronze, which is just around the corner in the next alcove. This is the bronze that was almost refused entrance into the country by the custom house officers on the score that it wasn't art. But it is, unmistakably. Any one can see that now, posed, as it is, in an agreeable light, and chaperoned by a big plaster cast of the Louvre's antique "Victory of Samothrace." The custom house people, by way of punishment, should be compelled to come to the show every day for a month and sit in front of the two pieces and learn definitely the difference between art and merchandise. The Boccioni bronze has the ripple and flow of life, of a figure moving in a breeze, or as Jimmy Savvo says so marvelously in the turn he is at present doing in one of the local theaters — "like a dream walking."

The cataclysmic crush to see the Van Goghs earlier this winter may have bred in the bosoms of the sponsors of this exhibition a desire for "a repeat," and though I fear, for reasons stated at the beginning of this article, that the wish may not be fulfilled for them, nevertheless there are a number of pieces here exposed, that might again arouse the mob spirit, were the proper combination of hysterics, scandal and vituperation marshalled against them.

For instance, the celebrated "Nude Descending a Stairway," by Marcel Duchamp, which once set this entire country by the ears, has a wall-panel all to itself, and must again enchant the young people of today in the manner in which it formerly enchanted their fathers, for it returns this time, if you please, a classic. A second classic is another glittering brass bird by Brancusi, to which also, the Customs House officials might pay a vist of etiquette, since once they were quite unkind to Brancusi. Still another reappearance is that of the gorgeous early "Abstract" by Kandinsky, which is as handsome and as fresh as when it first flashed upon startled New Yorkers at the Armory Show.

But reappearances are not apt to be inflammatory. The talkative part of the new generation seems to have grown up

in full consciousness and full approval of the works that have been mentioned and is now struggling with entirely new problems, and which are illustrated sufficiently in the exhibition to enable those who wish, to take sides. These problems are posed for the most part by a group of artists loosely ranked together under the banner of "surrealism." Those who get farthest away from nature in this new group, such as Hans Arp, Hélion and Mondrian, ought, logically, to invite the most discussion; yet since they vanish so far away from Mother Earth into the realms where the planets speak to each other in esoteric terms, the probabilities are that our public will not believe they mean it and will not, consequently, get very much heated.

Paul Klee, the German, and Joan Miró, the Spaniard, on the other hand, just because they do deal in more approachable matter and indulge in whimsicalities which we can fully measure and appreciate, may come in for the onslaughts of the Philistines — if the Philistines do get busy. Joan Miró's big composition, in one of the upper rooms, is, in the present writer's opinion, one of the greatest triumphs of surrealism, and it is to be hoped that it may find its way eventually in the modern museum's permanent collection.

The show, as a whole, however, is Pablo Picasso's. He walks away with it, as might have been expected. In every department he makes himself felt, but in several of his great compositions on the second floor galleries he wins the battle single-handed for abstract art and convinces the unprejudiced that they are face to face with undoubted masterpieces.

There were a few murmurs to be heard on the occasion of the private view that the battle need not have been fought in quite so single-handed a fashion, but we can let such murmurs pass. The "Trois Masques" would have helped the show, as has been said, but then it was already exhibited in New York on two occasions; and Léger, Hélion and Braque, who could have been better represented, have been frequently exposed here and are thoroughly admired by our "advanced" pupils. Absolute perfection in exhibitions is not to be thought of here on earth; and we ought to be satisfied with just a portion of perfection. I am, at any rate.

The New York Sun, March 7, 1936

A MARIN RETROSPECTIVE

THE LONG-AWAITED John Marin exhibition at the Museum of Modern Art, 11 West Fifty-third street, is now open to the public. It occupies the first and second floors of the building, with a special investiture — very spacious, and with the white walls that the Marin color schemes seem to demand, and so the public has an excellent opportunity to study water colors that have been in seclusion for some years, but which grew in fame in spite of this seclusion.

The collection was chosen and arranged by Alfred Stieglitz, who for so many years has been sponsoring this artist, and it has been recruited from the collections of the Gallery of Fine Arts at Columbus, Ohio; Fogg Art Museum, Metropolitan Museum, Phillips Memorial Gallery at Washington, D.C., and these individual connoisseurs — A. E. Gallatin, Philip Goodwin, Mr. and Mrs. Samuel A. Lewisohn, Georgia O'Keeffe, Fairfield Porter, Paul Rosenfeld, Mr. Bryner-Schwab, Robert H. Tannahill and Mr. Stieglitz himself.

Of all those who have ever been professionally concerned or interested in the doings of John Marin, I dare say I am his oldest acquaintance; and yet among all this gradually expanding group of those who pretend to know him, I also dare say I am the one who knows least of his personal idiosyncrasies.

This is not so much carelessness on my part as a willful preference — born in me the moment I began work as a critic of art — to form my estimate of a painting from the painting itself rather than from the manners of the artist at a dinner table. In fact I'm not certain I ever saw John Marin eat, though I once did live for a short time in the same house with him, and this long years ago, before the war, and before any of Mr. Marin's numerous biographers had ever heard of him.

It was in Venice where Mr. Marin, with his stepmother, father and brother, descended upon the hotel I was domiciled in, and where I am certain I saw others of the family eat. But Mr. Marin was more furtive. You didn't see him do anything if he could help it. When cornered, he was affability itself, but if

he saw you coming in time, or any of his family coming, he much preferred to bolt into the nearest doorway, be it of a church or café, so long as it offered escape.

Nevertheless, I had several chats with him, the matter of which I have completely forgotten. Probably we didn't discuss art, for at that time I had no more thought of becoming an art critic than he had of becoming America's premiere aquarellist. But I liked him. There was no offense in his exclusiveness (or perhaps "apartness" is more descriptive). He was incorrigibly immersed in the business of interrogating nature for himself and had no time for interruptions.

He conformed completely to my idea of an artist, though I don't think I should have picked him out as one marked for worldly success. He already had the hatchet-hewn face that has since been made familiar to the world by Gaston Lachaise's portrait-bronze. Indeed I have never been able to see the slightest change in his lineaments made by the years and perturbations that have since rolled over our heads. He was born old and has remained young.

In Venice Mr. Marin was by way of being an etcher, and some of the prints achieved at that time still hold a place in the collections. Considerably later I heard of him in Paris as joining with a group of young American water colorists sponsored by or attached to the American Club of those days. The little show the young men put on got into the cables, and probably because of that bit of luck, quickly came to America.

When Marin shortly after appeared in the little gallery of Mr. Stieglitz at 291 Fifth avenue, he already had so distinct a style in the use of water color that the work of his Parisian companions automatically faded from the scene. By this time I even forget who they were. But distinct as was the Marin style at the time of his first New York exhibitions, there was nothing in it to disturb the sensibilities of the purists. The colors were sparkling and pleasant and practically every drawing could be called honestly a poem. It was a young man's irresistible lyricism that impelled them. They were not profound but they were natural and unforced.

There was much commendation for them, particularly upon the lips of young people. I recall no adverse criticisms. Possibly the water colors were not sufficiently challenging to upset official opinion; but the younger connoisseurs do not look for profundities from their own set but for assurance. The

one among them who doesn't ask how it should be done but goes ahead and does it, gets their admiration at once. Marin, for all of his "apartness" seemed to respond to this approbation just like a regular human being and with each show he put on, his assurance gained and very soon he painted with an authority that at times was positively militant. When the young people told Marin he was "great," apparently he felt he had to be great.

There was also the obligation to justify "291." In the little gallery generaled by Mr. Stieglitz so much pulling down of the academy had been done that suddenly it dawned upon all the talkers and listeners that some building up had to be done, too. Marin, of course, was occasionally among the listeners and though no fingers were pointed directly at him, his subconscious got on the job and produced results.

The light-hearted singing troubadour who had come from Paris, changed into a serious dramatist almost over night. The little dancing boats in the harbor from which the artist had previously heard tinkling melodies, now bounced about on positively black waves and against gray skies; and the recurring tune sounded mighty like a dirge. The towering buildings of lower New York also occupied his attention and he did them in a perfect frenzy of appreciation of their significance and importance. He became an excited and exciting painter.

The war by this time had come upon us and had a lot to do with this nervousness of Marin. In personal contacts he seemed as cool and aloof as Voltaire is said to have been during the seven years' war, but when the year's supply of water colors was collected by Mr. Stieglitz for his annual Marin show, it was noticed that the passion in the drawings amounted to violence. Fortunately they were practically abstract and as the numbers of persons at that time in America capable of apprehending an artist's emotion when expressed in abstract terms was limited, no unnecessary increase in the current war fury could be traced to them. The drawings themselves, however, were certainly furious but I think it was merely Marin's response to the furiousness that was in the air.

In any case, there is an explosiveness about the "downtown series" of drawings and about a group of sunset pictures of the same period that sets them apart from the entire range of Marin's work and gives them an especial interest. Dynamics are not necessarily a value in themselves, but a pure expres-

sion re-enforced by unusual energy naturally takes precedence over milder statements from the same source. There is such a thing, of course, as tearing a passion to tatters, of applying too much power to too frail a theme, as poor Caruso did in his last two breathless years with the "furtiva lagrima" that had previously been so exquisite; but Marin was fortunate in his rages to be raging against such things as Maine sunsets and New York skyscrapers; subjects, one must admit, that can stand any amount of pressure.

After the war, Marin calmed down much in advance of the rest of the populace, and his mountain views in New Mexico and his accounts of ships in distress off the coast of New England had a precision of statement that suggested a serene mind. There was still a certain amount of excitement in them, for Marin is an artist who catches fire from a motif, but it is a contained excitement like that in Gluck's Orfeo and vehemence was not allowed to interfere with elegance.

As elegance seems to be more in request than passion, it happens that Marin's later days have witnessed an increase in his public, and so it is not so strange to have an extended representation of his work in a public museum as it would have seemed once. Elegance, however, cannot have been a conscious pursuit of his, and it may occasion him some surprise to be told that he has it, for elegance, like style itself, is, or ought to be, unaware. . . . It's just the bloom on the peach — but it's what sells the peach.

The New York Sun, October 24, 1936

DALI AND THE SURREALISTS

THE BEST place this week to overhear chance remarks — if you collect chance remarks — is the Julien Levy Gallery, 602 Madison avenue, for it is there that Salvador Dali, the surrealist, is showing his latest and most astounding pieces. Whatever else you may say about surrealism it sure is a great incentive to conversation, and the choice bits you overhear are always illuminating.

I meant to have taken along my notebook to the fashionable vernissage at the Modern Museum's show of surrealism last week in order to jot down the flotsam and jetsam of the occasion, but forgot to do so, and so my precarious memory only permits me to offer you two "overheards" from that event. Of course, I intend to haunt regularly the Julien-Levy-Salvador-Dali show, with my notebook, for these things that people say have their bearings upon the pictures, and will be very useful in judging the effect of this new art upon the laity. (That word "laity" reminds me, somehow, of the Archbishop of Canterbury. I wonder what the Archbishop of Canterbury would think of Salvador Dali's pictures.)

But first I must tell you what I heard at the Modern Museum. On the stairway of that institution there is at present shown an enormous mask, constructed by an artist named Wallace Putnam, and ornamented with a strange miscellany of household utensils, including a mousetrap, bits of wire, hair brushes, &c., and as I was going up I met an intensely respectable couple coming down. The man had a solid, substantial air, most probably a banker, a man with an instinctive feeling for values, and after gazing in awe-struck astonishment at the mask for a moment, he turned to his wife and said, unsmilingly: "Never throw anything away." Almost at the same moment two young men passed me on the stairway going up, and one of them had a wild look in his eyes. His friend asked him, in consternation, "What's the matter?", and he replied: "I don't know but I don't feel right." Of course, neither one of these "overheards" takes you very far into the depths of sur-

realism, but by the time you have amassed a hundred such revelations, I feel pretty sure you will have sufficient material to take the measure of the movement completely.

But to get back to the Archbishop of Canterbury and the laity! I think it would reassure his Grace the Archbishop if somebody would inform him that there is a whole lot of the Academy in Mr. Dali's art. The criticism that is most generally leveled at the Academy is that it depends too much upon subject matter, but Mr. Dali certainly depends a lot upon subject matter, too. Indeed, there is more subject matter in one of Mr. Dali's works than in an entire Academy exhibition put together, even when the said Academy exhibition includes several compositions by Harry W. Watrous.

Mr. Dali's great masterpiece called "Suburbs of the 'paranoiac-critical' afternoon (on the outskirts of European history)" is calculated to keep any earnest student busy for an entire afternoon deciphering it. This picture is not only Mr. Dali's masterpiece, but it is the incontestable masterpiece of surrealism to date; and that statement is intended to convey the information that it also overtops anything that the old master in this line, Hieronymus Bosch, ever put forth in the way of horror. I don't know much about Hieronymus Bosch, but I have always suspected that he lived in a jittery time, something like ours, with all sorts of uncertainties about his finances, the state of his soul, &c., &c., and consequently had a perfect right to have nightmares. Besides, it was before the advent of Dr. Freud of Vienna, and he did not run the additional risk of being psychoanalyzed.

But, anyway, Mr. Dali goes him miles better. There are some shapes that look like arms clutching things in the picture, and if one thing in a dream is more disturbing than another, it is the fear that monstrous and incredibly forceful hands are about to clutch you; and Mr. Dali poses this amorphous shape in front of a landscape that out-vies those of Maxfield Parrish in literalness of detail, and here and there, in places where they horrify you most, the artist drapes bits of raw meat.

This must be the very picture that the artist described in a communication to the Academy and which was published in the Academy's Commonplace Book last month, as follows: "I used to balance two broiled lamb chops on my wife's shoulders and then by observing the movement of tiny shadows produced by the accident of the meat while the sun was setting, I was

able to obtain images sufficiently lucid and appetizing for an exhibit in New York."

The movement of the tiny shadows has been correctly apprehended in this picture, just as the artist says, but once the eye catches sight of "the accident of the meat while the sun was setting" then firm conviction seizes one that it will be hopeless to thresh this matter out with the Archbishop of Canterbury. Hieronymus Bosch? Yes, perhaps. But not Salvador Dali. He's too near our present predicaments.

The New York Sun, December 19, 1936

MALVINA HOFFMAN'S

SCULPTURES AT RICHMOND

À LA FIN, the hemstitching was perfect. For a time it seemed as though it were to be one of the major disasters of the year. Everybody was helping, but there was so much to do. Miss Anne Morgan was playing hookey, the other name for which is golf, and Mrs. W. K. Vanderbilt, who was substituting for her, was sent out hurriedly to the nearest shop to get more cheesecloth.

It takes yards, of course, when you are giving an exhibition. You always run out and have to have more. This time was no exception. The Malvina Hoffman Exhibition of Sculpture at the Virginia Museum of Fine Arts would be as nothing if more yards of cheesecloth were not available at once; so Mrs. W.K. flew to the bidding of necessity, and returned, as they say, "with the goods."

But the next morning, Saturday, to be exact, in the midst

of breakfast (batter-bread, fishballs and café à la crème) a
lady emitted the anxious cry: "We didn't finish hemstitching
the cheesecloth."

"Does it matter?" asked another who seemed, to at least
one impartial observer to be completely engrossed with the
batter-bread (it is made with cornmeal into little round cakes,
is softish in the middle and you put lots of butter on it and
eat it with knife and fork. It's a superb confection).

"Matter? Absolutely, it matters. Of course it's got to be
hemstitched. Let's go to the museum at once and get busy on
it. We've still got time."

"Nonsense," said Miss Malvina Hoffman herself, "who
ever'll notice whether it's hemstitched or not?"

"We will," exclaimed all the art critics en masse, "we'll
notice it particularly."

"You would," returned Miss Hoffman, with a withering
glance. "I forgot all about you," and then, in an aside to the
anxious one, she added. "It had better be hemstitched."

And it was, perfectly; and hence there were no slightest
little faults of any kind to be found in the Malvina Hoffman
Sculpture Exhibition in the Virginia Museum of Fine Arts.

In Richmond, Malvina Hoffman is up against stiff com-
petition. Richmond is by no means so easy to conquer as New
York. The Richmond taste, these hundred years and more,
has been founded on Houdon, and than Houdon there is no
better taste the world over. Houdon, one might say, is all taste.
Compared with the great Michelangelo, it is true, he is un peu
academic. There is, however, no slightest hint of reproach to
Houdon in this. As I am always telling my friend Harry W.
Watrous, who used to be president of the New York Academy
of Design, the academic is a soul-necessity; especially here
in America. Ninety per cent of us subsist upon it, thrive very
well upon it. Henry Ford of Detroit says the same thing;
though, naturally, Mr. Watrous didn't have to wait for us to
tell him this — he knew it already.

All that is meant, in this connection, by the word "aca-
demic," is the difference that there is between fact and idea;
Michelangelo representing idea and Houdon fact. Michelangelo
was an impassioned, fiery individual who couldn't get along
even with his own relatives, let alone the several popes who

gave out all the important jobs to artists. He brooded continu-
ally over an ideal state of living that was impossible to realize
upon this earth. Houdon, on the other hand, accepted the
world "as is." He was, in the Virginian sense, civilized. It was
probably he who insisted that Washington should keep on his
gloves in the famous portrait-statue in the rotunda of the
Richmond Capitol. The gloves did not discommode Washing-
ton in the least.

No one quite believes, of course, the malicious remark of
Henry Adams about the awkward appearance of Abraham
Lincoln at his own inaugural ball, that "it was evident that Mr.
Lincoln's white kid gloves quite spoiled the evening for him";
but just the same I recall no other of our Presidents save this
Houdon Washington who wears white marble gloves for pos-
terity. The visit to the Capitol to see this most important piece
of staturay in all the Americas is necessarily a rite for all the
Northern attendants upon Miss Hoffman's exhibition, since
it emerges that her art ties up with Houdon's rather success-
fully. Anyway it leans more toward Houdon than toward
Michelangelo.

Even natural-born Virginians might find it apropos and
helpful to climb the Capitol steps for this purpose of compari-
son. Incidentally, it will be noticed that the busts of the seven
other Presidents and the Marquis de la Fayette in the niches on
the side walls pay no attention whatsoever to the Father of Our
Country. They glance anywhere but at him! Each seems en-
grossed in his own affairs! Woodrow Wilson is more engrossed
than any of the others. But after all it's not odd, this behavior
of theirs. Being President of the United States is no cinch. It
takes all of whatever you've got.

The best time to view the Malvina Hoffman sculptures is
immediately after luncheon at the Commonwealth Club, where
they have a way of doing oysters in a brownish-colored sauce
and serving them with miraculous pancakes that put you en
rapport with the higher flights of human fancy at once. Miss
Hoffman's talent, however, is one to which one might easily
adjust oneself even without the pancakes. It does not soar into
the interminable ether where the breathing is difficult for most
people, but goes great distances in a horizontal direction and
with the utmost steadiness.

But heights and depths and widths are designations un-
important in themselves, the main thing being the quality they
measure. Who was the wise person who made the reassuring
remarks about the wide rivers and the deep ones? Was it
Schopenhauer? Or Emerson? Probably it was Thoreau. Any-
way he made it clear that it was the "volume" that put the test
on the rivers, the wide ones being just as valuable as the deep
ones, when the last analyses of them were made by the power
plants along their banks.

And so it is, of course, in this way that one judges Miss
Hoffman's flights. She went all around the world, thus accumu-
lating mileage that puts Houdon's and Michelangelo's timid
peregrinations to shame, and returned safely home again laden
with artistic spoil in the way of accurate transcriptions from
the living, walking poems that still thrive in the far places of
the earth; and also with tales of adventure which it was no
trouble at all for her to transform into a best seller. Every-
body in Richmond has read Miss Hoffman's "Heads and Tales,"
loves it and loves her in consequence.

Thanks to that book, the mystery of sculpture has been
robbed of half its terror. One, in fact, might almost now live
with sculpture. One could at least live with Miss Hoffman's
reliefs glorifying "Pavlova and the Dance"; and Richmond
probably will live with it, now that it seems how admirably it
fits the room in the Virginia Museum where it is shown. But of
that possibly more anon.

March 7. – It is not precisely "news" that Pavlova and
Miss Hoffman were intimate friends. The intellectuals on both
sides of the ocean who were irresistibly conquered by the great
dancer always stepped aside willingly, nevertheless, to permit
Miss Hoffman to offer their thanks officially. They felt, possi-
bly, that though it might not be a matter of life and death to
Pavlova to receive thanks, yet on the other hand it was cer-
tainly a matter of life and death to Miss Hoffman to utter
them. Uttering them was her career for a while. It enabled her
for the first time to be articulate in bronze and her "Pavlova
and Mordkin" followed the dancers around the circuit and
finally became almost as familiar as they were. The piece has
not, in the present writer's opinion, all the academic merits of
the portraits of savages made for the Field Museum, for
Pavlova, like Michelangelo, represented ideas, and it was the
idea as she presented it and not the mask of the dancer that

beat upon the soul like unearthly music. Artists who, like Dr. Faustus in the play, attune themselves to "worlds above the moon," would scarcely care to put into concrete form the visions of another artist. Houdon might, but Michelangelo certainly would not.

Yet the Richmond affection for both Miss Hoffman and the dancer were appreciably heightened Sunday night, March 7, when Mrs. John Kerr Branch opened her great house on Monument avenue to the flower of the city and a few interlopers from the North and gave them a "first showing" of a cinematic record of some of the Pavlova masterpieces, including the celebrated dance of the "Swan." The records were made in the later years of the artist's life and at a time when film technic had not reached present-day competence, yet the old, familiar spell enwrapped, unmistakenly, all those in attendance. . . . Their hushed subjection was marked. . . . And at that moment, so it seemed to me, the Pavlova reliefs were sold to the city of Richmond.

The New York Sun, March 13, 1937

SOUTINE – AND THE PUBLIC

IT SEEMS to be natural to begin an acquaintance with Soutine with a profound distaste for him, and this feeling persists long after the students discover that the affair is mutual and that Soutine detested you long before you detested him. Surely never was there a more crabbed – I believe that's the word the gypsies use to describe the quality – artist since the world began, and he is so contorted and twisted in his procedures that I shouldn't be at all surprised to have him turn out to be a gypsy in the end.

But that doesn't prevent him from being a very great painter, just the same. One by one the Soutine paintings that first converted the Parisian connoisseurs and shook them out of their original dislike are coming to this country, and the more of them we see the more evident it becomes that Soutine must be ranked with the great. A new collection of his works has just been placed on view in the Valentine Gallery and in more ways than one they are amazing productions.

Even if I were to confine my remarks to a description of this artist's painting technic I could scarcely conceal from you that his manner is defiant to an outrageous degree, for the man begins a picture with his palette in the condition at which other artists leave off, and in fact he seems to work with the muddy leavings begged or filched from more prosperous neighbors, but before he gets well into the picture, believe me, he makes the colors shriek.

It may be muddy paint, but Soutine contrives to suggest that it is the kind of mud in which you find jewels. There is the gleam of something precious and valuable in the most unlikely places in the composition, just as there is in the best things of our Albert Ryder, though you feel that poor Ryder never knew how the valuables got there, but that Soutine did know precisely how they came there. But by this you mustn't take it that Soutine works exclusively in browns. On the contrary, he loves wild colors and has much wildness in every picture, but the loud and disreputable reds he uses look as though they had been dragged through the gutter before he got them.

As though this were not enough in itself to frighten good, innocent people, Soutine distorts. And he goes mad at intervals. He paints screwy-looking people with tiny heads like those you see in the circus freak shows, and he makes the eyes of some of them flare out at you so that you yourself can hardly return the glance, just at first, and the picture as a whole suggests that it has been partly melted in a furnace during one moment of its manufacture and then reassembled while still too hot to be held comfortably, and therefore the parts do not fit perfectly.

I see that you shudder at the description.

Yet I haven't told you the half.

But in spite of all this the man is great. No richer paintings than these have been shown here this winter. No richer

painting is to be found in our Metropolitan Museum, not even among the ancients. Every inch of the canvas is "painted," but I suppose you have to be an artist to know what that means. It means that each touch is sincere — from the artist's point of view. So much contemporary painting is perfunctory. There is nothing perfunctory about Soutine's work. It is meant. It may be meant hatefully, but it is meant intensely — and that is what you chiefly ask of an artist.

Now if I have cowed you at all by these remarks, the next thing you will be asking is: "How did he get that way?"

It will probably be answer enough to tell you that Soutine was the intimate friend of the lamented Modigliani. The tragic privations that finally proved too much for Modigliani have been so well publicized that there is no need to repeat the horrid details, but it sufficiently explains Soutine to say that he shared them. Paris still echoes with stories of the fantastic methods employed by the two tragedians in the effort to exist without money; and the stories are so shocking that one finally understands why Soutine cannot forgive — even after prosperity came to him personally — cannot forgive the world for the indignities he suffered.

The New York Sun, May 8, 1937

TCHELITCHEW'S PORTRAITS

LATE TUESDAY evening when the polls closed and the votes were counted in the Julien Levy Galleries it developed that Pavel Tchelitchew as well as Mayor LaGuardia had been elected. The results, in both instances, were scarcely surprising. In Pavel's case, certainly, the conclusion was fore-

gone, for all the forty-eight persons in the highest social circles who are permitted to address Cecil Beaton by his Christian name had already seen the portraits in the artist's studio and passed upon them favorably.

Against such a decision as that, of course, there is no recall. All forty-eight were present again in the Julien Levy Galleries on election day, along with Cecil himself, and about 418 other persons who do not have the honor of Mr. Beaton's acquaintance but who follow his lead in matters of art. Sherry was served. This had no bearing on the success of the occasion, as connoisseurs insist that they think more clearly after sherry than before, and they are probably in the right and in any case there was no real necessity for thinking, the thinking having been done already, and only enjoyment being called for, and this would come about naturally – the forty-eight being present – but undoubtedly the sherry assisted. So you may readily understand that there can be no exaggeration in stating that a good time was had by all.

It was, in fact, the first "occasion" of the winter, and there may not, in truth, be such another, for these brilliant personages who made it are but birds of passage and will soon be flitting to Miami, Hollywood and that place in Idaho (isn't it?) where they ski. So it was lucky that all forty-eight could be present at the launching into the great world of Mr. Tchelitchew's portrait of Lincoln Kirstein, the well-known writer and balletomane, for this is certainly the artist's masterpiece to date and probably the reason for the rush of the other celebrities to get painted by him.

It is painted in Mr. Tchelitchew's best Bellini manner with incredible niceties of touch, prodigal in invention, and charged with some, but not too much, psychology. The protagonist wears a scarlet and black jacket, probably part of his working clothes at the Mertopolitan Opera House and this it is, no doubt, that makes the picture recall Bellini so distinctly, for the garment compares gallantly with the best that Renaissance bravi could obtain, yet Mr. Kirstein got his, you may be sure, from one of the better department stores in this town, Mr. Kirstein being an exceptionally able young man. This review seems to be running into long sentences. You must bear with it. It's the Russian influence. Mr. Kirstein himself could not escape this influence and looks positively Slavic in the portrait; so much so that you might think him stemming from that

other ballet company, the one that's just been doing "Coq d'Or" so nicely. But anyway it's a highly successful portrait and certain to create envy in the bosoms of other portraitists and also in the bosoms of the would-be sitters who do not all succeed in crashing the studio door. Mr. Tchelitchew cannot paint everybody, that's understood.

These frustrated sitters are counseled, by way of recompense, to take another look at the portrait of "Miss Edith Sitwell" — also in this exhibition — and then to ask themselves whether they really have the courage for this exalted kind of portraiture — for heroism of a sort is undoubtedly required. Miss Sitwell, being British, has withstood the temptation to be Slavic, but fell heavily for the other temptation that Satan — I mean Mr. Tchelitchew, of course, but of course I do not mean anything wrong by this — that Satan, I repeat, had to offer, and became even more medieval than Mr. Kirstein. She is shown in consultation with a recalcitrant Muse. She has paper and pen all ready, but the words will not come. She wears a loose-easy-going robe quite unlike the things Molyneux has been turning out lately for the Duchess of Windsor. But nothing helps. She has let her hair down. It is of no avail. The words will not come. And, incidentally, Miss Sitwell's hair, when let down like this is simply terrible.

Gazing at this debacle, one of Mr. Beaton's girl friends, herself most marvelously coiffured, was heard to murmer: "I wonder if this will bring Gertrude back to Pavel" — for one of the most deplorable tragedies in modern art history is the well-noised fact that when Miss Sitwell so enthusiastically "took Pavel up" in London, Miss Stein, with equal enthusiasm "let him down." But when internationally famous ladies, such as these, quarrel about their geniuses, nothing that mere men may do helps. The chances are, if this really is a gesture of the sort indicated, that Pavel will now lose the patronage of both. Mr. Beaton, who knows all parties to the intrigue, and loves them all, remained singularly calm at the party. Perhaps there's nothing to it. Or perhaps the Modern Museum will hastily buy the portrait and pack it away somewhere where Miss Sitwell will never encounter it. One must hope for the best.

The New York Sun, November 6, 1937

ALFRED MAURER

ALFRED MAURER is dead but his pictures are still asking questions. It may be too soon to answer these questions definitely. It certainly is too soon to answer the most important one, i.e., as to the ability of these pictures to please on their own intrinsic merit; for as yet it is impossible to separate them from the charm of the dead man who painted them. But that they have the power to go on asking the question is something.

There is a small exhibition of the artist's work in the Hudson Walker Gallery and it concentrates on the "difficult" phases and ignores the flower paintings which present no problems. It even includes the early figure painting which won a prize at the Carnegie International years ago and which is so conventional that one wonders what inner light suddenly flared up in the painter's soul and induced him to swing so far to the left. Could it be that merely winning the prize scared him?

But I see I am putting too severe a test upon this work. It is too much to try to separate the man from his work. That, after all, is never done. It is the recognition of the man in the work, in fact, that gives it worth. What I meant to say is this: That I welcome the present opportunity to see if the paintings impress the new school of connoisseurs who know nothing of the artist's story.

Something of that story they will probably instantly guess from the sequence of the pictures themselves, for a certain wildness increases in the pictures as they go on and comes to a climax in the self-portrait and after that it is almost not news to announce that Alfred Maurer committed suicide. It is the idea of "Horla" over again, for Maurer's end, like De Maupassant's, was foreshadowed in his work.

Like all problems of the sort, the pros and cons are so inextricably mixed that it is difficult to unravel them. Maurer's career as an artist, for instance, was entirely honorable. He lived exclusively for his art and in sharp contrast to most of the painters of today who never lift a paint brush to canvas

352

without thought of the box office results. He deliberately turned his back on the easy career of an academician and whether you look upon this as sense or nonsense it clearly proves, at least, that he had the courage of his principles. This action alone won him the special attention of those who like to look upon the "artist as hero."

Unfortunately, Maurer lived in a period when it was obligatory for a young artist to go abroad and in Paris Maurer got into trouble. That is to say he landed in the midst of the revolution of the "Fauves" and learned that the right way to paint was to do all the things that the Beaux Arts professors said you shouldn't do. This turned Maurer into a semi-abstract painter. He never quite gave up a subject. He always had one, but he treated it with a freedom that was highly satisfactory to a young man who had gone abroad especially to acquire something with which to shock his fellow-Americans upon his return home.

That was the trouble that Maurer got into. He learned style, as travelers abroad are always doing, by wholesale. His new style was not so much a growth as a mere change of garments. He felt his original manner (which won him a prize at Pittsburgh) to be hollow, else he would not have discarded it and though he finally got used to his new Parisian style and said things in the end fullheartedly through it, yet there always remained in his painting the tingle of a foreign accent. This was not so much his fault as it was the fault of the period he belonged to. You remember, you weren't considered an artist in those days unless you did have a foreign accent. Duveneck, Chase, Twachtman, Hassam and so on down the line – all had mannerisms acquired from fashion-mongers abroad.

But Maurer did have some things to say and said them full-heartedly. He began doing the depressed (and compressed) young women who linked up with the movement to do away with frustrations and inhibitions that came in with the study of Sigmund Freud. Sherwood Anderson thought these young women were wronged factory-workers and was all for them, and the artist, for a while. Personally I was not so sure the young women were factory workers in distress. I suspected the curious compressions and elongations of their heads came about through the new aesthetic – the necessity to fit them to the elongated panels. In any case, weird and strange though they were, they were painted in a broad, assured manner that

at once destroyed them as propaganda – if that had been the intention – and converted them into works of art. You no longer saw them as starvelings of humanity but as peculiar beings living a life of their own.

So there you have the two aspects of Maurer at which I stop. First, there was the life, which was admirable and wholly what an artist's life should be, and heroic enough to make you think him entitled to a degree of fame for that alone. Then, against this, is the feeling that the painter's style, peculiar though it is, did not wholly spring from the artist's own experiences with life. Finally, I offset this last reproach, since it seems to be a reproach in which all may share, for we Americans do not seem to be a nation of stylists in paint. So I have decided that Alfy Maurer will go on asking his questions. I do not think he will be dropped.

The New York Sun, November 27, 1937

DEMUTH MEMORIAL EXHIBITION

THE MEMORIAL exhibition in the Whitney Museum of the late Charles Demuth is astonishingly reassuring. All the drawings look valuable and desirable. This is largely because they are well shown. The Demuth water colors are unlike other American water colors and the Whitney Museum is unlike other American museums. The two go well together.

Demuth's art is precious or it is nothing. If you will see actual jewels in a museum you will know what I mean. Emeralds and diamonds that glow with conscious value upon a lady's finger suddenly become cold and lifeless when transposed to a vitrine in a museum.

Possession and intimacy are necessary to a Demuth water color.

The Whitney Museum is a reconstruction from several dwellings that must have been exceedingly comfortable in their time, and certain of the galleries retain a warm and agreeable "residence" feeling. One of them, on the second floor, is a symphony in tones of rose, luxuriously carpeted and with perfect window curtains, and in this room the loveliest of the flower paintings are shown. Or is it that they are the best? Might it not be that the flower pictures relish their pleasant surroundings and perform well because of them? I am inclined to think that is it. The entire exhibition is seductive and, due to the clearness and distinction of the workmanship, is bound to be a popular success, but one or two of the rooms have the white walls that are necessary for strictly modern pictures, and on them some of the Demuth drawings have that jewels-in-a-museum look that has been referred to. Burglars who rob museums are, of course, very reprehensible persons, yet any method that brings a museum jewel back into private circulation is not altogether to be despised.

The anticipated public favor that is to be allotted to this exhibition is a curious instance of what an artist can do with his public once he has gained a public, for Demuth practiced many devices that are not forgiven to all American painters. For instance, many persons who condemn cubism as the sin of all sins, have openly admired the several water color versions of Sir Christoper Wren church steeples without seeming to be aware that the drawings are cubistic. It is quite refined and delicate cubism but it is cubism just the same. Then there are the series of illustrations to novels by Henry James and Zola which have acquired a great deal of local fame, and which some critics (myself included) rate as the best things that Demuth did, and yet they are calligraphic; and officialdom in America doesn't yet know what calligraphic draftsmanship is and consequently is bound to disapprove of it for at least ten years to come. On top of these there is a whole roomful of stylized symbols, headed by the "I Saw the Figure 5 in Gold," which looks so handsome, as now shown, that I'll wager any sum you mention that the average man from the street will forget to be mystified by it. And yet, as a rule we New Yorkers do not care for mystical pictures. This special permission to the artist to do as he pleased was won by the delightful flower

studies which radiated such an air of "sweetness and light," especially when owned, that their admirers quickly began to feel that Demuth could do no wrong.

At the same time this cubism, this calligraphy, and this symbolism are not especially creative and that is probably the reason why they are so little challenging. Cubism and calligraphy were simply part of the art-jargon in the period in which he grew up and he used them just as he used the current speech. Cubism was not necessary to him as it could have been, conceivably, to an artist who could accept the world on no other terms, but being very distinctly a citizen of the world he "played up" the fashions from Paris with a degree of amusement and certainly with great competence. He may be said to have translated cubism "into American," and to have added to it some of his native elegance.

Elegance was an insistent aspiration with him. He once told me that he admired Fragonard enormously and that the thought of Fragonard often guided his impulses. No reflections from Fragonard, however, are visible in his work, unless you think the French master helped the distant American to some of his clarity. There is certainly enough elegance in the still life of "Grapes and Turnips," shown in the entrance hall, to have guarranteed it an acceptance at the Court of Louis XIV in spite of the (perhaps) lowly turnips. In fact, these Demuth turnips are royal. No others in art match them.

The special concern of the students, however, is the opportunity provided by this event, to renew acquaintance with the Demuth illustrations to "The Turn of the Screw" and "The Beast in the Jungle," by Henry James; illustrations that startled the art world a generation ago and then were promptly whisked away into private collections. These drawings are done in scribbled lines that would have horrified the pedantic followers of the Atelier Gérôme if they had not already been somewhat quelled and defeated by the cubistic revolutionaries of the day, but unprejudiced younger observers were so impressed by the Demuth intensity of feeling in these drawings that they did not recognize that method as calligraphic and succumbed to the horror, and morbidezza, and general screwiness that the artist had extracted from the fearsome novels. Since that day a whole school of young Americans have practiced calligraphy with an assiduity worthy of the Chinese,

but these drawings by Demuth remain the most distinguished contributions yet made to this kind of expression.

The New York Sun, December 18, 1937

DUVENECK

THE EXPLANATION for the comparative subsidence of a once prodigious reputation is afforded by the just-opened exhibition of the works of the late Frank Duveneck in the Whitney Museum of American Art.

Duveneck was a technician. He learned practically all the technic the old masters in Europe had to offer, but he had little use for the technic after he had learned it. He was a technician, but not an artist.

In the old days when all America was getting to Europe as fast as the steamers could carry them there Duveneck was a prince among his fellows. He was the quickest and the cleverest at ferreting out the secrets of the museums. When he was but 28 he had already painted the picture now called "Woman With Forget-Me-Nots" and it looks so like a Rubens that it might easily be mistaken for a Rubens. But so great was the craze in those days for learning how to paint in the way they painted in Europe that this reprehensible proceeding of painting "just like Rubens" was hailed as a triumph of virtuosity and the Duveneck studio in Munich and later in Florence was crowded with American pupils eager to do the like.

Years later these pupils and their friends were to awaken to the fact that what America really wanted was not painting à la Europe, but painting à la America, and they were com-

pelled to step back and make way for several men, such as Albert Ryder, Winslow Homer and George Fuller, who had not been especially clever in acquiring studio tricks, but who had made acquaintance with American life and its backgrounds and knew how to get the native feeling into their pictures.

There was no campaign for these men (or as we now call it, "ballyhoo"). On the contrary the excitement was all for the returning stylists from abroad, but little by little, it dawned upon everybody, including the experts, that the Homer, Ryder, Eakins, Fuller, Blakelock paintings filled the bill. They were homely, if you like; they lacked grace; but they "had something" — they were "us." By the time this was discovered it was also discovered that these native sons were money-makers, as far as the experts were concerned, and that settled the matter.

At the present moment, it must be confessed, the native sons are carrying the business of being "homely" too far. They are selfconscious about it and the Missourian, Texan and Californian brands of patriotism are uncouth. Patriotism doesn't have to be uncouth to be real. So it will not in the least harm some of the rougher young painters of the day to take a look at the Duveneck paintings, now that they are here, and see if they cannot clarify some of their methods by comparing them with Duveneck's. They will see readily enough, I believe, that technic, even when very expert, is not enough; and that the glibbest brush strokes in the world are unavailing if nothing is said with them; but for all that clearness of technic is a help to any artist and Duveneck had it.

Consequently, Duveneck's "studies," for they were always that, will have an interest for painters for some time to come, even though they do seem entirely "reminiscent" to the general public. When the time comes, if it ever does, that we will have greatness united to grace, then we may forget him; but until then he at least reminds us of the grace.

In regard to his own accomplishment, he seems to have reached his top stature in portraiture, and especially in those of his fellow artists. He has done nothing much better than the portrait of William Gedney Bunce. The unfinished "Lady With a Veil" runs it a close second. But it is disconcerting to see how trite the artist could be in such a composition as the "Page Playing With a Parrot," and it is a testimony to the prestige Duveneck once enjoyed that it should have been preserved all these years, though it does him disservice now.

And still another technical problem recalled from the past by these pictures is the artist's use of bitumen. This paint was considered a scandal, especially by the early impressionists, who said it turned black, but there were those who claimed they knew how to use it. Apparently Duveneck knew how, for in the unfinished version of "Amy Folsom" the bitumen can be seen dripping rather pleasantly toward the bottom of the canvas and it has not turned black. Wasn't it the unfortunate Munkaczy whose pictures all turned inky black because of bitumen? Apparently he should have used it thinly like Duveneck.

The New York Sun, April 16, 1938

GLACKENS'S MEMORIAL EXHIBITION

THE STORY of William Glackens is the tale of a natural-born illustrator who turned to painting and plunged deeper and deeper into confusion as he pursued this new vocation. The memorial exhibition of the late artist's work, in the Whitney Museum of American Art, gives testimony to the valiant and unflagging spirit with which he strove to overcome fate, but also makes plain the tragic nonsuccess.

This is a bitter and unwelcome opinion to have to express, but since it seems altogether too likely that it will be also the opinion of the many it is just as well to say it and get it over with. Mr. Glackens was a charming man, by all accounts, who had a talent for friendship as well as undoubted gifts as an illustrator, and the affection felt for him by his fellow artists persuaded many of them that he was a genuine colorist as well as a creative painter — for the heart has a way of beguiling

the judgment very often in these cases. In the recent years this championship of theirs has insensibly diminished, but enough of it remains to make the task of talking sense in this matter extremely difficult.

For the truth is that Mr. Glackens was not a colorist and it was the desperate effort to correct this defect in his equipment that made him forget the chief business of a painter — which is to say something in paint — and led him into a self-conscious preoccupation with technic, and the moment any painter sinks into that morass he is no longer an artist.

The chances are that he would have enjoyed a much wider renown if he had clung to black and white illustration throughout his career, and there is also a chance that he might have gone somewhat further if he had remained content with the limited and gloomy palette that he used when first taking the brushes up, for one of the earliest of his canvases, the "Chez Mouquin" attained a degree of naturalness and ease that he was never again to equal.

But it is blackish, and all the pictures of the 1905 period, which are grouped together in adjoining galleries, are blackish. He must have been scolded by his friends for this dependence upon a black base, or, since impressionism was the reigning cult at that date, he may have scolded himself, for the succession of the pictures shows that he threw his pots of black paint out the window and became a violent impressionist almost overnight, trailing along abjectly in pursuit of the secrets of Renoir.

One cannot become a colorist by force of will, however. If that were so we should all be brilliant colorists. Glackens's disaster lay in the fact that he could not see form in color. When he applied the tints they too often lay flat on the surface of the canvas instead of rounding into the forms of nature. In the 1924 "Nude" the blue in the legs makes them quite unsolid and the pink of the cheek does not follow the curve of the cheek, and in the nearby portrait of a young woman the same misfortune of formless color takes the painting of the hand which sinks into a deadly blue. Glaring lapses such as these must have been visible to the artist himself and form the probable explanation for the sense of strain that seems to increase rather than to lessen as his struggle with recalcitrant color went on. The glaring reds and blues do not have the lightness and vivacity of the master impressionists but burden the land-

scapes with a hot and arid stuffiness that is intolerable, and the very pigments themselves assume an unwieldy stickiness testifying to the labor involved.

When the visitor finally reaches the upper rooms where the black-and-white drawings are shown, all the embarrassments of this occasion are forgotten, for here are natural and spirited accounts of episodes in the life of the city, and even when these accounts are extremely complicated, as in the descriptions of parades in the streets and holiday festivities in the parks, there is a balance and security to the compositions and a spontaneity in the lines and a wit in the characterizations that make them all highly acceptable. Even here there is a tinge of Frenchiness to the style, for in the early days of Glackens's illustrative work it was practically impossible to be an artist in the United States without casting sheep's-eyes at what Forain and Steinlein and Willette and the rest of them were doing, but since Glackens really was a gifted draftsman in black-and-white he was able thoroughly to digest his borrowings and keep them submerged. Such indebtednesses are common to all artists, for one must begin somewhere in forming one's style and when the style is actually accomplished and the manner becomes personal then no harm is done. Glackens in illustration was, as we now say, "himself." His work in this line was much appreciated by editors and by the general public and doubtless will continue to be.

The New York Sun, December 17, 1938

1939–1952

BALTHUS

ABOUT THE only thing Paris has to offer in rebuttal to the on-
slaught of Salvador Dali is the work of young Balthus, and so
Pierre Matisse made a hasty trip across the ocean lately and
has just returned to open a Balthus show. He is no more than
just in time. The Dali excitement is raging furiously a few
doors further west on Fifty-seventh street, but perhaps the
Balthus offering may assuage it.

It has some peculiarities, too — if it is peculiarity that you
are after — but the chances are that you won't "get" it if you
are past forty. Perhaps even being past thirty-five may handi-
cap you. At any rate the quite young get certain overtones
from these pictures that are not easily apparent to their
seniors. Just what it is I can't tell you precisely, being, un-
fortunately, past the age myself; but it has something to do
with being young in a nasty way.

You know there are two kinds of young people — the nice
ones and the unpleasant ones. These unpleasant ones have a
strange kind of militancy. Not being content with being ter-
rible themselves, they seem determined to wreck the entire
world and make everybody else terrible. I have been told that
M. Balthus is a quite nice young man and I have every reason
to believe this in spite of the fact that his work does hold an
uncanny fascination for the other sort of young people. They
get in the corners of the gallery and gloat over it in a most un-
seemly way but, as I said before, if you are over thirty-five you
won't in the least know what they are gloating about. In that
case you will have to look at it "just as painting."

Fortunately you can do that. There is some painting there
for you to look at. M. Balthus is a sort of a young Courbet. He
sees nature in a broad, big way. Also people. He puts every-
thing down on canvas in a big way and is not afraid of colossal
undertakings. His enormous panel called "Summer" is am-
bitious beyond anything that has been attempted lately, but
the artist brings it off very well indeed. It is not as sturdy as the
same thing by Courbet would have been but it has excellent

qualities of its own — qualities the great Courbet would have frowned upon, qualities that may be grouped under the general catagory of wit. Courbet wouldn't have tolerated that little figure away back on the hills and so impossibly related to the figures in the foreground. He liked things to relate — definitely. But if you view this work through the doorway of the second gallery you will be delighted with the way young Balthus "relates" all the planes in his big landscape. He can "relate," too, in his fashion.

The paintings, however, are by no means the whole thing of this show. Probably the feature, for the literary-minded, will be the series of drawings made to illustrate the tale of "Wuthering Heights." The mere announcement that a young French artist has seen fit to do such drawings will be sufficient bait to lure the bookish to the rooms. What could any Frenchman get from a tale so firmly intrenched in the secret places of British consciousness as "Wuthering Heights"?

The answer is that it is a young Frenchman who does this. The word "young" in this connection becomes exceedingly troubling, and I confess again that I do not get all the connotations though recognizing that my very young friends get them all. Baffled octogenarians who have thrilled all their long years to the disorderly and un-British story by the half-savage, half-lady Emily Bronte must admit that the Heathcote and Catherine in the book have points of kinship with the untameable youngsters who are causing so much trouble in the world of today, but even so, that doesn't explain all the self-justification that the unkempt rascals seem to get from these drawings.

Needless to say, Emily Bronte herself might not have objected strenuously to these versions of her people, but Charlotte Bronte most certainly would. Charlotte you see, was the friend of Thackeray and loved to look at the pictorial world from his point of view. She would have admitted willingly enough that Heathcote and Catherine were wild but she would have had it expressed in the Quakerish terms of Thackeray's own drawings. Young Mr. Balthus of Paris, however, is no Quaker. Go to the exhibition and see for yourselves what he has done to the famous children of the moors. When he says they are wild, believe me, they are wild.

The New York Sun, March 25, 1939

PICASSO'S GUERNICA

WHAT, FROM any point of view, is the most remarkable painting to be produced in this area — the already famous "Guernica" by Picasso — has arrived in this country and is being shown in the Valentine Galleries for the benefit of the Spanish refugees campaign. This is the most sensational event in a season that has not been too prodigal with excitements, and to see it is an obligatory experience.

It was painted two years ago as a decoration for the Spanish pavilion in the Paris World's Fair and it was instantly recognized by most connoisseurs as an extraordinary achievement and destined without doubt to be regarded as Picasso's masterpiece. Certainly it is the most stunning attack that has yet been made upon the eyes and nerves of the art-loving portion of the public.

It will be much talked about and long talked about. Years after the present war fevers shall have been replaced by some other kinds of fevers — for in the long history of the world there never has been a time when human beings have not itched with unholy desires of some sort, and so it seems likely that we shall continue to be the bad numeros that we have always been — years hence, I repeat, when we shall be able to look on this present period with detachment, just because we shall then be immersed in some other kind of deviltry, we shall regard this "Guernica" as the most concrete and powerful statement of the hatreds generated by these political wars of the present.

It is full of war passion. It was begot out of the rage felt by the artist when he learned of the destruction in the late war of the old Basque town of Guernica. You don't have to be especially susceptible to cubism to understand it. It is only too plain. Death and destruction are furiously indicated and the gestures of the victims have a largeness and a ferocity unequaled in art since medieval times.

This sounds like propaganda and in fact the picture was intended to be such, but it ended in being something vastly

more important — a work of art. Picasso is an ardent communist and in painting "Guernica" he was attacking Franco with might and main, but the futility of propaganda in the hands of an artist is once more illustrated, for always in the case of the good artist the genius of the painter takes charge of the situation and the politician in him disappears in the effort to turn out a good picture. People who see the picture in this country and who respond to its horror will see it simply as an argument against war in general. Picasso aimed it at one set of disputants but it puts the course upon all disputants. Death is very similar on both sides of the battle lines.

Technically the work is overwhelmingly clever. It is twenty-eight feet in width and the great reduction necessary in the photo reproductions destroys the surface variety that the picture has, though it does give an idea of the massive composition founded on a great triangle, with the lighted lamp at the apex of it, and not by accident, for nothing in the picture is an accident. With this vast mural are shown some of the many preparatory studies for it, all of them in bold, unerring lines that are amazing in force. Picasso is continually inventing. Apparently for every new set of emotions that creeps into his life he has to have a new set of symbols, and so we behold him prodigal, on the present occasion, with a group of revolutionary forms that no one on earth but he could have achieved, and all of them have a compelling authority that demands their acceptance into the new language that all the lesser artists will shortly be using.

For reasons of his own, Picasso did this picture in black and white. He can be a great colorist when he chooses to be and there seemed no special necessity to asbtain from color in the Spanish Pavilion — but, of course, he had his reasons. Even in the black and white artists will still find color, however, for there is an emphatic and lyrical play of values against values that runs all through the piece. It actually looks richer and more eloquent as it hangs now in the Valentine Gallery than it did in Paris, for the light that falls upon it is eminently becoming and emphasizes the unity of the design and its tremendous and dramatic thrust.

"Guernica" has already been exhibited in London and will doubtless be shown in some of our other cities before seeking permanent asylum in some museum. It had been supposed all along, by the prophets, that it would be the star item in the

opening exhibition of the Museum of Modern Art, which is scheduled for next week, but the express stipulation of the artist that it should be shown for the benefit of political refugees prevented this arrangement.

The New York Sun, May 6, 1939

OPENING OF THE NEW
MUSEUM OF MODERN ART

THE CURIOSITY aroused by the factory-like façade of the new building of the Museum of Modern Art has at last been appeased. The structure is now finished and open for business. It houses a collection of paintings, sculpture, photographs, and designs that is fully as startling as itself, and by the time these words appear in print all the tongues in the art world of the city will be wagging furiously, for in spite of all the education in modernity that we have undergone not all of us, it seems, are as modern as we might be. We still have much to learn and this museum is here to show us.

The collection now shown is wonderfully like that of the famous and historic Armory Show. The atmosphere, at least, is the same, and although a quarter of a century has elapsed since that event, the whirligig of time presents no new shocks comparable to the old ones. That is to say, all those who were bullied by the Armory Show into an acceptance of a new viewpoint upon the pictorial world will not now have to change again. The chief heroes remain the same. Picasso and Matisse and Redon and Rousseau and Marcel Duchamp and Maillol and Lehmbruck are still on deck, and very much on deck.

To be sure, most of these artists have not remained idle all these years, and have gone on from wonders to more wonders; and in addition we know more about them and their special set of values than we used to know, and so Alfred Barr and the other rulers of the new museum have known where to seek the most significant productions by the new masters and have had astonishing luck in acquiring them for the present occasion — with the result that New York now has the opportunity to study the finest and most complete exposition of the "modern idea" that has yet been put together anywhere in the world.

It is certain to affect the public profoundly and in turn, like its famous predecessor, will make history. It has been designed not only to justify the building of the new museum, which it does emphatically, but to accompany the activities of Mr. Whalen's World's Fair and there is not much doubt that it will prove to be the most constructive effort in that direction put forth by any of our institutions.

Before going on to a recital of the "attractions" of the show it would be just as well to take a look at the new building, for, talking of heroes, that, after all, is the main one. The façade has been disturbing New Yorkers, even the most up-to-date of them, during all the months of its construction, by its stark and machine-made simplicity. It contained nothing, so it was feared, that resembled architecture in any way, but now that the scaffoldings have been removed and the chromium and glass have been polished up the extreme cleanliness of the affair mitigates somewhat the nudity, although the unregenerate will doubtless insist that the front calls loudly for some flagpoles or other ornament. Possibly one of those weird contraptions of Sandy Calder that he calls "mobiles" might save the situation. They had one once on the old building and there is no apparent reason why there shouldn't be one on the new, flopping around in the breeze and casting helpful shadows on the blank wall.

Philip Goodwin and Edward Stone, the architects, doubtless read humbly and prayerfully all that the most famous Le Corbusier ever said about houses being "machines to live in" and resolved to make the museum a machine to show pictures in and nothing more. Flexibility is one of the new items in the new architecture and everything inside the building may be changed around, as the necessity calls for changes, and

so it may well be that the outside may undergo changes, too. For instance, the museum is blessed with a backyard which is utilized for the showing of sculpture and which extends through to Fifty-fourth street, and since it happens that this rear wall of the building has a shade more of seductiveness than the front one it may eventually be turned into the main entrance façade. Why not?

However, it can't be conceded yet that even the rear wall reeks with charm. I went to a dinner party on Monday night at which someone interrupted the general talk but demanding if anyone knew the French word for "loveliness." I suggested "charme" and M. Louis Carré, who was present, suggested "tendresse," but neither of these definitions quite suited our inquirer. Neither do they suit the façades of the Modern Museum. Certainly, and with all due respect to M. Louis Carré, "tendresse" wouldn't do.

If the façade of the building confirms the suspicion that I have entertained this long while past, that New York simply cannot afford a curved line, the interior refutes the impeachment arrogantly, for the exhibition space is divided into innumerable alcoves that weave into each other like rose leaves on a larger scale. This provides the intimate approach to the pictures that is now deemed essential. I believe it was the late Dr. Bode who discovered that even the very best pictures can sometimes be quite nullified by the vastness of old-fashioned galleries, and since his time there has been a general effort to fit the rooms to the pictures instead of vice versa.

All through the present exhibition the intelligent effort can be felt to save each work of art from any interference from its neighbors. True, it is the most modern pictures that fare best. It struck me that I had never seen the celebrated "Canotiers" by Renoir, which has been borrowed from the Phillips Collection in Washington, look so faded and unforceful as it does on the present occasion. On the other hand, the Matisses and Picassos and Mirós burn with new fire. Before quitting the subject of the architecture temporarily — it will be much discussed — I must also add that these picture alcoves disdain coziness. Apparently, in the new museums, we shall be expected to stand up, look quickly, and pass on. There are some chairs and settees, but the machine-like neatness of the rooms does not invite repose. The old-time habit of sitting in front of a masterpiece for half an hour "drinking it in," as it were, will

soon be out of date. However, the museum's reply to all this is, that they intend to shift the partitions about later on, so with some expert shifters on the job, coziness may yet be attained.

As for the art thus exhibited, it provided in such liberal quantities and is of such a challenging quality that it is impossible to gauge it properly in the rush of this hasty review. The general public is sure to be excited by the display and the wits among them will doubtless fasten upon some eccentric items and play them up much as they did years ago for the Armory Show. For my part, I confess my two chief thrills occurred when meeting two old friends — the "Sleeping Gypsy" by Henri Rousseau, and the "White Girl" by Whistler — very dissimilar pictures, but both of them capable of arousing all the poetry that happens to be dormant, in the bosom of the beholder.

It was especially startling to remeet the "Sleeping Gypsy," for much has happened to the picture since the days when it formed part of the late John Quinn's collection and it has not only been the center, in Europe, of curious lawsuits involving the artist's rights in a picture even after it has been sold to someone else, but has also had doubts cast upon its attribution to Rousseau — doubts now happily dissipated. It remains one of the most amazing pictures of modern times, compounded entirely of the stuff of which dreams are made of, and owing nothing to the literary tricks of the more fashionable surrealists. It has been graciously lent by its present owner, Mme. E. Ruckstuhl-Siegwart of Switzerland; but wouldn't it be wonderful if she would concede it to us permanently — for a price?

"The White Girl" by Whistler, is lovelier than ever and has a fortunate light that makes her almost unbearably beautiful. She is in the alcove with several of Winslow Homer's grandest sea pieces, and this room takes on the character of a Salon d'Honneur and will prove a safe and consoling retreat for those who are entirely baffled by the flaming outlawries of Picasso, Matisse, Miró, Beckmann and Rouault. One of Picasso's very latest portraits, with both eyes showing full-size though the face is in profile, is included. This picture may very well happen to be heir-in-chief to the witticisms that used to be leveled, years ago, at Marcel Duchamp's "Nude Descending a Stair." Or, perhaps, this doubtful honor will be bestowed on Gaston La-

chaise's "Floating Figure," which is now for the first time shown in bronze. Lachaise's enormous "Man," in bronze, is also shown outdoors in the garden, along with the newly acquired "Assia," by Despiau, a gift to the Museum by Mrs. Simon Guggenheim; and many other notable bronzes.

The New York Sun, May 13, 1939

EL GRECO

WITH COUNTESS Mercati heading the list of sponsors there can be no doubt now but that El Greco is Greek. The matter has sometimes been disputed. Not the actual birthplace, of course. It seems reasonable to believe that he was born in Candia and Crete is sufficiently Grecian for passport purposes, but what does a passport tell you about its possessor's soul? And did El Greco have a Greek soul? That's the question.

The exhibition now on at Knoedler's for the benefit of the Greek War Association may help you to a conclusion but it is a conclusion, I may as well warn you, that each one concludes for himself. Especially in parlous times such as these when nations are here today and gone tomorrow birthplaces seem to have very little to do with souls. El Greco's soul certainly flamed up in Spain. Did that make him Spanish? Our onetime Jimmy Whistler loomed up as a world figure against the London background. Did that make him English? Is the celebrated Dr. Einstein still a German in spite of his flight to Princeton? It's all very puzzling and apt to lead us upon dangerous ground. And with Greeks and Romans again struggling for the same old territories they disputed so many centuries ago it will probably be wiser to concede the point to the Count-

ess Mercati and to concentrate upon the question of souls irrespective of nationalities.

So then, to begin all over again, was El Greco a soul? I say he was all soul. I say that in all this period since the renaissance taught us how to paint no painter has been so spiritual as he. William Blake, it is true, walked more confidently with God but El Greco walked with the angels. It is almost a shame to have to admit it but there was certainly a touch of snobbishness in the way William Blake possessed God and tried to hurl God's thunderbolts upon erring mankind. El Greco wasted very little time condemning other sinners and occupied himself exclusively with worshipping. While there is no denying that William Blake saw a heaven that suited himself El Greco saw a heaven that suited everybody.

When the skies open up, in one of El Greco's great pictures, and one of the world's greatest masterpieces, and you see the angels preparing to receive the soul of Count Orgaz, then the most arrant pagans feel the need to bow down and worship. That, they concede, is heaven. Emily Dickinson and William Blake and John Sebastian Bach and the other pure spirits never seem to have been afraid of the descriptions of the hereafter that are to be found in Revelations but most of us lesser mortals get distinctly terrified at the goings and comings of the angels, at the falling stars, and the "seven bowls full of the last seven plagues," and the tree of twelve fruits whose leaves were "for the healing of the nations"; but when El Greco takes us by the hand, we willingly enter in, and with no more misgivings than when we go to Carnegie Hall for a Boston Symphony concert.

That's what El Greco's heaven was, I think; just a Boston Symphony concert. They say he had music with his meals, and most probably he had the musicians play all the time he was painting. That would explain why some of the passages here and there in an El Greco painting are rather jumpy, for the musicians in those days were not so mechanically proficient as they are compelled to be in the machine age, and it also explains why the look of ecstasy invariably brightens up the El Greco saints and why the miracles occur right here before your eyes. He painted to music.

In such a work as the "Expulsion from the Temple," which has been lent by the Minneapolis Institute of Art, there are countless little errors in draughtsmanship in places where

they do not matter in the least, but there is no question what-
ever as to the authenticity of the drama that this amazing
artist compels you to assist in; for that is what you do, and
why you pay no more attention to the details of the drawing
than El Greco did. And in the still more Grecoesque picture
of "St. John the Baptist," there is such a ferment of spirituality,
such a sense of almost anything being likely to happen at any
moment, that only a dull and completely lethargic person
could be aware that the famous "elongations" in draughtsman-
ship are also present.

They are always present in the best El Grecos. They are
there because the artist was worshipping the majesty of the
Saint's soul and not concerned with the exact physical mea-
surements of his body. Certain writers contend that these
elongations were intentional — but I do not think it necessary
to believe that. They cite the defense El Greco was once
obliged to make in a lawsuit in regard to this very matter, that
"to be dwarfed is the worst thing that can befall any kind of
a figure" but it is to be noted that this defense was made after
the picture was painted and only when someone else had
objected to the extreme height of his saints. There is very
little positive knowledge of El Greco's methods and principles
of painting, but practically all you need to know is there in
his pictures. He is his own best authority.

The New York Sun, January 18, 1941

MODERN ART IN RICHMOND

AT ALL events, Richmond is a gentleman (Richmond, Virginia,
I mean). The most acceptable of recent definitions of gentle-
manliness — "grace under stress" — is attributed to a purveyor

of best-sellers whose works I never read chiefly because there is so much stress in them that grace is totally lacking; but, at all events, "grace under stress" was the especial trait of the Virginians on the night of the first showing of the Walter Chrysler collection of extremely modern art, and therefore Richmond is a gentleman.

In fact the behaviour was too good. It was scarcely natural. In the case of a completely shattering experience the nerves even of a gentleman are entitled to an approximately 10 per cent shatter without leaving any aftermath of reproach but on the night of January 16 in Richmond there was no visible shatter whatever. Gov. Price was affability itself. Mayor Ambler looked absolutely unworried. Perhaps they had been tipped off in advance. Or perhaps they had been reading the evening papers, and in considering the imminent collapse of the whole known world had decided that the loss of their previous art conceptions was a mere detail.

The haute noblesse of the Southern capital had been fortified by an excellent dinner at the Governor's mansion before going to see the pictures but even so were unable to rise to the level of His Excellency's nonchalance. Their manners were unexceptional, as has been said — but one felt the tenseness. There were no loud shrieks of protest as on similar occasions in New York in times past. Everyone smiled nicely and commented in low voices careful not to injure the feelings of visitors from Manhattan and appeared to be looking at the pictures rather than at Mrs. Byron Foy's new dress. (I was mistaken in this. The Richmond newspapers next day contained masterly and appreciative analysis of Mrs. Foy's costume. "A heavy rolled collar was affixed halter fashion over the low decolletage," sounds quite as puzzling as the same writer's descriptions of the Picassos on display.)

In the midst of the party, one of the officials of the museum who had already been living with the pictures for some days, whispered to me: "You've got them stunned," but I, an outsider, could not see the evidence upon which he based his theory. To me it was just a nice party and attended by such remarkably good looking people that I afterward concluded that none but the good looking had been allowed in. So, with all these perfect manners functioning to the limit, it seems too soon to estimate the success of this event, for, obviously, it was Richmond that was being tested rather than the Chrysler

collection. However, Richmond's secret opinions will come to light, sooner or later, and the first outcries in the Richmond press will, doubtless, be lived down.

For instance, Isabelle Ziegler, the official critic for the Richmond News Leader, remarks of the "Mme. Cézanne" that Cézanne "was so afraid of women that he painted his not particularly appealing wife uncounted times," and that is a comment that will definitely interfere with Miss Ziegler's welcome when she returns to Paris after the war. Madame Cézanne most people agree, was thoroughly appealing, if you know what the word appealing means. She was certainly not a glamor girl but she did appeal. And for Henri Matisse, this critic was even more severe. "The fifteen works by Henri Matisse, chief of the hoodlums, and the artist whom polite people didn't even mention a few years back, seem almost without importance today."

Henri Matisse a hoodlum! That is an amusing idea, and sufficiently novel. The work that no doubt incited the remark is the big study for "La Danse," made in preparation for the famous mural decoration now in Moscow, and, as it happens, better shown in Richmond than I have ever seen it elsewhere. It is up in the air, where it belongs, with lots of space around it, and the primitive ease and assurance of the dancing figures are most impressive. If Miss Ziegler should change her mind about Henri Matisse later on, she will join the numerous company of those who have, for twenty years ago it was the fashion to say harsh things about him, although I don't believe he was ever dubbed "hoodlum" before.

The New York Sun, January 25, 1941

OPENING OF THE NATIONAL GALLERY

WASHINGTON, MARCH 20. – "Grim-visaged war hath smoothed his wrinkled front and now instead of mounting barbed steeds to fright the souls of fearful adversaries" hath spent a quiet interval taking stock of benefits forgot; benefits bequeathed to us from former periods.

All Washington, from the highest to the lowest (I won't mention who the lowest is, and you all know the highest), spent the week worshiping in dazed amazement the sweet Madonnas and noble portraits of the "Mellon Collection" and if they moralized at all upon the extraordinary occasion of such a gift by such a private citizen to such a world then they must have decided that the true lesson of the event is something that will be revealed to us later. There was prodigious vocalization, but practically nothing said.

Certainly the Madonnas were inscrutable (probably because we now have so little faith) and the Van Dyke, Rubens and Goya grandees, precisely like those in real life who attended the private view Monday night, looked as though nothing special were happening and as though, in any case, this were certainly the best of all possible worlds.

Yes, they still call it the "Mellon Collection" – in Washington. I said to the taxi driver: "Take me to the National Gallery," and with a scowling glance he replied: "You mean the Mellon?" I said, never being much of a disputant, "Yes, the Mellon"; and off we went to it.

There is a certain justice in this. After all, it was Mr. Mellon's idea. He had the knack of acquiring first-rate works of art in a time when it was much less easy to acquire them than in good King Charles's time, and supplemented the knack with the intelligence to see that, in the end, such things rightfully belong to the public at large.

In the course of time, no doubt, Washington will realize that the gesture of Mr. Kress in giving his great collection to the nation is equally generous, and that in fact it is this willingness of his to add his pictures to Mr. Mellon's that truly

378

makes the gallery national. For Mr. Widener's great collection is already in the offing, waiting only for a proper opportunity to be moved into this new museum, and Chester Dale's contribution of some of his early American portraits to the present exhibition suggests that there may be further additions from that source. These earliest donors to a great enterprise will always be of special interest to connoisseurs, but when they shall be followed by the collectors of the future, as certainly they will be, then even the taxi drivers of Washington will realize that greater than any individual is the nation and greater than any possible private gallery will be the National Gallery — and that will be its name.

But you should have attended the private view Monday night: You really should have. It was something — and very American. When the great American public strives to attend an event that has been sufficiently advertised — and the opening of the Mellon-Kress collections had been well advertised — there is no stopping it. Pressure had been brought to bear from all quarters and, although ten thousand invitations had been issued, ten thousand were not enough.

On the Sunday afternoon before, venturing into one of the museum's offices to do a little surreptitious typewriting, I inadvertently overheard the telephonic plea of a Congressman for just a few more tickets for some of his constituents and marveled at the deft and charming way in which he was frustrated. I then saw that with such tact and finesse in the directorial division, the new National Gallery was certain to get on. Half of any museum's chances for success consists in the ability to say "no" delightfully.

Of the ten thousand invited, they say, and I believe it, that eight thousand attended. Coming down from the Sulgrave Club where David Finley had given a hundred of us a fortifying dinner, we were stopped several blocks away, marshaled into three lines of cars, and after that crept onward only by inches. A journey, ordinarily of ten minutes, required, on this occasion, fifty, and by the time we got inside the preliminary speaking had begun.

President Roosevelt was to make his acceptance speech in a gallery off the already famous rotunda with the black marble columns, but we late-comers were around the corner from it, and so far away that at first I thought myself doomed not to hear the chief speaker. But suddenly there was a stir,

the crowds parted, and a fainting lady was borne past on a stretcher. It was intensely dramatic. Just like a picture by Goya. Soon several other ladies fainted and were borne out on stretchers.

No men fainted. No thin ladies fainted. All the ladies who collapsed were bulky, so that with each casualty three people of ordinary size could get in to take the spot vacated. For that reason, and without any undue pushing on my part, I soon found myself within the coveted inclosure – and right next to Belle DaCosta Greene and Chester Dale.

The President looked pale and exceedingly worn. Dr. Devol, who was present in attendance upon Mr. Kress, said that it was merely a combination of fatigue and the Klieg lights, and that the announced vacation and a little rest would be sure to put him all right.

Belle DeCosta Greene insisted that the President, when mentioning the donors to the exhibition, had stuttered when pronouncing the name of Chester Dale. For such an expert and experienced broadcaster, this is almost inconceivable, yet I, too, had had the same impression, though as one of the fainting ladies was being borne past at the moment, with all attendant confusion, I could not be sure.

The word, of course, went out on the air and millions of people heard it, and if they decide that Miss Greene is wrong in this matter, I trust they'll not write in to me to say so. I have enough trouble attending to my own fan mail without bothering about hers. If she's wrong, let her stay wrong, I say.

Chester Dale himself certainly could not have stuttered even had he wished, for the sudden change from Miami to the icy blasts of the hurricane in Washington had completely bereft him of voice. Walter Damrosch, who thinks music and therapeutics to be closely allied, assured him that if he would keep saying "Em, Oou, Oh, Ah" he would soon have his voice back where it belonged, but Mr. Dale refused to take his first music lesson before such a vast assemblage. He whispered, for that was all he could do, that he was going straight back to Miami.

The galleries and corridors of the new building are exceedingly handsome and exceedingly effective in the showing of pictures. There seems to be no dissension from this. Amateurs and professionals agree in liking the equipment. Admira-

tion for the exterior of the edifice is not so unanimous, but in a museum, after all, it is the galleries that are the essential, and in this instance they are all right. Of course, the presence of such a tumultuous and picturesque mob made any study of the pictures difficult, but I had had two previous days of daylight for their inspection and knew that they were being shown as perfectly as they could be anywhere in the world.

It was gratifying, too, to see how neatly the gay modern crowd fitted into the background thus provided. Lots of the girls were gowned in brilliant reds and this may have helped in making the scene Goyescan, for in every direction I was constantly seeing "groups by Goya." The Goya motif was suggested, of course, by the wounded ladies being borne out on litters, but where, of all places, do you think they took them to recuperate? To the Goya Room — and I wondered that the Marquesa de Pontejos did not step down from her portrait to proffer advice and comfort to the stricken ladies stretched out so galantly on the marble floor beneath her — for she, too, had been to the wars.

I ought to add, I think, in justice to the architects, that these casualties should be attributed to the emotional stress of the times and not in any way to the air-conditioning system which seemed to me to be functioning perfectly.

Next morning, on the train bound northward, the groups nearest me were unmistakably Philadelphian. It is not so much the women as the men from that city who betrayed their place of habitat. I don't know particularly what it is — but you always know them. However, in any case, I should have "placed" them, for they had scarcely adjusted themselves in their cushioned seats before one of the men sung out to an acquaintance several seats further down the aisle: "What'd you think of Joe's flowers?"

That, of course, was the proof positive. The reference was to Mr. Widener's acacias. Mr. Widener, it seems, grows the most marvelous acacias of anybody, and as a gesture of friendship to a gallery to which he is already related, sent a whole forest of these beautiful plants to glorify one of the patios of the new museum. They were banked in great masses around the fountain and against the supporting columns, and the whole effect was, to put it mildly, as pretty as a picture. I thought of them during the "private view" and wondered if

the press of the multitude would be a menace; but I suppose nothing happened to them or Joe's friend would certainly have informed us of the disaster.

The New York Sun, March 22, 1941

EDWIN DICKINSON

ANY ONE sensitive to the art of painting ought to recognize good painting in the work of Edwin Dickinson. So I should think. Yet, though he has been exhibiting now for some time he appears not to be generally known. This is a situation that ought to be corrected. So I should think. But there are difficulties in the way.

In the first place, he is a serious painter. We all say we like serious painting — but do we? Perhaps Mr. Dickinson is too serious. Here is a man who paints as cleanly, as neatly, as progressively as Whistler yet who probably never smiles once as he perceives he has made a happy touch on the canvas and who holds himself dourly, unrelentingly to the completion of the task he has set for himself.

There is none of Whistler's hilarity. There are no concessions to the public in any way. There are no divertisements. There is nothing but the stanch integrity of a man determined to paint nature according to his lights. There is nothing but painting. Is that enough? It ought to be — if you like painting.

Mr. Dickinson is an ascetic. He is an early New England settler. He is a Quaker, or possibly even a Shaker. I hasten to add that actually I know nothing of the private life of this man. All that I say in regard to his character is pure surmise — garnered from the pictures themselves — which are now on

show in the Georgette Passedoit Galleries, 121 East 57th street. That, however, is all I ever care to know about an artist, that which his pictures tell me. In the present instance we certainly have an artist who leads an inner, Emersonian existence.

It is, in fact, so cloistered that I have a certain shyness, a sense of guilt, in opening the shutters, pulling the curtains to one side and thus exposing to the chilling, critical inspection of the world, the work of a citizen who has got along fairly well so far in private and who might go utterly to pieces if jostled too severely by the crowds on 57th street who instantly put a price-mark on anything that claims to be a work of art.

Such disasters have already occurred. I myself have killed several artists with kindness. If you don't know what I mean, I will explain. Years ago there was a young man who hated the world because he thought, mistakenly, that the world hated him. He consequently put so much venom into the landscapes he painted that I, recognizing the force of the expression, called special attention to them. Thereupon buyers appeared, money rolled in, comforts were indulged in, and the young man lost his hate. He then proceeded to paint a series of insipid, fatuous pictures that promptly cost him his new-found friends, and when he died, as he did not long ago, there were few to recall that he once had a chance at a career.

This whole modern business of instantly holding pictures up for appraisement as though they were stocks and bonds, and with the critic acting as salesman or possibly as school-master, is something the ancients didn't have to contend with, and may partly explain the unflinching quality of their work. They may have striven, it is true, to please "the duke," but one duke is easier to please than a committee, a jury, or the populace at large; and as Americans are always peculiarly self-conscious when attempting to be artists, it still remains the safest plan for them to be their own dukes; that is, to retire into strictest solitude and to paint for themselves alone.

So, if I say that Edward Dickinson's work lacks "allure," that is merely because I am on the witness stand and obliged to tell the truth, but it is not necessarily anything that Edward Dickinson himself should pay attention to. In fact, if his work in next year's exhibition should contain any traces of "allure" I should be horrified and should feel that I had killed yet another artist, for if anybody saunters up his alley at all it will not be "allure" that they are after.

On the contrary, it will be to verify the rumor that we have at least one artist of undoubted integrity in our midst. The humor that makes it "so amusing" to note how Whistler did "this little bit over in the corner," or Hokusai this fantastic tree, or Constantin Guys's way with an ankle, was not for him. As I said before, Mr. Dickinson never smiles. He looks out on the landscape, or at himself in the mirror, and has no intention of ameliorating anything. He is as implacable, in that respect as Thomas Eakins was, though Thomas Eakins had so much drama that you scarcely noticed he lacked humor. But Thomas Eakins was a recluse, too; you may remember.

The New York Sun, April 5, 1941

RALPH BLAKELOCK

FOLLOWING ITS recent Winslow Homer exhibition, the Babcock Galleries, 38 East 57th street, now call attention to another of the American old masters by arranging a Ralph Blakelock show. It's a small show but it will do. It shows the several periods of the artist's career; giving pleasure to patriotic collectors and providing lessons in the art of painting to students.

The several "top-notchers" in the collection explain the artist's reputation, a reputation that was seriously interfered with for a time by the flood of spurious "Blakelocks" that came upon the market during the artist's long last illness. The formula for the Blakelock moonlights and sunsets was so pronounced that, in a superficial way, it was easily enough imitated, and as the great Blakelock moonlights were safely hidden away in private collections, the general public became quite confused by the prevalence of the "fakes."

My own enlightenment in regard to Blakelock (and that of many others as well) came with the dispersal at auction of the famous Catholina Lambert Collection, for in it were two pictures by Blakelock that were incontestably great. Both were shimmering moonlights with the foliage and the foreground linked in the dark shadows that the great Chinese landscapists so often affect and which has so much justification in nature. Both paintings went far beyond the domain of paint into the realm of pure poetry. The larger, and finer, of the two pictures, was purchased for the Toledo Museum, and the second one, which was almost as good, went to the late Senator Clark, and is now reposing, I think, in the Smithsonian Collection at Washington. I don't know of any better moonlights anywhere.

Once an artist's masterpieces lodge in a museum his reputation is safe, and his lesser examples and the dubious imitations of the "fakers" have a way of drifting off into the corners of the anterooms where they do harm to nobody. The chief difficulty in fostering the reputations of our great men, lies in the great distances between the cities, which entails more traveling than the great public is willing to undertake for its education. So, just because Toledo already owns a great Blakelock I would like to see that city own some more, for I am a great believer in massing the attack upon the public's consciousness. If I, I argue, as a young man would journey all the way to Madrid just to see the El Grecos, then surely the amateurs of the future would willingly journey out to Toledo to see the Blakelocks, if only Toledo had enough of them.

Particularly it would be excellent for the Toledo Museum to possess the "Sunrise, No. 9," for though this work is not great in itself it shows how the greatness was achieved. It provides the lesson for students of painting that I have referred to. It was painted when Blakelock was but 21, and there was no higher effort in it than to get at the "facts" of nature, but the artist went at this job so thoroughly and assembled so many facts, and organized them so intelligently, that he got a sound basis for his later romanticism. It's the same sober diligence that you see in the early work of Winslow Homer, in Degas, and in most masters whose later freedoms are tolerated. It's the freedom that comes from knowledge.

The New York Sun, January 16, 1942

MONDRIAN'S FIRST ONE-MAN SHOW

PIET MONDRIAN, who is famous in two hemispheres, is having his first one-man show anywhere in the world at the Valentine Galleries. How to moralize on this circumstance is not easy. Are one-man shows, then, so unnecessary to fame? Perhaps we had better not go into that matter too deeply.

Mondrian is the most modern of painters. He deals in rectangles boldly constructed by unrelentingly black lines crossing upon a white ground and with patches of pure color inclosed sparingly here and there. This, you may be surprised to know, is the artist's attempt "toward the true vision of reality." Obviously plenty of definitions are required to elucidate this "vision" and Mondrian, in a supplement to the catalogue, supplies them. If you are as unprogressive as I think you are, dear reader, you are in for a considerable struggle with these definitions, but, my advice is, not to throw the catalogue away, but to keep it and ponder over it, and then go occasionally to see the Mondrian paintings. As William M. Ivins says of the Rembrandts at the Metropolitan Museum, words cannot explain them, and the only thing to do is to look at them. The same applies, with almost added force, to the works of Mondrian.

The New York Sun, January 23, 1942

TAMAYO

THOSE INTERESTED in cultural relationships with nations to the south of us would do well to take a look at the Rufino Tamayo paintings in the Valentine Gallery, 55 East 57th street. There's culture for you! Perhaps if we really see it, these Mayans (Rufino Tamayo is Mayan Indian) may begin to see us, too.

And that's what we want, isn't it?

For those who are merely pressing on the political end of the matter it may be a difficult lesson in comradeship, for the idiom that Tamayo uses is as curious to the modern eye as the original spelling in a poem by Chaucer — but once it is looked at frankly it turns out to be fully as rewarding. This artist presents the strange anomaly of an individual intensely alive to all the implications of contemporary æsthetics yet whose innermost, sacred feelings spring unmistakably from a Maya past that is so remote that it is practically beyond the reach of history.

Since it is indubitably honest, this mixture of modern refinement with ancient savagery is deeply touching. How does it come about? No one may say — least of all the artist. We talk of the changing times but this thread that stretches from a distant and invisible past and seems likely to continue into the equally invisible future is something to hold on to. It appears to defy time. Aldous Huxley, who has been down in this Maya country, says that "time was evidently at the very heart of the Maya religion. To grasp time intellectually seems to have been the first duty of the initiated few."

But the initiated few should have consulted their artists. When Rufino Tamayo uses color with the inventiveness of a Picasso and with all the elegance of a Braque and at the same time applies them to symbols that have been in uninterrupted use for thousands of years, you have a continuity that is delightful and reassuring both to gentleman and savage. Time marches on but the end of the world is not yet. Each famous stela in the Mayan jungle signalizes an important date, says

Aldous Huxley, and that is all very well but what is a date compared with the assurance that life is everlasting?

And anyway Rufino Tamayo makes a date, too. To connect him with Picasso and Braque relates him to the calendar as effectually as anything a stela could do. He is much the best artist to have come to us from Mexico. In the first place, he paints. And in the second place what he paints is steeped in poetry. Beside him both Rivera and Orozco seem like hard-boiled and commonplace illustrators.

To attempt to choose the best performances in the present exhibition is idle for each picture seen separately seems to be in the No. 1 class, but the pictures that have animals in them do have a peculiar and quite special charm. The one of "Birds" gives me the impact of the tropics emphatically. For all I know it may have been painted in our Bronx Zoo, but given a Mayan to paint it, and at once you hear the raucous squawks of these uneasy aviators and begin thinking back a thousand years to the beginning of things.

The first excitement, however, for the amateur will be the recognition of the constantly varying color schemes of these pictures. It is curious and impressive to see each "arrangement" so individualized and yet so dominantly hall-marked by the personality of the artist. The variations in the key of brown in the "Woman With Guitar," the silvery blues in the Woman, and the reserve and strength of the "Red Mask" — these things are both original and distinguished.

New York Sun, February 13, 1942

MATTA AND THE HENRY CLIFFORDS

"THAT ONE," said I, pointing to the biggest Matta in the Matta exhibition at the Pierre Matisse Gallery, "might be sold, I should think, to the Cliffords."

"It has already been purchased," said Mr. Matisse, "by the Cliffords." You could have knocked me down, as they say, with a feather. I had no idea that I was so psychic. I had no idea that I knew the Cliffords so well.

But, after all, it is not so surprising that I should have guessed well on this occasion. In every sensational exhibition of the winter, the most important picture present, and the one that represented the greatest buying courage, has invariably been "lent by the Henry Cliffords." One gets to expect this. So perhaps I'm not so psychic. Perhaps I'm merely logical. But anyway this time definitely "a bell within me rang," as Alice Toklas would say. I intend to claim whatever credit attaches to it.

However, this close affiliation of mine with the Cliffords was no sooner established than it was brought to a sudden halt. Shortly after deciding that the vast canvas, with its display of daylight fireworks and showers of unmistakably precious jewels, was just the thing for them, and that their guests, eyeing this picture from comfortable sofas, would be so ecstasiated that they would never know whether their after-dinner coffee had been properly rationed with sugar or not rationed at all; shortly after deciding all this, I repeat, I turned my back on the Clifford Matta and walked over to another one which, were I buying a Matta this week, would certainly be my Matta.

It is much smaller than theirs, and not so fireworky, and yet more dramatic. I'm not saying which of us did the better choosing. I suspect the Cliffords of being "forward-thinking." I, on the contrary, am inextricably tied up with the present. I cannot think beyond today. I like drama, and I like my drama to lead up to one inescapable impact. I am a regular Joe Louis for that. When Joe passes there may be no more knockouts and everything may be decided on "points."

389

I admit the Clifford picture has more points than mine. It has as many points as there are dots in the Milky Way on a clear night; and in the new era, to which we are being so rapidly propelled, no single individual may be permitted to have one drama all to himself, but groups of people will be sitting on the Clifford cushions and enthralled by two dozen dramas, all happening at once, and liking it better that way. The "mass era" may be upon us at any minute now.

My Matta is called "Opening of a Grain of Rice," but it wasn't the title of the picture that got me, it was just the drama, as snug and coy a drama as those we used to see in the Palais Royal, only much more serious. Nothing that ever occurred in the Palais Royal was ever serious. I suppose it's those billowy reds at the bottom of the canvas that associates the picture in my mind with the late King Alfonso's favorite theater. The actual opening of the grain of rice leaves me cold. I'm no Japanese. But I maintain the picture has drama.

I neglected to compare all the titles with the pictures, and now I am sorry for it, for I find one of them is called "Escarlata la mujer de Babylonia," and I certainly would like to know what that is all about. It sounds slightly risqué, don't you think? But fortunately it's one of the abstract ones, and practically everything passes the censor when abstract. It is one of the "oil-pencil" drawings, and all of these are spirited, and electrically colored and with contrasts of texture that the artist seems to manage just as easily in this difficult medium as he does in the regular oil-paints.

This is Matta's second exhibition in New York. The other one you didn't attend, but this one you will be obliged to attend, if only for the "cultural relations" angle of the affair. Matta is from Chile. But you'll enjoy it.

The New York Sun, April 3, 1942

THE GOLDEN AGE IN AMERICA

IF YOU have tears to shed prepare to shed them now. The golden age of these Americas has definitely passed. The mirrored reflection of it is all we have left; and even with these so few years that have passed, how unbelievable it is that we were once so grand!

Go see the magnificent pearls and costumes in the portraits of the Golden Nineties Exhibition, now shown at the Hotel Gotham for the benefit of the Red Cross; you'll scarcely credit it else. Notice the sense of security in the ladies who supported the grandeurs of those days. Not one of them had ever heard of the name of Marx. Not one had read "Mein Kampf," nor even "One World." All believed implicitly in the permanence of incomes and the divine rights of the wives of American millionaries.

The "Age of Innocence?" Certainly. Why not? There were a few minor discrepancies in the plan of things, but not many. Occassionally the more finished exploits of Mrs. Jack Gardner in Boston, and the severe comments of Harry James, seemed to accuse New Yorkers of crudity, but once the dinner lists had been checked over by Harry Lehr, and the chosen guests for Mrs. William Astor's ball, had had a preliminary look at each other at the Monday night opera, they knew very well that they were, as we now say, "sitting pretty." It was the best of all possible worlds and New York was the center of it.

How fantastic it is that we, in this simple Jeffersonian republic, should ever have arrived upon such a plane of splendor and how still more fantastic that all of it now should have vanished like a dream! What a comment on life that is! The few remaining owners of fabulous strings of pearls now keep them in lock-boxes and the ladies who possess square-cut jewelled rings like those worn by the first Mrs. Clarence Mackay in the Boldini portrait would scarcely dare, these dark nights, to take them to the opera. The coach-and-fours no longer start from Holland House and for that matter, where on earth is now the Holland House?

"Why, why?" the bewildered spectator asks, "must there be this eternal flux? Why cannot perfection, once it has been reached, remain? Why should Eve be shown the Garden of Eden and then so quickly dismissed from it? Why bother about the ideals we are never allowed thoroughly to test? Why should the great Pericles, with all his wisdom, shatter the most famous of all republics merely to defeat the Persians? Why were labor unions invented? Why? Why?" But see here, friend, go see the show and do your own moralizing, and above all, do your own weeping. I positively can do no more!

The painters, naturally, were the best that money could buy. John Singer Sargent was the prince of them. It got so, finally, that you simply had to be painted by him. He landed one year in New York, so he told a friend, already saddled with commissions to do sixteen "heads" at $5,000 per. But the constant struggle with pearls and laces and Worth costumes wore him out. By the time we had reached that other war and he tried to do a "President Wilson" for patriotic reasons he simply wasn't up to it. In the "Mrs. H. McK. Twombly," the "Hon. Mrs. Frederick Guest" and the "Mrs. Henry White," he was, however, particularly up to it, and it is easy to see why the ladies thought it indispensable to be painted by him.

Also, of course, there was Philip de Laszlo, who did pearls so well. See the "Mrs. Whitelaw Reid" on the present occasion. You must remember that imitation pearls in those days had not been brought to perfection. Mr. de Laszlo knew the difference between a $100,000 string and a $250,000 string, and made it apparent. And Boldini! Boldini apparently went into a whirlwind of emotions whenever he attempted a portrait of a fascinating American heiress. His brushes misbehaved in extraordinary ways at times. I always thought his best in that line was the one of "Mrs. Harry Lehr" which used to hang in the Paris residence. Where is it now, I wonder? And the portrait by Madrazo of the Countess Szechenyi's mother, "Mrs. Cornelius Vanderbilt," is still a charming production. And the vivid view of "Mrs. Philip Lydig," by Zuloaga, is just as apt to make you jump, as a rencontre with the lady herself would have done.

What a definite and glamorous period the "Golden Nineties" provided for us. Who'll be the next people to have such a place in the sun? The Russians? Vice-President Wallace seems

to think so. Well, it wouldn't be a bit more surprising for them to have it than for us to have had it and lose it.

The New York Sun, May 7, 1942

CALDER

THE SANDY CALDER exhibition in the Museum of Modern Art might just as well be called "Les Fleurs du Mal," for everybody living, from Mrs. Roosevelt down (or up) knows that this is the period "du Mal," the period in which advancement in morality is not so evident as our increased cleverness in the use of metals; and since, of all metal work, the Sandy Calder specimens are the most flowerlike, you can readily see that this artist has as much right to the title as Baudelaire had.

But Baudelaire used it first of course. Baudelaire, seen in perspective, turns out to be a great moralist though his contempoaries thought him just the reverse. He didn't recommend the Mal of his own period for general consumption, but the fact that he called it Mal shows that he knew what it was, so the point is, and this is what makes him moral, that even from the Mal he was able to pluck flowers.

There he was as truly moral as Emerson in his essay on "Compensation" and by culling flowers from a world which has a tendency to grow more and more metallic Sandy Calder mounts to the same plane. It is the business of the artist to do this, naturally. The good artist is invariably a moralist whether he knows it or not and even if that were not his intention, for in being a good artist he confirms nature, applauds nature and, as the mariners say, "stands by" nature in every emergency.

The present emergency is one of the most terrific that nature has ever experienced and it is only those among us most persuaded of nature's invincibility and power to recover from every rejection she gets at the hands of human-beings (and I'm not thinking so much of plucked eyebrows and painted finger nails as of the difficulties a tree has in growing on Fifth avenue and the general hardness with which we have chosen to surround ourselves) — and it is only such of us who feel this, I repeat, who rejoice in Sandy Calder's ability to salvage from our unlikely modern materials an art-form that sways in the breeze like a bamboo reed on a river-bank.

For in spite of the fact that this artist builds his constructions of wire and wooden disks and metal tubes, he never fails to appeal for help, when beginning one, to Ariel or Boreas or whatever imp or god it is who presides over the laws of motion — and generally the help is supplied. His exhibition in the Modern Museum contains an astonishing number of proofs that nature never can be entirely thwarted and that even when at the last gasp, as I presume nature is at the moment, she can still supply to poets and to genuine artists the manna which the soul craves and upon which alone the soul thrives.

The Sandy Calder constructions lend themselves, just as a tree does, to the lights that change as the sun marches across the sky and yield to any invitation from the wind, and the vagrant eye is held to the incessant variations of shadows and groupings, wondering if ever they will fall, by chance, into disorder — but they never do. Invariably nature triumphs and one gets the idea that Sandy Calder is one of nature's pets. But that isn't so. He is simply a good artist.

The New York Sun, October 29, 1943

GEORGIA O'KEEFFE

THE LEADING stars of the American Place are encouraged to write as well as to paint. This, I think, is a mistake. I agree with Sir Joshua Reynolds, whose slickest bit of wisdom was the advice he gave to one of his pupils: "An artist should sew up his mouth"; meaning, obviously, that what couldn't come out that way might come out in the painting.

But in spite of Sir Joshua and me, Georgia O'Keeffe has been and gone and done it. She has written a piece for her current exhibition explaining why she makes pictures from the bleached bones of the desert — and it is very good. It is practically a poem. If she had only taken a few lessons from Marianne Moore it might have been a real poem. But anyway it is very good. Here is part of it:

"A pelvis bone has always been useful to any animal that has it — quite as useful as a head I suppose. For years in the country the pelvis bones lay about the house indoors and out — always underfoot — seen and not seen as such things can be — seen in many different ways. I do not remember picking up the first one but I remember from when I first noticed them always knowing I would one day be painting them. A particularly beautiful one that I found on the mountain where I went fishing this summer started me working on them.

"I was the sort of child that ate around the raisin on the cookie and ate around the hole in the doughnut saving either the raisin or the hole for the last and best.

"So probably — not having changed much — when I started painting the pelvis bones I was most interested in the holes in the bones — what I saw through them — particularly the blue from holding them up in the sun against the sky as one is apt to do when one seems to have more sky than earth in one's world.

"They were most wonderful against the Blue — that Blue that will always be there after all man's destruction is finished. I have tried to paint the Bones and the Blue."

It's rather good, don't you think? But what Miss O'Keeffe

fails to tell you is that she is a natural-born decorator with an urgent, inner leaning toward the abstract; a leaning to which, being a 100 per cent American, she has never dared yield. Were she abstract she'd lose her public and, as she has a considerable public, naturally she hates to do that. So she holds the enormous pelvis bone up against the sky and puts in a nice round moon for good measure, and those who, unlike George Santayana, cannot reduce entities to essences may see, unmistakably, that it is a pelvis and a moon; and handsome at that.

But those few other Americans who apprehend the essences – I believe there are only twelve of us in the country, not including Einstein, who do – will notice that the pelvis is a subterfuge and that Miss O'Keeffe's real pleasure consisted in going all out for decoration with only a minimum of facts about life and death.

It's no wonder that George Santayana left the country. But it's Miss O'Keeffe's best picture to date.

The New York Sun, January 15, 1944

THE DEATH OF MONDRIAN

THE SUDDEN death on Tuesday of Piet Mondrian shocked a much wider circle than the little group who knew the artist personally, for all those who look on contemporary painting at all knew that he was one who had rigorous ideals and molded his life and his work to meet them.

There is so much that is loud, pretentious and false in the modern world, and the art of advertising is practiced so astutely by candidates who are not astute in any other direction,

that you would imagine the populace would be completely fooled by the constant clamor for fame. Yet it is not so. The public is never completely fooled and somehow sincerity and honesty shine out all the more brilliantly in the end against the dull background of the struggling incompetents.

What is required of the artist is that he have a life of his own. What is necessary to his style is that it be distinct. These two requirements, so obvious and so simple, are nevertheless difficult to attain in communities where mass-teaching is practiced and mob-thinking indulged in.

Mondrian's aim as an artist was to make a purely æsthetic appeal. His constant effort was for more purity, more simplicity and more precision. His early arrangements of straight lines on white surfaces were not without lyricism. The lines had the softened edges of the "artist touch" and the lyricism became symphonic when tones were introduced to hold the composition together in a largish manner.

The later pictures grew clearer and clearer, as though all the intense laboratory lights of modern science had been flung upon them. The "touch" was gone from them, Apparently it was not permitted; and the black lines divided the whites inexorably, inflexibly, and determined the amount of primary color to be used with a rightness that was unquestionable to the human eye. This painting of precision, like an instrument of precision, registered the intellectual atmosphere of today as aptly as Fra Angelico's purities measured the spiritual ecstasies of an earlier time.

It may be urged, and in fact has been, that style, when refined to this degree, is no longer the concern of the great public, and even so great an authority as Ernest Renan has said that no doctrine is suitable for wide public consumption unless it be sugar-coated with considerable myth. Absolute purity itself seems to be a myth and "the essences" into which, Santayana says, all human efforts eventually drift, become a matter for the consideration of the professors. Nevertheless professors and scientists are the rulers of these days – are they not running all the governments? – and it is enough for us private citizens to know that science approves of essences, purities and Mondrianic efforts.

I met Mondrian but twice, both times at small dinner parties with other artists where it was difficult to sound him out, but even without a word his severity of character and tendency

to self-discipline could be gauged in his austere face. He looked like his own pictures. It could be judged that he lived an intense mental life and weighed all the world's values on scales of his own. At the same time and in spite of his age he looked on life with unfatigued eyes. Mme. Martin, the Brazilian ambassadress, herself an artist and young enough to take a certain pride in claiming to be what the psychics call an "old soul," asserted that Mondrian himself was definitely a "young soul." Mondrian smiled at this accusation sadly, uncomprehendingly; but made no denial. Youthfulness of soul is never aware of itself so perhaps the lady was right.

The New York Sun, February 5, 1944

JEAN HÉLION

THE DIFFICULTY with the Jean Hélion exhibition in the Paul Rosenberg Gallery is that there is some perplexing psychology mixed up with it. It represents a very great change of attitude toward his work and the change apparently has something to do with Hélion's captivity in Germany. But what?

Did those two years of physical hardship and mental anguish bring him, as the saying is, "back to earth"? Did his complete separation from the life-stream of Paris, from communion with his fellow-modernists, from civilized habits of all kinds, cause him to lose the faculty of dreaming? Did the nightmarish activities which he recounted so vividly in his remarkable book, "They Shall Not Have Me," cause him finally to conclude that a landscape cannot be so important as the people in it? Did he vow in certain frantic moments during his agonizing efforts to escape that, if he did escape, he'd devote

himself to actual people rather than to the harmonies that flit occasionally like music through their heads?

At any rate, something like that is what has happened to his pictures. They are of people. They are heavily stylized, so heavily stylized that they come dangerously near to being wooden, like the marionettes that appear in certain of Eugene O'Neill's plays and in certain minor ballets. Could the artist, the startled observer asks, have picked up a germ in Mittel-Europa? Or is he merely addressing his remarks to Mittel-Europeans in a properly heavy language?

This is confusing. Added familiarity with these pictures may supply the answers to the questions they propound, but in the meantime it is impossible not to regret the lack of the elegance that used to be the artist's hallmark. It may be said that when a prisoner of war is cutting his way through barbed wire fences elegance of deportment is the last thing he thinks of. "Etiquette is suspended for the evening." Those who know Hélion know that it could only have been suspended for that evening. Elegance is his middle name. Of his former graces he employs for these descriptions of his recontacts with society only dynamics and certainties of composition. As far away as the pictures may be seen they hold together perfectly and say what they have to say emphatically.

The New York Sun, March 18, 1944

LÉGER'S DIVERS

A SECOND opportunity to see recent works by Fernand Léger, the modern French master of the abstract, who may be going back to the home country any day now — since the invasion,

they say, is all set – is provided by the display in the Jacques Seligmann Galleries, 5 East 57th street. It is all to the good.

The show is devoted to the development of a single theme, "The Divers," told over and over again, with great force, simplicity and directness, and never with so much force and simplicity as in the final big composition for which all the others in the show were preparation. It is astonishing that so much liveliness and variety can be provoked by the exploitation of one single idea. It reminds one of the well-known song by Cornelius, "Ein Ton," only much more overwhelming, naturally, for its cumulative effect.

It also gives the reply direct to all the silly people who say that "any child can paint these modern things." No child has yet painted anything like these Légers; nor ever will. No child has such clear concepts of things seen in nature and adds to this clarity the resolution to pursue the image to its final, stylized and acceptable form.

Go see these "Divers," s'il vous plait. I shall be curious to see if they overwhelm you, too. I shall be curious to see if, as the late Count Leo Tolstoi would have said, they "affect" you; for this great moralist held that "there is one indubitable sign distinguishing real art from its counterfeit – namely, the infectiousness of art." Do you suppose you could be affected or infected by Léger's art? If not affected, would you then call it counterfeit and align yourself with Count Tolstoi?

Poor Tolstoi had the noblest principles and the falsest applications of them of any one who ever wrote about art. Not even Ruskin had such facility in making mistakes. Don't forget that it was Tolstoi who said that Shakespeare's Hamlet was a sham, an imitation of a work of art, and that Beethoven's Ninth Symphony was not a whit better. Do you still cling to Tolstoi rather than to Léger?

The fact is there are truths that relate to every stage of human progress from first to last, from the lowest to the highest, and in Count Tolstoi's morbid preoccupations, in the later years of his life, with the miseries of the very poor he practically repudiated the satisfactions of an educated taste. The reforming zeal had so hipped his vision that about all that remained to him was folklore art, which is all very well but by no means the whole story.

Now, Fernand Léger is neither a Shakespeare nor a Beethoven, but in the present moment in the history of the

evolution of abstract art, his paintings do appeal to the educated. Would you prefer not to be educated? And as to that, I can't even see why they should necessarily offend Count Tolstoi's peasants. They could get from the pictures what they used to get from the stained glass windows in the cathedrals and if they should fail to estimate the reserve of mysticism that appeals to the initiate and which continually feeds the imagination of those who have imaginations – then it is just too bad for the peasants. Or perhaps they'll get it in their next reincarnation. I believe we were all peasants once.

The New York Sun, April 22, 1944

ANDRÉ MASSON

ANDRÉ MASSON has long been conspicuous among the modern painters of France but stay-at-home Americans have not had sufficient opportunities to see on what his reputation depends. This situation is now corrected. The Paul Rosenberg Gallery shows his recent paintings and the Buchholz Gallery not only shows his drawings but issues a special book of drawings called: "Nocturnal Notebook."

Of the two exhibitions the student is recommended to study first the paintings in the Paul Rosenberg Gallery, for there you will find the artist in full dress, attired in the utmost splendor, as though for a coronation ceremony or something of that sort; and curiously enough, André Masson is much more winning when all dressed up for Sunday than he is when, discarding all his garments he finds himself tout nu and confronted with all the mysteries of life.

As a rule it is just the other way with artists. The more

intimate you are with them the greater your chances for liking their work, and the way to get intimate with them, most people agree, is to study their drawings, but the André Masson drawings in the Buchholz Gallery are so severe that some timid inquirers will certainly draw back in alarm; and when they go farther and peer into the "Nocturnal Notebook" then they will really be frightened.

The trouble is that André Masson is an intellectual. This term when leveled at a painter is often a reproach, but I do not mean it to be such in his case. The ordinary intellectual gets his effects self-consciously and therefore is not an artist at all. But André Masson is not that sort. He is a genuine painter and colorist and a mystic as well, and that is what makes it so extraordinary that he can skeletonize his thought as he does in the "Nocturnal Notebook." He says he made them all on a sleepless night in May and it is evident that his "subconscious" was struggling with the problem of the beginnings of all life. His germinating seed and waving grass stems could really be dated in the year one and though it is all very well for George Santayana to talk about the Essences toward which we are all drifting, only the sternest realists care to consider the Essences from which we took birth. We pretend we like to know all — but as a matter of fact we don't.

But the moment André Masson starts to dress up these ideas we begin to lose some of our fright, and by the time we reach such drawings as the "Nude Under the Star," the "Cat," the "Cleft Earth" and "Shadow and Light," the chances are, unless we put strict rein upon our feelings, that we shall be admiring them unreservedly, for the artist knows all about textures, and soft gray tints, and dramatic contrasts and fiery lines, and, hypnotized by all these attractions one soon forgets the stark skeleton with which the artist started.

Back in the Paul Rosenberg Gallery there are no skeletons. Everything is gala. The thoughts back of each picture are, you may be sure, as forthright and rugged as the argument in a poem by John Donne (M. Masson is an admirer of that genius, it seems), but by the time the canvases arrived in the Rosenberg Gallery they were blooming with all the colors of the rainbow and the flowers of the garden. They were calculated to feed the mind indefinitely and I think they succeed. They are abstract compositions of great distinction. I suppose I

should have mentioned that word "abstract" sooner but probably if you didn't already know, you guessed.

The New York Sun, May 6, 1944

MORRIS GRAVES

THE TWO Morris Graves items in the Whitney Museum exhibition gave a definite hint that this young Lochinvar of the West had moved up a step in his rating as an artist. The current group of new paintings in the Willard Gallery, confirms this impression. Morris Graves is now some one for serious art lovers to know.

It is with a bit of trepidation that this cautious commendation is bestowed. It may be that he is still too young to be praised openly even though he does deserve it, for as soon as the barrage of publicity opens up on a young American artist the chances are nine to one that he will go to rack and ruin promptly, no matter how gifted he may be. Somehow, in this climate, early success is practically fatal.

So I would not wish to do any harm to Morris Graves.

In the course of a generation or so of careful watching this department has observed at least a dozen men emerge into the spot-light of public attention and then wilt away into the second-rate ranks of comparative obscurity; and all this because they couldn't stand being constantly looked at, nor resist the impulse to capitalize upon the publicity while the publicity was good. Had they been given ten or fifteen years more in which to get acquainted with the world and to find out what they really wanted to say about it they might have been better

able to resist the flattery of the injudicious. As it was, they sank into that saddest of all classes – the "might have beens."

When Morris Graves first appeared at the Modern Museum a few years ago he had a good press and, in general, a sympathetic reception but not enough praise to turn his head. I forget what I wrote about him but I recall thinking that his advent would not have been so surprising in the Natural History Museum as it definitely was in the Modern Museum for his work suggested that he was the child of a lady ornithologist by a geologist father. The birds and other creatures that he drew had the curious air of being "specimens" flattened but on paper for the purposes of scientific study. But they were something new. It was apparent that the young artist had had an odd mental bringing up, and a still odder way of recording his experiences. But this, of course, was all to the good.

In the new show in the Willard Gallery the ornithology and geology are shelved somewhat to permit Morris Graves to emerge on a larger scale as artist. They are still there, however, but used dramatically and painted with a bold authority that is most impressive. The thinking in these pictures is sometimes early-Pliocene and sometimes still earlier than that with a suggestion of alarm and even cruelty in the insistence on handsomeness in a rumbling period when human beings had not yet dared to grace the earth.

But if the thinking be so remote, the morals that are drawn are strictly contemporary – and so is the treatment. The big mural "Under the Grinding Rivers of the Earth" is terrifying at first glance but the primeval fish escaping from danger down in one corner, provides an escape for the observer as well. "Ha, he is getting away. He's defeating those clashing forces. Maybe I too can defeat the clashing forces," he repeats to himself in the language that has been taught us by psychologists; and he ends in thinking the artist a poet and the picture beautiful.

The New York Sun, February 3, 1945

THE WORK OF LÉGER

FERNAND LÉGER, like those two celebrated Helen Hokinson ladies in the New Yorker, found himself "couped up in America" in 1939 because of the outbreak of the war. Unlike the two ladies he made no moan but settled down quietly to work and has been here, perforce, ever since. Two galleries now show his winter's work; the Valentine Gallery, 55 East 57th street, and the Samuel Kootz Gallery, 601 Madison avenue.

Before venturing upon this unexpectedly prolonged visit to America, Léger had been thought the nearest of our kin, spiritually, in the European art circles, for we were machine-mad and machine-minded and Léger admired our machines so much that he began thinking and painting in terms of the machine and very soon evolved decorations and murals that quite justified the "machine age." As real love is generally reciprocated a great deal of honest American affection began to be felt in return for this artist and I suppose that was the attraction that brought him over here in 1939. The "rapport" thus established still exists and Léger has many stanch American admirers but, oddly enough, the liaison with American thinking is not so apparent as it used to be and with each year of his stay, his production has grown more French. This year it is very French.

Perhaps it's not so odd after all. A psychologist would probably think it natural enough that a Frenchman "cooped-up in America" the while his own country were overrun by enemy troops would brood exclusively upon such a condition. At any rate this one, apparently, has.

The last big New York exhibition of Léger concerned itself with a theme, "Les Plongeurs," that he brought with him, having seen a group of swimmers diving from the docks, as he was leaving; and the whole show was an expansion of this one theme into many directions, constantly varied, never fatigued, and culminating in an apotheosis of the subject so complete and satisfactory that it left nothing more to be said about "Les Plongeurs."

True to his method of working, Léger saw last year a group of bicyclists in repose who impressed him, much as the divers had done, as being good material, and both the exhibitions now open illustrate his preoccupations with this idea. Already his larger variations on this theme have the power and thrust of ancient stained glass windows but even the first and smaller versions are welded into such firm and secure compositions that they make a valuable contribution to any wall.

It is the fashion to speak of the stained-glass quality of these productions, but no other term so truly describes these big groups of figures with wide bands of violent color traversing them in a way that seems both grand and natural. You don't question the colors that refract from an old window; and the Léger colors, too, have an authority of their own. But if you do happen to concern yourself with these bicyclists as people (most amateurs of modernism are so engrossed with the general style that they pay no attention to such details), you will observe them to be Parisians. What there is that makes the Parisian bicyclists so different from ours I can't say precisely, but the difference is there in the Léger pictures; introduced all unconsciously, no doubt, by the artist.

The New York Sun, April 14, 1945

CHARLES SHEELER

CHARLES SHEELER's work is tense, taut and tight. It is always serious. It is quite American. "Tense, taut and tight" are not altogether complimentary terms to be applied to paintings, but Charles Sheeler gets away with them. His pictures are liked — and by Americans.

Why is this? I ask the question — but hesitate to answer it.

The new Charles Sheeler pictures in the Downtown Galleries go, at times, beyond tenseness into hardness. Americans don't seem to object to that trait either. Certainly they accept it without a whimper in the sculptures of Paul Manship, and the mechanics in the abstracts of Stuart Davis which offend me seem to offend no one else. At least, mine were the only outcries.

But are we drifting as a nation into general hardness? It's my country and, of course, I intend to stick along with it no matter what happens but I must confess I don't like hardness. I don't like bleakness and bareness and if Charles Sheeler has been holding the mirror up to nature and if half these things he says are true then he's got me worried. For myself I like a little fun once in a while. People who cannot occasionally play might just as well be Germans; or so I think.

Charles Sheeler, however, is a natural-born ascetic. He is what the cross-word puzzlers call an "essene." He is now much more essene than he used to be. When he first did those Bucks county barns in watercolor they were tense and taut, it is true, but they also had a neatness that verged upon elegance. When he was sent for by Henry Ford to photograph the smokestacks and engines of Detroit he did them with undeniable elegance. I remember that I was a bit scared at the time, thinking "this is the end of painting when machines can be made to flower into elegance in this fashion."

And now I am still more scared for Charles Sheeler seems to be spurning even this elegance of his. He is stripping all the garments from art. He paints a Shaker barn as though he himself were a Shaker. He is like a Mondrian who dispenses with charm. He refuses to beguile you in any way. He merely says: "Here is the thing, take it."

And the docile American public do take it. They now buy "things." All present indications imply that Charles Sheeler will not die, neglected, in a garret. On the contrary he will probably finish in a suite at the Waldorf — which, of course, would be O.K. with me — for I am a sentimentalist and love to see virtue rewarded — and what I think "gets" the American public in this intrigue with Charles Sheeler is, just as it was in the case of Mondrian, an admiration for his unflinching integrity.

We can always be counted on to cheer for the highest

type of morality even when we have no slightest intention of practicing it ourselves. We prefer to have the other fellow do it. Hurray for Charles Sheeler.

The New York Sun, April 13, 1946

CHAGALL

AT THE MUSEUM OF MODERN ART

MORE THAN most artists who have had one, Marc Chagall profits by the retrospective show of his paintings in the Modern Museum. He has never entirely lacked appreciation in this city for his works came with the stamp of Parisian approval upon them and collectors promptly appeared with sufficient courage to buy them, but the single pictures in occasional shows never quite explained the artist to a public that is always just a bit afraid of fantasy – his specialty.

With this big exhibition, where the artist carries you right out of this world into the realms of imagination where everything is as startling as it was to Alice in Wonderland and where anything can happen and does happen, he takes you with him easily. It is likely he will take most of us with him this time, not even those escaping who used to be known as the "lower classes," for really Chagall isn't above the heads of anybody and plays continually with the elementary mental pasttimes of humanity.

When his first examples appeared here there was some skepticism about the cows leaping over house-tops, about the figures with two faces and those with none at all, about the drunken fiddlers at the weddings, and the candelabra and

other things floating in the air. It was thought to be an effort at eccentricity, and especially since the colors were raw to the point of barbarity.

But the complete showing vindicates the artist. It is curious to note how thoroughly it does so. The artist, it seems is a poet. He is a first-rate colorist. He is an expert painter. He does whatever he sets out to do, and if there should be any trouble in the doing of it, he manages to conceal the effort from the spectator. The repetition of the cows, roosters and fiddlers up in the air is no more wearisome than the aspect of Fujiyama in the background of the Hokusai prints, for the symbol is not so much the real thing in the picture as the presence of the artist invisibly but persistently there. He is charmed with the jugglery he is able to do with his toys; his excitement is catching, his behaviour as a painter alluring.

What amazes and touches the beholder is the Russianism that this artist carries with him into distant lands. His latest pictures, after five years of New York, are as undiluted Russian as the earliest known ones, and though I had occasion to remark only a few weeks ago that the new pictures had an increased suavity in the brush-stroke that might be a concession to our rage for refinement, nevertheless the essential matters in the work were as Russian as Gorki. And if you ask how we Americans can assay the true Russian atmosphere, I can only say that we always do. Genuineness may be recognized when nothing else is. New Yorkers laughed with instant glee at the drunken peasants in the Shostakovitch opera, "Lady Macbeth From Minsk," done some years ago, knowing them to be the real thing. If you remember them at all, you must recall how perfectly Chagall they were. Chagall corroborates all the Russians.

James Johnson Sweeney, who arranged this exhibition, writes a documented history of the painter for the catalogue, giving details of the early village life, and of the later recognitions of the artist in Paris by the poets Cendrars and Apollinaire. In discussing the impossibility of charting the no-man's-land in which imaginative artists work, he quotes this excellent remark by André Lhote: "It is the glory and the misery of the artist's lot to transmit a message of which he does not possess the translation," and follows this up with Chagall's refusal to explain his work; "They are only pictorial arrangements of images that obsess me. The theories which I

would make up to explain myself, and those which others elaborate in connection with my work are nonsense. My paintings are my reason for my existence, my life and that's all."

The New York Sun, April 13, 1946

DUBUFFET

THE LATEST news from Paris is not exactly reassuring to those who hoped the war would put an end to "all that nonsense of cubism" and give us back something – if not pure Greek – then at least as near to it as Hiram Powers got with his American Greek Slave of years ago. It happened that way with the original French Revolution you know, but this recent World Revolution seems to have been different.

Bulletins from the city of light proclaim the painful fact that art is now no easier for dull people than it has been these twenty years past.

We got sufficient warning in the Henry Moore show of sculpture, for though this English artist softens his French with the accent of "Stratford-atte Bowe" he never attains the placidity reached by our Hiram Powers. On the contrary he provokes thought. And now we meet the paintings at Dubuffet (in the Pierre Matisse Galleries), the first French artist to emerge with a challenge from the war-chaos, and find that he is by no means a classic David. Far from it. He is a primitive, a conscious, determined, willful primitive; but no more like our Grandma Moses than Henry Moore is like Hiram Powers. Very dull people will never have a chance with him.

But the bright ones are already keen upon his trail. The Lee Aults have already bought one; and so has Mrs. Sadie A.

May, of Baltimore and Blanche Knopf, of New York. Always interested in how movements start, I asked Pierre Matisse what arguments he used to persuade Mrs. Knopf to buy the "Pink Cow" by Dubuffet which she lends to the present exhibition. "No argument at all," Pierre replied. "No persuasion. She bought it all by herself in Paris. I merely brought it over for her." And there, I suppose, you have the explanation. Paris! Everything seems to clear in Paris. So many things back up the artist there and help you to understand.

What makes Dubuffet difficult for us Americans is his extreme nonchalance in regard to facts. Grandma Moses deals in facts; nice facts of course, but still facts; but Dubuffet takes as many liberties with the facts as a musician does with the theme that starts him off. He plays with them like an adult child — if you know what I mean. What wins the attention of those who are caught in his charms are his richly faded colors, his plastic touch and a lambent wit that is so hard to define that it might as well be dubbed abstract.

Dubuffet started as a gifted and flippant amateur whose artistic exploits amused his literary friends so much that they had to write about them; and this easy publicity aroused in turn the envy of certain other artists who didn't have it; so much so that they said things in rebuttal. In a brochure that has just arrived from over-seas the artist defends himself delightfully and irresistibly. He admits everything he is accused of and answers, practically, "so what?"

He begins every paragraph with "il est vrai que . . ."; and the first one is: "It is true that the method of design employed in these paintings is totally aloof from the kind of expertism generally found in pictures by professionals and it is also true that no one would need to undergo special studies or to have in-born gifts in order to do things like them. To that I reply that I find such studies and gifts exceedingly tiresome, their effects tending to suppress all spontaneity, to cut all communion, and to swamp the work with ineffectiveness. The most gracious way to talk is perhaps, after all, to use the simplest words; and to walk beautifully is it necessary to have longer legs than other people, or to walk upon one's hands?"

What can you say against that? Obviously nothing. It seems to be the perfect justification for the perfect primitive.

The New York Sun, January 10, 1947

WINSLOW HOMER

IT CAN be done here. We can produce great art. Winslow Homer is the answer. As time goes on it becomes increasingly evident that he is our best man, the one who puts most into pictures of that which Americans have got out of life. There is a show of them now on at Wildenstein's; and believe me it is a show. Attendance at it should be made compulsory by law. It would strengthen the country.

We have everything necessary to the incitement of the production of masterpieces. We have birds equal to the skylark that Shelley heard, we have mountain lions equal in grace to those that Barye sculpted and Delacroix drew, we have snakes (heaven save us!) equal to the one that twirled around the Laocoon, and we have horses quite as beautiful as those on the inside relief of the Arch of Tito in Rome. We have everything save the will to do or die for beauty; but so far, and in spite of Walt Whitman's strident shouts to the poets to be up and at it, Winslow Homer is the only one to respond with the required measure of creative energy.

What did Winslow Homer have in the way of equipment? Above everything else — valiance! I once asked a musician what were the simple essentials to a musical piece. After thinking a moment he replied: "Two ideas that oppose each other and after a while one of them wins out!" When I repeated this to other musicians they invariably laughed. Definitions in art are always perilous, and always disputed. Perhaps that's the fun of them; but in any case I thought there was something in my friend's idea and I saw myself applying it nicely to Winslow Homer's work.

What were his two ideas? Water and rock. He saw the primeval conflict between those two elements and matched himself grandly to the portrayal of it. Something in the invincibility of his own soul finally taught him what a rock was. It is the difference between him and his 1,000 imitators that they have never felt the savage defense of those Maine rocks against the always attacking sea. I have said this so often that

I am a bit ashamed to be saying it again, yet it has to be repeated each time the Winslow Homer sermon is preached. They all could do the water, but knowing only how to do water, there was no contest. Homer alone comprehended granite.

Rising to greatness with the solution of this problem of opposing forces, it appears now that the sea had no further secrets from this artist. Certainly he rose to each great task in turn and conquered it with strange ease. In such pictures as "Eight Bells," "The Lookout," the "Signal of Distress," &c., it is no longer the rocklike cliffs against the sea but rocklike men against the sea — and essentially the painting formula is the same. It is impossible to say that they are greater than the sea-coast pictures because all of them, both sets, are upon a super-human level. All of them are what we call masterpieces and must be known as such wherever in the world they may be shown.

Like most of those who now look upon Homer with awe, I have had to go backward in my acquaintance with him, for I began at the top with the famous watercolors and the sea-pieces I have mentioned and only learned of the Civil War pictures and the various domestic scenes much later, but I am happy to report that I loved them all without exception. In seeing them I had the advantage of already knowing Homer to be great, for, as I said last week in my note upon the Picasso show, in the case of a great man it is necessary for the intelligent to go along with him wherever he goes.

With Homer this presented no difficulty. On the contrary, the simple and unpretending honesty of the early performances makes the later metamorphosis into the great style all the more dramatic and astonishing. How did Homer's painting language become so flexible? It seems like a blessing descending on him from on high. Every brush stroke in the "Signal of Distress" says what the whole picture says. How did he fix upon such perfect types for his woodsmen hunters and guides? The picture of the "Hound and Hunter," owned by Mr. Clarke and the watercolor version of the same theme, owned by Mr. Henschel, are such miracles of excitement and art and such sound Americanism to boot, that were I to write this article over again, I should be tempted to devote it entirely to them. But as a matter of fact, I feel that way about each item in the show.

The New York Sun, February 21, 1947

MARY CASSATT

UP AT the Wildenstein Galleries they are saying that this present one is the first big one-man show that Mary Cassatt has ever had here. This must be so, for of course they must know what they are talking about, yet it does not represent a belated vindication of the artist nor a restoration to public attention, for she has never needed the one nor been without the other.

In my own somewhat long term of watching our public's behaviour toward its artists I have never known a time when there were not plenty of Mary Cassatts around, always well placed, and always respected.

"Respected," I believe, is the word. Not a creative talent, not path blazing, not the head of a significant and far-expanding school; but a sensitive, submissive and quite intelligent member of one that had already been launched when she came upon the scene.

Hard knocks in abundance had been administered to Manet and Degas, two impressionist chieftains who were formative influences upon the style Miss Cassatt was to have, and when it developed later into recognizable shape and she was invited to join the impressionists and show with them, there was still enough public antagonism against the group to give her a militant feeling in accepting the challenge.

But she was enchanted to be "in it." She said: "At last I could work with absolute independence without considering the opinion of a jury. I hated conventional art; I began to live." Americans as a rule adore being in on any movement. It is one of our frailties and it is what gets us into most of our scrapes, but Miss Cassatt got into no scrapes because of her espousal of a debatable cause. The animosities of the critics continued to be leveled at Manet and Degas and Monet and I have no record of any insults hurled at Miss Cassatt, though doubtless she got talked to severely by her conventional friends in Paris.

Her new confreres, Degas, Manet, Monet, Pissarro, et al, were entirely artistic personages and not to be accused of political-mindedness, yet they were engaged after all in a

struggle that meant life or death to them and doubtless they were well enough aware of the advantages of having a rather rich American lady as a member of their party. She was indeed an appreciable help. She not only did some buying of their works but induced some of her American friends to do likewise.

It was in this way that the famous Havemeyer collection came about. Mrs. Havemeyer was obliged, so she once told me, to keep most of her novel purchases made through the agency of Miss Cassatt, closeted until her friends and the public in general got used to them, but this finally did come about and in the end they became one of the chief glories of the Metropolitan Museum.

Rainer Rilke said in one of his famous letters that all women artists have to have at least one masculine shoulder to lean upon. Miss Cassatt leaned upon Degas, just as our Miss Beaux leaned upon Sargent. It shows chiefly in the drawing, which is always clearly and cerebrally understood. Otherwise her work is feminine enough. In fact she is the most feminine of all the women painters who have managed to get acknowledged on both sides of the ocean.

She became a specialist in maternity cases and in her madonna-and-child pieces it is the child who is invariably chief protagonist. These children have a peculiar and winning vitality. This naturally invites analysis and it gets it in the catalogue quotation of a mournful remark made by the artist in old age about having "mothered children only in painting." Certainly in art she mothered them well.

The New York Sun, October 31, 1947

GIACOMETTI'S

FIRST AMERICAN EXHIBIT

JEAN-PAUL SARTRE, it would appear, is attempting to carry the entire intellectual and cultural weight of modern France upon his shoulders. Jacques Prevert, who may turn out, in the end, to be the greater genius of the two — for genius is not to be measured by size and weight, as David taught Goliath several thousand years ago — is of no help at all in the present emergency.

Jacques Prevert has no inclination whatever to carry weights upon his shoulders. On the contrary he takes the grossest materials and blows them into shimmering bubbles which spatter so lightly against the walls of the Bibliothèque Nationale that the institution is not even aware that it has received a permanent dent. Jean-Paul Sartre, on the other hand, never disguises the weight of any enterprise he undertakes, and when he wishes to disconcert the directors of the Musée de Luxembourgh (for art and ethics are alike his province) he marshals every Gatling gun available for the purpose.

But I see I am about to mix my metaphore up, for the sculptor Giacometti is the least like a Gatling gun of any sculptor ever heard of, though he does sound like one in the detonations M. Sartre utters in his behalf. This is because M. Sartre uses the word "space" in his analysis of the sculpture in the catalogue for the first exhibition of the artist's work in the Pierre Matisse Gallery.

M. Sartre says that Giacometti destroys "space" which is almost as horrifying a thing to say as to say that he destroys the precious atom. Now "space" is a bad word and I know several scientists of repute who will get up and stamp out of the lecture hall in protest whenever the word is mentioned. Particularly that business of "space turning upon itself" is repellent. M. Giacometti not only turns upon himself but upon everything else, repudiating everything that has gone before him, including the lovely and majestic contours of Maillol.

The argument is this; Jean-Paul Sartre says that painters put distant figures into their pictures and if you approach you may get nearer the canvas but you do not get nearer those figures. This seems to him a desirable arrangement, as no doubt it is, but he adds that the sculptors in the museums do not practice this virtue. As you advance upon their work they confront you with such a multiplicity of planes and relationships of parts that the essence of the whole performance vanishes in a cloud of confusion.

This sounds like going to some trouble to get into trouble and when you see the actual Giacometti sculptures in the Pierre Matisse Gallery the argument sounds more far-fetched than ever.

For these sculptures are the queerest that have ever come to us from abroad with such high recommendations. They are thin to the point of stringiness and do not invite you to touch for they have been built in sticky white plaster which results in picky surfaces. Happily you are not asked to touch. M. Sartre insists that the sculptor gives you only a distant view of people and you are not supposed to go near. If you did they would still seem to be far off. Also they are intangible and "have the ineffable grace of seeming perishable." They certainly have that. Just like human beings. Just like New York architecture.

M. Giacometti himself usually destroys them, looking on them as sketches and never quite satisfied with them. This sounds very engaging and is probably what entranced Jean-Paul Sartre. The childlike artist is always irresistible. But lately some of his friends have stayed his hand and hid his hammer. M. Giacometti could do with a little cash. It was thought the time had come to sell some of them.

No doubt the Modern Museum will buy one; also the Chicago Institute; also the Walker Gallery; also those several museums in California; also the Henry Cliffords of Philadelphia; for these very odd statues, combined with the reasonings of Sartre, are the kind that make talk and talks seems to be a modern necessity. As Jacques Prevert says of the musicians in one of his poems:

> "Tout le monde parlait
> Parlait, parlait;
> Personne ne jouait."

The New York Sun, January 23, 1948

BONNARD

AT THE MUSEUM OF MODERN ART

WHEN AGE descends upon a human being, and the circumstances are otherwise propitious, mellowness results. It does not always happen but clearly this is nature's intention. This is argued because of the blessings which follow in the wake of mellowness. The moment an individual is seen to have ripened properly then people immediately begin to love him.

Among the artists this has been proven true recently by Renoir and now even more noticeably by Bonnard. Renoir had a long lifetime of being admired but in Bonnard's case, owing to his shyness and to his intense objection to being considered a public character it was only slowly realized that a bloom had come to this quiet artist's color that was altogether exceptional and that this, added to his devotion to the strictly bourgeois ideals of French living (his subjects, you might say, seldom got far away from the buffet and almost never outside the dining room) constituted him a patriot of the first order.

He had been neglected in his early days because of the excitements over Cézanne and the post-impressionists and because he did not seem to deny sufficiently the Monet-Manet period which had just passed into history nor promise excitements of his own. Excitement, in fact, was not Bonnard's speciality, and the neglect, in consequence, was a blessing in disguise, allowing the artist to consult his own taste unmolestedly and to perfect his way of saying in paint that this world was a really delightful place to live in and that France occupied one of the most delectable corners in it. Once arrived at this point it was seen that he had ripened, had become quite mature in fact, and was presenting phases of French life in a way to make him one of the outstanding artists of the period. It was impossible not to love him for this and so the public immediately proceeded to do so.

But because of this hesitancy in becoming a public person the memorial exhibition of the Bonnard paintings in the

Museum of Modern Art (shown also in the Cleveland Museum) will be apt to strike the general public as a revelation, as news; for though a few enterprising American collectors have known these pictures for a dozen years or more, the layman has been unaware of all this loveliness. The event, in fact, may be said, to have brought the real Bonnard to us for the first time and to have made him international.

The career is shown very completely in the present exhibition and contains lessons for the collectors, the art critics, the art promoters, and the art students. It begins with a room full of the non-sensational early paintings which left us all so cold years ago but which contain, nevertheless, hints here and there of the Bonnard that was to be. Pictures No. 2, No. 4 and No. 5, near the door as you enter, are as much Bonnard as any that were to occur later, though of course without the famous ripeness.

It was not until I reached the 1914 pictures that I jotted in my catalogue "Here it comes," meaning the mellowness, but after that it came with a rush and all the pictures had it. I find I can't quite define "mellowness" satisfactorily, but anyway some of its attributes are ease in the presence of grandeur, freedom from frenzy and a general tonal balance of perception. Bonnard was not interested in proselyting for schools or theories, and I don't believe he was much concerned with the methods of rival artists, yet all the same, echoes from the outside world creep into his style here and there pleasantly and without in the least interfering with the general Bonnard spirit. By echoes, I mean some of the big spatial divisions in the delightful "window" pictures which remind one slightly of Mondrian, the "Table with Music Album" which suggests Matisse, the "Checked Table Cloth" which was some Paul Klee resemblances, and finally the long row of landscapes which are practically and adorably abstract.

The New York Sun, May 14, 1948

REGINALD MARSH'S DRAWINGS

THERE DOES seem to be an increase of style on the part of Reginald Marsh in the drawing he now shows in the Frank K. M. Rehn gallery, an increase in what we call – for lack of a better term – lyricism; and an increased effort toward simplification of statement.

If I say we could do with still more of the same it will sound no doubt like the perpetual scoldings of the critics but, que voulez vous? the critics must scold and scold until Reggie Marsh becomes as great as Daumier and Heaven knows he has not reached that point as yet. Rowlandson, perhaps. It may be he is edging in on Rowlandson, but not Daumier; and it is the very great kind of greatness we are yearning for in these United States and we don't see why Reginald Marsh shouldn't make an extra effort in that direction as well as any one else.

The angels in Heaven, who are not critics, rejoice in any sinner that repenteth but in the arts repentance is not valid unless followed by good works. St. Peter, who is a critic if there ever was one, will say to Reg: "Show me what you've done." Now you can't fool St. Peter. He has already seen the famous drawing called "La Soupe a Quatres Sous" and he knows that the "Bowery at Doyers Street" is not in the same class. So he will say to Reg: "Son, you're not ready for this place yet. You've got to simplify, simplify, simplify. Better stay in Purgatory a while until you do better."

This, of course, is hard advice to an artist who specializes in drawings of the millions on the summer beach of Coney Island, but simplifying the millions doesn't mean doing away with them but organizing them. There is an artist called Raffet who painted whole armies and who got by St. Peter almost as easily as Daumier and all he did was to give you the whole army in one impact on the eye so that in a shuddering glance you knew what the whole thing was about.

In the "Bowery at Doyers Street" you don't quite know what it is about. You see that it is sordid. The isolated men scattered through the street are unwashed. One of them gives

a sharp look at another who lurks behind a corner. Somehow that doesn't seem sufficiently important. What actually interested this would-be enthusiast was the way the girders of the elevated were drawn. They were done beautifully. But why go all the way down to Doyers street just to see girders?

As for Rowlandson, I suppose he did get through the Pearly Gates finally, but there is no use pretending he has as many stars in his crown as Daumier. It takes a lot of purifying before such habitual vulgarity is washed away, and I hope Reginald Marsh will give this problem some of his attention. His dancers in the "New Gardens" pictures look like lost souls. I suppose very pretty young girls dance occasionally with disreputable old gentlemen, but certainly the artist, in such cases, should do something about it. Reginald Marsh does nothing. He simply doesn't care. Daumier would have sailed right in and rescued all those girls.

The New York Sun, December 10, 1948

THOMAS COLE

THE THOMAS COLE revival at the Whitney Museum presents an awkward problem for critics. Pushed away from Europe as we have been during the recent years and compelled, in our search for spiritual guidance, to go out into the woods and look for gods of our own, there has developed a tendency – some call it patriotism – to think that very good gods lurk behind every tree.

But gods are not so plentiful as that and they do not lurk behind trees. God lives in the bosoms of the seekers for God and He becomes manifest only when belief is confirmed into

certainty by accumulated evidence of His Presence. In other words, young countries have particular difficulty acquiring the habit of perfection since not enough people have as yet struggled for it and it is inconceivable that a lone first explorer in a new country – however gifted, should stumble upon it accidentally or recognize it if he did.

Looking back in a detached way at recorded history, we now can see easily enough why Adam's mistake in the Garden of Eden was inevitable. A standard of behavior, a sense of style, a knowledge of what art really is can only be built upon a vast amount of experience; upon, if you like, a vast amount of corrected mistakes.

Thomas Cole, like Adam, knew an Eden when he saw one and he found it in the Catskills in the 1830's, and like Adam again, failed to cope with the attractions of the place. He couldn't resist any of them – and that was his undoing.

When he came to painting his pictures of this Eden he hadn't the courage to leave anything out. He put every stick and stone into his compositions and the crags and waterfalls, believe me, lost nothing in his way of telling of them.

This was all right, of course, but unfortunately it wasn't great art. For a long time our people thought it was. They were delighted to have such a fuss made over their own rocks and rills, as who wouldn't be? and in that period of ardent aspiration and large programs for the future the difference between a super-salesman and a St. John of the Wilderness was not easily made out.

It required several generations of yet more strenuous aspiration before the general populace and a few painters in particular began to realize that art was chiefly a matter of choosing, and that a genuine artist ought to have something of the divine in his make-up. We apply the term "creator" to them, well aware that the same term is applied to the Sublime Creator of the Universe. They too must stand up to nature as though they owned it.

Thomas Cole did a certain amount of arranging in his pictures but very little elimination. Hence the grandeur of statement that you get in the best of Claude Lorrain, Turner and Constable – a grandeur that suggests that God is speaking through these men – is lacking in his work. Recognizing this, we do not, however, relinquish any part of our ancient affection for Thomas Cole. We owe him the gratitude we bestow

upon pioneers. Some one had to do the rough work, and certainly he did his share.

Without him we never would have had a Ralph Blakelock or a Winslow Homer. It would only be necessary to place the Blakelock "Moonlight" owned by the Toledo Museum beside one of these by Thomas Cole to see the enormous difference there is between pre-Civil War and post-Civil War aesthetic thinking in America.

The New York Sun, January 14, 1949

ARP

EXPLANATIONS do very little explaining in regard to modern art, and arguments seldom convince. In fact I have never known nor heard of a conventional art lover won to modernism by talk. The only way the "twain do mix" is by possession, and if only the old-timer can be induced to own one of the things and live with it a while, then the chances are he will shortly join the parade of worshipers along with his youthful friends.

The main army of the modernists is made up of those who insist upon being modern at all cost, of those who instinctively seek for the accent of today in every department of living. Such, of course, will not have to be coaxed to study the work of Jean Arp, lately arrived in this country, and now showing in the Buchholz Gallery. They know all about him and adore him already. The trouble will be with "those others."

And it is with "those others" I mostly have to deal. Well, I have no intention of worrying them any more than they are worried — for it must be a worry to feel that they are out of touch with their own period — nor to throw dust in their eyes

by means of strange words. So I will be as clear and as brief as possible on the subject of Jean Arp.

He ranks today among the twelve most prominent artists of modern Europe. Like Brancusi, like Mondrian, he aims at reducing life to the simplest possible terms. Like both the others he gets it so very simple at times that it is no wonder that outsiders think it isn't art at all. Some of his upright figures in the present show look like the bone your dog drags home. Others resemble stones found upon the beach washed into smoothness by countless ocean waves. The pebbles on the beach, we all know, are not art. Pure nature is not art. The contamination of human interference must enter in before art occurs.

Arp's first pieces to become known here looked like enlarged replicas of rain-drops on the window pane, rounded, amorphous shapes that, though very slight, somehow fixed your attention. Almost subconsciously you recognized something in them, a something that might possibly change at any moment into something else; in other words, the quality of life.

At first, like most observers, I was skeptical about these pieces, but in subsequent encounters I had two "recognitions" which induced me to look upon Arp with respect. I will tell you them – and then let you go, for this time.

The first was at a Modern Museum show of applied art where some glass bowls for flowers had shapes obviously derived from Arp and were quite good looking. So I said to myself: "Ho, ho, one must really hand it to Mr. Arp. After all he has something." The second occasion occurred in the home of a private collector where a relief by Arp hung on the wall above the open fireplace. It was the suggestion of flames leaping up that no doubt helped the association, but anyway the shapes of the Arp relief had a curious buoyancy as though they, too, would stir and ascend. Again I spoke to myself and said, "Ho, ho, Mr. Arp. So that's it."

These still may seem slight matters to you, gentle reader, but don't be too sure in the Atomic Age, that anything is slight.

The New York Sun, January 21, 1949

JACKSON POLLOCK

THE NOTE of advance is sounded at once in the entrance hall by Jackson Pollock. For the first time I looked with respect and sustained interest upon one of his pictures. Previous works by him which I had seen looked as though the paint had been flung at the canvas from a distance, not all of it making happy landings. Even the present one has a spattered technic, but the spattering is handsome and organized and therefore I like it. The effect it makes is that of a flat, war-shattered city, possibly Hiroshima, as seen from a great height in moonlight. There is sparkle to the color and hints of a ribbon of a river holding the glimpses of the city together. The composition looks well in the entrance hall and will be the most discussed picture in the show.

The New York Sun, December 23, 1949

CONVERSATION PIECE

THE CONVERSATION at the James Johnson Sweeneys' dinner was not particularly brilliant. In fact it was not at all brilliant. Neither Marcel Duchamp nor I am inclined that way, preferring to talk quietly and speculatively (unless forced) and Salvador Dali was probably too tired from a hard day's paint-

ing, and of course the Sweeneys, both Laura and James, are far too civilized to attempt to outshine a dinner guest.

Yet several days later I found myself still pondering over some of the things that were said and regretting that I had not jotted them down promptly and exactly. For a day, or for two days, I can remember a conversation, if I have really listened to it, with a fair degree of accuracy; but when a week passes by the whole thing becomes generalized and if I now try to recall some of the assertions that were made I am not at all sure I can tie them to the individual who uttered them.

Being what we were, two painters, two critics and the wife of a critic, it was inevitable that our talk should be shop-talk. I may have begun it when quitting the cocktail table for the dinner table by apologizing to Marcel for having stated in one of my reviews that most of the hurrahs for the sculpture of the Italian Marini had in reality been leveled at Paris in reproach for not having recently produced anything comparable. Marcel, living in New York, is the acknowledged but unofficial ambassador of good will from France to this country and so, if there were any inaccuracies in this surmise of mine, he would be the one to know it. But he readily enough confirmed my suspicion, agreeing that Marini was strong and worthy of all praise, but that there did seem to be a hint of something political in the excess of applause that was lavished upon him. If this were so – if it were true that a group of malcontents with Paris had crystallized here, then the obvious retort of Paris would be, someone suggested (probably Dali), instantly to produce a new genius to confute them. But Marcel, whose lean face had become slightly suffused with pink as though he found discomfort in the line our talk had taken, smiled cynically and said that geniuses were never produced by prestidigitation in any country. "Besides," he added, "we in France have no immediate need for new ones being so very content with the large supply we still have." It was the ambassador speaking.

He then went on to make the assertion that has been troubling me slightly ever since. He said: "You speculators think the time has come to say au revoir to Picasso, Matisse, Braque, Dufy et al., and you are eager to make acquaintance with the new boys who will astonish us and, of course, shock us in some new and unexpected fashion. You know that theoretically the revolution is due and you are impatient for it, but

I am here to tell you that there won't be one. Revolutions are démodé. There is no real need for them. They did not use to have them. They are modern inventions . . ."

There was a protest here from several voices at once, like those protests you hear in the Opera Quiz during the Metropolitan broadcasts, and after the hubbub had subsided a bit, Marcel, with a slightly fatigued air, consented to agree that Delacroix had been a real enough revolutionary, cutting sharply away from the official patterns of his time, but he positively refused credence to any earlier art-rebels and insisted again that revolutions had been overdone, stylized like modern business tricks and would not bear intelligent analyses. "This is a time of peace," he added. "Why not prolong it?"

As to all this I was not quite convinced. Not that I have any objections to "peace," though the word has taken on curious overtones at this particular period, but in the regarding of revolutions as obsolete I remained sceptical. I seem to be two-sided on the subject. Actually I think a conscious effort at usurpation, like the tactics of some of our politicians aspiring to the presidency, are always suspect, but on the other hand the world does turn 'round, and every so often an apparently new outlook upon life is reached, and in spite of the fact that dry-as-dust critics a century later looking at the affair un-enthusiastically are certain to say "plus ça change, plus c'est la même chose," nevertheless something that resembles a revolution may be distinguished on the faded records. However, in my experience — and I've seen two of them — the final triumph of the Impressionists and the still more emphatic triumph of the Post-Impressionists — the real business of the revolution seems to work underground, like the mysterious forces described in Henry Adams' *Rule of Phase as Applied to History.* They are invisible to the most acute observer and yet they overwhelm the world in the end with new necessities, new habits and even new religions. They seem to emanate from the masses who remain unaware of what they are putting forth.

Consequently this peace which Marcel talks about completely passes my understanding. To me it looks merely like fatigue, wartime fatigue. It's the price France is still paying for those two infernal wars. As soon as she gets her breath, as soon as we all get our breath, the Old Nick that is within us human beings will begin to stir again, altercations will arise, fists will bang the tables in cafés none of us have heard of be-

fore, and eventually several winners in the arguments will be recognized as heroes, will take on the attitudes of heroes – and the movement will be on. Marcel Duchamp will not be the only one to be surprised. We shall all be surprised for none of these heroes will be the ones the guessers expect. Henry Adams makes it quite plain that such matters are unguessable. But having mentioned Henry Adams and having cited the word "masses" another and more dubious suspicion enters my head. Since it seems we are destined to be fooled anyway, perhaps we have been fooled already. Perhaps these newcomers are already here and have already made their "play" – as they say at Monte Carlo. I am thinking of all that connotes with that word "masses." With the increasingly evident reluctance of "labor" to labor, it appears possible in the future that all the extras to mere living we shall do for ourselves or do without. We shall be our own cooks, our own ditch-diggers, and if we yearn for paintings will be obliged to paint ourselves. Something on this order is suggested by the vast army of Sunday-painters now beating on the museum doors and claiming fraternity with Poussin.

Somehow the prospect does not allure me much. For one thing I should immediately lose my job. There would be no demand for critics in such an era, and with no one howling for a standard, shortly there wouldn't be one. I shouldn't like that. You wouldn't either, dear reader; but, as Carl van Vechten once coldly suggested to me, on my complaining that I didn't care for Mary Garden's voice production, "Perhaps, you'll have other pleasures."

Art News, September 1950

PICTURES FOR A PICTURE

OF GERTRUDE

THE "HOMAGE" to Gertrude Stein offered by the Yale University Art Gallery is a pretty gesture certain to captivate the fancy of the great American public which so unexpectedly took Gertrude to its heart without waiting to understand her, and the only pity about it is that she cannot be there among as many of the pictures from her collection as the Gallery found possible to reassemble in New Haven in this effort to do her honor as a collector. Or will she not be there? Those who ever knew her, those privileged ones who managed to meet her in the sacred precincts at 27 rue de Fleurus, will not be sure. Certainly, as long as they live, they will not, in their mind's eyes, ever separate Gertrude from the pictures she defended so valiantly in words that echoed around the world in the years just before the first of our great wars.

As a collection, Gertrude's, in proportion to its size and quality, was just about the most potent of any that I have ever heard of in history. To be sure, there was that unholy row in fifteenth-century Florence when Leonardo and Michelangelo made marvelous battle drawings in rivalry with each other, but since then there had been no comparable uproars of talk until certain early-twentieth-century Philistines attempted to tell Gertrude Stein and her brother Leo that their pictures by Cézanne, Picasso and Matisse were not art! ! ! Then, in effect, all H___ broke loose. It was the battered and bruised Philistines returning from these unequal contests to America who proved to be the most effective agents in spreading the gospel of modernism on this side of the ocean. Their distorted accounts of what happened, instead of damning Gertrude and Leo forever, "launched a thousand ships" in the direction of Paris, for most of those who heard the stories realized that however good or bad modern art might be, it was distinctly evident that lots of fun could be had on the rue de Fleurus and they wished to be in on it. After the Armory Show had

ended and everybody in America had said something witty about Marcel Duchamp's *Nude Descending a Staircase,* the crowds of pilgrims became too dense for even Gertrude's energy to cope with, and her "Saturday Nights" gradually became less frequent and certainly less tumultuous. By the time I reached them, in 1912 or 1913, an evening party with Gertrude Stein and Alice Toklas (Leo Stein had already lost the faith and deserted the ship) was much like a party anywhere else though, of course, livelier. What made it lively was the presence of all the striking new young artists in Paris talking shop, the pleasantest kind of talk there is for those who talk it.

But there were no altercations. How could there be? Everybody had been vindicated. Cézannes had suddenly increased in price and the Metropolitan Museum, much against its will, had been obliged to buy one. Furthermore, the better dealers everywhere knew that works by Picasso and Matisse were merchandisable. But the stampede to acquire them got in the way of further Stein purchases. A year or two later when I happened to cite one of them to Gertrude as a "good buy," she shrugged her shoulders and said: "Of course I'd love to have it but I can no longer afford Picassos. They've grown too expensive. You seem to forget that when we formed our collection all our artists had their reputations to make and we had practically no competitors. Now, it is very different." There was no reproach, no sadness to this remark of hers. Jubilation rather. Apparently she delighted in this emphatic confirmation of her taste. What differentiated her from all other collectors was the fact that she collected geniuses rather than masterpieces. She recognized them a long way off. She spotted them when young. I don't know how old Picasso was when the bell began ringing in Alice Toklas' bosom at her first encounter with him, but I do know that it was a long time after that before the bells began ringing in any New York bosoms. Consequently this very delightful and truly informing art collection was notable more for early discernment than for final achievement. It was not rich. It did not contain a *Guernica,* a *Three Musicians* or a *Seated Woman,* but it basked in all sorts of premonitions of the masterpieces, such as these, that were to come along later.

For instance, there were the views of Spanish towns by Picasso which convinced Gertrude that cubism had had its

birth in Spain, "ready-made" in those undoubtedly cubic houses imbedded in the Spanish hills, rather than in the famous re-mark of Cézanne's which is usually credited with starting the boys off on that tangent. She often expatiated at great length on this topic and wrote about it, too, convincing practically everybody of this theory except myself. Two admirable ex-amples of the real cubism, by Braque and Picasso, done in the early period when the two were working at the formula along such similar lines that their productions were not easy to tell apart, hung near by, and came in handy for the arguments. The large sprawling nude by Matisse, now called *Blue Nude,* in the Cone Collection of Baltimore, was already one of Ger-trude's items, I think, but am not sure, for I may have begun my acquaintance with it the day Gertrude piloted Mildred Aldrich and me out to the Matisse studio at Clamart where it then was. Mildred, who didn't quite like the picture, squirmed with embarrassment not knowing what to say to the artist awaiting her comment. Finally she blurted out: "I don't think I could take that pose." And when Matisse, who had almost as much embonpoint as she had, retorted: "Et moi non plus," we laughed, and the situation eased. Back again at 27 rue de Fleurus, I took great satisfaction in such small things as the *Man with a Pipe* (lent to Yale from the Harriman Collec-tion), a study by Cézanne for his great picture of *The Card Players;* the small study of *Bathers* also by Cézanne (lent by the Cone Collection); and a maquette by Picasso of colored cut papers posed, in a glass box, in recession to each other like old fashioned stage-sets, and managing to retain the Picasso painting-touch just the same. Also, Gertrude once showed me a portfolio of Picasso landscape drawings, studies of trees and bushes by a river bank, done in the leafless winter-time, and quite remarkable. I have never heard what became of them nor have I ever heard them mentioned. Probably Alice Toklas still guards them.

But most remarkable of all these pictures and the one most meriting the term "masterpiece" is the portrait of Ger-trude herself by Picasso. This strange, powerful, insistent, un-forgettable work always brings to mind that sometimes-heard axiom: "A masterpiece is not a masterpiece at the moment of its creation, but becomes one as it ripens with time." Certainly this one startled all observers at first glance save the one who counted most, the sitter for it, who, true to form, instantly

recognized the finality of its characterization. Any child, of course, can see the oddities in the drawing of the face, the appraising eye lifted so curiously, and the general mask-like effect of the whole, but Picasso knows all there is to know about facial construction and did what he did consciously. Evidently he was already toying with the scheme of "several aspects at once" that he brought to such riotous conclusions in the Dora Maar series of portraits put forth not so long ago. In any case, this Gertrude Stein portrait keeps her strangely alive and enables her to dominate any room in which she finds herself — much as she used to do at 27 rue de Fleurus.

Art News, February 1951

JACKSON POLLOCK

WISHING TO see the Jackson Pollock paintings at the Parsons Gallery I found it necessary to employ football manoeuvres to get in, the room being already so crowded. The scene if photographed might have been mistaken for an alcove of the Stock Exchange upon a busy day, but the disputants unmistakably were art students, not brokers. (You can always tell them.) For the most part they had turned their backs upon the pictures and were not pontificating about them but rather imploringly asking each other how they, too, could do masterpieces such as these on display. I felt like telling the nearest questioner that if he had been the constant reader of *Art News* that he should have been, he would have known exactly how to do them, for Mr. Alfred Barr explained away last spring to our readers how Mr. Pollock placed his canvases flat upon the floor and dripped paint on them from a height, uniting the

tactics of handball to the brushwork of the ancients, and thus coming upon his Hiroshima effects honestly. Peering over the heads of the students to see a portion of a Pollock, I thought it might be the one I had seen and admired at the Whitney Museum last year, but could not be sure, and part of another might have been the masterpiece that Mr. Hess commended in the current show of abstracts at the Museum of Modern Art. Paleontologists, of course, can reconstruct the whole animal for you from a mere segment of bone, but art critics have to have the whole picture in order to come to an opinion about it. For my part, on these occasions, I use the word "masterpiece" relatively, calling it Mr. Pollock's masterpiece, but not necessarily the world's masterpiece, though if the world later on insists upon it, as Hiroshimas both real and pictorial become more frequent, I shall assent to it amiably. For I take the world as I find it, not as I would wish it. I confess I enjoy this present student excitement about Jackson Pollock, whether it materializes into something more solid than excitement or not, and the more particularly, since Mr. Laurence Campbell, of the League's staff, tells me that the artist was once a pupil of Thomas Hart Benton! This wild departure of pupil from master puts a certain cachet upon Pollock. As a rebel he runs true to form and consequently will be watched.

Art News, March 1951

DR. BARNES R.I.P.

NOW THAT Dr. Barnes is dead all the tongues are loosed. . . . People can say anything, without fear of those dreadful reprisals — and believe me they will. That will be the danger

when the time comes to sum up the man's achievements and do justice to him. This time has come, of course, but just at the moment there is such a confusion of distorted anecdotes being hurled about that one hesitates to choose among them and there is the temptation to throw them all into the discard. And yet — and yet — the paralyzing terror which the amazing Doctor managed to put upon the entire American art world of this generation is something that will not fade quickly from the memory, and the chances are that in the final story it will assume an importance and an interest quite comparable to that of the great collection which he assembled, remarkable as that collection is.

So the biographers who are already, no doubt, sharpening their pencils and oiling their typewriters, will need plenty of help from the honest and unprejudiced persons whose contacts with the Doctor were beneficial in order to offset somewhat the defamations of those whose feelings got hurt when they were turned away with contumely at the doors of the Foundation in Merion. Oddly enough the small group of very distinguished citizens who were known to be on good terms with Dr. Barnes, including Professor John Dewey of Columbia, his late Excellency and still excellent Billie Bullitt of Philadelphia and Miss Kit Cornell of the New York stage, never, to my knowledge, came to his defense publicly when the victims of the Doctor's vituperation wished to vituperate back. I suppose he instructed them not to. I can easily imagine him saying: "I can handle this." And he did, marvelously effectively. I have known many brave and clever men who thought it the better part of valor to run for shelter when the Doctor began speaking up. Among these, for instance, was the famous John Quinn, equally astute as a lawyer and as a collector. His collection, in its day, was just as notable as that of the Barnes Foundation in this. He knew all the tricks of the law courts, was of the militantly Irish type, was accustomed to taking charge of the case when artists got into difficulties of any kind, and yet once on coming into collision with Dr. Barnes he decided, after thinking the matter over, that it would be wiser to keep out of the argument rather than win it, though certain that he could. This remained the model behavior which lasted for some time and those who ignored this pattern invariably came to grief. When the affair was over they always wished they hadn't.

My own acquaintance with the Doctor was not particularly illuminating. It began stormily enough, but ended after many years in an atmosphere of aimiability. I first heard of him in the early years when I was writing for *The Dial,* then edited by Scofield Thayer who was so princely in his attitude towards his writers that he never eliminated a comma from their copy without first consulting them by telephone. So I was vastly surprised one day to be called up and informed that *The Dial* would be obliged to cut out a little anecdote from my Paris letter involving Braque, Dr. Barnes and Gertrude Stein. I protested, thinking the story innocent enough and knowing that anything about Gertrude always, as we say, "went over big," but I protested in vain. I was told that the situation was unexplainable, but very serious, and that anything about Dr. Barnes could not be printed just then. It appeared that Dr. Barnes was at war with *The Dial*, threatening death and destruction, to the magazine and ready to use any means to accomplish his ends, and as a matter of fact, it is to the strain of this conflict that I have always attributed the nervous collapse of Scofield Thayer which followed shortly after and brought on in its turn the death of *The Dial.*

However, all that was not my affair. My moment came later. When the memorial show to William Glackens occurred at the Whitney Museum I gave an adverse report of it in the *New York Sun*, holding in short, that a first rate illustrator had become lost when the artist took up painting. I admired somewhat the first big picture put forth by Glackens, the *Chez Mouquin*, but the long string of imitation Renoirs that followed after it, and which were his chief claim to attention, were not for me. This comment created a commotion. The group of painters most closely united to the Whitney Museum, all of whom adored Glackens, for it seems he really was an adorable person, decided not to like me for a while and, furthermore, the news came to me, from that source, that the great Dr. Barnes of Philadelphia was also much annoyed. The specific message said that he was actually preparing two heavyweight boxers (one would have been enough) to come over to New York to give me a horse-whipping. This threat was too barbaric to be alarming and I paid no attention to it; and of course nothing of the sort happened. It probably was just one of those rumors with which Greenwich Village in those days was rife. But everybody knew, of course, that

Glackens had helped in making the first purchases for the Foundation, so it was reasonable to suppose that the Doctor might have said something to somebody.

However, time passed along. Quite a lot of time passed along, and then one morning I was both pleased and astonished to receive an invitation to be Dr. Barnes' guest at Merion upon the occasion of a reception to be given there for Vollard, the famous Parisian expert and dealer who first exploited the work of Cézanne. The invitation added that M. Vollard would honor us with an address – a double excitement and pleasure. I accepted at once though pondering somewhat upon my possible status as a guest. The invitation, I knew, I owed to Étienne Bignou whose galleries both in Paris and New York had always been closely allied to Dr. Barnes; but did the latter know? I wondered, and therin did the Doctor injustice. He never took chances on things like that. He knew precisely who his guests were to be. We were a rather gay party going down, almost filling a Pullman, and being met at North Philadelphia by a flock of motors which whisked us quickly to Merion. In one of these motors I had my first and only chat with Professor John Dewey, but at this late date I can't recall a word we may have said to each other – which makes me slightly ashamed of myself. At the gates of the Foundation we met with a hearty welcome and I found myself being greeted by name. Mrs. Barnes, too, made a point of seeking me out and being particularly kind, so that it became apparent that the former villain was now looked upon as a friend. M. Vollard's address was given in French, very rugged and invincibly bourgeois, like himself, and as soon as he sat down M. Bignou repeated it in meticulous English for the benefit of the Foundation's pupils, all of whom were in attendance. After these pupils had retired, the New York guests were allowed to wander at will through the many galleries and those who wished were fortified by glasses of whisky (and soda) of a quality not often met with. I reserved my allowance until after I had made the tour of the rooms for it was then I needed fortifying. Truly the collection, on first acquaintance, is a staggering one; but I won't go into it now further than to say that the three high points for me were: (1) the meeting again with the Cézanne *Card Players* which I had seen many years previously in Paris at the little Vollard gallery, carelessly stacked on the

floor and leaning against the wall; (2) the Matisse portrait of a Riff chieftain, which remains to this day one of my favorite Matisse masterpieces; and (3) the group of remarkable Soutines which gave me my first inkling of this artist's stature. By the time the dinner hour arrived we had all made sufficient discoveries to put us in a holiday mood and the table-talk was animated in the extreme. The dinner itself was admirable in every way, good food, more of that fabulous whisky (of which the Doctor was said to have an unlimited supply) and the sense borne in upon all of us that we were participating in a really exceptional occasion. If there had been the faintest touch of eccentricity anywhere in this entertainment I failed to notice it.

Again a few years passed and again I got an invitation to come see the collection, but this time, to my grief, I could not accept. The young Pinto boys (two of them, I think) were given a show in the Bignou Gallery and Dr. Barnes himself supplied the introduction for the catalogue. In my little notice of the show in the *New York Sun*, I saw fit to quote about an inch from Dr. Barnes' remarks. This pleased him inordinately and immediately he wrote asking me down for any week-end in May I chose, saying I could have the entire museum to myself after the pupils had left on Saturday, and adding that all that I wished of the famous Scotch would equally be at my command. This would have been the perfect chance to study both the collection and its owner, but unfortunately all my week-ends that May were already irreclaimably taken — and the opportunity never came again.

This is the sum of my experience with Dr. Barnes, not very illuminating, as I have already said, but showing at least that he could be kind and gracious. I suspect there were more of these private graces than he has been given credit for, and so I hope, when the biographers do get busy they will minimize the psychiatric approach, for so far we have had almost nothing but that, and play up the revelations that may be wormed from Dr. Dewey, Mr. Bullitt and Miss Cornell. How inestimable and clarifying a boon it would have been, in a situation like this, had there been by chance a dictaphone record of one of Miss Cornell's conversations with the Doctor on the subject of the difficult art of Soutine! But I don't imagine the fates arranged anything so satisfactory for us as that would have

been. There might, though, be some available notes in Dr. Dewey's diary – if he has one. I shall continue to look in that direction.

Art News, September 1951

HALF A CENTURY OR
A WHOLE CYCLE

IN THE first decade of this century when *Art News* was extremely young (born 1902), the term Hudson River School, as applied to American art, was a term of reproach, meaning not so much *native* as *native without style,* or – as we would say in the present state of our sophistication – *hick.* Style was something to be purchased in Europe, preferably in Paris where the most celebrated emporiums for it were located; and those who had already got some of it were the heroes of our preoccupation. That these heroes of fifty years ago, whose names were signed to the pictures that always got the best places in the National Academy exhibitions of those days, no longer "occupy" us, or at least not much, and have been succeeded at long last by a militant group of young painters and sculptors who boast the exactly opposite tentatives of wishing to separate from Europe rather than to cling to it, indicates that something like a cycle in our history has been achieved. Are we not now in 1952 peremptorily demanding and hesitantly claiming from our men the very qualities which once we refused to acknowledge in the works of our despised predecessors of the Hudson River School? For whatever else they

lacked they certainly had the quality of being to the manner born.

Actually, in those still youngish days of myself and my artist-friends, we knew too little of the Hudson River people to despise them. What we felt for them was merely vague indifference born of a superciliousness handed down by the snobs of preceding generations and accepted by us unthinkingly. Supposedly they were pathetic specimens unworthy of serious consideration and so we didn't bother with them. Who wished this evil-thinking upon us? Who launched a thousand ships to foreign shores to accommodate the mad rush of tourists, once we had learned to be ashamed of our Hudson River? I never did find out, but I suspect the seeds of it came over in the *Mayflower* and have lurked suspiciously in the byways ever since. Certainly as far back as I go in my studies I find traces of it. In 1843 the brilliant Margaret Fuller spent a *Summer on the Lakes* and wrote a book about it, visiting by boat Cleveland, Chicago and even remote Mackinaw. She was fascinated by the Indians and enraptured by the unspoiled beauty of the suburbs of the settlements, but being *über alles* a feminist, she wept copious tears over the tragic fates of the lady-wives of settlers, when they were ladies, as sometimes they were; for, being one herself, she knew precisely what the poor things were giving up for the sake of their exploring husbands, and in concluding her estimate of their predicament said this: "Everywhere the fatal spirit of imitation, of reference to European standards, penetrates and threatens to blight whatever of original growth might adorn the soil." This was in 1843, mind you, long before the flight of Henry James, George Santayana and boat-loads of lesser lights led worried observers into suspecting that, after all, our design for living, wonderful as it was, was not complete enough to satisfy all the requirements of the soul nor even the requirements of certain specialized eyes. Henry James, so Edith Wharton reported, "often bewailed to me his total inability to see the 'material,' financial and industrial, of modern American life." Wall Street and everything connected with the big business world remained an impenetrable mystery to him, and knowing this, he felt he could never have dealt with the American scene. George Santayana, after confessing that he never had much sympathy with those aesthetic souls that fled

from America because the "voices there were too rough," fled finally himself because of the leanness of the New England background against which he had been so uncomfortably but prosperously lodged for so many years. Although not quite a churchman, he yearned for the neighboring pageantry of the Church and is even now happily and unrepentently ensconced in a nursing home in Rome and breathing in the picturesqueness of ecclesiasticism and the sense of the past "for free," as we say, and without any special obligation to attend Mass. This wears only a slight aspect of cheating for, after all, Mr. Santayana was born a Spaniard and brought to the States quite as much as he took away. By the same token, and for the same reason, the voice of criticism is seldom raised against the painter John Singer Sargent, for without his own consent he was born, truly of American parentage, but in Italy, and actually, if not legally, was a European ever after.

But in regard to Kenyon Cox, thought by some, fifty years ago, to be an American Ingres; William M. Chase an American Manet; and John Twachtman, Alden Weir and Childe Hassam doing the Pissarro, Monet and Sisley stuff for us — the case is very different. All of them, vigorously advertised as evangelists of the foreign method of painting, ended in becoming self-conscious mannerists. It is true all of them were gifted and Twachtman and Weir were genuinely poetical, but their borrowed clothes did not fit them so well as they supposed and Albert Ryder, who knew next to nothing of foreign fashions and was poet first and painter second, was already taking rank above them in the public estimation. Their heyday was already declining in the period just before the first great World War, which was also the period when I was called in to look at their work professionally for the *New York Sun;* and it seems rather cruel, looking back at it from a distance, to note how brusquely they were shuffled off the pages of the newspapers to make room for the sensations of the famous Armory Show of 1913. Those of them still surviving at the time expressed their horror at the work of the Post-Impressionists and oncoming Cubists in screaming words which did no good. Their time was up and almost before we knew it they were buried in museums or in remote private collections and had dropped out of casual studio conversations.

With their eclipse something else dropped out of New York life which I can't help regretting. It may be that I was

younger then and more in contact with "goings-on," but I do believe more actually was going on, of a social nature, I mean, and that the artists had more fun. There was a closer link between artists and people-in-general than I can detect now. Mr. Chase gave a party for the great Carmencita in his studio the like of which has not been seen since (for Carmencitas are not frequent); Mr. Saint-Gaudens, so the medallist John Flanagan told me, occasionally asked in a lot of friends for a concert by a string quartet; and the excited attendance of "important people" at the Academy when a new Sargent portrait came along are part of my remembrance; and the second part of it is of a greater animation in Greenwich Village than exists there, I fear, at present. It is true, e.e. cummings still lives in Patchin Place and Edgar Varèse still resides on Sullivan Street, but the happenings in the Village life do not echo around the town as they used to. What "occasions" they were, to be sure, when *Emperor Jones* and e.e. cummings' *Him* were first played in the Provincetown Theater, and what a lot they did for the denizens of the quarter! And où sont les neiges d'antan?

Like all the other sinners of forty years ago I used to go abroad every summer and thought nothing of it until 1913, when, going over as a journalist I was obliged to look a little more concernedly at what I saw. Confronted with the mobs of American art students at the Cafés du Dôme and Rotonde, filling the sidewalks completely and at times making even the roadway impassable, suddenly the scales fell from my eyes and the spectacle shocked me. What are we all doing here? I asked myself angrily. Have we no life of our own that we must come here to find out what life is all about? — for there was scarcely a pretense that it was technique that the students were after. By that time it had been generally agreed that all the A.B.C.'s of painting and sculpture could be learned in America as well as elsewhere, and so at once on my return I began scolding about the truants I had seen. I even went so far as to print a lot of their names, begging them, like a holy missioner, to come back into the fold ere it was too late. Naturally none of them heeded the outcry. However, home they did come the very next year when the great war burst upon us. Convinced as I am that war consumes spirit as avidly as it does property and that Sir Norman Angell is quite right in declaring that no one ever wins a war, nevertheless most of

us, looking about to see what we could salvage from the ashes in 1918, secretly began to feel that what had been lost to the world in Europe would eventually be refound in America.

On their return, however, the prodigals complained that America had become a much harder place to live in than it used to be, and there did seem to me to be some truth in the accusation. The consolations of Greenwich Village, as I have already said, appeared diminished and in the more frequented parts of the metropolis the eye was hemmed in by hardness in every direction and the extraordinary newness of everything prevented the play of fancy. It was difficult to grow attached to a skyscraper and the streets had nothing else to offer. Years before this, Lord Houghton (Monckton Milnes), when visiting Walt Whitman had said: "Your people do not think enough of themselves. They do not realize that they not only have a present but a past, the traces of which are rapidly slipping away from them." Were he to revisit us now from the Shades he would more than think his prophecy confirmed by fact. New York has destroyed its past. It must be for that reason — for the total lack of mellowness — that our artists since the war turn more and more to hardness as a method of expression, and hardness, say what you will, is not lovable. Not only that but it constitutes a positive danger, keeping the nations with whom we would most like to be friendly at arm's length. André Siegfried has lately been studying the tendencies of civilization as they are manifested here in the United States, and in the last of his articles to appear in the *Figaro*, January 10, 1952, one finds this significant passage: "Il y a un idéalisme américain, c'est incontestable, mais il s'alimente d'appels matériels et s'exprime guère qu'en mesures quantitatives. De là vient, je crois, l'èchec de la propagande américaine dans le monde. L'esprit human demande encore autre chose."

Think that over, fellow-citizens. . . . Had this little memorandum of changes occurring within fifty years been attempted a month ago I should probably have ended it upon the above lugubrious note, and I should certainly not have used the word "cycle" in the beginning without some hope of justification for it, since that word suggests a return to a point completing a circle, but at the moment of this writing something of the sort seems to have happened. A few American artists, at long last, seem to have gone completely native, and for the first time since these wars, it has not been necessary to

stumble over references to Matisse, Juan Gris, Picasso, Léger, etc., etc., before arriving at the exhibitor's part of the work. I refer of course to the exhibition of "Fifteen Americans" at the Museum of Modern Art, and this may surprise you, for I have been told at the Museum that the show did not enjoy a "good press." This must have been, I am persuaded, because the press saw it only once, for the extremely large canvases of Jackson Pollock, Mark Rothko, Bradley Walker Tomlin and Clyfford Still are certainly breath-taking and bewildering at first contact. They take seeing. As far as I have heard, the accounts of them which you have already read in *Art News* are the only ones to grant the exhibition the importance which I, too, am convinced it has. The trouble hinges, of course, on this question of size. How big can you get with impunity? Immensity must be distinguished from inflation, a very bad word especially in these days; and simplicity, desirable as it is, must be kept away from the abyss where it vanishes into nothingness. But Tomlin, Pollock and Rothko use size as a weapon, and this is especially the case with Rothko, who unites it to simplicity to suggest the serenities and possibilities in vast regions on earth where people are not. Or, perhaps he merely looks at us from another planet. Dissenters there are to his right to do this sort of thing, and there will be many more to claim these gigantic pictures to be part of the irrepressible American braggadocio that Dickens and Kipling accused us of years ago; but for my part I conclude that when big sizes and largish styles say something, then big sizes and largish styles are justified. And Pollock, Rothko, Tomlin, Still, Lippold, Kiesler and Baziotes, in their various ways, say plenty. And at this, I hold, a new cycle begins.

Art News, June, July, August 1952

ENVOI

SHORTLY BEFORE *Henry McBride's death the Archives of American Art had asked for an interview to have a voice recording made of his thoughts on art. To have to speak while a recording machine was whirling away in the room frightened him, and he responded that he felt he was then too old and that one could place greater reliance on his written word.*

But a book with some of his writings Henry McBride did wish. During the late nineteen fifties he had consulted with Daniel Catton Rich about a reprint of his best contributions to The Dial. *A selection was made but it became apparent that these essays alone covered too short a period to reflect the scope of his work.*

After Henry McBride's death I reopened the subject with Dan Rich, who agreed to review all of Henry McBride's writings, both for the Press and for Art publications. It was a long and often unavoidably interrupted effort. Writings over a period of more than forty years had to be read and selections made. Regrettably, many important pieces had to be eliminated. The final choice forms the pages of this book — an always interesting, witty and informative story of the flow of art of Henry McBride's time.

My appreciation goes to Daniel Catton Rich for the fine selection he made, but also to my friends, Harold Ogust and Andor Braun, with whose help this book has now become a reality, fullfilling Henry McBride's most cherished wish.

Maximilian H. Miltzlaff

INDEX

447

R

S